Alfred H. Barr//Ina Blom//Otto Carlsund//Amilcar de
Castro//Lygia Clark//Lynne Cooke//Anthony Davies//
Stephan Dillemuth//Judi Freeman//Liam Gillick//
Ferreira Gullar//Peter Halley//Jean Hélion//Joe
Houston//Jakob Jakobsen//Fredric Jameson//
Reynaldo Jardim//Lucy R. Lippard//Sven Lütticken//
Nina Möntmann//Hélio Oiticica//Lygia Pape//Gabriel
Pérez-Barreiro//Mai-Thu Perret//Catherine Quéloz//
Gerald Raunig//Bridget Riley//Irit Rogoff//Emily
Roysdon//Meyer Schapiro//Claudio Mello e Souza//
Theon Spanudis//Hito Steyerl//Léon Tutundjian//Theo
van Doesburg//Kirk Varnedoe//Marcel Wantz//Franz
Weissmann//Stephen Zepke

WITHDRAWN

Abstraction

Whitechapel Gallery
London
The MIT Press
Cambridge, Massachusetts

Edited by Maria Lind

ABSTRACTION

Documents of Contemporary Art

Co-published by Whitechapel Gallery
and The MIT Press

First published 2013
© 2013 Whitechapel Gallery Ventures Limited
All texts © the authors or the estates of the authors,
unless otherwise stated

Whitechapel Gallery is the imprint of Whitechapel
Gallery Ventures Limited

ISBN 978-0-85488-208-3 (Whitechapel Gallery)
ISBN 978-0-262-51836-9 (The MIT Press)

A catalogue record for this book is available from
the British Library

Library of Congress Cataloging-in-Publication Data

Abstraction / edited by Maria Lind.
 p. cm — (Whitechapel: documents of
contemporary art)
Includes bibliographical references and index.
ISBN 978-0-262-51836-9 (pbk. : alk. paper)
1. Art, Abstract. I. Lind, Maria, 1966– editor of
compilation.
N6494.A2A228 2013
709.04'052—dc23
 2012030684

10 9 8 7 6 5 4 3 2 1

Series Editor: Iwona Blazwick
Commissioning Editor: Ian Farr
Project Editor: Sarah Auld
Design by SMITH
Justine Schuster, Maria Juelisch
Printed and bound in China

Cover, Doug Ashford, The Ordinary (2010) (detail).
Tempera on panel, 14 x 12.5 in. (35.5 x 31.5 cm).
Courtesy of the artist.

Whitechapel Gallery Ventures Limited
77–82 Whitechapel High Street
London E1 7QX
whitechapelgallery.org
To order (UK and Europe) call +44 (0)207 522 7888
or email MailOrder@whitechapelgallery.org
Distributed to the book trade (UK and Europe only)
by Central Books
www.centralbooks.com

The MIT Press
55 Hayward Street
Cambridge, MA 02142
MIT Press books may be purchased at special
quantity discounts for business or sales promotional
use. For information, please email special_sales@
mitpress.mit.edu or write to Special Sales
Department, The MIT Press, 55 Hayward Street,
Cambridge, MA 02142

Documents of Contemporary Art

In recent decades artists have progressively expanded the boundaries of art as they have sought to engage with an increasingly pluralistic environment. Teaching, curating and understanding of art and visual culture are likewise no longer grounded in traditional aesthetics but centred on significant ideas, topics and themes ranging from the everyday to the uncanny, the psychoanalytical to the political.

The Documents of Contemporary Art series emerges from this context. Each volume focuses on a specific subject or body of writing that has been of key influence in contemporary art internationally. Edited and introduced by a scholar, artist, critic or curator, each of these source books provides access to a plurality of voices and perspectives defining a significant theme or tendency.

For over a century the Whitechapel Gallery has offered a public platform for art and ideas. In the same spirit, each guest editor represents a distinct yet diverse approach – rather than one institutional position or school of thought – and has conceived each volume to address not only a professional audience but all interested readers.

Series Editor: Iwona Blazwick; Commissioning Editor: Ian Farr; Project Editor: Sarah Auld; Editorial Advisory Board: Achim Borchardt-Hume, Roger Conover, Neil Cummings, Mark Francis, David Jenkins, Kirsty Ogg, Gilane Tawadros

The abstract
draws artists towards itself
as a semi-autonomous zone
just out of

reach

Liam Gillick, *Abstract*, 2011

Maria Lind
Introduction//Abstraction

Why abstraction today? By some it has been argued that ever since its early twentieth-century formulations, abstraction never went away,[1] yet for a long period after the 1960s its presence was marginal. It can easily seem an obsolete phenomenon or redundant artistic strategy, but there are now a number of reasons for returning to abstraction, as it reinvents itself in relation to a diversity of twenty-first-century concerns. Since the late 1990s there has been a palpable interest in abstraction, particularly among young artists and other cultural producers, who have both recontextualized its formal legacies and re-situated it within performative, social interpretations. Furthermore, there is engagement with the idea of abstraction as it relates both to economic processes and to the politics of representation, in terms of the articulation, procedures and protocols that inform them. This formalist focus on the 'how' of things is an approach that has resonated in such differing realms as the so-called new public management of neoliberal governance and the Occupy movement that contests it.[2]

As an artistic and intellectual practice, with multiple expressions beyond the visual arts, one of abstraction's key characteristics is the capacity for self-reflection. Abstraction was first used explicitly as a visual strategy and aesthetic category by the artistic avant-garde in the early twentieth century. Although Paul Gauguin contended that all art is an abstraction, it is important to consider abstraction in its self-conscious and specific forms. Originally it was linked to social and political utopias, yet it is most commonly known through the post-war art criticism of Clement Greenberg and his followers, in which a focus on medium-specificity and self-reflexiveness creates a withdrawn space for visual art, resistant to narrative and to contamination by the legacies of war and fascism, or the emergent culture industry of late capitalism. Such different trajectories in abstract art's history reflect the variety of versions of abstraction at play from the beginning: contradictions, rifts and exceptions are typical of abstract art, even within one and the same oeuvre. To this day abstraction is characterized by the co-existence of ideal and matter, transcendentalism and structuralism – an ambiguity not to be shied away from but instead acknowledged and explored. This anthology suggests that we pay attention to and reconsider certain crucial features, some clearly 'worldly', others idealistic, and yet others that combine both aspects, that characterize abstraction's intriguing resurgence.

The focus here is on abstraction from the late 1950s to the present, less discussed than its precedents. The texts explore and complicate three main

strands: *formal, economic* and *social* abstraction (returning to the Latin origin of the word in *abstrahere*: to withdraw).[3] Several writings discuss aesthetic traits and structural approaches that adopt visual codes derived from the modernist employment and understanding of abstraction, and three texts from the pre-1945 period – by Alfred H. Barr, the first director of the Museum of Modern Art, New York; the American art critic Meyer Schapiro; and the European *Art Concret* group – are included due to their exemplary status in terms of influence on subsequent understandings of abstraction.

Formal Abstraction. Artists as diverse as Kazimir Malevich, Wassily Kandinsky, Aleksandr Rodchenko, Varvara Stepanova, Vladimir Tatlin, El Lissitzky, Olga Rozanova, Katarzyna Kobro, Piet Mondrian, Theo van Doesburg and Hilma af Klimt came to develop different and yet related forms of abstraction during the era covered by these earlier texts. They did so in a rapidly changing world marked by technological and political inventions that gave rise to polemical and conceptual responses by artists. Both the crass materialism of bourgeois mass culture and the advance of photography provoked a self-reflexive and idealistic enquiry into art and its function. The effects on art itself were manifold: fragmentation of form, the pushing of recognizable imagery to the limits, deep analysis of basic principles of painting and an interest in 'the machine'. Geometry was understood by many to have exceptional powers, and there was a crucial shift from the principle of simplification and reduction from the visible world to one of creating something entirely new. From the outset ornament and decoration play a certain role in abstract art; a sense of 'moral mission' recurs throughout its history; and a number of its proponents show an interest in architecture and space, viewing their practice in terms of 'construction'.

According to an influential genesis story, 1915 marked the introduction of abstract art in the form of Suprematism. At the legendary group exhibition '0:10', in a commercial gallery in Petrograd, all reminiscences of the material world were excluded from Malevich's paintings. Thirty-nine non-representational canvases, including the very first one entitled *Black Square*, were installed densely in one room. With *Black Square* Malevich moved from symbol to formula, a sign with its own right to life. A sign, furthermore, which has become the almost mythical point of origin of abstract art. According to the art historian Briony Fer this is precisely a myth, and instead of taking it at face value she questions the phenomenon of 'firstness'. Moreover, she repositions abstract art's canonical history, suggesting that collage rather than Cubism was a necessary pathway to abstraction's emergence.[4]

In addition to coining the term Suprematism, Malevich referred to 'non-objective' (essentially, non-representational) art, seeing these innovations not as isolated phenomena but part of a global development of art.[5] This internationalism

was shared by the avant-garde in general and the 'abstractionists'[6] in particular, many of whose members travelled widely. It survived in circles around concrete art after 1945. A second wave of abstraction occurred around 1930 when international but short-lived groups were formed, such as the Paris circles of *Art Concret, Cercle et Carré* and *Abstraction-Création*. Theorization often accompanied practical art-making among these and other artists working with abstraction. As part of the process of developing various abstract languages, the Russian Constructivists, for example, formulated the concept of *faktura*, i.e. the character of the pictorial surface. Here the texture is considered to have expressive power and the focus is oriented toward 'real' materials rather than the material as a medium of illusion. Artists such as Rodchenko and Stepanova experimented early on with purely pictorial elements such as surface qualities and the interaction between line and colour, but eventually combined this interest – the internal logic of formal invention – with a desire to transgress the border between high art and life. It was anticipated that a technological mode of vision would create a new subjectivity, which in turn would lead to a new type of citizenship. This may be contrasted with the stated metaphysical concerns, often elaborated in writing, of Malevich and Mondrian, who, in a manner that would become typical of much abstract art discourse, focus on the coexistence of immanence and transcendence.

The way the work of these artists, and abstract art more broadly, has been understood is highly informed by what Barr presented in his exhibition 'Cubism and Abstract Art' at MoMA in 1936. 'Abstract' can be both a verb and a noun, he states early on in the catalogue introduction, and is therefore an ambiguous term. In his typical manner of analysing and categorizing art in formal terms, he contrasts 'near-abstractions' – which, as in Futurism, Dada and Surrealism, retained some subject matter – with 'pure-abstractions', which earn most of his sympathies. Another dichotomy he proposes is between an intellectual, geometric, austere and logical abstraction that derives from Cézanne and Seurat and an emotional, intuitional, biomorphic or decorative abstraction that goes back to Gauguin and Matisse. Exemplars of the first tendency were early Soviet and European constructivism and concretism, of the second: Kandinsky and Abstract Expressionism.

Meyer Schapiro's 1937 essay 'Nature of Abstract Art' offers a different, even opposing, reading of abstraction. Here the author's commitment to materialist history is stated by moving away from abstraction as a phenomenon associated with transcendence and purity. Instead, he argues for the need carefully to ground interpretations of abstraction in specific and concrete conditions. This runs contrary to Barr's ahistorical and universalist formalism but also cautions against overly simplistic material interpretations of avant-garde art. In comparison the *Art Concret* group's 1930 manifesto *The Basis of Concrete Painting*

is radically self-referential. It calls for a universal art that consists solely of planes, colour and absolute clarity, exploring the idea of creating the entirely new, without reference to existing surroundings. Moreover, it asserts that artworks can be conceived in advance of execution. Concrete art in this tradition, in particular by Max Bill and the so-called Zurich school, came to bridge the pre-war and post-war periods, connecting abstract practices and traditions otherwise considered far apart.

Both immediately before and after the Second World War concrete art was considered the apex of contemporaneity and internationalism. Artists from Eastern Europe to Latin America and Asia shared both a reduced, non-representational geometric language and a belief in universal progress. For them concrete art was sophisticated and engaged, quintessentially of the time. It pointed straight to the future, without historical baggage. A whole network of galleries, institutions and events – such as the Galerie Denise René in Paris, the São Paulo Bieñal, founded in 1951, and Zagreb's 'New Tendencies' (*Nove tendencije*) exhibitions of 1961, 1963 and 1965 – facilitated the visibility and discussion of this constructivist-inspired movement. Artists themselves travelled across continents and political borders to exhibit together. One term for this type of art was 'cold' or 'systemic' abstraction, often contrasted at the time with the gestural and intuitive 'hot abstraction' of lyrical versions such as *art informel* and tachism – the former name coined by the critic Michel Tapié in 1950 and the latter in 1954 by his colleague Charles Étienne to describe, sometimes interchangeably, the work of artists such as Hans Hartung, Henri Michaux, Jean-Paul Riopelle and Wols.

In stark contrast to the pre-war groups and the trans-war concretists, a number of affiliated but individually working young artists emerged in New York during and after the Second World War. Artists such as Jackson Pollock, Mark Rothko, Clyfford Still and Barnett Newman aimed at visualizing absolute feelings by means of abstraction.[7] Mostly in large-scale, non-representative and performatively executed paintings, they wanted to evoke the tragedy of existence, overbearingly actualized in the atrocities and aftermath of the war. In a manner typical of the abstract expressionists, Rothko saw the self as the main subject matter and art as a metaphysical exercise. Art was universal and absolute; it functioned as a visualization of pure ideas. If one wants to find the basic, metaphysical truth of life, painting is the answer in Rothko's universe. At the same time he understood transcendence to be non-depictable. He wanted to convey the symbolic without symbols. Furthermore, the phenomenon of presence was crucial to his own work, based on a radical pictorial conception.

Functioning as an overview of post-war abstraction in the United States, Kirk Varnedoe's essay emphasizes the tension between its new, often high-strung, forms compared to the European avant-garde, and the resistance to its

foundations. An artist such as Newman argued that the Americans penetrate nothing less than the 'world-mystery' in order to capture the truth of life. They should generate forms that correspond to abstract intellectual content, and not paint 'design-images'. This is the term that Newman gives to what he takes to be empty and decorative painting based on geometric forms. Instead, like the Creator, the abstract post-war painter attempts to 'wrest truth from the void'.[8] Moving swiftly between works by Pollock, Jasper Johns, Frank Stella, Donald Judd, Sol LeWitt and other US artists, and searching for abstract hybrids, Varnedoe juxtaposes the physicality and directness of Pollock's work with Johns' deadpan and cool attitude. An important aspect of the text, which points to current concerns with articulation, is its emphasis on the actual making of art and the significance of taking a close look at abstract art, to experience it in the flesh. The less there is to see, the more important it is actually to look closely.

Together with Paul Klee, Anni and Josef Albers, Newman helped broaden the understanding of impulses towards abstract art by emphasizing the importance of Native American work. Amerindian abstraction significantly questions dominant formalist versions of abstraction heralded in the US since 1945. This type of abstraction is connected with aesthetic experience bound to symbolic functions and is manifested as an integral part of the applied arts, which in that context is the central artform. The dichotomization of art/artefact is the foundation for the neglect of the applied arts, the latter's frequent use of abstract languages, and the evaluation of non-Western art.[9] It is noteworthy that Newman was against art history, despite his lifelong preoccupation with Mondrian's work. Instead he turned towards 'native art' for inspiration in relation to abstraction. He saw this form of 'abstraction' as 'real', rather than the abstraction of the avant-garde, which in his view was merely formal abstraction of the 'unknowable'.[10] This is not unlike Barr's distinction between 'near-abstractions' and 'pure-abstractions', but with entirely different references.

Another influential example of expanded art-historical perspectives on abstraction was the 1985 exhibition 'The Spiritual in Art: Abstract Painting 1890–1985' at the Los Angeles County Museum of Art, accompanied by Judi Freeman's extensive glossary in the catalogue. Since then it been impossible to overlook the many connections between abstraction and spiritualism in which cosmic imagery, vibrations, synaesthesia, duality and sacred geometry play central roles. Kandinsky and spiritualism, Mondrian and theosophy, Duchamp and alchemy are just three examples of such preoccupations. As opposed to Barr, the curator Maurice Tuchman contended that Cubism was not as central in the transition from representation to abstraction as notions of spirituality and symbolism.

Bringing in a wider geographical, political and social horizon, Gabriel Pérez-Barreiro's text also moves beyond the implication that abstract art is homogenous

and universal. Instead of cementing ideas of original-copy, centre-periphery and clichés about the Other, he encourages us to examine both the intention and the specific contexts of geometric abstraction in Latin America from the 1930s to the 1970s. Concrete art in Argentina, for example, was implicated in broader political struggles than in Europe. Latin-American artists were often accused of being derivate of the European avant-garde whereas in fact they developed a new, syncretic form of abstraction based on mutation and blending. The critic Luis Enrique Pérez-Oramas has called this phenomenon 'alterform', signifying complex intellectual transmutations.

In this culturally rich environment, the collectively authored Neo-Concrete Manifesto gives voice to the urge of Rio de Janeiro-based artists and critics such as Lygia Pape, Lygia Clark and Amilcar de Castro to counter the rational tendencies of concrete art both locally and internationally. For them art could be a mode of emancipation. The purpose was to demystify and destabilize aesthetic and commercial value through the use of the body, the senses and the subjective. Pape's formally diverse body of work participated in neo-concretism's overturning of the taxonomy of art in general, and the rationalism of much concrete art in particular. Geometric rules are first obeyed, in her early woodcuts and wooden reliefs, and later disobeyed, allowing forms to lose both their purity and hierarchy. In performative, anthropologically inspired videos, and installations with metal wire and light, new syncretic forms of abstraction eventually took shape.

Similarly, Hélio Oiticica took his own phenomenologically inclined work, where structure, colour, time and space fuse, as the starting point for discussions about the relationship between concrete and neo-concrete art. Like his colleague and friend Lygia Clark, he had started as a painter in the tradition of concrete art, at first absorbing but then reinventing the languages of constructivism, underlining the experimental, experiential and even emancipatory aspects of art. In his text he distinguishes between non-objects, elsewhere described as pluri-dimensional structures, and work within the tradition of concrete art. The former tend to be dynamic and temporal and the latter static and analytic. Like action painting in the US, Oiticica's maquettes – large, coloured pavilion-like constructions – and his large-scale paintings are performative. They offer a life-experience of colour. His interest, here, is to move away from the picture plane, as a conservative element of representation, towards structures that become temporal.

A parallel take on post-war abstract reinvention is Lucy Lippard's essay and exhibition 'Eccentric Abstraction'.[11] Looking at work by, among others, Eva Hesse, Lee Bontecou, Bruce Nauman and Louise Bourgeois, and introducing notions of sensuality and irreverence, Lippard offers a vigorous alternative to rational forms of abstraction, drawing on some of biomorphic abstraction's surreal tendencies. Although eccentric abstraction is often manifested in sculptural works she argues

that it has more in common with abstract painting, for example in its use of colour. New materials generating unexpected surfaces, and shapes and colours evoking sensual experiences are introduced, sharing Pop art's naughtiness and perversity. This also relates to non-objective art's self-confidence. Other characteristics are formal wholeness; long curves that are both voluptuous and mechanical; incongruity, where opposites become complementary rather than contradictory; and the absence of a form-content dichotomy. A single form often combines image, shape, metaphor and association, triggering an erotically suggestive aesthetic experience. Having been described by others as 'sick' and 'the aesthetics of nastiness', 'the rhythm of post-orgasmic calm instead of ecstacy' is how Lippard chooses to describe the style. Compared with figuration, she maintains that abstraction remains a more potent tool of the unfamiliar.

Joe Houston argues that the contemporaneous development of Op art – a decorative synthesis of art, science, technology, physics, optics and experimental psychology – was one of the most commercialized and therefore popularly spread forms of abstraction. Artists such as Julian Stanczak, Bridget Riley and Richard Anuszkiewicz relied on the legacy of concrete art at the same time as they were trying to deal with mass culture and the modern technological world. This perceptual version of abstraction was mediated and disseminated through a global network of, among others, galleries and collectors devoted to constructivist aesthetics. With nodes in as diverse locations as Brazil, Croatia, Switzerland, France and Sweden, concrete art continued the internationalist spirit of pre-war abstraction. 1965 was the year when Op, thanks to the exhibition 'The Responsive Eye' at MoMA, New York, became synonymous with perceptual abstraction, at the moment when public interest in art was growing and the desire to consume was flourishing. Like Varnedoe with abstract art in general, Houston underlines that Op art insisted on experience, not least immediate experience, as a form of knowledge that places the viewer centre-stage. That the viewer needs to be in the limelight in Op art is forcefully argued by Riley as well, in her 1965 text 'Perception is the Medium'. Since 1961 Riley has limited her vocabulary to abstract shapes. Here abstraction is the effect of an intense experience of sight, and part of explorations of equivalences and parallels, rather than illustration.

Another contemporaneous version of abstract art was so-called post-painterly abstraction, as expressed in the work of Helen Frankenthaler, Morris Louis and Jules Olitiski, among others. The term was invented by Clement Greenberg to describe the work based on sharp and lucid colours, thin layers of paint and lack of tactility in an exhibition at the Los Angeles County Museum of Art in 1964. 'Hard-edge painting' was originally used around 1960 to describe the work of mainly California-based artists such as John McLaughlin and Lorser Feitelson. Eventually the term referred to painting from the US which showed an economy

of form with clean and clear abstract shapes and fullness of colour. The Zero Group in Germany, the first transnational European group after the Second World War, whose members included Heinz Mack, Otto Piene and Günther Uecker, explored 'new beginnings' through a reduced vocabulary employing light, movement, objects, actions and magazines, among other elements. Like the Zero artists, Frank Stella turned away from colour and instead focused on structural and compositional problems of abstraction. Simplicity in general and flatness in particular were important, and he was striving for non-relational compositions which were able to avoid the balance of earlier, European, geometric art. In Stella's case the painting should be impersonal, dispassionate and even non-metaphysical. 'What you see is what you see': the painting had become an object.

The monochrome embodies some of the features of Stella's work. Since the early twentieth century it has stood for the limits of abstraction. Thus it has also been associated with the death of painting. In the hands of Malevich, Rodchenko, Yves Klein, Piero Manzoni and Robert Ryman it represents ultimate radicality but also muteness. However, it is clear that the meanings range from the aesthetic to the social and political. It is simultaneously mystical and concrete – the metaphysical, spiritual and immaterial on one hand, and on the other, the literal, the materially present.[12]

Another artist whose work operates within the field of abstraction yet mutates it is Blinky Palermo. His limited oeuvre has become known for its artifice, humour and decoration, replacing German traditions of romanticism, expressionism and the 'spiritual'. He was a student of Joseph Beuys in Düsseldorf and a collaborator of Gerhard Richter. The topic of Lynne Cooke's essay is the radically different readings by a number of art historians of his irregularly shaped small objects with intensive colours, paintings made of commercial cloth, and wall paintings hovering between the phenomenological and the banal. These interpretations range from the formalist and transcendental to the socio-economic and conceptual but all testify to the 'porosity' of Palermo's work, a feature not unusual within abstract art.

Abstract painting of the 1980s is often connected with Günther Förg on one hand and Peter Halley on the other. Both use the idiom of abstract painting with ease. Förg developed yet another approach to abstraction: the unlikely combination of abstract painting and photography which is the focus of Catherine Quéloz's text. He uses a restricted but varied formal vocabulary, for example in his 'duochromes'. The paintings are formally reduced, taking on board space in general and architecture and the exhibition space in particular. Unlike Abstract Expressionism, there are no spiritual claims here, although the works are made in a lively and rather spontaneous way, with a certain speed in execution. Instead of working with the notion of 'gesture' he employs 'attitude'.

Economic Abstraction. Another set of texts, all dating from the 2000s, engage with abstraction through the consideration of an increasingly abstracted world in terms of its economic, social and political conditions. Such economic abstraction is primarily dealt with in art as a subject or theme. A background here is the Marxist stipulation that in capitalism there is a crucial difference between use value and exchange value, and that the process which makes this possible is one of abstraction. Fredric Jameson draws a parallel between such abstraction at play in the metropolis and in modernism. With the power and influence of finance capital, where money is turned into sheer numbers, a new kind of immaterial value arises, together with a new form of abstraction. This abstraction is associated with postmodern art, as well as with the less palpable abstraction of logos and images which, like financial capitalism, take on a life of their own. They become 'autonomous', in parallel with value in financial capitalism. Jameson's main question here is how this new abstraction of value affects lived experience. He argues that ideas of temporality, rather than image theory, can help us understand this. As opposed to the long cycles of earlier capitalist epochs, the current stage is characterized by rapid change and daily speculation, leading to new patterns of investment and consumption. Thus the ideology of communication in general in late capitalism and the primacy of language in particular stimulate a focus on temporality which for Jameson is oriented neither to history nor to the future. Instead it signifies a form of suspension of time. Once more, abstraction is identified as being 'out of time'.

Peter Halley is also concerned with abstraction's relation to time. He de-emphasizes the formal aspect of abstraction and instead points out that both the disjunction of time and space and the use of the model as a form of representation are essential to understanding an ever more abstract existence. He goes on to argue that abstraction is the main intellectual technique of the twentieth century. Halley's understanding of abstraction recalls one of the first elaborations on the nature of abstract art as symptom of societal and cultural conditions: *Abstraction and Empathy: A Contribution to the Psychology of Style* (1907), by Wilhelm Worringer. Why and how the urge for abstraction occurs in Egyptian, Byzantine, Mediaeval and Expressionist art of his own time is the focus. Suggesting that aesthetic subjectivism and its focus upon empathy leads to the use of organic and naturalist forms rather than abstract ones, Worringer speculated that abstraction originates in inner unrest, effected by conditions in the external world – the more turbulent the outer world, the more abstract the art. However, according to Worringer abstraction is more instinctive than spiritual and intellectual; calm is instigated by extracting individuality from depicted objects so as to distil their most typical features.

One of the key texts in this group is Sven Lütticken's 'Living with Abstraction'

(2008). Referring to the ideas of Theodor Adorno, Peter Osborne and others, he elaborates on how abstraction is universally implemented through capitalism, drawing connections between the abstraction of social and economic conditions and those mechanisms that turn abstract concepts into code. All this happens within a culture with plenty of abstract art, and an economy in which we literally 'live under abstraction'. This has been extended to the logic and distortion of scale engendered by the post-Fordist/late capitalist economy. The conditions of work and production are other pertinent points of reference here, as well as the abstract nature of modern finance. With a similar backdrop, and by proposing the idea of the 'style site' – an unorthodox linking of topics, objects and times, as in the work of Liam Gillick and Tobias Rehberger – Ina Blom assigns new roles to artistic abstraction. Style sites complicate the relationship between aesthetic and affective forces in capitalism, on one hand, and the productive value of obliqueness and hermeticism on the other.

In her contribution Hito Steyerl identifies 'the uncertainty principle of modern documentarism', in which a military version of abstract expressionism appears in cell phone photographs from Iraq. The closer you get the less there is to see. This uncertainty principle should not only be seen as a problem but as the most important feature of documentary practices today. To question truth claims has always been part of their history and Steyerl urges us to focus on the 'intensity of the problem of truth' as it appears now. One way in which this is played out is the tension between assumptions that documentarism is enlightened and critical and the fact that documents tend to be 'condensations of power'. This points to the fact that the significance of documentary forms lies more in how they are organized than what they depict, a consideration of issues of articulation which is the backbone of abstract art. Today they are partaking in affective economies, like the colour-based terror alert in the US discussed by Brian Massumi that is an example of how the formal powers have taken on 'the artistic gesture of abstraction'. We are beyond the aestheticization of politics – now politics are closer to pure perception and become aesthetic as such. At the same time as politics move beyond representation, political and symbolic representation are both undermined and become abstract. They are post-representational, and yet they somehow speak of truth: the cellphone pictures express the uncertainty that governs documentary image production as well as the contemporary world. Or they are, as Steyerl writes, 'perfectly true documents of that general uncertainty'.

The urge to think of abstraction both phenomenologically and ontologically, rather than only formally, is also present in Deleuze and Guattari's notion of 'art as abstract machine'. They maintain that aesthetics equals experience and that art permanently researches its own conditions. Stephen Zepke's contribution

highlights that 'art as abstract machine' is an imperative which urges action – not representation but construction, not just a new reality but a new kind of reality. It offers an 'onto-aesthetics' of art. The main features of art as abstract machine are matter and function, and yet it has no form and does not represent anything. It 'constructs construction', which comes close to a DIY approach, and construction and expression are its main dimensions. The abstract part of the machine is, on one hand, that which is model-like, and on the other, that which is neither subjective nor objective. Art as abstract machine deterritorializes the palpable world while stimulating new communities and new methods of self-organization.

Social Abstraction. The third strand examines the emergence in art practice of social strategies of abstraction, or withdrawal. Among other things, social abstraction implies stepping aside, a movement away from 'the mainstream', suggesting the possibility that artists could have more space to manoeuvre within self-organized – 'withdrawn' – initiatives in the field of cultural production. Notions of autonomy are often explored within social abstraction. Although it may look like escapism it is more like a retreat, an attempt to gather strength in tough situations. It is about checking out of preconditioned patterns. To be left alone, a temporary rather than permanent check-out, which can be likened to a strategic rather than essentialist form of separatism. Thus social abstraction is primarily an organizational and methodological – performative – form of abstraction.

'Collective autonomy' is a concept that involves a form of non-individual detachment, based on the terms of cultural production set by the market and by the State, now increasingly run on a business model.[13] Anthony Davies, Stephan Dillemuth and Jakob Jakobsen collaborated on a manifesto, *There Is No Alternative* – the name taken from the famous right-wing doctrine – that adopts capitalism's own methods of opacity and flexibility in order to counter neoliberalism. Thus they opt for a separatist, radical withdrawal from the mainstream, including its institutions. Their alternative is self-organization in its many different formations. In the curated project *Opacity*, curator Nina Möntmann and artists such as Kajsa Dahlberg and Gardar Eide Einarsson employed collective methods in institutions in Oslo, Vienna and Stockholm to research, analyse and produce an alternative to the ever more tangible imposition of populist programmes in art institutions. Working with opacity, or partial withdrawal, questioning whether it is possible to achieve an opaque political activism, they explored the idea of a kind of activism that would allow individuals to be politically active without being politically organized.

For Irit Rogoff, smuggling is a useful metaphor for the type of semi-clandestine and trespassing theoretical and curatorial practice in which she and several others engage. In such an activity, borders are not necessarily

it is
at its core
a
non-identity
/
a tool
that doesn't require
a cohesive
identity
or
voice
to enter into negotiation
with others
/
it may reside
within social forms
but doesn't need to
take on
an identifiable
social form
itself
/
contagious
and
inclusive,
it disseminates
and
multiplies

Anthony Davies, Stephan Dillemuth, Jacob Jakobsen, 'There is No Alternative: The Future is Self-Organized', 2005

respected and that which is rejected does not have to be repeated. This is valuable in 'the production of new subjects in the world', her stated concern in this collaborative project involving another theorist and an artist. 'Embodied criticality' is her own term for this shift away from more detached criticism and critique to a criticality that is implicated and kind of secret at the same time. Conditions of production are also central to the work of Mai-Thu Perret, who since 1999 has worked on a fictive 'master narrative' entitled *The Crystal Frontier*, which deals with a group of young women who have dropped out of contemporary urban life and retreated to the desert to form a self-sustained commune named New Ponderosa Year Zero, in the Southwest of the United States. *The Crystal Frontier* is manifested in a variety of forms, such as excerpts of the text printed on posters, sculptures, garments and installations. We follow these women as they start from scratch but eventually create a kind of institutional machine that produces new forms of subjectivity.

Liam Gillick's *Abstract* is an abstract piece of art in itself, consisting of a commissioned text and a sequence of black and white images. In dense terms it explores the tension between the abstract and the concrete. He argues that the attraction of abstraction is that it is a semi-autonomous zone, albeit one that is essentially out of reach. Nevertheless artists keep on trying to forge the abstract, even if it is about the representation of something impossible. Therefore the abstract involves both neo-romanticism and failure, and Gillick himself expresses the desire to make the abstract more concrete. This is formulated by someone who is somewhat of a pioneer of contemporary abstraction, cutting across the concerns of abstract art via the 'applied' arts, utopian ideas, post-minimalist formal reduction, the simulacra-inspired abstraction of the 1980s and contemplation of both economic and social abstraction.

The fourth and final manifesto in the volume addresses withdrawal, resistance and pleasure. Emily Roysdon's *Ecstatic Resistance* wants to 'celebrate the impossible' by taking resistance as something pleasurable. She argues for the importance of embodied, lived experience and the necessity of reorganizing the cultural imaginary and reimagining political protest. In addition to being a manifesto, *Ecstatic Resistance* exists as artwork, practice, partial philosophy, set of strategies and group exhibitions. In 2010 two 'sister' exhibitions were on view simultaneously in Kansas City and New York, involving work by artists such as Sharon Hayes, Yael Bartana, Adrian Piper and A.L. Steiner. The text breathes a desire to be firm and playful at the same time, to 'queer' normative behaviours. For example, Joseph Beuys' softer-sounding 'social sculpture' – embodying the notion that every individual can be an artist – here becomes 'political sculpture', a tougher form of engagement, in which change is demanded on a formal level.

A different form of resistance is at stake in Gerald Raunig's essay, which

situates the debate on abstraction and withdrawal within the tradition of institutional critique. He favours less reactive forms of resistance. In his discussion of the value of 'instituting', he emphasizes the importance of finding new forms of institutional criticism. This is a procreative approach to criticism inspired in part by Michel Foucault's 'non-escapist terms of escape', which involve a measure of withdrawal but at the same time shape something new. While being philosophically grounded, the text is at the same time sympathetic to self-organization in general and activist approaches in particular. There is a sense of perceived urgency, which in today's culture and society more often takes the shape of organizational and opinion-forming condensations and intensifications. Abstract art's legacy of risk-taking finds a contemporary translation here.

To create the entirely new was central for an artist such as Mondrian. Even if today his idea that art's purpose is to express true and universal reality is hard to embrace, he also drew attention to other aspects that still pertain to abstraction. A distinct difference between the discussion around abstract art in the twentieth century and today is the disappearance of the rhetoric of 'the absolute', 'truth' and 'the universal'. The grand narratives have become micro-utopias. More relevant, however, is Mondrian's idea that contrary to common assumptions abstraction is not a means to simplify something but to intensify. Moreover, 'pure abstract art' is the most objective possible rendering of the world; it is, in his terms 'true Realism'.[14] The thought that abstraction is the most apt way of describing contemporary existence is shared by several contemporary thinkers. In Antonio Negri's 'Letter to Gianmarco on the Abstract', written to the painter Gianmarco Montesano in 1988, the abstract is described as a new kind of nature, and community, that we inhabit. In a postmodern world where everything is 'factitious' (man-made), we plunge into the abstract. Like art when it became abstract a century ago, this reveals a new quality of being. It might not be the most pleasurable experience but, like being in prison, Negri argues, it is a way of reaffirming life, albeit in an odd way.[15]

While attempting to define modernism as a philosophical concept which is bound neither to a historical period nor a social domain, the philosopher Peter Osborne has rather sweepingly stated that the modern is a real abstraction. This enables the modern to be translatable to various times and places, thanks to its genuine abstractness.[16] The Martiniquan writer and critic Édouard Glissant made a defence of opacity based on its opposition to the Western obsession with transparency and discovery. Historically, transparency has been deployed to reduce 'the other', but opacity does not allow this kind of reduction.[17] However, according to Glissant, the opaque does not have to be completely impenetrable – there is a degree of openness to the shield, but this is at the discretion of those instituting it; in other words, those who claim the right to difference and self-determination.[18]

1 See, for example, Mark Rosenthal, *Abstraction in the Twentieth Century: Total Risk, Freedom, Discipline*, catalogue (New York: Solomon R. Guggenheim Museum/Harry N. Abrams, 1996). In this perspective, there have been no neo-abstract movements since the 1960s.

2 A number of exhibitions and publications have highlighted the resurgence of abstraction within contemporary art. 'Abstruction', with work by Jessica Bronson, Yunhee Min, Jessica Rankin and Lisa Sigal, addressed narrativity, architecture and craft in relation to abstraction, curated by Eungie Joo at Artists Space, New York, in 2003. Artists such as Dave Hullfish Bailey, Kasper Akhöj and Mariana Castillo Deball explored the tension between abstraction and concrete social circumstances in 'Abstract Derive' at Ludlow 38, New York, in 2010. It was curated by Axel John Wieder and Tobi Maier. The same year, 'Abstract Resistance', including work by artists as diverse as Willem de Kooning, Lynda Benglis, Thomas Hirschhorn, Gedi Sibony and Cathy Wilkes, was on view at the Walker Art Center in Minneapolis. The exhibition dealt with the abstract qualities of death, violence and conflict. Yasmil Raymond was the curator. Publications include the 'Neue Abstraction' special issue of *Kunstforum* in January/February 2011 and Bob Nickas, *Painting Abstraction: New Elements in Abstract Painting* (London and New York: Phaidon Press, 2009).

3 Some of these questions are also part of the research project *Abstract Possible* which follows, examines and complicates the three tendencies discussed in the introduction: formal and economic abstraction, and 'withdrawal-strategies'. *Abstract Possible*, which I initiated and curated, is a research project in the sense that it evolved over a longer period, exploring a set of questions in relation to physical and spatial articulations which in turn led to further iterations. *Abstract Possible* developed in collaboration with a number of hosting institutions and organizations, in episodes over a period of three years. The institutions were linked more coincidentally than conceptually, as several of the iterations have followed on invitations which I received independently of one another and to which I responded by proposing something to do with *Abstract Possible*. It started in the project space of Malmö Konsthall with 'Abstract Possible: The Trailer' in November 2010. A number of artists – such as Doug Ashford, Claire Barclay, José Léon Cerrillo, Goldin+Senneby, Wade Guyton, Mai-Thu Perret and Walid Raad – were asked to participate in more than one of the sub-projects: 'Abstract Possible: The Tamayo Take' (Museo Tamayo, Mexico City, March to August 2011); 'Abstract Possible: The Zurich Test' (White Space, University of Zurich, May to June 2011); 'Abstract Possible: The Stockholm Synergies' (Tensta konsthall, Bukowskis auction house and the Center for Fashion Studies, Stockholm University, January to April 2012); 'Abstract Possible: The Birmingham Beat' (Eastside Projects, Birmingham, England, October to December 2012); and the final iteration at the Künstlerhaus Stuttgart in Spring 2013, followed by a book documenting the entire project.

4 See Briony Fer, *On Abstract Art* (New Haven and London: Yale University Press, 1997). Her reading of abstract art is psychoanalytically informed and emphasizes the fantasies, anxieties and pleasures involved in work by, for example, Malevich, Mondrian, Jackson Pollock and Eva Hesse.

5 When Solomon Guggenheim opened his first museum in Manhattan in 1939 it was called the Museum of Non-Objective Painting.

6 Rosenthal uses this term, see note 1.

7 Harold Rosenberg, 'Action Painting (1952). This is an influential essay on the painterly abstraction of the New York school.

8 Barnett Newman, 'The Plasmic Image' (1945); reprinted in *Barnett Newman: Selected Writings and Interviews*, ed. John P. O'Neill (Berkeley and Los Angeles: University of California Press, 1990).

9 See César Paternosto's introduction to *Abstraction: The Amerindian Paradigm* (Societé des Expositions du Palais des Beaux-Arts de Bruxelles, 2001).

10 See Barnett Newman, 'The First Man Was an Artist' (1947), and 'The Sublime is Now' (1948); reprinted in *Selected Writings and Interviews*, op. cit.

11 The exhibition 'Eccentric Abstraction' took place at the Fishbach Gallery in New York in the autumn of 1966. Lippard's text of the same title describes the work of a wider range of artists than were included in the exhibition.

12 See *Monochromes: From Malevich to the Present*, ed. Barbara Rose (Berkeley and Los Angeles: University of California Press, 2006).

13 See, for example, Brian Holmes, 'Artistic Autonomy and the Communication Society' (2003), in *Unleashing the Collective Phantoms: Essays in Reverse Imagineering* (Brooklyn: Autonomedia, 2008) in which he evokes this idea of collective autonomy in relation to contemporary artistic production in order to facilitate greater self-determination in the making of collective imaginaries. He also directly connects it with art as the ultimate commodity in the wake of the policies of the Reagan-Thatcher era, as well as the Third Way politics that have led to investment banks and corporations becoming central sponsors of art institutions. Referring, on one hand, to the work of the sociologist Cornelius Castoriadis, and on the other, to the activist artist group *Bureau d'études* he emphasizes the importance of imagining other possible realities. The strategy of exiting and taking the matter into your own hands, like the various forms of counter-globalization protests, is promoted as a viable alternative. Collective autonomy is here taken to be a distinctly shared experience, as opposed to the rhetoric of individualism that often accompanies the idea of autonomy.

14 Piet Mondrian, 'Toward the True Vision of Reality' (1942), in Mondrian, *Plastic Art and Pure Plastic Art* (New York: Wittenborn, 1945).

15 See Antonio Negri, *Art and Multitude* (1990) (Cambridge, Massachusetts: Polity Press, 2011).

16 See Peter Osborne, *Philosophy in Cultural Theory* (London and New York: Routledge, 2000).

17 See Édouard Glissant, 'For Opacity', in *Over Here: International Perspectives on Art and Culture*, ed. Gerardo Mosquera and Jean Fisher (New York: New Museum of Contemporary Art/Cambridge, Massachusetts: The MIT Press, 2004).

18 This recalls Gillick's distinction between the transparency-driven artists of context art and the opacity-inclined artists affiliated with the so-called relational aesthetics. Not surprisingly there are more attempts at abstraction among the latter.

coloured structures

function organically
in a fusion of elements

and are a separate organism
from the physical world

Hélio Oiticica, 'Colour, Time and Structure', 1960

FORMAL ABSTRACTION

Alfred H. Barr
Cubism and Abstract Art//1936

Abstract

[...] 'Abstract' is the term most frequently used to describe the more extreme effects of [early twentieth-century art's] impulse away from 'nature'. It is customary to apologize for the word 'abstract', but words to describe art movements or works of art are often inexact: we no longer apologize for applying the ethnological word 'Gothic' to French thirteenth-century art and the Portuguese word for an irregular pearl, 'Baroque', to European art of the seventeenth century. Substitutes for 'abstract' such as 'non-objective' and 'non-figurative' have been advocated as superior. But the image of a square is as much an 'object' or a 'figure' as the image of a face or a landscape; in fact 'figure' is the very prefix used by geometers in naming A or B the abstractions with which they deal.

This is not to deny that the adjective 'abstract' is confusing and even paradoxical. For an 'abstract' painting is really a most positively concrete painting, since it confines the attention to its immediate, sensuous, physical surface far more than does the canvas of a sunset or a portrait. The adjective is confusing, too, because it has the implications of both a verb and a noun. The verb *to abstract* means *to draw out of* or *away from*. But the noun abstraction is something already drawn out of or away from – so much so that, like a geometrical figure or an amorphous silhouette, it may have no apparent relation to concrete reality. 'Abstract' is therefore an adjective which may be applied to works of art with a certain latitude, and since no better or more generally used word presents itself, it shall be used from now on in this essay without quotation marks.

Near-Abstractions and Pure-Abstractions

The ambiguity of the word abstract as applied to works of art is really useful for it reveals the ambiguity and confusion which is inseparable from the subject. Perhaps keeping in mind the 'verb' and 'noun' meanings of abstract may help to clarify. For example, the Suprematist painting by Malevich [an exhibit in 'Cubism and Abstract Art', The Museum of Modern Art, New York, 1936] is composed of a black and red square. This painting has absolutely no dependence upon natural forms. It is purely abstract in its genesis as well as in its final form. In it Malevich carried out his programme by combining two of the elementary geometrical forms which he had set up as the fundamental vocabulary of Suprematism. This painting is *abstract* in the 'noun' sense of the word. Similar to it are Mondrian's *Composition* and Gabo's *Space Construction*. Different in character and genesis but equally abstract, at least

in intention, are certain paintings of Kandinsky, who used non-geometrical as well as geometrical forms. These works of Malevich, Mondrian, Gabo, Kandinsky, may be called *pure-abstractions*.

However, Mondrian's 'plus and minus' composition of 1915, despite its appearance, is not a pure-abstraction. It is actually based upon a seascape, just as Van Doesburg's painting has been *abstracted* (note the verb) from the form of a cow. After 1920 Mondrian and Van Doesburg abandoned the process of 'abstracting', and composed pure-abstractions.

Arp's reliefs are also impure abstractions, even though their forms are so far removed from nature that it is often difficult to tell whether a given object represents a head or a cloud or Paolo and Francesca. Similarly, a Picasso landscape of 1912 may sometimes be mistaken for a still life or a portrait. The cords which tie these works to nature are tenuous, but unbroken – nor would the artist wish them broken. In fact Arp and Picasso usually *name* their works – 'Guitar', 'Head', or 'Fork and Plate'. Because of these vestiges of subject matter, even though little more than a name, it is clear that such works should be described as quasi- or pseudo- or near-abstractions. Perhaps the last is the least objectionable.

To resume: pure-abstractions are those in which the artist makes a composition of abstract elements such as geometrical or amorphous shapes. Near-abstractions are compositions in which the artist, starting with natural forms, transforms them into abstract or nearly abstract forms. He approaches an abstract goal but does not quite reach it.

There are of course several variations within these two classifications and several without, for example, the famous Kandinsky *Improvisation, no. 30* in which the artist intended to paint an abstract composition but unconsciously (he says) introduced a couple of cannon in the lower right hand corner. So we have in this case a near-abstraction which the artist had intended to be a pure-abstraction.

Dialectic of Abstract Art

Abstract art today needs no defence. It has become one of the many ways to paint, carve or model. But it is not yet a kind of art which people like without some study and sacrifice of prejudice. Prejudice can sometimes be met with argument, and for this purpose the dialectic of abstract painting and sculpture is superficially simple enough. It is based on the assumption that a work of art, e.g. a painting, is worth looking at primarily because it presents a composition or organization of colour, line, light and shade. Resemblance to natural objects, while it does not necessarily destroy these aesthetic values, may easily adulterate their purity. Therefore, since resemblance to nature is at best superfluous and at worst distracting, it might as well be eliminated. Hans Arp, although he long ago abandoned pure-abstraction, has expressed this point of view with engaging humour:

Art is a fruit growing out of a man like the fruit out of a plant, like the child out of the mother. While the fruit of the plant assumes independent forms and never strives to resemble a helicopter or a president in a cutaway, the artistic fruit of man shows, for the most part, ridiculous ambition to imitate the appearance of other things. I like nature but not its substitutes.

['A propos d'art abstrait', *Cahiers d'Art*, vol. 6, no. 7–8 (Paris, 1931) 357]

Such an attitude of course involves a great impoverishment of painting, an elimination of a wide range of values, such as the connotations of subject matter, sentimental, documentary, political, sexual, religious; the pleasures of easy recognition; and the enjoyment of technical dexterity in the imitation of material forms and surfaces. But in his art the abstract artist prefers impoverishment to adulteration.

The painter of abstractions can and often does point to the analogy of music, in which the elements of rhythmic repetition, pitch, intensity, harmony, counterpoint, are composed without reference to the natural sounds of either the 'helicopter' or the 'president in a cutaway'. He looks upon abstract painting as independent painting, emancipated painting; as an end in itself with its own peculiar value.

To support their position defenders of abstract art during the past twenty-five years have often quoted a famous passage from the *Philebus* of Plato, Section 51c:

> *Socrates*: What I am saying is not indeed directly obvious. I must therefore try to make it clear. I will try to speak of the beauty of shapes, and I do not mean, as most people would think, the shapes of living figures, or their imitations in paintings, but I mean straight lines and curves and the shapes made from them, flat or solid, by the lathe, ruler and square, if you see what I mean. These are not beautiful for any particular reason or purpose, as other things are, but are always by their very nature beautiful, and give pleasure of their own quite free from the itch of desire; and colours of this kind are beautiful, too, and give a similar pleasure.

Near-Abstractions and Their Titles
Why then do Arp and Picasso give names such as 'Head' or 'Still Life' to works which are so abstract that at first glance they baffle recognition of any resemblance to nature? Why do they not, like Malevich and Kandinsky, go the whole way and call their pictures simply 'compositions' or 'improvisations'? This naming of near-abstractions after concrete objects certainly confuses and exasperates the layman who might otherwise be ready to enjoy the beauties of form and colour which the near-abstractions offer.

For this reason critics and amateurs of abstract art have sometimes considered the titles given by Arp or Picasso to their near-abstractions as stumbling blocks

which may well be ignored or forgotten. This is, however, an unwarranted simplification of which, as has been remarked, the artists themselves do not approve. For a cubist painting or an Arp relief is a *near*-abstraction, and offers an impure and ambiguous enjoyment to which the title is a guide. It is not merely the primary relationship of form and colour *within* the picture which are enjoyable but also the secondary relationships between the picture and the subject matter of which the picture is an abstraction. Take for instance Picasso's *Violin*: starting with the idea or image of a violin Picasso makes an angular, quasi-geometrical composition which displays his power not merely of *composing* abstract forms but of breaking up and assimilating natural forms. As evidence of this abstracting and transmuting process and as a guide to our enjoyment of it he leaves certain vestiges of the violin, the spiral line of the scroll, the shape of the sound-holes, the parallel lines of the strings and the curves of the purflings; and as further explanation he gives the name of the original object – *Violin*. [...]

Abstract Art and Politics

It is its style, its abstract quality, as a general rule, and not its content or avowed programme, that has from time to time involved abstract art in politics. Exceptions to this generalization were Futurism and Surrealism. The former in much of its programme anticipated Fascism and the latter has been involved in Communism.

Pre-war Italian Futurism was latently Fascist in its patriotism, aesthetic enjoyment of war and exhortation to the dangerous and dynamic life. Marinetti, its promoter, is now a Fascist senator, and Boccioni, its most important artist, died in military service, from the effects of a fall from his horse.

In Moscow after the Revolution, the Russian Futurists, Suprematists and Constructivists who had been artistically revolutionary under the Czar came into their own. For three years they dominated the artistic life of the larger cities, taught in the art academies, designed posters, floats in parades, statues to Marxian heroes and gigantic cubistic façades to screen the Winter Palace during mass celebrations. Malevich's *White on White* of 1918 might have counted as a *tabula rasa* upon which to build a new art for a new order, but it was as unintelligible to the proletariat as his earlier Suprematist pictures had been to the bourgeoisie. Tatlin's and Rodchenko's constructions may have been abstract exercises in technological discipline but what the land desperately needed was practical mechanics. Highly cultivated Bolsheviks, such as Trotsky and Lunacharsky, understood and supported the artists of the advance guard, but Lenin, with his broad and penetrating vision of the practical needs of the USSR, found no joy in the Suprematists, the Cubo-Futurists and Tectonic Primitivists. He summarized the left-wing art and literature of 1920 as 'the infantile disorder of Leftism' and felt that movies were more useful to the Soviet State. In 1921

came the New Economic Policy, the era of reconstruction and practical materialism. An attitude of toleration towards Leftism turned to impatience. A schism appeared in the ranks of the artists themselves. One faction wanted to maintain art for art's sake; their opponents wanted to put art at the service of the new order. The atelier of Pevsner and Gabo at the Moscow Academy was closed; they and Lissitzky left for Berlin; Kandinsky left for Germany to join the Bauhaus; Malevich took a post in less influential Leningrad; and most of the Suprematists and Constructivists who stayed in Moscow left art, in the narrow sense of the word, for typography, photography, posters, movies, engineering, stage design, carpentry – anything but painting or sculpture. Today abstraction or stylization in art is still considered a 'left deviation' in the USSR and is discouraged.

The political atmosphere of the Dadaists, the West-European contemporaries of the Russian Leftists, might be described as anarchist. That of their successors, the Surrealists, was Communist, although it would be hard to find anything specifically Communist in their paintings. The schism which had divided the Moscow Constructivists of 1920 reappeared ten years later in Surrealism. Louis Aragon, the Surrealist writer, insisted, as Tatlin and Rodchenko had done, that the artist should place his talents practically and exclusively at the service of the Revolution. The Constructivist heretics who insisted upon the independence of art had found it advisable to leave Communist Moscow for Social Democratic Germany; but the Surrealists, Communist or not, continue to work in Paris without serious molestation from either the Left or the Right (except when showing films).

Abstract art which had begun in Munich flourished in post-war Germany. In addition, the aesthetic ideals of the Dutch *De Stijl* group and of the Russian Constructivists were brought to Berlin by refugees from active Soviet philistinism or its more passive Dutch equivalent. Gradually abstract art, and the architecture which it influenced, became associated with the Social Democracy in the minds of its bitter enemies, the National Socialists. Modern architecture of the 'International Style' had been used extensively in the housing developments authorized by Social Democratic burgomasters.

To the Nazis the cultural expression of the shameful fourteen years between the Treaty of Versailles and the National Resurgence of 1933 was – and is – anathema. Abstract art was considered *Kunstbolschewismus*, and after the Nazi revolution many artists were dismissed from official positions or otherwise 'discouraged'. The flat roof and the white, clean lines of 'Bauhaus' architecture were likewise forbidden in favour of a renascence of genuine *Biedermeier* (the German version of the International style of the 1830s).

About the same time, in the early thirties, the USSR turned against modern architecture in favour of a monumental style derived from Imperial Rome and the Czarist eighteenth century. But fascist Italy and conservative England, to

complete the confusion, accepted modern architecture with enthusiasm. The railroad station in Florence has been completed in the *stile razionale*, and Lubetkin, a former Russian Constructivist, has designed new buildings for that British stronghold, the London Zoo.

This essay and exhibition might well be dedicated to those painters of squares and circles (and the architects influenced by them) who have suffered at the hands of philistines with political power.

Two Main Traditions of Abstract Art

At the risk of grave oversimplification the impulse towards abstract art during the past fifty years may be divided historically into two main currents, both of which emerged from Impressionism. The first and more important current finds its sources in the art and theories of Cézanne and Seurat, passes through the widening stream of Cubism and finds its delta in the various geometrical and Constructivist movements which developed in Russia and Holland during the War and have since spread throughout the World. This current may be described as intellectual, structural, architectonic, geometrical, rectilinear and classical in its austerity and dependence upon logic and calculation. The second – and, until recently, secondary – current has its principal source in the art and theories of Gauguin and his circle, flows through the Fauvisme of Matisse to the Abstract Expressionism of the pre-War paintings of Kandinsky. After running under ground for a few years it reappears vigorously among the masters of abstract art associated with Surrealism. This tradition, by contrast with the first, is intuitional and emotional rather than intellectual; organic or biomorphic rather than geometrical in its forms; curvilinear rather than rectilinear, decorative rather than structural, and romantic rather than classical in its exaltation of the mystical, the spontaneous and the irrational. Apollo, Pythagoras and Descartes watch over the Cézanne-Cubist-geometrical tradition; Dionysus (an Asiatic god), Plotinus and Rousseau over the Gauguin-Expressionist-non-geometrical line.

Often, of course, these two currents intermingle and they may both appear in one man. At their purest the two tendencies may be illustrated by paintings of twenty years ago: a Suprematist composition by Malevich and an Improvisation by Kandinsky. The geometrical strain is represented today by the painter Mondrian and the Constructivists Pevsner and Gabo; the non-geometrical by the painter Miró and the sculptor Arp. The shape of the square confronts the silhouette of the amoeba.

Alfred H. Barr Jr., extract from catalogue introduction, *Cubism and Abstract Art* (New York: The Museum of Modern Art, 1936); reprinted paperback edition (Cambridge, Massachusetts: The Belknap Press of Harvard University Press, 1986) 11–19.

Meyer Schapiro
Nature of Abstract Art//1937

Before there was an art of abstract painting, it was already widely believed that the value of a picture was a matter of colours and shapes alone. Music and architecture were constantly held up to painters as examples of a pure art which did not have to imitate objects but derived its effects from elements peculiar to itself. But such ideas could not be readily accepted, since no one had yet seen a painting made up of colours and shapes, representing nothing. If pictures of the objects around us were often judged according to qualities of form alone, it was obvious that in doing so one was distorting or reducing the pictures; you could not arrive at these paintings simply by manipulating forms. And in so far as the objects to which these forms belonged were often particular individuals and places, real or mythical figures, bearing the evident marks of a time, the pretension that art was above history through the creative energy or personality of the artist was not entirely clear. In abstract art, however, the pretended autonomy and absoluteness of the aesthetic emerged in a concrete form. Here, finally, was an art of painting in which only aesthetic elements seem to be present.

Abstract art had therefore the value of a practical demonstration. In these new paintings the very processes of designing and inventing seemed to have been brought onto the canvas; the pure form once masked by an extraneous content was liberated and could now be directly perceived. Painters who do not practise this art have welcomed it on just this ground, that it strengthened their conviction of the absoluteness of the aesthetic and provided them a discipline in pure design. Their attitude toward past art was also completely changed. The new styles accustomed painters to the vision of colours and shapes as disengaged from objects and created an immense confraternity of works of art, cutting across the barriers of time and place. They made it possible to enjoy the remotest arts, those in which the represented objects were no longer intelligible, even the drawings of children and madmen, and especially primitive arts with drastically distorted figures, which had been regarded as artless curios even by insistently aesthetic critics. Before this time Ruskin could say in his *Political Economy of Art*, in calling for the preservation of mediaeval and Renaissance works, that 'in Europe alone, pure and precious ancient art exists, for there is none in America, none in Asia, none in Africa'. What was once considered monstrous now became pure form and pure expression, the aesthetic evidence that art feeling and thought are prior to the represented world. The art of the whole world was now available on a single unhistorical and universal plane as a panorama of the formalizing energies of man.

These two aspects of abstract painting, the exclusion of natural forms and the unhistorical universalizing of the qualities of art, have a crucial importance for the general theory of art. Just as the discovery of non-Euclidian geometry gave a powerful impetus to the view that mathematics was independent of experience, so abstract painting cut at the roots of the classic ideas of artistic imitation. The analogy of mathematics was in fact present to the minds of the apologists of abstract art; they have often referred to non-Euclidian geometry in defence of their own position, and have even suggested an historical connection between them.

Today the abstractionists and their surrealist offspring are more and more concerned with objects and the older claims of abstract art have lost the original force of insurgent convictions. Painters who had once upheld this art as the logical goal of the entire history of forms have refuted themselves in returning to the impure natural forms. The demands for liberty in art are no longer directed against a fettering tradition of nature; the aesthetic of abstraction has itself become a brake on new movements. Not that abstract art is dead, as its philistine enemies have been announcing for over twenty years; it is still practised by some of the finest painters and sculptors in Europe, whose work shows a freshness and assurance that are lacking in the newest realistic art. The conception of a possible field of 'pure art' – whatever its value – will not die so soon, though it may take on forms different from those of the last thirty years; and very likely the art that follows in the countries which have known abstraction will be affected by it. The ideas underlying abstract art have penetrated deeply into all artistic theory, even of their original opponents; the language of absolutes and pure sources of art, whether of feeling, reason, intuition or the sub-conscious mind, appears in the very schools which renounce abstraction. 'Objective' painters strive for 'pure objectivity', for the object given in its 'essence' and completeness, without respect to a viewpoint, and the Surrealists derive their images from pure thought, freed from the perversions of reason and everyday experience. Very little is written today – sympathetic to modern art – which does not employ this language of absolutes.

In this article I shall take as my point of departure Barr's recent book [*Cubism and Abstract Art*, 1936], the best, I think, that we have in English on the movements now grouped as abstract art. It has the special interest of combining a discussion of general questions about the nature of this art, its aesthetic theories, its causes, and even the relation to political movements, with a detailed, matter-of-fact account of the different styles. But although Barr sets out to describe rather than to defend or to criticize abstract art, he seems to accept its theories on their face value in his historical exposition and in certain random judgements. In places he speaks of this art as independent of historical conditions, as realizing the underlying order of nature, and as an art of pure form without content.

Hence, if the book is largely an account of historical movements, Barr's conception of abstract art remains essentially unhistorical. He gives us, it is true, the dates of every stage in the various movements, as if to enable us to plot a curve, or to follow the emergence of the art year by year, but no connection is drawn between the art and the conditions of the moment. He excludes as irrelevant to its history the nature of the society in which it arose, except as an incidental obstructing or accelerating atmospheric factor. The history of modern art is presented as an internal, immanent process among the artists; abstract art arises because, as the author says, representational art had been exhausted. Out of boredom with 'painting facts', the artists turned to abstract art as a pure aesthetic activity. 'By a common and powerful impulse they were driven to abandon the imitation of natural appearance' just as the artists of the fifteenth century 'were moved by a passion for imitating nature'. The modern change, however, was 'the logical and inevitable conclusion toward which art was moving'.

This explanation, which is common in the studios and is defended by some writers in the name of the autonomy of art, is only one instance of a wider view that embraces every field of culture and even economy and politics. At its ordinary level the theory of exhaustion and reaction reduces history to the pattern of popular ideas on changes in fashion. People grow tired of one colour and choose an opposite; one season the skirts are long, and then by reaction they are short. In the same way the present return to objects in painting is explained as the result of the exhaustion of abstract art. All the possibilities of the latter having been explored by Picasso and Mondrian, there is little left for the younger artists but to take up the painting of objects.

The notion that each new style is due to a reaction against a preceding one is especially plausible to modern artists, whose work is so often a response to another work, who consider their art a free projection of an irreducible personal feeling, but must form their style in competition against others, with the obsessing sense of the originality of their work as a mark of its sincerity. Besides, the creators of new forms in the last century had almost always to fight against those who practised the old; and several of the historical styles were formed in conscious opposition to another manner – Renaissance against Gothic, Baroque against Mannerism, Neoclassic against Rococo, etc.

The antithetic form of a change does not permit us, however, to judge a new art as a sheer reaction or as the inevitable response to the spending of all the resources of the old. No more than the succession of war and peace implies that war is due to an inherent reaction against peace and peace to a reaction against war. The energies required for the reaction, which sometimes has a drastic and invigorating effect on art, are lost sight of in such an account; it is impossible to explain by it the particular direction and force of the new movement, its specific

moment, region and goals. The theory of immanent exhaustion and reaction is inadequate not only because it reduces human activity to a simple mechanical movement, like a bouncing ball, but because in neglecting the sources of energy and the condition of the field, it does not even do justice to its own limited mechanical conception. The oppositeness of a reaction is often an artificial matter, more evident in the polemics between schools or in the schemas of formalistic historians than in the actual historical change. To supply a motor force to this physical history of styles (which pretends to be anti-mechanical), they are reduced to a myth of the perpetual alternating motion of generations, each reacting against its parents and therefore repeating the motions of its grandparents, according to the 'grandfather principle' of certain German historians of art. And a final goal, an unexplained but inevitable trend, a destiny rooted in the race or the spirit of the culture or the inherent nature of the art, has to be smuggled in to explain the large unity of a development that embraces so many reacting generations. The immanent purpose steers the reaction when an art seems to veer off the main path because of an overweighted or foreign element. Yet how many arts we know in which the extreme of some quality persists for centuries without provoking the corrective reaction. The 'decay' of classical art has been attributed by the English critic Roger Fry to its excessive cult of the human body, but this 'decay' evidently lasted for hundreds of years until the moment was ripe for the Christian reaction. But even this Christian art, according to the same writer, was for two centuries indistinguishable from the pagan.

The broad reaction against an existing art is possible only on the ground of its inadequacy to artists with new values and new ways of seeing. But reaction in this internal, antithetic sense, far from being an inherent and universal property of culture, occurs only under impelling historical conditions. For we see that ancient arts, like the Egyptian, the work of anonymous craftsmen, persist for thousands of years with relatively little change, provoking few reactions to the established style; others grow slowly and steadily in a single direction, and still others, in the course of numerous changes, foreign intrusions and reactions preserve a common traditional character. From the mechanical theories of exhaustion, boredom and reaction we could never explain why the reaction occurred when it did. On the other hand, the banal divisions of the great historical styles in literature and art correspond to the momentous divisions in the history of society.

If we consider an art that is near us in time and is still widely practised, like Impressionism, we see how empty is the explanation of the subsequent arts by reaction. From a logical viewpoint the antithesis to Impressionism depends on how Impressionism is defined. Whereas the later schools attacked the Impressionists as mere photographers of sunshine, the contemporaries of Impressionism abused it for its monstrous unreality. The Impressionists were in

fact the first painters of whom it was charged that their works made as little sense right side up as upside down. The movements after Impressionism take different directions, some toward simplified natural forms, others toward their complete decomposition; both are sometimes described as historical reactions against Impressionism, one restoring the objects that Impressionism dissolved, the other restoring the independent imaginative activity that Impressionism sacrificed to the imitation of nature.

Actually, in the 1880s there were several aspects of Impressionism which could be the starting points of new tendencies and goals of reaction. For classicist painters the weakness of Impressionism lay in its unclarity, its destruction of definite linear forms; it is in this sense that Renoir turned for a time from Impressionism to Ingres. But for other artists at the same moment Impressionism was too casual and unmethodical; these, the neo-Impressionists, preserved the Impressionist colourism, carrying it even further in an unclassical sense, but also in a more constructive and calculated way. For still others, Impressionism was too photographic, too impersonal; these, the symbolists and their followers, required an emphatic sentiment and aesthetic activism in the work. There were finally artists for whom Impressionism was too unorganized, and their reaction underscored a schematic arrangement. Common to most of these movements after Impressionism was the absolutizing of the artist's state of mind or sensibility as prior to and above objects. If the Impressionists reduced things to the artist's sensations, their successors reduced them further to projections or constructions of his feelings and moods, or to 'essences' grasped in a tense intuition.

The historical fact is that the reaction against Impressionism came in the 1880s before some of its most original possibilities had been realized. The painting [by Monet] of series of chromatic variations of a single motif (the *Haystacks*, the *Cathedral*) dates from the 1890s; and the *Water Lilies*, with their remarkable spatial forms, related in some ways to contemporary abstract art, belong to the twentieth century. The effective reaction against Impressionism took place only at a certain moment in its history and chiefly in France, though Impressionism was fairly widespread in Europe by the end of the century. In the 1880s, when Impressionism was beginning to be accepted officially, there were already several groups of young artists in France to whom it was uncongenial. The history of art is not, however, a history of single wilful reactions, every new artist taking a stand opposite the last, painting brightly if the other painted dully, flattening if the other modelled, and distorting if the other was literal. The reactions were deeply motivated in the experience of the artists, in a changing world with which they had to come to terms and which shaped their practice and ideas in specific ways.

The tragic lives of Gauguin and Van Gogh, their estrangement from society, which so profoundly coloured their art, were no automatic reactions to

Impressionism or the consequences of Peruvian or Northern blood. In Gauguin's circle were other artists who had abandoned a bourgeois career in their maturity or who had attempted suicide. For a young man of the middle class to wish to live by art meant a different thing in 1885 than in 1860. By 1885 only artists had freedom and integrity, but often they had nothing else. The very existence of Impressionism, which transformed nature into a private, unformalized field for sensitive vision, shifting with the spectator, made painting an ideal domain of freedom; it attracted many who were tied unhappily to middle-class jobs and moral standards, now increasingly problematic and stultifying with the advance of monopoly capitalism. But Impressionism, in isolating the sensibility as a more or less personal, but dispassionate and still outwardly directed, organ of fugitive distinctions in distant dissolving clouds, water and sunlight, could no longer suffice for men who had staked everything on impulse and whose resolution to become artists was a poignant and in some ways demoralizing break with good society. With an almost moral fervour they transformed Impressionism into an art of vehement expression, of emphatic, brilliant, magnified, obsessing objects, or adjusted its colouring and surface pattern to dreams of a seasonless exotic world of idyllic freedom.

Early Impressionism, too, had a moral aspect. In its unconventionalized, unregulated vision, in its discovery of a constantly changing phenomenal outdoor world of which the shapes depended on the momentary position of the casual or mobile spectator, there was an implicit criticism of symbolic social and domestic formalities, or at least a norm opposed to these. It is remarkable how many pictures we have in early Impressionism of informal and spontaneous sociability, of breakfasts, picnics, promenades, boating trips, holidays and vacation travel. These urban idylls not only present the objective forms of bourgeois recreation in the 1860s and 1870s; they also reflect in the very choice of subjects and in the new aesthetic devices the conception of art as solely a field of individual enjoyment, without reference to ideas and motives, and they presuppose the cultivation of these pleasures as the highest field of freedom for an enlightened bourgeois detached from the official beliefs of his class. In enjoying realistic pictures of his surroundings as a spectacle of traffic and changing atmospheres, the cultivated *rentier* was experiencing in its phenomenal aspect that mobility of the environment, the market and of industry to which he owed his income and his freedom. And in the new Impressionist techniques which broke things up into finely discriminated points of colour, as well as in the 'accidental' momentary vision, he found, in a degree hitherto unknown in art, conditions of sensibility closely related to those of the urban promenader and the refined consumer of luxury goods.

As the contexts of bourgeois sociability shifted from community, family and

church to commercialized or privately improvised forms – the streets, the cafes and resorts – the resulting consciousness of individual freedom involved more and more an estrangement from older ties; and those imaginative members of the middle class who accepted the norms of freedom, but lacked the economic means to attain them, were spiritually torn by a sense of helpless isolation in an anonymous indifferent mass. By 1880 the enjoying individual becomes rare in Impressionist art; only the private spectacle of nature is left. And in neo-Impressionism, which restores and even monumentalizes the figures, the social group breaks up into isolated spectators, who do not communicate with each other, or consists of mechanically repeated dances submitted to a pre-ordained movement with little spontaneity.

The French artists of the 1880s and 1890s who attacked Impressionism for its lack of structure often expressed demands for salvation, for order and fixed objects of belief, foreign to the Impressionists as a group. The title of Gauguin's picture – *Where do we come from? What are we? Where are we going?* – with its interrogative form, is typical of this state of mind. But since the artists did not know the underlying economic and social causes of their own disorder and moral insecurity, they could envisage new stabilizing forms only as quasi-religious beliefs or as a revival of some primitive or highly ordered traditional society with organs for a collective spiritual life. This is reflected in their taste for mediaeval and primitive art, their conversions to Catholicism and later to 'integral nationalism.' The colonies of artists formed at this period, Van Gogh's project of a communal life for artists, are examples of this groping to reconstitute the pervasive human sociability that capitalism had destroyed. Even their theories of 'composition' – a traditional concept abandoned by the Impressionists – are related to their social views, for they conceive of composition as an assembly of objects bound together by a principle of order emanating, on the one hand, from the eternal nature of art, on the other, from the state of mind of the artist, but in both instances requiring a 'deformation' of the objects. Some of them wanted a canvas to be like a church, to possess a hierarchy of forms, stationed objects, a prescribed harmony, pre-ordained paths of vision, all issuing, however, from the artist's feeling. In recreating the elements of community in their art they usually selected inert objects, or active objects without meaningful interaction except as colours and lines.

These problems are posed to some extent, though solved differently, even in the work of Seurat, whose relation to the economic development was in many ways distinct from that of the painters of the Symbolist and Synthetist groups. Instead of rebelling against the moral consequences of capitalism he attached himself like a contented engineer to its progressive technical side and accepted the popular forms of lower class recreation and commercialized entertainment as the subjects of a monumentalized art. From the current conceptions of technology

he drew the norms of a methodical procedure in painting, bringing Impressionism up to date in the light of the latest findings of science.

There were, of course, other kinds of painting in France beside those described. But a detailed investigation of the movement of art would show, I think, that these, too, and even the conservative, academic painting were affected by the changed conditions of the time. The reactions against Impressionism, far from being inherent in the nature of art, issued from the responses that artists as artists made to the broader situation in which they found themselves, but which they themselves had not produced. If the tendencies of the arts after Impressionism toward an extreme subjectivism and abstraction are already evident in Impressionism, it is because the isolation of the individual and of the higher forms of culture from their older social supports, the renewed ideological oppositions of mind and nature, individual and society, proceed from social and economic causes which already existed before Impressionism and which are even sharper today. It is, in fact, a part of the popular attraction of Van Gogh and Gauguin that their work incorporates (and with a far greater energy and formal coherence than the works of other artists) evident longings, tensions and values which are shared today by thousands who in one way or another have experienced the same conflicts as these artists.

The logical opposition of realistic and abstract art by which Barr explains the more recent change rests on two assumptions about the nature of painting, common in writing on abstract art: that representation is a passive mirroring of things and therefore essentially non-artistic, and that abstract art, on the other hand, is a purely aesthetic activity, unconditioned by objects and based on its own eternal laws. The abstract painter denounces representation of the outer world as a mechanical process of the eye and the hand in which the artist's feelings and imagination have little part. Or in a Platonic manner he opposes to the representation of objects, as a rendering of the surface aspect of nature, the practice of abstract design as a discovery of the 'essence' or underlying mathematical order of things. He assumes further that the mind is most completely itself when it is independent of external objects. If he, nevertheless, values certain works of older naturalistic art, he sees in them only independent formal constructions; he overlooks the imaginative aspect of the devices for transposing the space of experience onto the space of the canvas, and the immense, historically developed, capacity to hold the world in mind. He abstracts the artistic qualities from the represented objects and their meanings, and looks on these as unavoidable impurities, imposed historical elements with which the artist was burdened and in spite of which he finally achieved his underlying, personal abstract expression.

These views are thoroughly one-sided and rest on a mistaken idea of what a representation is. There is no passive, 'photographic' representation in the sense

described; the scientific elements of representation in older art's perspective, anatomy, light and shade are ordering principles and expressive means as well as devices of rendering. All renderings of objects, no matter how exact they seem, even photographs, proceed from values, methods and viewpoints which somehow shape the image and often determine its contents.

On the other hand, there is no 'pure art', unconditioned by experience; all fantasy and formal construction, even the random scribbling of the hand, are shaped by experience and by non-aesthetic concerns.

This is clear enough from the example of the Impressionists mentioned above. They could be seen as both photographic and fantastic, according to the viewpoint of the observer. Even their motifs of nature were denounced as meaningless beside the evident content of romantic and classicist art.

In regarding representation as a facsimile of nature, the abstract artist has taken over the error of vulgar nineteenth-century criticism, which judged painting by an extremely narrow criterion of reality, inapplicable even to the realistic painting which it accepted. If an older taste said, how exactly like the object, how beautiful! the modern abstractionist says, how exactly like the object, how ugly! The two are not completely opposed, however, in their premises, and will appear to be related if compared with the taste of religious arts with a supernatural content. Both realism and abstraction affirm the sovereignty of the artist's mind, the first, in the capacity to recreate the world minutely in a narrow, intimate field by series of abstract calculations of perspective and gradation of colour, the other in the capacity to impose new forms on nature, to manipulate the abstracted elements of line and colour freely, or to create shapes corresponding to subtle states of mind. But as little as a work is guaranteed aesthetically by its resemblance to nature, so little is it guaranteed by its abstractness or 'purity'. Nature and abstract forms are both materials for art, and the choice of one or the other flows from historically changing interests.

Barr believes that painting is impoverished by the exclusion of the outer world from pictures, losing a whole range of sentimental, sexual, religious and social values. But he supposes in turn that the aesthetic values are then available in a pure form. He does not see, however, that the latter are changed rather than purified by this exclusion, just as the kind of verbal pattern in writing designed mainly for verbal pattern differs from the verbal pattern in more meaningful prose. Various forms, qualities of space, colour, light, scale, modelling and movement, which depend on the appreciation of aspects of nature and human life, disappear from painting; and similarly the aesthetic of abstract art discovers new qualities and relationships which are congenial to the minds that practice such an exclusion. Far from creating an absolute form, each type of abstract art, as of naturalistic art, gives a special but temporary importance to some element,

whether colour, surface, outline or arabesque, or to some formal method. The converse of Barr's argument, that by clothing a pure form with a meaningful dress this form becomes more accessible or palatable, like logic or mathematics presented through concrete examples, rests on the same misconception. Just as narrative prose is not simply a story added to a pre-existing, pure prose form that can be disengaged from the sense of the words, so a representation is not a natural form added to an abstract design. Even the schematic aspects of the form in such a work already possess qualities conditioned by the modes of seeing objects and designing representations, not to mention the content and the emotional attitudes of the painter.

When the abstractionist Kandinsky was trying to create an art expressing mood, a great deal of conservative, academic painting was essentially just that. But the academic painter, following older traditions of romantic art, preserved the objects which provoked the mood; if he wished to express a mood inspired by a landscape, he painted the landscape itself. Kandinsky, on the other hand, wished to find an entirely imaginative equivalent of the mood; he would not go beyond the state of mind and a series of expressive colours and shapes, independent of things. The mood in the second case is very different from the first mood. A mood which is partly identified with the conditioning object, a mood dominated by clear images of detailed objects and situations, and capable of being revived and communicated to others through these images, is different in feeling tone, in relation to self-consciousness, attentiveness and potential activity, from a mood that is independent of an awareness of fixed, external objects, but sustained by a random flow of private and incommunicable associations. Kandinsky looks upon the mood as wholly a function of his personality or a special faculty of his spirit; and he selects colours and patterns which have for him the strongest correspondence to his state of mind, precisely because they are not tied sensibly to objects but emerge freely from his excited fantasy. They are the concrete evidences, projected from within, of the internality of his mood, its independence of the outer world. Yet the external objects that underlie the mood may re-emerge in the abstraction in a masked or distorted form. The most responsive spectator is then the individual who is similarly concerned with himself and who finds in such pictures not only the counterpart of his own tension, but a final discharge of obsessing feelings.

In renouncing or drastically distorting natural shapes, the abstract painter makes a judgement of the external world. He says that such and such aspects of experience are alien to art and to the higher realities of form; he disqualifies them from art. But by this very act the mind's view of itself and of its art, the intimate contexts of this repudiation of objects, become directing factors in art. Then personality, feeling and formal sensibility are absolutized, the values that underlie

or that follow today from such attitudes suggest new formal problems, just as the secular interests of the later middle ages made possible a whole series of new formal types of space and the human figure. The qualities of cryptic improvisation, the microscopic intimacy of textures, points and lines, the impulsively scribbled forms, the mechanical precision in constructing irreducible, incommensurable fields, the thousand and one ingenious formal devices of dissolution, punctuation, immateriality and incompleteness which affirm the abstract artist's active sovereignty over objects, these and many other sides of modern art are discovered experimentally by painters who seek freedom outside of nature and society and consciously negate the formal aspects of perception – like the connectedness of shape and colour or the discontinuity of object and surroundings – that enter into the practical relations of man in nature. We can judge more readily the burden of contemporary experience that imposes such forms by comparing them with the abstract devices in Renaissance art, especially the systems of perspective and the canons of proportion, which are today misunderstood as merely imitative means. In the Renaissance the development of linear perspective was intimately tied to the exploration of the world and the renewal of physical and geographical science. Just as for the aggressive members of the burgher class a realistic knowledge of the geographical world and communications entailed the ordering of spatial connections in a reliable system, so the artists strove to realize in their own imaginative field an art within the limits of a traditional religious content. The most appropriate and stimulating forms of spatial order, with the extensiveness, traversability and regulation valued by their class. And similarly, as this same burgher class, emerging from a Christian feudal society, began to assert the priority of sensual and natural to ascetic and supernatural goods, and idealized the human body as the real locus of values – enjoying images of the powerful or beautiful nude human being as the real man or woman, without sign of rank or submission to authority – so the artists derived from this valuation of the human being artistic ideals of energy and massiveness of form which they embodied in robust, active or potentially active, human figures. And even the canons of proportion, which seem to submit the human form to a mysticism of number, create purely secular standards of perfection; for through these canons the norms of humanity become physical and measurable, therefore at the same time sensual and intellectual, in contrast to the older mediaeval disjunction of body and mind.

If today an abstract painter seems to draw like a child or a madman, it is not because he is childish or mad. He has come to value as qualities related to his own goals of imaginative freedom the passionless spontaneity and technical insouciance of the child, who creates for himself alone, without the pressure of adult responsibility and practical adjustments. And similarly, the resemblance to psychopathic art, which is only approximate and usually independent of a

conscious imitation, rests on their common freedom of fantasy, uncontrolled by reference to an external physical and social world. By his very practice of abstract art, in which forms are improvised and deliberately distorted or obscured, the painter opens the field to the suggestions of his repressed interior life. But the painter's manipulation of his fantasy must differ from the child's or psychopath's in so far as the act of designing is his chief occupation and the conscious source of his human worth; it acquires a burden of energy, a sustained pathos and firmness of execution foreign to the others.

The attitude to primitive art is in this respect very significant. The nineteenth century, with its realistic art, its rationalism and curiosity about production, materials and techniques often appreciated primitive ornament, but considered primitive representation monstrous. It was as little acceptable to an enlightened mind as the fetishism or magic which these images sometimes served. Abstract painters, on the other hand, have been relatively indifferent to the primitive geometrical styles of ornament. The distinctness of motifs, the emblematic schemes, the clear order of patterns, the direct submission to handicraft and utility, are foreign to modern art. But in the distorted, fantastic figures some groups of modern artists found an intimate kinship with their own work; unlike the ordering devices of ornament which were tied to the practical making of things, the forms of these figures seemed to have been shaped by a ruling fantasy, independent of nature and utility, and directed by obsessive feelings. The highest praise of their own work is to describe it in the language of magic and fetishism.

This new responsiveness to primitive art was evidently more than aesthetic; a whole complex of longings, moral values and broad conceptions of life were fulfilled in it. If colonial imperialism made these primitive objects physically accessible, they could have little aesthetic interest until the new formal conceptions arose. But these formal conceptions could be relevant to primitive art only when charged with the new valuations of the instinctive, the natural, the mythical as the essentially human, which affected even the description of primitive art. The older ethnologists, who had investigated the materials and tribal contexts of primitive imagery, usually ignored the subjective and aesthetic side in its creation; in discovering the latter the modern critics, with an equal one-sidedness, relied on feeling to penetrate these arts. The very fact that they were the arts of primitive peoples without a recorded history now made them all the more attractive. They acquired the special prestige of the timeless and instinctive, on the level of spontaneous animal activity, self-contained, unreflective, private, without dates and signatures, without origins or consequences except in the emotions. A devaluation of history, civilized society and external nature lay behind the new passion for primitive art. Time ceased to be an historical dimension; it became an internal psychological moment, and the whole mess of material ties, the nightmare

of a determining world, the disquieting sense of the present as a dense historical point to which the individual was fatefully bound – these were automatically transcended in thought by the conception of an instinctive, elemental art above time. By a remarkable process the arts of subjugated backward peoples, discovered by Europeans in conquering the world, became aesthetic norms to those who renounced it. The imperialist expansion was accompanied at home by a profound cultural pessimism in which the arts of the savage victims were elevated above the traditions of Europe. The colonies became places to flee to as well as to exploit.

The new respect for primitive art was progressive, however, in that the cultures of savages and other backward peoples were now regarded as human cultures, and a high creativeness, far from being a prerogative of the advanced societies of the West, was attributed to all human groups. But this insight was accompanied not only by a flight from the advanced society, but also by an indifference to just those material conditions which were brutally destroying the primitive peoples or converting them into submissive, cultureless slaves. Further, the preservation of certain forms of native culture in the interest of imperialist power could be supported in the name of the new artistic attitudes by those who thought themselves entirely free from political interest.

To say then that abstract painting is simply a reaction against the exhausted imitation of nature, or that it is the discovery of an absolute or pure field of form is to overlook the positive character of the art, its underlying energies and sources of movement. Besides, the movement of abstract art is too comprehensive and long-prepared, too closely related to similar movements in literature and philosophy, which have quite other technical conditions and finally, too varied according to time and place, to be considered a self-contained development issuing by a kind of internal logic directly from aesthetic problems. It bears within itself at almost every point the mark of the changing material and psychological conditions surrounding modern culture.

The avowals of artists – several of which are cited in Barr's work – show that the step to abstraction was accompanied by great tension and emotional excitement. The painters justify themselves by ethical and metaphysical standpoints, or in defence of their art attack the preceding style as the counterpart of a detested social or moral position. Not the processes of imitating nature were exhausted, but the valuation of nature itself had changed. The philosophy of art was also a philosophy of life.

Meyer Schapiro, extract from 'Nature of Abstract Art', *Marxist Quarterly* (January/February 1937); reprinted in *Microhistorias y macromundos. vol. 3 – Abstract Possible*, ed. Maria Lind (Mexico City: Instituto Nacional de Bellas Artes y Literatura, 2011) 22–62.

Otto Carlsund, Theo van Doesburg, Jean Hélion, Léon Tutundjian, Marcel Wantz
The Basis of Concrete Painting//1930

We state:

1 Art is universal.

2 The work of art should be fully conceived and spiritually formed before it is produced. It should not contain any natural form, sensuality or sentimentality. We wish to exclude lyricism, dramaticism, symbolism, and so forth.

3 The painting should be constructed completely with pure plastic elements, that is to say, with planes and colours. A pictorial element has no other meaning than what it represents; consequently the painting possesses no other meaning than what it is by itself.

4 The construction of a painting and its elements should be simple and direct in its visualization.

5 The technique should be mechanical, that is to say, precise rather than impressionistic.

6 Absolute clarity should be sought.

Otto Carlsund, Theo van Doesburg, Jean Hélion, Léon Tutundjian, Marcel Wantz, 'The Basis of Concrete Painting', *Art Concret* (April 1930).

Kirk Varnedoe
Why Abstract Art?//2006

[...] Why abstract art? Let me dodge that question for a moment and start with a second one: Why abstract art of the last fifty years? The quick answer is that fifty years takes us to the mid 1950s, a crucial juncture in twentieth-century culture.

To say why it was crucial requires looking back even farther to the decades before World War II, when modern art in general and abstract art in particular had been dominated by Europe. The fragmentation and reassembling of the world effected by Pablo Picasso and Georges Braque in their Parisian cubism of 1909 to 1914 had allowed, encouraged, even goaded several artists, especially from outlying countries such as Holland and Russia, to push farther into a world of forms, leaving behind any trace of reference to recognizable objects or scenes. The invention of these new kinds of abstract or 'non-objective' art coincided with the cataclysm of World War I, and the artists involved explained their innovations in terms of contemporary revolutions in both society and consciousness, proposing in numerous manifestos that their art laid bare the fundamental, absolute and universal truths appropriate to a new spirituality, to modern science or to the emergence of a changed human order.

In the 1920s and 1930s these principles of abstract art were institutionalized in academies such as the Bauhaus in Germany, and they had a pervasive impact, reconfiguring the look of the man-made world in architecture, graphic design, film and photography as well as in painting and sculpture. But the original utopian aspirations of the pioneer abstractionists seemed thwarted, and their collectivist optimism discredited, by the rise of totalitarian governments and the eventual collapse of Europe into a second world war.

During and immediately after the conflagration of European culture in World War II, a new push toward abstract art occurred among younger artists in America, especially in New York. But this time the artists' motivations and ambitions seem sharply different. What came to be called abstract expressionism in the art of Jackson Pollock, Barnett Newman, Willem de Kooning, Mark Rothko and others emerged now from the context of surrealism, with its stress on visual free association. Abstract expressionist painting had its roots in the unconscious mind. It was, to paraphrase one of these artists, made 'out of ourselves', without any accompanying insistence on the former metaphysical or social agendas of abstraction.[1]

In the mid 1950s abstract expressionism was exported internationally in important exhibitions. It was a key moment in the emergence of this new kind of

American abstract painting. When Pollock died in 1956 in a car crash he was hailed by his prime champion, the critic Clement Greenberg, as the legitimate inheritor of the great tradition of European abstract art represented by cubist pictures such as Picasso's *Accordionist* of 1911. Pollock was said to have 'picked up for America the torch of innovations lit by Picasso', eliminating deep perspectival space, for example, as in *Lavender Mist: Number 1, 1950* (1950). Greenberg argued that Pollock had advanced the line of abstraction's logical progress toward its supposedly destined goal of expressing the essential visual qualities of painting without any extraneous literary content.

Yet if Greenberg could see Pollock's poured paintings as extending the European avant-garde tradition, these same works also displayed some radically new aspects. They brought the process of art-making to the fore, so that the painting seemed only like the record of the event documented by Hans Namuth in his famous photographs of Pollock pouring and dripping paint onto a canvas in his barn studio on Long Island. Pollock's work allowed for the forceful expression of chance in the way the paint fell uncontrollably in spatters and drips across the canvas, dissolving traditional distinctions between figure and ground. A picture such as *Lavender Mist* shows a nearly even dispersal of pictorial incident over the entire field of the canvas, yielding a new 'all-over' wholeness that seemed a kind of anti-composition. Moreover, the most celebrated of Pollock's drip pictures were big, up to five-and-a-half metres across, and this mural-like scale suggested a sharply different relationship between the body and pictorial space. In these ways Pollock's paintings seemed to offer a thoroughly new point of departure for abstraction.

But this moment in the mid 1950s also saw what has come to be seen as the death knell of abstract expressionism and the launch of an antithetical idea of art in Jasper Johns' *White Flag* of 1955, a deliberately deadpan work by a then unknown Southerner in his mid twenties. Whereas painting such as Pollock's seemed expressive of a heatedly urgent, physical, psychic and emotional engagement, Johns' painting seemed the opposite: coolly detached, diffident, suffused with irony – an impassive presentation of commonplace things. Johns seemed to resurrect a different European tradition of the pre-war era, not the tradition of Picasso and Cubism but the tradition of Marcel Duchamp and Dada, with its subversive pranks. The readymade imagery of *White Flag* recalled Duchamp's decision to select a urinal from a plumbing supplier, sign it and submit it to a New York art exhibition under the title *Fountain*. But Johns' scrupulously hand-painted flag transmutes Duchamp's idea of the readymade into something new. It is a way of making art rather than a way of *not* making it. Instead of remaining a hermetic in-joke, a piece of art about art, Johns' *White Flag* opened the way for artists to work in what his partner, Robert Rauschenberg, famously referred to as the space

between art and life.[2] Along with Rauschenberg's work, Johns' flag catalysed the explosion of a new realism in Pop art. This was a realism that embraced photography, advertising and the image-saturated world of modern media – everything that Greenberg's ideal of a pure abstraction had so strenuously excluded.

Our starting point in the mid 1950s, then, seems simultaneously to present a new form of abstraction and a new resistance to its premises. This contradictory development is what I want to document and explore. For many people who think and write about culture, this moment marks an even larger watershed between the end of modernism and the inauguration of a postmodern world, a great divide between the world of, say, Henri Matisse and Picasso and that of contemporary art. I am not one of those people, however, and this dichotomy is not what I am here to talk about. Those who believe in a strict opposition between modern and postmodern art will perhaps be discomfited by the story I have to tell. For instance, I want to show how strains from two seemingly opposite camps – from Johns and Pollock, for example, or from Picasso and Duchamp – overlapped and blended, and how the emergence of important new artistic languages depended precisely on those unexpected hybrids.

Let us look, for example, at Frank Stella's *The Marriage of Reason and Squalor* of 1959. Stella himself described this work as a piece of 'negative Pollockism' – a radical reaction against Pollock, and yet at the same time an extension of Pollock.[3] Many things about it – the all-over composition, wall-to-wall, edge-to-edge; the even distribution of emphasis across the canvas; the black industrial house paint – are a direct response to Pollock's work. On the other hand, Stella's stripes, as he himself has said, come directly from Johns. Stella's work does not seem to make sense unless we combine (rather than set in opposition) the modern Pollock and the postmodern Johns – just as Johns' handmade flag is unthinkable without the seemingly antithetical influences of Cézanne and Duchamp.

Conundrums such as this interest me a great deal. Moreover, I do not accept the modern/postmodern split because I do not put much stock in either – or any – 'ism'. Epochs do not have essences, history does not work by all-governing unities, and works of art in their quirkiness tend to resist generalities. Between the vague confusions of individual experience and the authority of big ideas, sign me up for experience first. Given one minute more to either parse critical theory or stammer toward the qualities of the individual work of art, I will use the time for the latter. Now this may sound like dumb anti-intellectualism, but I hope it is something better. Abstraction, of course, has a lot to do with ideas and theory. One of the valuable things it does more fiercely than a lot of other art is to make us think and read what others think: Greenberg on Pollock, Michael Fried on Stella, and so on. But it is also crucially about experience and about particulars. The less there is to look at, the more important it is that we look at it closely and

carefully. This is critical to abstract art. Small differences make all the difference.

For example, the next time someone tries to sell you on the mechanical exactitude of Stella's stripes, think again about the beautiful, delicate, breathing space in these stripes, the incredible feathered edge of the touch of the picture and the dark, espresso-ground, Beat-generation blackness that places the picture in its epoch. This does not translate well in photographs, and it is easy to lose in theory, yet it is critical to the experience of the picture. Hard examination and questioning of the specificity of works of abstract art, combined with the experience of the viewer, are our best ways to hold out against and to test 'big ideas'. What we want to do is cut through the gas and grab the ideas that flow out of and drive us back toward such confusing, gritty particulars of experience, rather than the ideas that constantly and confidently blend such things into soupy generalities.

Still, even though these talks [A.W. Mellon Lectures] will focus on individual works and creators, I am going to try to indicate the connection of these artists and their art with broader histories: the Cold War and Vietnam, America versus Europe, capitalism and socialism, and so on. While I make no pretence to inclusiveness, there is so much ground to cover that I am necessarily going to paint, time and again, with comically broad brush strokes. Thus those who prefer reductive generalization and crude caricatural summary will probably find a lot to like.

Here are some of the stories I want to tell in the course of these lectures. I will begin, in the next lecture, by talking about the 1950s. One of the standard art-historical accounts of recent years tells how, in the 1950s, the CIA and the Museum of Modern Art colluded to promote abstract expressionism as an American tool in the Cold War battle. This paranoid cliché is not only flawed in itself but also hides more interesting, complex confusions and overlaps between, on one hand, the pre-war tradition of constructivism, with its agendas of science and objective order, both aesthetic and social, and, on the other, new styles that utilized similar forms but with very dissimilar premises. A key example is the work that Ellsworth Kelly did in Paris in the early 1950s, such as the beautiful 1951 work called *Colours for a Large Wall*. The painting resembles but is crucially different from the maths-based, systematic art of the Zurich 'concrete' artists such as Richard Paul Lohse, whose *Complementary Groups Formed by Six Horizontal Systematic Colour Series* dates from about the same year that Kelly painted his *Colours for a Large Wall*.

Compared to Pollock's broad, gestural abstract expressionism, work like Lohse's seemed very retrograde. It looked back to the beginnings of the concrete art movement in the early 1930s. Suddenly, in the 1960s, Kelly's work was exhibited along with minimalist avant-garde work by younger artists such as Carl Andre, as if Kelly and Andre were doing the same thing. Andre's floor piece of 1969 seems to have exactly the same modular construction and the same rigour as Kelly's *Colours for a Large Wall*. In the 1950s, when abstract expressionism

defined the New York School, Kelly left New York for Paris. The story of his artistic formation there, and of his co-optation in the 1960s by Minimalism, will provide a different view of the 1950s.

Then [in the third and fourth lectures] I want to turn to the 1960s, and to Minimalism in its multiple forms. This new kind of hard-edged abstraction emerged around 1960 in sharp reaction to the loose, gestural abstract painting that had followed from abstract expressionism. Minimalism was so drastically reductive that it appeared utterly nihilistic. But within the dead certainties that it seemed to propose lurk many an ambiguity and contradiction. I want to examine the battles within – and overlaps between – the different readings of this new direction in abstract art. Minimalism claimed to be purely American in its philosophical grounding – in its 'I've got to kick this to believe it' empiricism. This represented a willed and self-proclaimed split with Europe. But at the same time the art seems to coincide with and to draw on European art – on the work of Romanian sculptor Constantin Brancusi, for example, and on Russian constructivist art. I also want to contrast the strains of Minimalism that appear in New York and Los Angeles. For example, in 1966 New York artist Robert Morris makes a box painted neutral grey that has a reductive feeling, a feeling of utter objecthood; in the same year, the Los Angeles artist James Turrell uses light projection to conjure a box that does not exist at all, that is purely a light illusion, that has entirely to do with playing on the sensorial. While Turrell on one coast is creating inner events, Morris on the other is creating something that only exists outside.

Then I want to look at the varieties of minimalist art in between. Between the grey neutrality of Morris and the shining illumination of Turrell's *Afrum-Proto*, one might position something like Donald Judd's open aluminium boxes of 1969. Judd is someone we want to explore for his combination of a seemingly rigorous reductive geometry and odd materials – Harley-Davidson paint, galvanized metal, coloured Plexiglas, for example – materials that offer a different kind of delicacy and subtlety than one finds in Judd's manifestos.

I am interested in looking at the degree to which 1960s Minimalism expresses something quintessentially American. Some scholars have told us that Pollock's loose gestural freedom and broad cowboy scale offered an epitome of American society, and that the CIA plotted to promote his work in Europe for just this reason.[4] More recently, other scholars have told us the exact opposite: that American society is really dominated by corporate capitalism, that Minimalism expresses an industrial aesthetic, and that it is therefore in collusion with the military-industrial complex.[5]

I will look at how Minimalism changed very swiftly around 1968, as seen in works such as Richard Serra's *One Ton Prop* and Eva Hesse's *Accession II*. In this short time span – between the Morris and Turrell in 1966, and the Serra and

Hesse in 1968 – one sees a rebellion against the pure, strict, seemingly neutral geometry of Minimalism. In the case of Hesse's piece, with its rubber tubing entering the inside of a cube, we find a new kind of organicism with entirely different psychological and social ramifications, particularly in regard to the body and women. It is so interesting to think about how the Pollock exhibition of 1967 inflected the change and interpretation of Minimalism after it, and how two things that represented the macho ideal in art – Pollock's bold athletic drip paintings and Judd's stern cubes – in combination became an ideal vocabulary for feminist art in the late 1960s and early 1970s.

Another aspect of Minimalism I will explore is how it changed in its relationship to scale and the body. In contrast with an inert cube such as Morris' grey box, Serra's four pieces of lead poised against one another threaten to collapse; they have a real-time relationship to gravity and to the body that dramatically changes the premises of Minimalism.

These changes, effected by a younger generation who were inheriting the vocabulary of Minimalism in the late 1960s, also come to bear on the earlier minimalists themselves and what they do in later years. Thus the Minimalism of Judd or Morris in the early 1960s that had been proposed as an art of immediacy – an art of awareness of the sensory relationship to the object in the present tense – becomes in the 1980s and 1990s an art par excellence of memory and the monumental. It also takes on a new relatedness to America and to the American landscape, in works such as Walter De Maria's amazing *Lightning Field* near Quemado, New Mexico, an array of stainless steel, javelin-like rods in a giant, empty Southwestern landscape, making up a grid that extends for a mile along one axis and for a kilometer along the other. A work like this changes what scale means for Minimalism and releases the potentially megalomaniacal desire for control into a whole new environment, quite different from its containment in the early boxes of the 1960s.

From works like De Maria's in the 1970s, I will move on [in the fifth lecture] to the 1980s and away from weighty issues into apparent jokes. The opening premise of this lecture on satire and irony will be the truism that an abstraction often inadvertently looks like something. For example, Roy Lichtenstein's *Large Spool* from 1963 was designed to look something like one of Stella's striped paintings, *Zambezi*, of 1959. It is an extended joke about the relationship between Pop, as Lichtenstein practised it, and Minimalism, as represented by Stella's black painting. It is just one of any number of examples of Pop artists – Lichtenstein, Andy Warhol, Claes Oldenburg and others – thumbing their noses at the pretensions of minimal art, and bringing those pretensions back to earth by showing that exactly the same designs appear in crass, man-made objects.

This forces open an issue – the relationship between abstraction and mere

design – that has lingered as a haunting doubt within the idea of abstract art. Yet Lichtenstein's jibe at Stella seems light-hearted or dryly ironic once compared with what begins to happen in the 1980s, with paintings such as Peter Halley's *Two Cells with Circulating Conduit* of 1985. The joke here is that Halley's painting looks a lot like a Barnett Newman. But Halley's painting is accompanied by an enormous commentary in which the joke becomes deadly earnest. Halley argues that there is a resemblance between Newman's paintings and diagrams of computer chips, and that this resemblance is not in fact coincidental, because the strictures and pretensions of hard-edged abstraction emerged at the same time that the hegemony of control and order became the dominant feature of modern society and philosophy.[6] Halley's argument here comes from the French philosopher Michel Foucault.[7] Following Foucault, Halley discerns a sinister, constraining order that links together the geometry of prisons, the organization of information in cyberspace, and the inclination toward geometric abstraction. Hence the presence of the word 'cell' in the title of so many of Halley's paintings, referring simultaneously to the modular unit of Newman-style abstraction and to the confining spaces of a prison.

Another representative figure of 1980s abstraction is Philip Taaffe. In a picture like *Blue, Green* of 1987, Taaffe takes a big blue arrow shape, quoted directly from early Ellsworth Kelly, and doctors it up with wavy lines and flower patterns, cheapening it and making it look like a trivial plastic decoration. Where Halley tells us that abstraction is all-powerful and dominating, Taaffe tells us that it is inconsequential and thin. This kind of politicized critique of abstraction dominates much of the 1980s.

From there I want to look at the larger question raised by all of these jokes and satires as to whether abstraction is even possible after Johns' flag and the triumph of irony in contemporary art. Can artists have it both ways? Can they be ironic *and* abstract? Among the paintings we will look at are Gerhard Richter's *Grey Streaks* of 1968, which has an obvious relationship to Stella's work, and at Johns' own paintings of the years 1972 to 1980, when he painted pure abstract pictures in a cross-hatch mode that seems like a geometrized variant of Pollock's all-over space and gesture. I want to examine the phenomenon of part-time abstractionists, artists such as Johns and Richter and Twombly, for whom abstract art is not an end-of-the-line distillation but rather one option among many. On one day, or in one week, or in one decade, they might make abstract work, but it would exist in counterpoint with the photographic realist work that they would make on the next day or week, or in the next decade. This is a phenomenon unique to the period after World War II.

Having moved through the 1960s, 1970s and 1980s, [in the final lecture] I will arrive at the present day, talking about the remarkable new installations at

the Dia Art Foundation facility in Beacon, New York, which opened in May 2003. The work on view at Dia includes a Michael Heizer piece, *North, South, East, West*, which consists of extremely large depressions cut into the floor and lined with Cor-Ten steel.

This was originally conceived in 1967, although it was only permanently realized at Beacon. In a large train shed at Beacon, there is a whole run of Richard Serra's 'torqued ellipses' designed in 1998. Thirty years stretch between Heizer's original proposal for North, South, East, West and Serra's series of torqued ellipses. In this time span there are huge changes in the status of abstraction, and particularly in the status of Minimalism. There are now monuments to the achievement of Minimalism all over the country. Following the model of the Rothko Chapel in Houston, the minimalist shrines range from Turrell's Quaker meeting house in Houston, to Judd's vast complex in Marfa, Texas, to De Maria's *Lightning Field* in Quemado, to Heizer's complex *City* monument outside of Las Vegas, and ultimately to Dia Beacon itself. The strange thing is that, despite the enshrinement and monumentalization of Minimalism, abstraction now seems to be in suspension, or even in eclipse. The great lions of Minimalism, like Heizer and Serra, are into or well past their sixties. It is not clear whether abstract art holds the same attraction for a younger generation, or whether the most contentious issue in visual culture of the twentieth century has now lost its urgency. [...]

In addition to all the 'how' stories about the way this art developed over several decades, I feel obliged to ask some 'why' questions, including ultimately the overarching one I deferred at the outset: Why abstraction? Why abstract art? [...] Beyond my liking abstract art, or your liking it, beyond the commitments of the artists who make it; and beyond the collectors and institutions that support it, *What is abstract art good for?* What's the use – for us as individuals, or for any society – of pictures of nothing? What's the use of paintings or sculptures or prints or drawings that do not seem to show anything except themselves – big holes in the ground, or huge curved pieces of steel?

I take this topic ultimately because it seems to me one of the most legitimate and poorly addressed questions in modern art. Put another way, I want to ask whether there is any grounding for abstraction, perhaps an underlying logic, or specifically a 'logic of the situation', to borrow a term from E.H. Gombrich. Almost fifty years ago, Gombrich gave the epochal Mellon Lectures that became his book *Art and Illusion*, and I want to recapture some of the excitement that must have filled the [Washington] National Gallery's lecture hall in 1956 when Gombrich spoke. He asked at that time one of the most resounding questions of all: Why does art have a history? Gombrich wanted to crack what he called the 'riddle of style': that is, to find an explanation for the succession of odd stylizations by which different epochs and civilizations have represented the visible world. He

opens *Art and Illusion* with a cartoon of Egyptian boys drawing from a model: given that the elements of the natural world have always looked as they do, and given that human vision has always functioned as it does, Gombrich wanted to know why ancient Egyptians and mediaeval Italian monks and baroque ceiling painters depict the world so differently.[8] He was intensely dissatisfied with explanations that rested on some quasi-mystical spirit of the age or zeitgeist. Instead he wanted an explanation of the history of art that had more scientific and philosophical rigour, that would take into account both the 'hard-wiring' of human perception and the way knowledge has progressed cumulatively through successive ages and societies. Gombrich's proposal, which drew on the best minds of his time in areas such as perceptual psychology and the philosophy of science, was that within the confounding variety of the history of Western art one could trace a long, halting but ultimately rational progress toward the development of a credible illusionism, that is, the feat of getting a viewer to conjure from painted marks on a flat surface a convincing illusion of such things as seamlessly receding space and three-dimensional volumes. Albrecht Dürer, in his 1525 woodcut of an artist trying to reason out the correct way to show a lute in perspective, reminds us how long and hard artists had to work to achieve this illusionism.

Gombrich delivered his Mellon Lectures in 1956, the year of Jackson Pollock's death, when abstract art appeared to be spreading triumphant. At the same time, realist illusionism, propagated on every pulp page and street corner billboard by magazine illustrations, advertisements, and above all by photography, was taken for granted by the wider public. Gombrich wanted to reproblematize that commonplace: to show that, far from being a merely servile copying of nature – we see it, we draw it – illusionist representation was a willed, hard-fought achievement of human culture. It was the result of a cumulative dialogue between invented conceptual schemas and their corrections – a dialogue that was worthy of being regarded, like science, as a unique virtue of the Western tradition, stretching from what he called 'the Greek miracle', in the vase painting and sculpture of the fifth century BCE, through Dürer and the Italian Renaissance up to John Constable's naturalist landscape paintings, such as his beautiful 1816 picture of Wivenhoe Park, Essex from the National Gallery of Art collection.

But this noble progress foundered when it came up against the wall of the oncoming twentieth century. As much as Gombrich cherished the triumph of illusionism, he disliked and mistrusted its demise in abstract art. The antipathy was partly personal. Gombrich was, after all, a Renaissance scholar, and his tastes and sympathies were grounded in an earlier humanism. But his was also an intellectual and even ideological bias. Gombrich thought that abstraction was understandable as an extension of the history of decorative pattern-making, as in Alhambra tiles, rugs, basket weaves and the like. But – if I can risk summing up and

interpreting his many writings on the subject of abstract art – he saw the claim that modern abstract art might be something more than decoration as based either in mystifications about abstraction reflecting hidden metaphysical truths or in specious arguments that the tides of history somehow required such innovations.

It was precisely that lethal combination of belief in 'higher ideals', stretching back to Plato, and pronouncements about the 'requirements' of history, grounded in Hegel, that Gombrich's close friend, the philosopher Karl Popper, in his wartime book *The Open Society and Its Enemies*, had recently scourged as the false philosophical foundations of totalitarian thinking, propounded by both Fascism and Soviet Communism. Thus, to put it far more crudely than Professor Gombrich, the implicit message of *Art and Illusion* is twofold. On one hand, Gombrich argues that the construction of illusionist naturalism is directly consonant with the neurological hard-wiring of human nature. On the other, he suggests the progressive way illusionism developed also makes it the appropriate 'house style' of the best liberal traditions of free inquiry and criticism in the open society of the West. Conversely, Gombrich's subsequent put-downs of abstract art present its excesses as being, at best, whims of trendy fashion, and, at worst, tainted with the most dangerous policies of totalitarian thought.

I admire so much about *Art and Illusion*. Rather than critique the flaws that have become evident in Gombrich's arguments over time, I want to wonder with you whether there can ever be an argument for abstract art that is as good, as generous, as ambitious and as challenging as Gombrich's argument for its opposite. Because as he rightly saw, all the many claims about timeless universal forms and historical destinies that have been used to explain modern abstraction are, however sincere or sophisticated, intellectually bankrupt. There are not any 'hard' reasons why abstract art has to be. Nor any teleology that explains why it developed as it did. And it is useless to keep looking for those kinds of justifications.

This does not invalidate abstract art. The familiar arguments that abstraction is just a big hoax, a colossal version of the 'emperor's new clothes', perpetrated on a duped public by cynical art mandarins, seem like tiresome whistling in the dark. Abstract art has been with us in one form or another for almost a century now, and has proved to be not only a long-standing crux of cultural debate, but a self-renewing, vital tradition of creativity. We know that it works, even if we're still not sure why that's so, or exactly what to make of that fact. To borrow the phrase of the apocryphal contemporary academic, 'Okay, so it works in practice. But does it work in theory?' What is still needed, what seems well overdue, is to make the case for a logic of abstract art, as *Art and Illusion* made the case for illusionism, that would describe it (with respectful opposition to Gombrich's own dismissals) both as a legitimate reflection of the way we think individually and as a valid and valuable aspect of liberal society.

This is, of course, a tall order, not least because at the start of the twenty-first century we have very different ideas about how our minds work and how a just society functions. Looking at early minimalist works by artists such as Sol LeWitt and Dan Flavin necessitates revising and expanding Gombrich's idea of *making*, by which he meant the invention of forms and schemas, the mind's primal work in building knowledge. Especially in the last fifty years, a lot of abstract art has demonstrated that our intelligence innovates not by making things up out of whole cloth or by discovering new things about nature, but by operating with and upon the repertoire of the already known: by adapting, recycling, isolating, recontextualizing, repositioning and recombining inherited, available conventions in order to propose new entities as the bearers of new thought. In the case of art, these conventions are dumb, man-made forms like cubes, stripes and other architectural configurations. With illusionism, the argument could be made that art progressed by a series of corrections, made according to the unchanging standard of nature and perceptual mechanics. But there obviously is not any standard of measurement or external resemblance by which we could correct abstractions such as LeWitt's or Flavin's, or establish their relative success or failure. So we have to expand our sense of the drives wired into human cognition, recognizing that we are set up not just to make connections and find resemblances, but also to project meanings onto experience.

In *Art and Illusion* Gombrich discussed the classic drawing that looks like both a duck and a rabbit. We can see either the duck with its beak to the left, or the rabbit with its ears to the left, but we cannot see both at the same time, so we have to decide to see it as one animal or the other. Gombrich uses the drawing to illustrate the way that our visual perception involves what he calls 'the viewer's share', that is, the active imposition of an interpretation on incoming experience. The point made by the duck-rabbit drawing can be broadened into a suppler and more inclusive notion of cognition as a process of finding meaning in the world.

Gombrich's model reminds us that works of art are vessels of human intention. The problem is that he judges artistic schemas exclusively by how well they transcribe reality. This is a useful yardstick for discussing representational art, but it is not much help in talking about artists whose goal is to have *no* reference. In abstract art, we face the problem of interpreting images that resemble any number of things, but look like nothing in particular. This situation is lovingly summed up in another cartoon that is, in effect, the modern inversion of Gombrich's cartoon of Egyptian boys drawing from a model.

Where Gombrich remains useful, here, is in reminding us that abstraction, even more than illusion, can never reside solely in the intention of the artist, but must also be in the eye of the beholder. Artist X may think he's making something that looks like nothing, but Viewer Y may think the work is just the colour of

Aunt Emmy's purse, or curves just like the bent blade of his favourite golf club, or involves the key principles of 1911 Picasso. I could take the case of Donald Judd's early minimal sculptures as somewhat comic examples. These early Judds are what he called 'specific objects'; that is, things that do not seem to be either painting or sculpture, that escape category, that are not familiar, that cannot be pinned down as to what they are.[9] Judd intended these works to be entirely idiosyncratic, outside the common bounds of descriptive language. But in fact he himself, and his viewers and critics, immediately started to categorize these objects, and continued to do so. In the literature on Judd, one of these weird works is known as the 'Letter Box', while the other is commonly referred to as 'The Bleachers'. Other early Judds got nicknamed 'The Harp' and 'The Lifeboat'.[10]

Almost as fast as artists can open blank slates, others hasten to inscribe something on them, trivially at first, as in this case, but eventually with more serious freights of meaning. Hence the difficulty of enforcing the 'abstractness' of abstraction. Pollock told an interviewer that when he poured his paintings, he was ever mindful to suppress unwanted imagery or any apparent figuration that his lines might inadvertently suggest. 'I try to stay away from any recognizable image; if it creeps in, I try to do away with it.'[11] Since then artists have worked harder and harder to keep the crutch of resemblance permanently kicked out from under their viewers. They understand that abstraction is most successful and effective when association and meaning appear to be out of reach. The absence of resemblance allows the work to embrace a great range of intuitions barely imaginable before the work was done, and only marginally present in the artist's conscious intention.

Take for example the huge painting – about four by six metres – done in 1970 by Cy Twombly. [*Untitled* (1970), in the collection of The Museum of Modern Art, New York.] Drawn with what looks like chalk but is actually an oil crayon on grey ground, it is one of his so-called blackboard series; this label is itself a kind of joke, like the descriptive titles people gave Judd's work. In fact, it is not a blackboard, and this forces us to deal with what it is. But what is it? It is a kind of furious scribbling, a seemingly mindless repetition of the same hand-drawn gesture. But the gesture is repeated so often and on such a scale that it begins to vault into a different set of references. We lose sight of the arm or the wrist, and begin instead to be aware of the scale of the whole body. And then, because the overlays and densities begin to create a sense of space or depth that is nowhere cued by perspective but is suggested by the blurring, cloud-like structure, we lose awareness of the scale of the body as well. My wife, who is an artist, said of this picture it's so large and complex that it has its own weather. We sense that it has a kind of energy to it, a pulse like that of a cosmic nebula. And we keep reaching for analogies – weather, night sky, impulsiveness – for a vocabulary that in the end describes nothing other

than this picture. We grapple with the combination of things the picture presents: with minute, intimate and grand scale; with flatness and depth; with huge energy and vast, dissolving serenity. And we continually wind around something that never becomes any particular thing but itself, that has all of the complexity and energy that only it has, and that did not exist before.

Gombrich showed that, in representation, recognition and resemblance required interpretation. But abstractions such as Twombly's show that interpretation does not demand recognition or resemblance and may in fact profit from its absence. In cases like this, abstract art absorbs projection and generates meaning ahead of naming, establishing the form of things unknown, sui generis, in their peculiar complexities. This is one of abstraction's singular qualities, the form of enrichment and alteration of experience denied to the fixed mimesis of known things. It reminds me of the joke about the person who invented the cure for which there was no known disease. At the same time, this expanded, open-ended process of matching forms with meanings, by means of projection and cued invention, constantly turns abstractions into representations in a broadened sense, and defines the nature of abstract art in our time. In early modern art, abstraction was often promoted (or scorned) as a final destination, an ultimate endpoint of art, the culmination of a progressive divorce from appearances, or the terminal cancellation of everything that art required. But by now we have seen art declared 'dead' too many times, and we're weary of going to fake funerals. (My colleague Robert Storr taught a course in abstract painting a few years ago that he called 'Dead but Won't Lay Down'.) In our model of history, there is not any progress at all, in the sense of straight-line, cumulative refinement toward a fixed goal. We have seen the end of the line become a departure station frequently enough to understand that even the seemingly purest abstraction that looks like a fat zero is in fact often an egg waiting to hatch. Not the period at the end of the story, but an ellipsis … (to be continued) within a looping and branching system that ties together a wide range of visual representation: loquacious, laconic, dumb, and all stops in between. Within that system, the abstract artist may colonize a new realm of feeling, as Twombly does, unique to his or her forms, and may also invent a new alphabet which a great many others – artists, designers, filmmakers, and so on – can use to represent the world in very different ways.

For an example of how things get recycled, let's look at the use of mirrors in Minimalism and postmodernism. In 1965, Robert Morris created a set of untitled mirrored cubes that were just that: cubes with mirrors fixed to the five visible sides. These may have had something to do with his desire to produce a totally neutral, industrial-looking form – something that seemingly is not made by the human hand, has no room for touch, is absolutely hard – and with his desire to force us to recognize the space around the object as part of the work of art.[12] Then,

in 1968, when a new organicism appeared in Minimal or postminimal art, Morris created a very different piece, using mirrors stuck into a pile of thread waste.

In the same year, Robert Smithson made his *Red Sandstone Corner Piece*. This is like an inside-out version of one of Morris' mirrored cubes, with a pile of broken sandstone inside it. Smithson may have got the idea of using mirrors from Morris, but his use of them was radically different. His combination of mirrors with natural materials had to do with a science fiction idea of crystallography, with the notion of the inertness of mineral matter as a paradigm for the entropic universe and for the way that life forms lose their energy; it had to do with the idea that glass is made by grinding up sand, and that the two are different states of the same thing. For Smithson there was a pseudo-scientific rationale to using mirrors, but the mirrors themselves functioned as abstract elements in his work.

In the 1970s the young artist Jeff Koons comes along and puts an inflatable rabbit and flower on a mirror in the floor corner position – the same mirror arrangement that Smithson used, but with a completely different effect. We are no longer in the world of entropy and crystallography; we're in the world of boutique design. The mirror suggests glitz and glamour. This evolution reaches its final realization when Koons puts the mirror *on* the rabbit by recasting the rabbit in shiny stainless steel instead of plastic. This amazing object is often taken to be the ultimate symbol of Reagan-era glitz, a critique of the commodification of society. So the inclusion of the mirror begins as a neutral, formal element in Morris, becomes a sci-fi image in Smithson, and finally provides Koons with a symbol for the hard sheen and glamour of American consumer culture.

In this fashion, abstract art, while seeming insistently to reject and destroy representation, in fact steadily expands its possibilities. It adds new words and phrases to the language by colonizing the lead slugs and blank spaces in the type tray. Seeming nihilism becomes productive, or, to put it another way, one tradition's killer virus becomes another tradition's seed. Stressing abstract art's position within an evolving social system of knowledge directly belies the old notion that abstraction is what we call an Adamic language, a bedrock form of expression at a timeless point prior to the accretion of conventions. If anything, the development of abstraction in the last fifty years suggests something more Alexandrian than Adamic, that is, a tradition of invention and interpretation that has become exceptionally refined and intricate, encompassing a mind-boggling range of drips, stains, blobs, blocks, bricks and blank canvases. The woven web of abstraction is now so dense that, for its adepts, it can snare and cradle vanishingly subtle, evanescent and slender forms of life and meaning. The tradition of abstract art has recently shown time and again that, for those who learn it, it can make something out of apparent nothing. All in all, this is a good thing.

Like Gombrich's illusionism, abstract art is a construction that began in

Western Europe but that has proved useful for a broader world. Early modern society created – and we have inherited – that paradoxical thing: a tradition of radical innovation. Abstraction is a remarkable system of productive reductions and destructions that expands our potential for expression and communication. Just the same, this is a risky business. Abstract art is a learned language, and not always easy to understand. I do not mean there is nothing to be had from an unprepared, naïve encounter with Flavin's *monument* for V. Tatlin, or with a blank, waxy monochrome canvas by Brice Marden. Nor do I mean to endorse the sense of cultish elitism that requires an MA in art history and a subscription to *Artforum* to understand what goes on in the Chelsea galleries. Dealing with recent abstraction is neither like falling off a log nor like solving differential equations. But the fact is that it does profit from some prior knowledge. Because contemporary abstract art operates within a long tradition, it helps to be aware of the parameters and rules of that tradition.

Understanding the tradition of abstract art sharpens our experience of what we are seeing. The idea that you need to learn about abstract art to enjoy it strikes some primal nerve, arousing our anxiety about authentic versus fake experience. It offends the know-nothings, who fall back on: 'I don't know art, but I know what I like.' But this cliché flies in the face of our common sense awareness, reinforced a thousand times in our life, that some of the most deep-seated pleasures of our natural selves – from sex and food on up to music – involve appetites that had to be educated. If these pleasures are rooted in crude instinct, they nonetheless grow in depth and power as we acquire hierarchies of discrimination, until second nature is nowhere separable from the first. Yet visual art – and abstract art most particularly – remains one of the last bastions of unashamed, unrepentant ignorance, where educated experience can still be equated with phony experience. In regard to abstract art, this syndrome becomes ever more acute as the tradition gets fatter and the works get leaner. What we see gets simpler, and what we can bring to it gets more complex. So we are constantly worried that we are being played for fools by works like Flavin's sculpture or Marden's painting. What makes the anxiety even worse is the fact that this is an art that, by its very nature, wilfully and knowingly flirts with absurdity and emptiness, dancing on the knife edge of nonsense and beckoning us to come along.

Why put up with it? Because we want what only this risk has been able to give us. Of course, what we want from many of the forms of our culture is comfort and continuity, a sense of connection to enduring traditions, a respite from the relentless clocks that drive our individual lives. But, in modern society, we also live with a sharply ambivalent, painfully keen awareness that our lives are irremediably different from those of the past. We rise each day to a particular mix of sharpened pleasures and deepened anxieties that quickens our sense of

separation from other days – a century ago, a decade ago, two years ago. This arouses in many of us a hunger for a culture that affirms this sensation, by giving us new forms that give shape to our feelings, our moment in history – as distinct from the feelings of our forebears, even of our youth. We torment (and flatter) ourselves with the belief that it has not all been said, that life as we live it is more complex than has until now been articulated. And in order to allow room for the new cultural forms we feel might be adequate to this vivifying hubris and doubt, we are willing to accept the destruction of past cherished norms, to endure large measures of disorientation in the present, and to sift through a great deal of dreck.

Abstract art is propelled by this hope and hunger. It reflects the urge to push toward the limit, to colonize the borderland around the opening onto nothingness, where the land has not been settled, where the new can emerge. That is part of what drives modernity: the urge to regenerate ourselves by bathing in the extreme, for better and for worse. What is remarkable is that abstract art, which was initially advanced by its advocates as a culture of crypto-religious, timeless certainties associated closely with the new monolithic collectivism in society, should have been reinvented and flourished the last fifty years as a paradigmatic example of secular diversity, individual initiative and private vision. It is a prime case of modern Western society's willingness to vest the fate of its communal culture in the play of independent subjectivities, and to accept the permanent uncertainties, pluralities and never-ending, irresolvable debate that come with that territory. […]

1 [footnote 2 in source] Barnett Newman, 'The Sublime is Now' (1948); reprinted in Clifford Ross, ed., *Abstract Expressionism: Creators and Critics, an Anthology* (New York: Harry N. Abrams, 1990), 127: 'We are creating images whose reality is self-evident and which are devoid of the props and crutches that evoke associations with outmoded images, both sublime and beautiful. We are freeing ourselves of the impediments of memory, association, nostalgia, legend, myth, or what have you, that have been the devices of Western European painting. Instead of making cathedrals out of Christ, man or "life", we are making it out of ourselves, out of our own feelings.'

2 [4] Statement by Robert Rauschenberg in Dorothy Miller, ed., *Sixteen Americans*, catalogue (New York: The Museum of Modern Art, 1959) 58: 'Painting relates to both art and life. Neither can be made. (I try to act in that gap between the two.)'

3 [5] Stella said that, 'I tried for something which, if it is like Pollock, is a kind of negative Pollockism … I tried for an evenness, a kind of all-overness, where the intensity, saturation and density remained regular over the entire surface': Cited in William S. Rubin, *Frank Stella* (New York: The Museum of Modern Art, 1970) 29.

4 [7] See Max Kozloff, 'American Painting during the Cold War', *Artforum* (May 1973) 43–54; Eva Cockcroft, 'Abstract Expressionism: Weapon of the Cold War', *Artforum* (June 1974) 39–41; and

Serge Guilbaut, *How New York Stole the Idea of Modern Art: Abstract Expressionism, Freedom and the Cold War* (Chicago: University of Chicago Press, 1983); see also the critique of these views by Michael Kimmelman: 'Revisiting the Revisionists: The Modern, Its Critics and the Cold War', in *The Museum of Modern Art at Mid-Century: At Home and Abroad; Studies in Modern Art 4* (New York: The Museum of Modern Art, 1994) 38–55.

5 [8] Anna C. Chave, 'Minimalism and the Rhetoric of Power', *Arts* (January 1990), 44–63.

6 [9] Peter Halley, *Collected Essays, 1981–87* (Zurich: Galerie Bruno Bischofberger, 1988); see, in particular, 'Nature and Culture', 'The Crisis in Geometry' and 'The Deployment of the Geometric'.

7 [10] Michel Foucault, *Discipline and Punish: The Birth of the Prison* (1975) (New York: Vintage Press, 1995).

8 [11] Ernst Gombrich, *Art and Illusion* (1960) (Princeton: Princeton University Press, 1961) 33.

9 [12] Donald Judd, 'Specific Objects', *Arts Yearbook*, 8 (1965) 74–82; reprinted in Donald Judd, *Complete Writings, 1959–1975* (Halifax: Press of the Nova Scotia College of Art and Design/New York: New York University Press, 1975) 181–9.

10 [13] For the 'Letter Box', see James Meyer, *Minimalism: Art and Polemics in the Sixties* (New Haven and London: Yale University Press, 2002), caption to fig. 34; for the 'Bleachers', see the caption to fig. 40; for 'Harp', see the caption to fig. 45. The piece known as the 'Lifeboat' is reproduced in James Meyer, ed., *Minimalism* (London and New York: Phaidon Press, 2000) 85.

11 [14] Pollock's remarks were captured in Dorothy Seiberling's notes for her profile of Pollock in the 8 August 1949 issue of *Life* magazine. Seiberling's unpublished notes are cited in Steven Naifeh and Gregory White Smith, *Jackson Pollock: An American Saga* (New York: Clarkson N. Potter, 1989) 591.

12 [15] In 'Notes on Sculpture, Part 2', originally published in *Artforum* (October 1966), and reprinted in Gregory Battcock, ed., *Minimal Art: A Critical Anthology* (New York: E.P. Dutton, 1968) 232, Morris writes that: 'The better new work takes relationships out of the work and makes them a function of space, light, and the viewer's field of vision.'

Kirk Varnedoe, extracts from 'Why Abstract Art' (the first in Varnedoe's series of A.W. Mellon Lectures, delivered at the National Gallery of Art, Washington, DC, in Spring 2003); reprinted in Kirk Varnedoe, *Pictures of Nothing: Abstract Art Since Pollock* (Princeton: Princeton University Press, 2006) 20–45.

Judi Freeman
Abstraction//1986

[...] To abstract means to 'withdraw'; to 'take away secretly'; to 'draw off or apart'; to 'disengage from'; to 'separate in mental conception'; to 'consider apart from the material embodiment, or from particular instances' (*Compact Edition of the Oxford English Dictionary*, s.v. 'abstract'). These meanings can be documented as far back as the sixteenth century. Taken individually or in combination, they were central to discussions about abstraction in the early years of the century. Descriptions of the process of abstraction have ranged throughout the twentieth century from secret removal to the creation of something visionary.

The association of abstraction in art with meaninglessness is derived in large measure from Wilhelm Worringer's *Abstraction and Empathy: A Contribution to the Psychology of Style*, published in Munich in 1908. Worringer equated *abstract* with *angular* and *anti-naturalistic*. Guillaume Apollinaire further divorced the abstract from reality when he devised the concepts of 'pure painting' and 'pure art': an art that would be to painting 'what music is to poetry'. In a 1913 or early 1914 sketchbook annotation Piet Mondrian elaborated: 'One passes through a world of forms ascending from reality to abstraction. In this manner one approaches Spirit, or purity itself' (quoted in Robert P. Welsh and J.M. Joosten. *Two Mondrian Sketchbooks 1912–14* [Amsterdam, 1969]). Wassily Kandinsky similarly distinguished the abstract, a style of painting with few references to representational motifs, from the gegenstandlos, literally 'without object or objectless'.

Art criticism from the 1940s through the early 1970s has encouraged the association of abstraction with non-representation. Recent scholarship, however, has reasserted the subject in abstraction and has begun to rediscover meanings that were neglected by these previous generations of scholars and critics. In this new work scholars are echoing Worringer's thoughts of nearly seventy years earlier: 'Now what are the psychic presuppositions for the urge to abstraction? We must seek them in these peoples' [artists, writers, philosophers] feeling about the world, in their psychic attitude toward the cosmos ... the urge to abstraction is the outcome of a great inner unrest inspired in man by the phenomena of the outside world; in a religious respect it corresponds to a strongly transcendental tinge to all notions' (Wilhelm Worringer, *Abstraction and Empathy* [Cleveland, 1967] 15). [...]

Judi Freeman, extract from 'Abstraction', in *The Spiritual in Art: Abstract Painting 1890–1985*, ed. Maurice Tuchman with Judi Freeman (Los Angeles: Los Angeles County Museum of Art/New York: Abbeville, 1986).

Gabriel Pérez-Barreiro
Geometry of Hope//2007

[...] What is 'The Geometry of Hope'? The title of this exhibition brings together the two threads that epitomize abstract art from Latin America: on the one hand, geometry, precision, clarity and reason; on the other, a utopian sense of hope. This title arose as a contrast to the 'geometry of fear', a term coined by Herbert Read in 1952 to describe the atmosphere of post-war angst in British art and its expression through aggressive and unstable geometric forms, as in the work of Kenneth Armitage, Lynn Chadwick and others. A quick overview of Latin-American geometric art from the same period reveals a completely different panorama: colourful and playful kinetic sculptures, experimental objects as catalysts for community building, manifestos calling for joy and the negation of melancholy. And yet this glimpse of post-war Latin America could not offer a sharper contrast with our current worldview, accustomed as we are to associating Latin America with failure, poverty and pessimism, whereas we associate Europe with reason and progress. The exhibition and the catalogue, if they do nothing else, should remind us that there was a time when Latin America was a beacon of hope and progress in a world devastated by war, genocide and destruction. [...]

The first issue raised by any project of this nature concerns the question of a suitable framework within which to present these similar but nevertheless different artworks. What ties the works together, and what sets them apart from each other? More specifically, how do we deal with the fact that the works in the exhibition, although they appear similar in style and language, were produced by artists who often had little knowledge of each other, and whose geographical and temporal contexts – not to mention their artistic intentions – were often radically different? Most exhibitions of Latin American abstraction fall into one of two models: contextual or formalist. The contextual model – epitomized by such exhibitions as 'Art in Latin America'; 'Brazil: Body and Soul'; 'Art from Argentina'; and 'Inverted Utopias' – takes a geographical region as its starting point.[1] In these exhibitions, abstraction is one part of the story of how a particular region's culture developed, one step in a history about the formation of an identity. At its worst, this model reduces each movement to an illustration of a context. Moreover, exhibitions with 'Latin America' or 'Latin American' in their titles present contexts that have little or no connection as the same (Montevideo and Caracas, for example), in the interests of an overriding story about the development of a Latin American culture that is defined in opposition to another monolithic bloc (Europe or the United States). By contrast, the formalist model

radically decontextualizes artists, presenting works in terms of relationships that are based on optical or formal similarities. This is the model used in exhibitions such as 'Beyond Geometry' and 'Les figures de la liberté'.[2] In this model, Mira Schendel, Jesús Rafael Soto and Kazimir Malevich, for example, might converse in terms of the tension between icon and ground, in a true 'constellation' of meanings, one in which there is no *a priori* geographical or contextual framework.

Is there a third way between these models? Can we discuss context without being illustrative, while also recognizing that context is an essential element in the configuration of meaning? The first step in answering this question is to establish the unit of context. If 'Latin America' is too big a term, encompassing too much diversity and disconnection, is the name of a nation any better? Does 'Brazil', for example, allow us to distinguish between São Paulo and Rio de Janeiro When we talk about 'Argentina', do we really mean Mendoza, Salta and Córdoba?

'The Geometry of Hope' is structured around the city as the unit of context. The city is where ideas circulate, where different voices and intentions collide in the same physical space; a city is the hub of a network that is simultaneously local and international. As soon as we established a city-based model, we found it natural, indeed inevitable, to include Paris alongside the Latin American cities as a key reference in the development of geometric abstraction in Latin America, thus side-stepping the sterile Europe/Latin America opposition and recognizing the rich interdependence between, for example, Caracas and Paris. This geography of specific cities also allows us to see that geometric abstraction was largely a phenomenon of the large port cities on the Atlantic coast. These are the cities that received the most European immigrants, industrialized most rapidly, and created the most modern urban cultures. Therefore, rather than discuss abstraction in terms of its being a paradigm for Latin-American culture as a whole, it might be more accurate for us to talk about abstraction as a paradigm for an urban Atlantic culture, just as we might talk about different paradigms for the Andean, Pacific or pampas cultures. This kind of multidimensional cultural geography allows us to move away from stereotypical cultural generalizations based purely on language and difference, thus letting us use a more specific and complex model.

Once we had established the cultural geography of this exhibition, we faced the next issue: reading the works themselves. How could we attribute specific meanings to abstract objects that aspired to speak in a universal language? If the aim of the exhibition's framework was to avoid the extremes of contextual illustration and decontextualized formalism, then we needed to look at the *intention* behind a particular work. The question, therefore, was not what the work looked like but *why* it looked that way. Charles Harrison has posited the issue as follows:

A tendency to identify and exalt works of art in terms of their 'formal properties', their 'optical characteristics', their 'ineffable appearance', leaves representation of the experience they produce highly vulnerable to encapsulation within the typical terms of a dominant culture. Talk about works of art has nowhere else to go if it does not lead into enquiry into conditions and mechanisms of production.[3]

Therefore context should be seen not as an essentialist determinant of form and meaning, but rather as the stage on which ideas are processed and discussed.[4] Just as a foreign language seems incomprehensible at first, revealing nuances over time, so does all abstraction appear, at first glance, to reiterate the same meanings. Only by looking at intention within a context can we begin to distinguish radical differences between works that share the same formal vocabulary. Only through this examination of intention within context can we distinguish, for example, Madi's quasi-Dada questioning of the limits of the artwork from Tomas Maldonado's search for 'good form', or between Lygia Pape's narrative constructions and Lygia Clark's dissolution of meaning into tactile sensation.

Broadly speaking, there are two tendencies, or rather two *propositions*, within Latin-American geometric abstraction. One is based on a belief in reason, in an international language of abstraction that represents the highest stage in the evolution of modern art. For the artists whose work exhibits this tendency – Maldonado, María Freire, Willys de Castro, Soto, Carlos Cruz-Diez – the rules of the game are clear, and the practice of abstraction represents an ideological affiliation with an idea of progress based on Enlightenment beliefs. Where the other tendency is concerned, artists have used the same visual language to express the opposite of reason: a desire to undermine the rationalist discourse of modernity in favour of a deep questioning of the role of art in human experience (Madí, Clark, Hélio Oiticica). In this regard, Peter Bürger and Renata Poggioli have made useful distinctions between these two attitudes, emphasizing that the avant-garde, rather than reflecting an absolute characteristic, is entirely dependent on the circumstances of its creation.[5] Poggioli's distinction between *movements* and *schools* is particularly useful as a way of articulating relationships between Latin America and the rest of the world. The artist who joins a school does so by accepting a pre-established set of values, essentially 'buying in' to a style and its associated meanings. A movement emerges in order to oppose and question a school; its intention is to alter the rules of the game. Both attitudes are present in the Latin American art in 'The Geometry of Hope', just as they are present in Russia, England or anywhere else in the world. Working with these active, propositional, necessarily contextual categories, perhaps we can finally move away from discussions about who came first, or which art is 'derivative' and which 'original'. [...]

In an age of cynicism about politics, society and the relationship of art to social change, it is refreshing to encounter these works and propositions, and to recall a period when artists were committed to a radical transformation of their environment. Our enthusiasm for the modernist project in Europe is inevitably clouded by our knowledge that those ideals of purity and hygiene were translated – inevitably, it seems – into concentration camps and genocide. And in the United States, the history of high modernism has become rarified to such an extreme degree that we find it hard to extract a strand of idealism from an increasingly market-led art system. In the case of Latin America, the modernist project was certainly a failure in that dreams of development and progress were swept away by decades of dictatorship and social conflict, but modernism was also saved from association with social engineering and nationalist triumphalism. These relics from a recent past – paintings, sculptures, magazines and manifestos – seem to contain and embody a rich legacy that reminds us of another, alternative history of Latin America, a history of hope and optimism.

1 See, for example, Dawn Adès, ed., *Art in Latin America: The Modern Era, 1820–1980* (New Haven and London: Yale University Press, 1989); Edward J. Sullivan, ed., *Brazil: Body and Soul* (New York: Guggenheim Museum, 2001); David Elliott, ed., *Art from Argentina* (Oxford: Museum of Modern Art Oxford, 1994); and Mari Carmen Ramírez and Héctor Olea, eds, *Inverted Utopias: Avant-Garde Art in Latin America* (New Haven and London: Yale University Press/Houston: Museum of Fine Arts, 2004).

2 See, for example, Lynn Zelevansky, *Beyond Geometry: Experiments in Form, 1945–75* (Cambridge, Massachusetts: The MIT Press, 2004) and *Les Figures de la liberté* (Geneva: Musée Rath, 1995).

3 Charles Harrison, 'Modernism and the "Transatlantic Dialogue"', in Francis Frascina, ed., *Pollock and After: The Critical Debate* (London: Harper and Row, 1985) 221–2.

4 For example, Mari Carmen Ramírez's remarkable claim that Rhod Rothfuss's geometric compositions recall 'eyes', or carnival masks from Montevideo, can be read as a subtle continuation of stereotypes presenting Latin America as a land of anthropomorphism and carnivals; such a claim avoids any examination of the sophisticated debates about abstraction in the Rio de la Plata of that period. See Ramírez and Olea, eds, *Inverted Utopias*, 197.

5 See Peter Bürger, *Theory of the Avant-Garde*, trans. Michael Shaw (Minneapolis: University of Minnesota Press, 1984); and Renato Poggioli, *The Theory of the Avant-Garde* (Cambridge, Massachusetts: Harvard University Press, 1981).

Gabriel Pérez-Barreiro, extract from introduction, *Geometry of Hope: Latin American Abstract Art from the Patricia Phelps de Cisneros Collection* (Austin, Texas: Blanton Museum of Art/New York and Caracas: Fundación Cisneros, 2007) 13–27.

Amilcar de Castro, Lygia Clark, Ferreira Gullar,
Reynaldo Jardim, Claudio Mello e Souza, Lygia Pape,
Theon Spanudis, Franz Weissmann
Neo-Concrete Manifesto//1958

The expression 'Neo-Concrete' denotes a new stance in non-figurative
'geometric' art (Neo-Plasticism, Constructivism, Suprematism and the Ulm
School) and, particularly, in Concrete art, taken to a dangerously rationalist
extreme. Working in the fields of painting, sculpture, engraving and writing,
the artists presently showing in this first Neo-Concrete Exhibition have been
drawn together in the light of their own experience, with the contingency of
reviewing the theoretical principles on which Concrete art was founded, since
none of these principles satisfactorily 'understands' the expressive potential
revealed through these experiences.
 Born as part of Cubism, in a reaction to the Impressionist dissolution of
pictorial language, it was only natural that so-called geometric art should place
itself in diametrical opposition to the technical and allusive features of current
painting. While offering a broader perspective for objective thought, the latest
developments in physics and mechanics stimulate, in the followers of this artistic
revolution, a tendency toward an ever-increasing rationalization of the processes
and objectives of painting. A mechanistic concept of construction has taken over
the language of painters and sculptors, generating, in turn, equally radical
reactions of a retrograde character, as for example the magical, irrational realism
of Dada and Surrealism. Undoubtedly, while borrowing from theories that
consecrate the objectivity of science and the precision of mechanics, true artists
– as for example, Mondrian and Pevsner – have constructed their oeuvre and, in
their struggle with expression, overcome the limits imposed by theory. But the
production of these artists has been interpreted from the viewpoint of theoretical
principles that their work has denied. We now propose a reinterpretation of Neo-
Plasticism, Constructivism and other similar movements, on the basis both of
their expressive achievements and the prevalence of production over theory. If
our aim is to understand Mondrian's painting by examining his theories, we have
to choose between two options: either predictions of art's total integration into
the daily life of individuals seems feasible and we glimpse, in the artist's work, his
early steps in this direction, or this integration appears to be more and more
remote, and his work fails in its objectives. Either the vertical or the horizontal
planes do indeed provide the fundamental rhythms of the universe and Mondrian's
work is the application of this universal principle, or the principle is flawed and

his work is founded on illusion. But the truth is, Mondrian's work exists, alive and fertile, notwithstanding these theoretical contradictions. Viewing Mondrian as the demolisher of the surface plane and the line will be of no avail to us unless we envisage the new space that this destruction has created.

The same could be said of Vantongerloo and Pevsner. It doesn't matter what mathematical equations are to be found at the roots of a sculpture or picture by Vantangerloo, for the work only reveals the 'significance' of its rhythms and colours to the viewer's direct perceptual experience. Whether or not Pevsner took figures of descriptive geometry as a starting point is not an issue in face of the new space that his sculptures bring into being and the cosmic-organic expression that his forms reveal in this new space. It would be of interest, from a cultural standpoint, to determine approximations between artistic objects and scientific instruments, between the artist's intuition and the objective mind of a physicist or engineer. From the aesthetic point of view, however, the work becomes interesting precisely through those elements that transcend these external approximations: the universe of existential significations that it simultaneously founds and reveals.

Thanks to having recognized 'the primacy of the pure sensibility in art', Malevich spared his theoretical definitions from rational and mechanical limitations, while imparting to his painting a transcendental dimension that today grants him remarkable actuality. But he paid dearly for his courage to oppose both the figurative and mechanistic abstraction at the same time. To date, certain rationalist theorists still regard him as an ingenuous artist who had not quite grasped the true meaning of the new style … In fact, however, in his geometric painting, Malevich had already expressed dissatisfaction, a will to transcend the rational and the sensorial that nowadays irrepressibly manifests itself.

The Neo-Concrete trend evolved from a need to express the complex reality of present-day man through the constructive language of the new style. It denies the legitimacy of scientificist and positivist attitudes in art, and reintroduces the problem of expression while incorporating new 'verbal' dimensions created by non-figurative constructive art. Rationalism deprives art of its autonomy and replaces the non-transferable qualities of the artwork with notions of scientific objectivity. The concepts of form, space, time and structure, therefore – which in art language are connected to existential, emotional, and affective significance – are confounded with the theoretical applications of these terms in science. In the name of those prejudices currently being denounced in the field of philosophy (Merleau-Ponty, Ernst Cassirer, Susanne Langer) – and that are crumbling in all fields, beginning with modern biology, which surmounts Pavlovian mechanistic notions – the Concrete rationalists continue to view the individual as a machine among other machines, and are trying to curb their art to the expression of this theoretical reality.

We do not understand an artwork as a machine or 'object'; we see it as a quasi-corpus, i.e. a being whose reality is not limited to the external relations of its elements; a being decomposable for analysis that only fully reveals itself by means of a direct phenomenological approach. We believe that the work of art surpasses the material mechanism on which it is based, not because of some unearthly virtue, but because it transcends these mechanical relations (the focus of Gestalt) and creates for itself a tacit significance (Merleau-Ponty) that it brings up for the first time. Therefore, if we were to seek a simile for the work of art, we would be unable to find it in a machine or in an object, both viewed objectively; rather, according to Susanne Langer and Wladimir Weidlé, we would find it among living organisms. At any rate, this comparison alone would not adequately express the specific reality of the aesthetic organism.

The objective notions of time, space, form, structure, colour, etc., are not sufficient to comprehend a work of art and to explain its 'reality', because the work does not limit itself to occupying a place in the objective space. Instead, it transcends this space while creating in it a new significance. The difficulty of finding an accurate terminology to express a world that does not surrender to notions has forced art criticism to use words indiscriminately that betray the complexity of the artwork. Science and technology have had quite an influence here, to the point that, today, certain artists dazzled by this terminology try to make art by taking objective notions and applying them to their creative practice.

Inevitably, artists who proceed in this manner only illustrate *a priori* notions, for they are bound by a method that prescribes, beforehand, the result of the work. By refraining from intuitive creation and limiting himself to reducing his work to an objective body, made in an objective space, a simple reaction of stimulus and reflexive response is all that the rationalist Concrete artist asks of himself as well as of the viewer through his paintings. He speaks to the eye as an instrument rather than a human tool to apprehend the world and surrender to it. He speaks to the machine-eye, not to the body-eye.

It is because the work of art transcends mechanical space that, in the artwork, notions of cause and effect completely lose their effectiveness. Moreover, notions of time, space, form, colour – that did not pre-exist as notions for the work – are so intensely integrated that it would be impossible to speak of them as decomposable constituents. Neo-Concrete art asserts the absolute integration of these elements and believes that its 'geometric' vocabulary is capable of assuming the expression of complex human realities, as for example in a number of works by Mondrian, Malevich, Gabo, Sophie Taeuber-Arp and others. And if these artists themselves sometimes mistook expressive form for the notion of mechanical form, it must be made clear that, in art language, so-called geometric forms totally lose the objective character of geometry to transform themselves into

instruments of fancy. The Gestalt, as a school of psychology that interprets causal relations, is equally insufficient to elucidate this phenomenon that dissolves space and form as causally determined realities and renders them as time – as spatialization of the work. The expression 'spatialization of the artwork' means that this work makes itself always present; that it is constantly reviving the same dynamic impulse that created it and from which, in turn, the work has resulted. And if this description takes us back to the primordial and thorough experience of the real, it is because Neo-Concrete art aims at nothing less than to rekindle this experience. Neo-Concrete art creates a new expressive 'space' […]

Amilcar de Castro, Lygia Clark, Ferreira Gullar, Reynaldo Jardim, Claudio Mello e Souza, Lygia Pape, Theon Spanudis and Franz Weissmann, 'Manifesto neoconcreto', *Jornal do Brasil* (23 March 1959); translated in *Lygia Pape: Magnetized Space* (Madrid: Museo Nacional Centro de Arte Reina Sofía/Rio de Janeiro: Projeto Lygia Pape, 2011) 80–83.

Hélio Oiticica
Colour, Time and Structure//1960

The sense of colour-time has made the transformation of the structure indispensable. Not even in virtualized form, in its *a priori* sense of a surface to be painted, was use of the plane – that former element of representation – any longer possible. The structure then turns into space, becoming temporal itself: a time-structure. Colour and structure are inseparable here, as are space and time; and the fusion of these four elements (which I consider to be dimensions of a single phenomenon) takes place within the work.

Dimensions: colour, structure, space, time
It is not a combination but rather a fusion of these elements that takes place here, one that exists from the very first creative movement – fusion, not juxtaposition. Fusion is organic, while juxtaposition implies a separation of elements that is profoundly analytic.

Colour
I seek to bestow a sense of light upon pigmentary colour, in itself material and opaque. A sense of light can be given to all primary colours and others that derive from them, as well as to white and grey, although for this experience one must

privilege those colours that are more open to light: *luminous colours: white, yellow, orange, luminescent red.*

White is the ideal colour-light, the synthesis-light of all colours. It is the most static, and as such, favours silent, dense, metaphysical duration. The meeting of two different whites occurs mutely, for one is brighter and the other naturally more opaque, tending toward a greyish hue. Thus grey is infrequently used, because it is already born from the uneven luminosity between one white and another. White, however, does not lose its meaning in this unevenness, and because of this, grey still has a role to play in another sense, about which I will have more to say when I get to that colour. The whites that confront one another are pure, unmixed, hence also their difference from grey neutrality.

Unlike white, yellow is the less synthetic (colour), possessing a strong optic pulsation and tending toward real space, to an unmooring of itself from the material structure and to expanding itself. It tends toward the sign, in a more profound sense, and to the optical signal (or indicator) in a superficial sense. It must be noted that the meaning of the indicator is of no interest to us here, for coloured structures function organically within a fusion of elements, constituting an organism that is separate from the physical world, from the surrounding space-world. So its meaning would indicate a return to the real world and, therefore, a trivial experience, consisting merely in the signage and virtualization of real space. Here, the meaning of the signal is one of direction; it is internal to the structure and in relation to its elements, the sign being its profound, non-optical, temporal expression. Unlike white, yellow also resembles a more physical light, closer to terrestrial light. What is important here is the time-light sense of colour; otherwise it would still be another representation of light.

Orange is the median colour par excellence, not only in relation to yellow and to red, but also within the colour spectrum: its spectrum is grey. It possesses characteristics of its own that differentiate it from dark yolk yellow and from luminous red. Its possibilities still remain to be explored in this experience.

Luminous red differs from darker blood red and possesses special characteristics within this experience. It is neither light red nor vibrant, sanguine red, but a more purified, luminous red that does not quite become orange because of the red qualities it possesses. For this very reason, it lies within the spectrum of dark colours, but as a pigment it is open to light and warmth. It possesses a cavernous, grave sense, such as might be produced by a dense light.

The other derived and primary colours – blue, green, violet, purple and grey – may become more intense as they approach light, but they are colours of an opaque nature, closed to light, except for grey, which is characterized by its neutrality in relation to light. I shall not deal with these colours now, for they possess more complex relationships that have not yet been explored here. All we have seen thus

far is the relationship of colour to colour, of the same quality, in the sense of light. The colour-light of various qualities has not also been explored here, for such an investigation will depend upon a gradual development of colour and structure.

Structure

The development of structure occurs as colour transformed into colour-light and finding its own time, goes on to reveal its own core, to leave it naked. Seeing as how colour is time-colour, it would not be coherent if structure were not, also, or rather, that it did not become a time-structure. Space is an indispensable dimension of the work but, because it already exists in itself, it does not constitute a problem; the problem, here, is the inclusion of time in the work's structural genesis. The centuries-old surface of the plane, in which the space of representation was constructed, is stripped of all representative references because the colour planes meet from outside at a given line. Thus, the plane is virtually broken but does not cease to exist as an *a priori* support. Next, the rectangle is broken up, for the planes that [previously] met begin to slide organically. Here, the wall does not function as a *background* but as a space that is unlimited and foreign (albeit necessary) to a view of the work; the work is closed in itself as an organic whole, not sliding on the wall or superimposed upon it. The structure is then led into space by turning upon itself 180 degrees. This is the definitive step for the encounter of its temporality with that of colour; here, the spectator sees not only one side (in contemplation), but tends toward action, turning around it, completing its orbit, in a multidimensional perception of the work. From here on, evolution occurs in the sense of appreciating the work from all perspectives and investigating the work's dimensions: colour, structure, space and time.

Time

Colour and structure having arrived at purity, at the first creative state (static par excellence) of non-representation, it was necessary that they become independent, possessing their own laws. This leads to the concept of time as the work's primordial factor. But time here is an active element – duration.

In representational painting, the meaning of space was contemplative, and that of time mechanical. Space was what was represented upon the canvas, fictitious space, and the canvas functioned as a window, a field for the representation of real space. Time, then, was simply mechanical: the time from one figure to another or from that figure's relationship to perspectival space; finally, it was the time of figures in a three-dimensional space which became two-dimensional on the canvas. However, since the plane of the canvas began to function actively, it became necessary for a sense of time to enter as the principal new factor for non-representation. Thus, the concept of the *não-objeto* (non-

object) was born, a term invented and explained by Ferreira Gullar, and more appropriate than painting, given that the structure was no longer unilateral (as in a painting) but multidimensional. In a work of art, however, time takes on a special meaning, different from the meanings it possesses in other fields of knowledge; it is more closely linked to philosophy and to the laws of perception; but it is its symbolic meaning, in the sense of man's internal, existential relationship with the world, that characterizes time in the artwork.

Before it, man no longer meditates in static contemplation, but finds his own vital time as he becomes involved, in a univocal relationship, with the time of the work. Here, he becomes even closer to the pure vitality to which Mondrian aspired. Man experiences the polarities of his own cosmic destiny. He is not merely metaphysical but cosmic, the beginning and the end.

Space

As we have already seen, the concept of space also changes with the development of painting, and to trace that evolution here would be exhausting. Let us begin at Mondrian, for whom space was static, not a symmetrical stasis but a stasis related to the space of representation, opposed, for example, to the dynamism of futurism, which was dynamism within *the canvas*, while Mondrian's dynamic stasis entails making movement static within the painting while virtually dynamizing its horizontal-vertical structure. Mondrian does not conceptualize time; his space remains one of representation. The Concretists still conceptualize time mechanically and, in a way, as Ferreira Gullar so nicely puts it, take a step backward in this regard. Their concept of space is an analytic conceptualization of that space's intelligence which does not attain a temporal vitality, because it still contains residues of representation. This is no historical summary of Concrete art. Whereas the former is dynamic/temporal, the latter is static/analytic. I would add one more element to the four which I call dimensions (colour, time, structure and space), for although it is not a fundamental dimension it is a global expression bom from the work's unity and meaning: the infinite dimension. An infinite dimension not in the sense that the work might dissolve *ad infinitum*, but in the sense of its being unlimited, in the non-particularity that exists in the relationships between empty and full, colour imbalance, spatial direction, temporal direction, etc. Right now, I consider two parallel directions that complete themselves in the work: one in an architectural sense and the other in the musical sense of its relationships. The architectural meaning is more noticeable in the *maquettes*[1] and in the *large paintings*, the musical sense in the *equali* or the *nuclei*. The first *equali* is made up of five pieces in space (identical squares), but their relationship is not sculptural just because they are in space. They possess more of an architectural relationship, achieved in the *large paintings* and in the *maquettes*. Here, the predominant relationship is a musical

one, yet it is not because, as in music, the pieces create counterpoint or eurhythmy, or because they possess this same type of relationship to it, for musicality is not *lent to* the work but born from its essence. It [the *equali*] is, in fact, much nearer to the essence of music. In the large *nuclei*, the parts are not equal and the relationship is more complex (in fact, unpredictable). Because the idea is realized in three-dimensional space, it is tempting to approximate it with sculpture, but upon closer analysis this approximation is superficial and could only trivialize the experience; it might be more appropriate, albeit still superficial, to speak of *painting in space*.

The architectural relationships predominate and are more evident in the *large paintings* and *maquettes* because human scale enters into them. The *large paintings* are propped up on the floor and are approximately 5 foot 7 inches tall, tall enough to envelop [the viewer] in their lived experience, and the maquettes are truly architectural, some in a labyrinthine sense, others with sliding panels. What matters in these maquettes is the simultaneity (a musical element) of the colours among themselves, as the spectator turns them and becomes involved with their structure. Thus, it is noticeable that, from the very first non-object launched into space, the tendency for a – not totally contemplative, nor totally organic, but cosmic – *vivência*[2] of colour was already manifest. What matters is not the mathematical or eurhythmic relationship of colour, or its measurement through physical procedures, but its meaning. Pure orange is orange, but if it is compared with other colours, it will be light red or dark yellow or another shade of orange; its meaning changes according to the structure that contains it, and its signifying capacity, born from the artist's intuitive dialogue with the work at the time of its genesis, varies intimately from work to work. Colour is, therefore, meaning, as are the other elements of the work; a vehicle for *vivências* of all sorts (*vivência* is understood here in an all-encompassing sense and not in the term's vitalist sense). The genesis of the work of art is so connected to and communicated by the artist that it is no longer possible to separate substance from spirit, for as Merleau-Ponty has underscored, substance and spirit are dialectics of a single phenomenon. The artist's driving creative element is intuition and, as Klee once said: 'In the final analysis, a work of art is intuition, and intuition cannot be overcome.'

1 [footnote 3 in source] [...] Whereas 'model' designates a prototype, Hélio Oiticica considered his *maquettes* to be completed works, whether they were eventually built or not. [...]

2 [4] [...] this virtually untranslatable term denotes more than its English equivalent – 'life-experience', or 'lived experience', both of which lack its sensuous charge. [...]

Hélio Oiticica, 'Côr, tempo e estrutura', *Suplemento Dominical do Jornal do Brasil* (26 November 1960) 5; trans. and with notes by Stephen A. Berg, in *Hélio Oiticica: Body of Colour* (London: Tate Publishing, 2007) 205–7.

Joe Houston
1965: The Year of Op//2007

Perceptual abstraction, devoid of narrative and symbolic content, received initial attention in Europe, where the constructivist tradition maintained its aesthetic imprint. The New Tendency exhibitions that debuted in Zagreb in 1961 inspired similar shows in London, Venice and Paris of emerging abstractionists opposed to the 'informal' art of the previous generation. Following the commercial success of galleries like Denise René in Paris and Signals Gallery in London, the new art gained a foothold in New York, and artists from Canada, Britain, France and Germany were catching the attention of American dealers by the early 1960s. Betty Parsons, Sidney Janis, Howard Wise and Chalette Gallery exhibited the hard-edged geometric abstractionists, and Richard Feigen, Martha Jackson, East Hampton Gallery, Kootz Gallery and The Contemporaries showed some of the younger descendants of the constructivist aesthetic. A group of devoted collectors, including Joseph Hirshhorn, Seymour Knox and Larry Aldrich, sustained and promoted the work early on, hanging it in their own public museums. Architect Philip Johnson, a trustee of the Museum of Modern Art, was particularly influential in the careers of the young artists. (He bought a painting directly out of Tadasky's Soho studio, before the young artist had exhibited publicly. This, the artist's first sale, was immediately followed with a purchase by MoMA.) As well as cultivating his own collection, Johnson donated works by a number of the new abstractionists to the museum and encouraged such fellow architects as Minoru Yamasaki to incorporate the work in their commercial buildings. Chase Bank was among the first corporations to realize the architectural potential of optical art, amassing one of the first international collections of the nascent movement.

Post-war New York was an international economic and cultural centre, and home to a critical mass of acclaimed artists, but the city still counted only a handful of serious contemporary art galleries, sustained by a small clientele of wealthy benefactor-collectors. The arrival of Pop in the early 1960s promoted a democratic attitude in art and encouraged a broader, middle-class market for artists. Andy Warhol and Roy Lichtenstein helped to revive the printmaking medium, and museum shops and department stores nationwide were able to offer affordable multiples in addition to clothing, furniture and appliances. Perceptual abstraction arrived in this moment of increased public interest and conspicuous consumption.

The Museum of Modern Art was the first museum in America to recognize officially the new abstraction gaining momentum on its shores in the wake of the

New Tendency exhibitions touring Europe. William Seitz, a senior curator at MoMA, was well aware of what was happening in the studios of New York, and beginning in 1962, he extended his search to other American cities and to European capitals with the aim of mounting an exhibition of the international phenomenon. Though geographically and formally diverse, the new art was nevertheless distinct from the Abstract Expressionist school that MoMA was continuing to promote to international audiences. In his doctoral dissertation on Abstract Expressionism some years earlier, Seitz had emphasized structure, colour interaction and other formal elements that he now saw as the primary vehicles of the new perceptual artists.[1] The result was the greatly anticipated 'The Responsive Eye', which opened triumphantly at MoMA in early 1965, to unprecedented public interest.

Seitz did not propose an all-encompassing term to define the artists in his exhibition. His checklist numbered one hundred painters, sculptors and interdisciplinary collaboratives whose work employed a wide array of approaches, including hard-edged geometry, analytical structure, spatial illusion and perceptual ambiguity. The term Op came into parlance in late 1964, an invention of the American press, which was quick to define the new, hyper-visual art that Seitz was then gathering for his show. The minimalist sculptor Donald Judd was the first to use the term in his review of Julian Stanczak's exhibition 'Optical Paintings', but it was Jon Borgzinner, a correspondent for *Time* magazine, who promoted the clever derivation of Pop, then enjoying wide publicity.[2] Borgzinner's mother was an assistant at Martha Jackson Gallery and was aware of Stanczak's show if not of Judd's comments.[3]

Borgzinner's unaccredited article 'Op Art: Pictures that Attack the Eye' appeared in October of 1964 in *Time* magazine, with numerous colour illustrations. The following month, *Life* magazine published 'Op Art', opening with a large spread reproducing Bridget Riley's mesmerizing painting *Current*.[4] Also printed in anticipation of 'The Responsive Eye', this article defined Op for the public and helped to make Riley the movement's icon. With a solo exhibition running concurrently at Richard L. Feigen & Co, in Manhattan, and as part of a travelling group exhibition of new British art touring the States, Riley was poised to capture the lion's share of attention. Her electric composition *Current* was featured on the invitation and catalogue cover for 'The Responsive Eye', becoming, by default, a symbol of the new movement. In addition to her exacting and engaging paintings, Riley's public profile was amplified by such photogenic appearances in the press as Lord Snowdon's portraits of the artist emerging from her environmental painting *Continuum* that appeared in the pages of *Vogue* that fall.[5]

Following Julian Stanczak's 'Optical Paintings' show at Martha Jackson Gallery in 1964, other galleries followed suit, invoking the term in their exhibitions. Op

soon became synonymous with the new abstraction. Josef Albers was particularly opposed to the name 'optical art', considering it as nonsensical as 'wood carpentering or foot walking'.[6] He insisted to Stanczak, who was not consulted by Jackson in naming the show, that the term 'perceptual painting' was more accurate. A number of artists immediately disavowed the label of Op. The painter Ben Cunningham dismissed it as 'public relations' and kinetic sculptor George Rickey called it 'destructive'.[7]

Op art was not the first aesthetic movement to be named by the press – a number of styles and schools, dating back to Impressionism, were given their name by critics. In addition to lamenting the term, some bemoaned the broad characterization of Op as too superficial for the wide array of concerns and formal approaches grouped under the banner. However, few art-historical monikers can embrace the complexity of any school or movement, let alone one with such international reach. The polar differences between the dionysian figuration of Willem de Kooning and the platonic formalism of Barnett Newman seem difficult to reconcile under the single banner of Abstract Expressionism, yet these artists rallied together as such for self-empowerment. Despite protestations among artists, the word Op quickly struck a chord and helped the public to grasp the revolutionary shift away from representation and toward the act of perception. 'Op' was a more descriptive term than that of New Tendency, which had thus far defined the numerous branches of perceptual abstraction.

In addition to its visual appeal, Op gained currency as an appropriate aesthetic for the progressive era of the 1960s that heralded momentous advances in computers, aerospace and industry, the decade in which television finally penetrated 90 per cent of American homes. Science, in its broadest sense, was the engine of modernity that could provide the tools for global economic and social progress. Some perceptual artists appropriated its techniques and iconography in their work, even referring to their practice as 'research'. Gerald Oster, a scientist and artist, introduced fellow artists to the moiré effect and published his findings in *Scientific American* in 1963. Moiré fringes, garnered from the misalignment of two or more sets of parallel lines or other regular structures, reveal what Oster referred to as a 'simple analogue of complex phenomena' with a variety of practical applications.[8] New York artist Mon Levinson, who had neither a scientific nor a studio art training, noted that in the process of making his multi-layered moiré constructions, he was, in essence, 'discovering physics' in his studio. He considered moiré patterns to be empirical tools that 'permit the observations of another set of opposites which engage me: dynamics versus statics'.[9] Within this climate of experimentation, critic and curator Peter Selz described the movement in 1966 as trying to 'come to grips collectively with the mass culture in which they (the artists) live and to find an artistic affirmation for the modern technological world

... like their Bauhaus predecessors (they) appear to believe in man's perfectibility – or at least his improvement – and they hope to approach this goal by working collectively toward a synthesis of art, science and technology'.[10] The concept of art as a form of research distinguished a number of the collaboratives, most notably *Groupe de Recherche d'Art Visuel* (GRAV), whose interactive projects explored psychology, sociology and communication theory. In an essay titled 'Towards Science in Art', GRAV founding-member Francis Molnar outlined the aims of their interdisciplinary practice: 'The artists equipped with a solid scientific knowledge will be drawn to collaborate with the experts in order to establish the programme of an art that can truly be called humanist.'[11]

While physics, optics and experimental psychology motivated some of the Op artists, providing insight into the crucial process of perception, the connection of art to science is often only indirect. Gerald Oster, whom Seitz included in 'The Responsive Eye', provided an exceptional instance of the union of the disciplines. Technology, the functional application of science, was more directly visible in the systemic and computational structures and industrial materials that imbued much of the geometric abstraction with futuristic connotations. As a young immigrant working in Brooklyn, Rakuko Naito experimented specifically with commercial metallic paints as a means to move beyond the constraints of conservative Japanese tradition. This progressive association struck a chord not only with such New York artists as Frank Stella, a longtime friend of Naito, but also with Julian Stanczak in Cleveland, Lorser Feitelson in Los Angeles, and Vasarely in Paris, who likewise experimented with the new metallic. Like the nineteenth-century invention of the collapsible paint tube that attended the Impressionist revolution of plein-air painting, the development of any new material or medium carries aesthetic consequences, particularly at a time when modernity holds a promise of utopia. Vasarely had long been keen on the role of technology in the service of egalitarian progress, promoting the idea of the 'multipliable' work of art. In his 1954 manifesto 'Toward the Democratization of Art' he implores us not to 'fear the new tools which technique has given us. We can only live authentically in our own time.'[12] For Vasarely, geometry and physics have cosmic implications, as suggested by the titles of such works as *Lux Novae*, *Vega* and *Metagalaxie*. This programmatic theme in art became the subject of an exhibition of optical, kinetic and electronic art entitled 'Arte Programmata' that toured Britain and the United States concurrently with 'The Responsive Eye', and was sponsored by Olivetti Corporation, who were then launching the first desktop computer.[13] Computer technology carried theoretical, if not yet practical, associations for the artists engaged with structural systems, and 'programmed art' became a subdivision of the Op aesthetic, which GRAV member François Morellet referred to as 'the cybernetic choice' facing artists in 1965.[14]

However, nature, not technology, was the point of departure for the optical presentations of many of the artists, including Julian Stanczak and Bridget Riley. As Stanczak noted in 1965, 'In my work I do not try to imitate or to interpret Nature; but with the response to the behaviour of colours, shapes, lines, I try to create relationships that would run parallel to man's experiences with reality'.[15] Stanczak's teenage depictions of jungle vegetation, made while in exile on the Ugandan coast during World War II, convey undulating patterns of arabesque lines that he later distilled into rhythmic abstractions. The landscape is still discernible within the vertical strands of *Determinative Focus* (1962), and emerges in the unruly ribbons of *Remnants of Late Colour*, a pulsating composition of grey and red linear contours that evoke the mountainous furrows of the Ohio landscape in which he had recently settled. These natural structures become a schematic undulating pattern in *Provocative Current*, painted the following year.[16] The abstract motif of *Provocative Current* is an echo of historic renderings of nature dating back to Leonardo da Vinci's studies of water and to twelfth-century Chinese scroll paintings. The ability of abstract art to resonate with nature, rather than merely depict it, was acknowledged by Naum Gabo in a statement on *Abstraction-Création* made decades earlier: 'By means of constructive techniques today, we are able to bring to light forces hidden in nature and to realize psychic effects ... We do not turn away from nature but on the contrary we penetrate her more profoundly than naturalistic [art] was able to do.'[17] Riley's earliest pure abstractions were likewise an attempt to conjure for the viewer an experience of nature, a goal that she shared with Seurat, whose work provided an early model. Riley painted landscapes in Seurat's pointillist technique, gaining practical knowledge of optical vibration. She soon moved beyond the conventions of representation into the realm of pure sensation with abstract works such as *Static* (1961) or *Blaze*, which trigger in the viewer an experience equivalent to an atmospheric electric charge; not an illusion, but an 'event'. Riley denied any conscious connection to science or optics and employed only rudimentary mathematics in planning her compositions. Nevertheless, she stated in 1965: 'My work has developed on the basis of empirical analyses and syntheses, and I have always believed that perception is the medium through which states of being are directly experienced.'[18] This direct visual *and* visceral experience is central to the iridescent colour contrasts in Richard Anuzskiewicz's precise abstractions, the concentric radial quiver of Tadasky's concentric patterns, and the pulsating hues of Peter Sedgley's light projections. Movement, produced either optically or kinetically, engages the body in an active aesthetic experience. Op's lasting contribution lies in the tenet that experience is a form of knowledge.

The psycho-physiological experience of Op is sometimes cumulative but often immediate, requiring no art-historical education. But the relative speed of

sensory stimulation does not denigrate the quality or significance of the experience. The flickering patterns and spatial distortions generated by optical painting and sculpture can offer momentary fascination for the casual observer, providing easy fodder for its detractors to dismiss the art as mere optical illusions, or as what Kenneth Noland wryly termed optical 'delusions'. Op painters were criticized in the pages of the then rising art press, particularly *Artforum*, whose writing staff included prominent minimal and conceptual artists and theorists suspicious of sensational art. In a review of Stanczak's 'Optical Paintings' exhibition, Donald Judd revealed his ideological position: 'One of these paintings has green and magenta stripes and another red and blue lines. The intensity of colour is also greater in these. Red-and-blue is often used and is usually moderate in intensity and uninteresting. The lines are painted with a brush and vary in thickness …'[19] Written just months before the publication of his treatise on 'specific objects', Judd's matter-of-fact description of material and process emphasizes the object of Stanczak's art to the exclusion of any sensual experience. Judd also notes his concerns about the coming 'seasonal interest' that may sweep diverse work into one package, and in a literary roll of the eyes, ends the review with the two-word phrase: 'Op art.' Ironically, this terse summation would provide the name for the rising movement he feared, and Stanczak would become one of its most enduring figures.

The dismissal of Op by some leading critics was prejudiced by a theoretical distrust of painting, which was prominent in the movement. According to Judd, the main purpose of painting is illusion, and therefore, even formalist abstraction tends to suggest objects, figures and space – only monochrome canvases could avoid such allusions to the surrounding world. In any event, the flat, rectilinear plane was a limitation that was the 'main thing wrong with painting'.[20] Among artists, this discomfort with tradition prompted the use of shaped canvases and three-dimensional reliefs, and the addition of illumination to painting. Lucy Lippard called optical art 'The New Illusionism … an art of little substance with less to it than meets the eye'.[21] Barbara Rose considered it 'expressively neutral, having to do with sensation alone'.[22] Her remarks emphasize the theoretical divide between the epistemological and ontological viewpoints, privileging the conceptual over the experiential.

So quick was the art press to dismiss optically based art that a month before 'The Responsive Eye' opened, Sidney Tillim penned an article in *Arts Magazine* with the title 'Optical Art: Pending or Ending?'[23] The critical furore only increased after the enormous public response to the exhibition, which travelled to St Louis, Seattle, Pasadena and Baltimore with great fanfare, and the ensuing commercialization of its bold imagery. The misgivings noted by the art press stemmed in part from the broad curatorial brush with which Seitz had painted

his show, including among the artists descendants of European constructivism along with emerging American hard-edged or 'post-painterly' abstractionists. But the unprecedented popularity of Op was also partly responsible for its rapid downfall. Too easily assimilated into the marketplace and applied indiscriminately to all manner of functional design, it left some of the artists and their supporters disillusioned by the commercial art-world mechanism. The popular press also expressed a fascination with the rapidly growing market for the work of Op artists, some reviews of their work amounting to little more than a price list – another sensational angle.

The critical backlash against Op overlooked the particular strength of its best practitioners and its relationship to the contemporaneous, critically praised movements of Pop and Minimalism. The mass-media imagery of Warhol, Lichtenstein and James Rosenquist did much to engage the public by using familiarity and humour, subverting the pretension and elitism of art. Op too shared in this democratizing process. Its practitioners often spoke emphatically against elitism, and such artist collectives as *Anonima* and GRAV countered the individualist stance that had characterized the Abstract Expressionist movement. As Philadelphia-based painter Edna Andrade has noted, one did not need an education to understand Op, 'it was a truly democratic artform'.[24] Minimalists like Donald Judd and Robert Morris held the cult of the genius in similar suspicion, and adopted commercial materials and industrial processes concurrently with Op artists. Despite the apprehension with which Op's critics viewed painting as an inherently conservative medium, such painters as Vasarely, Riley and Morellet explored systems and periodic structures with conceptual rigour, technical invention and attention to the architectural environment. In these aspects the best of the movement's painting bears comparison not only with minimalist sculpture, but also with serial music and experimental film of the era.

The point of divergence between Op and other movements that emerged in the 1960s is, however, equally significant. Pop and Minimalism emphasized the material object of art and the artist's process as prime subjects. Unlike these – or any other post-war modernist movement – Op places the viewer's experience as its utmost subject. As Bridget Riley succinctly stated, 'perception is the medium',[25] a notion that recast John Dewey's philosophy of 'art as experience' for a new era. That search for the sensory 'event' found its natural extension in multimedia and installation – art practices that gained urgency in this historical shift from object to experience – and was perhaps the final salvo in the history of modernist abstraction.

The decorative potential and easy marketability of Op did not detract from the meaning inherent in the art. Its trembling patterns, vibrating colours and perilous structures reflect the psychic and social state of the mid 1960s, a period of

desegregation, urban riots, political assassinations and a televised war in Southeast Asia. Bill Komodore noted that he felt the stress everywhere around him when he stepped out on to the streets of New York: 'I tried to make that tension the subject of my work.'[26] This intention is well articulated by Anton Ehrenzwieg's characterization of the point of 'crisis' in his unstable visual systems. One writer noted that the preponderance of the target pattern in the paintings of Tadasky and others bore an unstated relation to the assassination of President Kennedy.[27]

In 1965, the year in which 'The Responsive Eye' toured America, comprehensive exhibitions were launched in Glasgow ('Art and Movement'), Brussels ('Lumière, Mouvement et Optique'), Bern ('Licht und Bewegung'), Tel Aviv ('Art et Mouvement: Art Optique et Cinétique'), and London ('Arte Programmata') among other places, proving Op's international cultural resonance. The runaway success of the movement was a mixed blessing for William Seitz as well as for the artists. A week before 'The Responsive Eye' opened, Seitz was already wistful about the untimely demise of perceptual art, [28] 'In the world of 1913 this could have led to a movement with the importance and duration of Cubism, Expressionism or Surrealism; but in the atmosphere of 1965 it is a question whether any new movement, tendency or style can withstand the public onslaught for so long.'[29] Seitz resigned from MoMA that year to assume directorship of the art museum at Brandeis University in Massachusetts, 'worn out and embittered' according to one account, 'by the storm he whipped up'.[30] Op was officially canonized as a movement in succeeding years and a number of books devoted to the subject appeared in Britain and the United States up until the early 1970s. Art history texts continued to note the movement, but often with such a qualification as: 'although its effects are undeniably fascinating, [the artists] encompass a relatively narrow range of concerns that lie for the most part outside the mainstream of modern art'.[31] Op lost its dominance to photorealism, superrealism and new narrative art of the 1970s, but its most esteemed practitioners continued to evolve their formal vocabulary and explore perceptual effects. Their insistence on an art of experience paved the way for innovative new forms of sensory-based art.

1 William C. Seitz, 'Abstract Expressionist Painting in America, An Interpretation Based on the Work and Thought of Six Key Figures', unpublished dissertation (Princeton University, 1955).

2 Jon Borgzinner, 'Op Art: Pictures that Attack the Eye', Time (23 October 1964).

3 According to Leah Gordon, Time magazine researcher and reporter who worked closely with Jon Borgzinner from 1963 to 1965, and assisted in the article of 23 October 1964. In an interview with this author in November 2006, Gordon recalled Borgzinner proposing, without premeditation, the term 'Op' for the emerging trend at a weekly story conference.

4 Warren R Young, 'Op Art', Life (11 December 1964) 132–40.

5 Vogue (15 November 1965) 96.

6 Josef Albers, 'Op Art and/or Perceptual Effects', *Yale Scientific* (November 1965) 8.

7 'Eye on New York: The Responsive Eye', CBS broadcast, 1965.

8 Gerald Oster and Yasunori Nishijima, 'Moiré Patterns', *Scientific American* (May 1963) 63.

9 Mon Levinson, *Vibrations 11* (New York: Martha Jackson Gallery, 1965) n.p.

10 Peter Selz, 'Arte Programmata', *Arts Magazine*, no. 39 (March 1965) 21.

11 Francis Molnar, 'Towards Science in Art', *Directions in Art, Theory and Aesthetics*, ed. Anthony Hill (Greenwich, Connecticut: New York Graphic Society, 1968) 209.

12 Victor Vasarely, 'Towards the Democratization of Art', *Directions in Art, Theory and Aesthetics*, op. cit., 104.

13 Olivetti's *P101*, a forerunner of desktop computers using magnetic cards, debuted in 1965.

14 François Morellet, 'The Choice in Present-Day Art', *DATA* (1968) 236.

15 Julian Stanczak, *Vibrations 11* (New York: Martha Jackson Gallery, 1965) 9.

16 Coincidentally, a number of American Op artists, Stanczak included, were enthralled by the aerial photography of Swiss naturalist Georg Gerster, whose Saharan desert photos were published in England in 1961.

17 *Geometric Abstraction in America* (New York: Whitney Museum of American Art, 1962) n.p.

18 Bridget Riley, 'Perception is the Medium', *ARTnews*, vol. 64, no.6 (October 1965) 32.

19 Donald Judd, 'In the Galleries', *Arts Magazine* (October 1964) 64.

20 Donald Judd, 'Specific Objects' (1965), in *Minimalism*, ed. James Meyer (London and New York: Phaidon Press, 2000) 209.

21 Lucy R. Lippard, 'New York Letter', *Art International* (March 1965).

22 Barbara Rose, 'Beyond Vertigo: Optical Art at the Modern', *Artforum* (April 1965) 31.

23 Sidney Tillim, 'Optical Art: Pending or Ending?', *Arts Magazine* (January 1965) 16–23.

24 Interview with the author, 2006.

25 Bridget Riley, 'Perception is the Medium', op. cit., 31.

26 Interview with the author, June 2006, unpublished.

27 Allen S. Weller, 'Circles, Men and Others', *The Joys and Sorrows of Recent American Art* (Champaign: University of Illinois Press, 1968) n.p.

28 His catalogue essay for *The Responsive Eye* assiduously avoids any attempt at christening a new movement of 'optical' or 'retinal' art. An expanded text on the subject he was reportedly planning was never published.

29 William C. Seitz, 'The New Perceptual Art', *Vogue* (15 February 1965) 143.

30 Howard Junker, 'Finders Keepers', *Harper's Bazaar* (November 1966) 144.

31 H.W. Janson, *History of Art* (1962) (New Jersey: Prentice Hall/New York: Harry N. Abrams, 1995) 804.

Joe Houston, '1965: The Year of Op', *Optic Nerve: Perceptual Art of the 1960s* (Columbus, Ohio: Columbus Museum of Art/London and New York: Merrell, 2007) 55–75.

Bridget Riley
Perception is the Medium//1965

[...] 'The Responsive Eye' was a serious exhibition, but its qualities were obscured by an explosion of commercialism, band-waggoning and hysterical sensationalism. Understandably, this alienated a section of the art world. Most people were so busy taking sides, and arguing about what had or had not happened, that they could no longer see what was actually on the wall. Virtually nobody in the whole of New York was capable of the state of receptive participation which is essential to the experience of looking at pictures. Misunderstandings and mistaken assumptions took the place of considered and informed judgement.

For this reason I should like to offer some basic information. To begin with, I have never studied 'optics' and my use of mathematics is rudimentary and confined to such things as equalizing, halving, quartering and simple progressions. My work has developed on the basis of empirical analyses and syntheses, and I have always believed that perception is the medium through which states of being are directly experienced. (Everyone knows, by now, that neuro-physiological and psychological responses are inseparable.)

It is absolutely untrue that my work depends on literary impulse or has any illustrative intention. The marks on the canvas are the sole and essential agents in a series of relationships which form the structure of the painting. They should be so complete as to need, and allow of, no further elucidation. The basis of my paintings is this: that in each of them a particular situation is stated. Certain elements within that situation remain constant. Others precipitate the destruction of themselves by themselves. Recurrently, as a result of the cyclic movement of repose, disturbance and repose, the original situation is re-stated.

I feel that my paintings have some affinity with happenings where the disturbance precipitated is latent in the sociological and psychological situation. I want the disturbance or 'event' to arise naturally, in visual terms, out of the inherent energies and characteristics of the elements which I use. I also want it to have a quality of inevitability. There should, that is to say, be something akin to a sense of recognition within the work, so that the spectator experiences at one and the same time something known and something unknown. I identify with this 'event'.

Other polarities which find an echo in the depths of our psychic being are those of static and active, or fast and slow. Repetition, contrast, calculated reversal and counterpoint also parallel the basis of our emotional structure. But the fact that some elements in sequential relationship (the use, for example, of greys or

ovals) can be interpreted in terms of perspective or *trompe l'oeil* is purely fortuitous and is no more relevant to my intentions than the blueness of the sky is relevant to a blue mark in an Abstract Expressionist painting.

It also surprises me that some people should see my work as a celebration of the marriage of art and science. I have never made any use of scientific theory or scientific data, though I am well aware that the contemporary psyche can manifest startling parallels on the frontier between the arts and the sciences. (Once, for example, I spent three weeks on a curve which was of vital importance for one of my paintings. Just as I had pinned up the final drawing on the wall of my studio, someone brought in a friend who was working on a secret project which involved the accumulation of energy. He also had begun work three weeks earlier on a particular problem, and the curve on which he had decided for his solution was identical to mine.)

I am writing only of my own work. Other artists now working in the Op field may agree with me partially or altogether, and some may not agree at all. Knowledge of a painter's intentions may be of interest, but in the last analysis stance alone will never make a work of art. Ultimately the degree of visual sensibility is the vital agent in transforming a concept into the indefinable experience which is presented by a work of art.

Bridget Riley, extract from 'Perception is the Medium', *ARTnews*, vol. 64, no. 6 (October 1965) 32–3; 66; reprinted in *The Eye's Mind: Bridget Riley, Collected Writings 1965–2009*, ed. Robert Kudielka (London: Ridinghouse/Thames & Hudson, 2009) 89–90.

Lucy R. Lippard
Eccentric Abstraction//1966

Only the ugly is attractive.
– Champfleury

The rigours of structural art would seem to preclude entirely any aberrations toward the exotic. Yet in the last three years, an extensive group of artists on both east and west coasts, largely unknown to each other, have evolved a non-sculptural style that has a good deal in common with the primary structure as well as, surprisingly, with aspects of Surrealism. The makers of what I am calling, for semantic convenience, eccentric abstraction, refuse to eschew imagination

and the extension of sensuous experience while they also refuse to sacrifice the solid formal basis demanded of the best in current non-objective art. Eccentric abstraction has little in common with the sculpture of the fifties, since it rarely activates space, nor with assemblage, which incorporated recognizable objects and was generally small in scale, additive and conglomerate in technique. In fact, the eccentric idiom is more closely related to abstract painting than to any sculptural forms. Many of the artists are around thirty years old and, like the structurists, began as painters rather than sculptors; when they moved into three dimensions, they did so without acquiring either sculptural habits or training. The increased influence of painting has undermined sculptural tradition, and provided alternatives to the apparent dead end of conventional sculpture. But where formalist painting tends to focus on specific formal problems, eccentric abstraction is more allied to the non formal tradition devoted to opening up new areas of materials, shape, colour and sensuous experience. It shares Pop art's perversity and irreverence. The generalizations made here and below do not, of course, apply to all of the work discussed. Its range and variety is one of the most interesting characteristics of eccentric abstraction.

If government-sponsored academic sculpture is rooted in a heroic and funereal representation left over from the ninetenth century, the primary structurists have introduced a new kind of funeral monument – funereal not in the derogatory sense, but because their self-sufficient unitary or repeated forms are intentionally inactive. Eccentric abstraction offers an improbable combination of this death premise with a wholly sensuous, life-giving element. And it introduces humour into the structural idiom, where angels fear to tread. Incongruity, on which all humour is founded, and on which Surrealism depends so heavily, is a prime factor in eccentric abstraction, but the contrasts that it thrives upon are handled impassively, emphasizing neither one element nor the other, nor the encounter between the two. Opposites are used as complementaries rather than contradictions; the result is a formal neutralization, or paralysis, that achieves a unique sort of wholeness. Surrealism was based on the reconciliation of distant realities; eccentric abstraction is based on the reconciliation of different forms, or formal effects, a cancellation of the form-content dichotomy.

For instance, in her latest work, a labyrinth of white threads connecting three equally spaced grey panels, Eva Hesse has adopted a modular principle native to the structural idiom. She limits her palette to black, white and grey, but the finality of this choice is belied by an intensely personal mood. Omitting excessive detail and emotive colour, but retaining a tentative, vulnerable quality in the simplest forms, she accomplishes an idiosyncratic, unfixed space that is carried over from earlier paintings and drawings. A certain tension is transmitted by the tight bound, paradoxically bulbous shapes of the smaller works, and by the linear

accents of the larger ones. Energy is repressed, or rather imprisoned in a timeless vacuum tinged with anticipation and braced by tension.

There are a good many precedents for the sensuous objects, one of the first being Meret Oppenheim's notorious fur-lined teacup, saucer and spoon. Salvador Dalí's extension of the idea, a fur-lined bathtub made for a Bonwit Teller display window in 1941, was a more potent vehicle for sensuous identification. The viewer was invited figuratively to immerse himself in a great fur womb, as he was 25 years later invited by Claes Oldenburg's gleaming, flexible blue and white vinyl bathtub. Yves Tanguy's 1936 object, *From the Other Side of the Bridge*, was another early example – a stuffed hand-like form choked suggestively off in two places by a tight rubber band extending from a panel marked 'caresses, fear, anger, oblivion, impatience, fluff'. Around 1960, Yayoi Kusama developed similar ideas in her phallus-studded furniture which, though unquestionably fecund, remained Surrealist in spirit: Lee Bontecou's gaping reliefs were a departure in the way they firmly subjugated the evocative element to unexpected formal ends, and in H.C. Westermann's *The Plush* (1964), fusion of the sensuous element with deadpan abstract form was completely resolved. Ay-O's 'womb box' and blind, or tactile peep-shows, Lucas Samaras' sadistic pin and needle objects and yarn-patterned boxes, Lindsey Decker's plastic extrusions which are both physically attractive and evocatively disturbing, even repellent, achieve similar effects without relinquishing the format of previous object art – mainly the box, plaque or vitrine motif.

Since the late forties, Louise Bourgeois has been working in manners relatable to eccentric abstraction – not so much non-sculptural as far out of the sculptural mainstreams. Her exhibition at the Stable Gallery in 1964 included several small, earth or flesh-coloured latex moulds which, in their single flexible form, indirectly erotic or scatological allusions, and emphasis on the unbeautiful side of art, prefigured the work of younger artists today. Often labially slit, or turned so that the smooth, yellow-pink-brown lining of the mould as well as the highly tactile outer shell is visible, her mounds, eruptions, concave-convex reliefs and knot-like accretions are internally directed, with a suggestion of voyeurism. They imply the location rather than the act of metamorphosis, and are detached, but less aggressive, than the immensely scaled work of her younger colleagues. In usual sculptural terms, these small, flattish, fluid moulds are decidedly unprepossessing, ignoring decorative silhouette, mass, almost everything conventionally expected of sculpture. On the other hand, they have an uneasy aura of reality and provide a curiously surrounded intimacy despite their small size. They provoke that part of the brain which, activated by the eye, experiences the strongest physical sensations.

Such mindless, near-visceral identification with form, for which the psychological term 'body ego' seems perfectly adaptable, is characteristic of

eccentric abstraction. It is difficult to explain why certain forms and treatments of form should elicit more sensuous response than others. Sometimes it is determined by the artist's own approach to his materials and forms; at others by the viewer's indirect sensations of identification, reflecting both his personal and vicarious knowledge of sensorial experience. Body ego can be experienced two ways: first through appeal, the desire to caress, to be caught up in the feel and rhythms of a work; second, through repulsion, the immediate reaction against certain forms and surfaces which take longer to comprehend. The first is more likely to be wholly sensuous, while the second is based on education and taste, the often unnatural distinctions between beauty and ugliness, right and wrong subject matter.

Eccentric abstraction has profited from the nineteenth century's discovery that sweetness, light and heroism were not the only valid subjects for art. In a broad sense all modern art is subject to the camp cliché, 'it's so bad it's good', which neutralizes opposites. As early as 1853, P.J. Proud'hon wrote: 'The image of vice, like that of virtue, is as much the domain of painting as of poetry. According to the lesson that the artist can give, all figures, beautiful or ugly, can fulfil the goals of art.' The words ugliness and emptiness are resurrected periodically even now in regard to new art styles. They and the modifying concept of anti-art, which rationalizes unfavourable reactions to the new, are obsolete. But nothing stays ugly for long in today's art scene. Following the line that dualism is also obsolete, some of these artists have tackled the almost impossible task of reconciling the two major attitudes toward art today, which are as mutually opposed as oil and water: the art-as-art position and the art-as-life position.

One element in their work that characterizes this attempt is the adaptation of aspects of Pop art to a non-objective idiom. While Pop art has had no direct influence on these artists, it was Pop that made palatable parts of the contemporary environment previously considered vulgar, ugly and inferior to the 'beauty' required by tastemakers in art, fashion and commerce. It opened up new possibilities for materials and attitudes, all of which must be firmly controlled from the aesthetic angle.

Frank Lincoln Viner, who has been working in this idiom since around 1961, has explored multiple areas of sensuality purged of sentiment, and is now concerned with a more stringent but equally non-sculptural direction, based on the juxtaposition of taut, boxy, hard forms against limp, random, soft forms, or the fusion of the two in a single work, such as his huge expandable hanging piece made of orange vinyl, silk-screened with large spiral shapes in blue and yellow and edged with a still more multicoloured fringe. The series of identical rectangular shapes are pierced by a central hole or corridor. His combination of garish pattern and disciplined form does not so much soften structural effect as it shifts the focus. In other works he has manipulated surface until it contradicts

the form it covers, armouring a soft surface with shiny metal studs while the hard forms are softened with irregular, wavy bands. Because he has consistently worked in this manner over a period of years, Viner has already excluded some of the more obvious aspects of eccentric abstraction with which others are still occupied. His work transcends ugliness by destroying the notion of ugly versus beautiful in favour of an a-logical visual compound, or obstreperous sight.

The size of Viner's latest works approaches an environmental concept. Most of these artists have, so far, avoided such ideas, largely because of their concern with formal wholeness. Harold Paris, who persists in a more sculptural concept, has made a series of rooms which extend the reconciliation of sensuous opposites to a more complicated level. The latest and most successful room even includes temperature change and electronic sound, controlled by the viewer's movements and pressures on the surfaces. Made primarily of various kinds of black synthetic rubber, each surface has its own chiaroscuro, glowing with absorbed or repelled light. Some are smoothly soft, others matt, others finely textured or ribbed. They and the folded, moulded organic forms fool the hand as well as the eye. A deceptively squashy looking shape will be hard as metal, while a flat, wall-like surface gives resiliently when touched. The sculpture itself is set up in a multipartite, aisle-like arrangement – small forms before larger, parent forms – augmenting the ritual quality of the entire environment.

These artists usually prefer synthetics and avoid materials with long-standing literary associations, but Don Potts (like Paris, from San Francisco) uses fur and leather with a wood veneer. More of a sculptor than most of those mentioned here, he converts his materials into surfaces of such commercial precision that they can be explored in a directly sensuous manner instead of as anecdotal devices. Potts' great flowing structures, or the planar piece that suggestively rubs its furred edges together, are luxury items that invite touch but repel emotion by their almost maliciously perfect appearance. *Up Tight, Slowly*, an immense undulating floor piece with a two-colour leather surface, is both sensuous and sensual; it forces a kind of attraction that might be said to border on titillation, were the form not so clearly understated.

The materials used in eccentric abstraction are obviously of distinct importance. Unexpected surfaces separate the work still more radically from any sculptural context, and even if they are not supposed to be touched, they are supposed to evoke a sensuous response. If the surfaces are familiar to one's sense of touch, if one can tell by looking how touching them would feel, they are all the more effective. As far as the American art discussed here is concerned, Claes Oldenburg has been the major prototype for soft sculpture. Though his work is always figurative, he divests his familiar objects of their solidity, permanence and familiarity. His fondness for flowing, blowing, pokeable, pushable, lumpy

surfaces and forms has none of the self-consciousness of, say, Dalí's illusionistically melted objects. By taking single manufactured items and readymade goods for his subjects, and using them with a high degree of abstraction, he bypasses the anecdotal barrier set up by the assemblagists with their combinations of objects. Several, though by no means all, of the younger abstract artists working in soft materials noted their possibilities through Oldenburg's work; it differed from earlier uses of cloth in that he uses the medium in full range – stuffed and slightly resistant, left loose and absolutely manipulable.

Taken together, the effect of an Oldenburg soft-canvas ghost-model for a giant light switch and the streamlined, hard final version make up a kind of before-and-after, or double-edged, experience. Similarly, the 'subject matter' of many of the works illustrated here could be said to be an understated metamorphosis. Though energy in any active, emotive sense is anathema to most of these artists, they have not rejected the idea of change but systematized it, suggesting the force of change rather than showing its process. Their work tends to be anti-climactic, with no crescendo or build-up of forms. Gary Kuehn, for example, makes structures that use asymmetry as a neutralizing agent. Precise rectangular sections melt into a broad, fibreglass flow. Kuehn's earlier works were more tumbling and active, more obvious in confrontation of box and flow, but in the recent pieces the flow is heavy, extremely controlled and self-contained, often separate from its parent form, epitomizing inactive contrast. Momentary excitement is omitted; the facts before and the facts after action are presented, but not the act or gesture itself. Kuehn has been working with a structural versus idiosyncratic combination for some three years now, building primary single forms and juxtaposing them first against pillows and soft objects, then bundles of bare branches or twigs, bright coloured plaster flows, or swatches of hair-like nylon fibre. The high finish and assurance of the recent work de-emphasizes novelty and oddity in order to stress and crystallize a concrete aspect of sensuous experience.

The use of a flexible instead of a fixed medium opens up an area somewhere between kinaesthetic and kinetic art in which moving or moveable elements are extremely understated, as opposed to the hectic 'technological' bases of most kinetic sculpture. Keith Sonnier's inflatable forms are sometimes static, sometimes 'breathing'. The ones that inflate and deflate boxy vinyl forms include a similarly boxy counterpart in hard, painted material – thus presenting two apparently contradictory states as parts of a single phenomenon – a very slightly speeded-up version of the kind of soft sculpture that can only be altered by touch. The rhythm gives life to inert forms while their static precondition is simultaneously noted: even when the inflated shapes do not move, they span space (from wall to floor) in a manner that suggests the lines of movement within

a single physical sensation. The clear vinyl forms give the effect of formal mass but physical impermanence, a strength derived from frailty.

Rutgers University, where Sonnier and Kuehn have taught, is a hotbed of eccentric abstraction, a phenomenon due mainly to the individual developments of the artists, but perhaps indirectly attributable to Allan Kaprow's unrestricted ideas and his history of involvement with bizarre and impermanent materials, which was influential there even after his own departure. Last year Robert Morris also taught at Rutgers and his older work mingled contradictory premises in a cerebral manner, opposing Oldenburg's intuitive approach. Jean Linder, who was making large painted phallic sculptures of epoxied and painted cloth in San Francisco, also taught at Douglas in 1965–66, when she moved away from the rough materials and techniques that characterize the so-called 'funky' art of San Francisco (mainly Berkeley). Now in New York, she makes furniture-like structures, overtly sexual in their imagery and utterly unexpected in their awkward and uninhibited forms. With soft clear plastics and vinyl fabrics she has developed a hallucinatory use of transparency; her best work is relatively simple and less imagist than abstract.

This applies to most of the San Francisco artists who deal with 'funk', described by a west-coast writer as a kind of rugged individualist's Camp, unofficial and inelegant: 'While Camp cultivates "good" bad taste in a way that, is often precious and even recherché, Funk is concerned more with the essence than the pose, and can even be "bad" bad taste if the Funk is mean enough.'[1] Whereas funky art, or west-coast eccentric abstraction, deals with a raunchy, cynical eroticism that parallels that of the New York artists, the west coast is more involved with assemblage than with structural frameworks. Among those artists with a more developed formal sense (as far as I can tell from the little work I have seen) are Wayne Campbell, Dennis Oppenheim, Rodger Jacobsen, Jeremy Anderson and particularly Mowry Baden's big fibrous, membrane-like *Traps*, as well as his more abstract ceramics.

Typical of a much cooler kind of Funk is Bruce Nauman, who lives in San Francisco and has shown once in Los Angeles. Nauman's paradoxical ideas and intellectual inventiveness recall those of Robert Morris, though the work bears no resemblance. He has manipulated blotchy synthetic rubbers, tinted fibreglass, painted woods and metals into a curious limbo between mere existence and establishment of barely marked areas of space. His recent pieces are concerned mainly with moulds – the negative positive and inside-out properties of hollow, open and solid forms and their enclosed or filled spaces. The older work is more random – a group of rubbery streamers, a thin T-bar with a slightly curved-out stem, an irregular 'melted' barrier arched against the wall, a roughly circular group of centrally attached rubber strips to be thrown arbitrarily on the floor. The

majority of Nauman's pieces are carelessly surfaced, somewhat aged, blurred and repellent, wholly non-sculptural and deceptively inconsequential at first sight. Their fragility suggests fragmentation, but they are disturbingly self-sufficient.

Kenneth Price, in Los Angeles, conveys an ambivalent sense of vulnerable hostility in his small, painted ceramic ovoids. The self-containment of the bright, dry armoured shell is at odds with the dark, damp tendrils emerging from the core. In later pieces the outer form is free and fluid, still biomorphically sensuous but avoiding any specific erotic reference, and in others, a single form – lumpy, independent, like a small island – is taken entirely out of the organic category. Though the metallic, glowing colour has the same sort of sinister refinement as the earlier pieces, the later ones are more arresting in their divorce from all extant sculptural tendencies. The fact that Price, a highly self-reliant artist, and by choice isolated from the stylistic mainstreams, has arrived at an unfixed asymmetrical flowing form that can be related distantly to Kuehn's and Nauman's is indicative of the extent to which such a non-sculptural idiom is in the air.

The naturalism, or organic metaphor, from which Price departs is disguised or understated by his use of brilliant or harsh colour and surfaces that range from translucently reflective to streaked and grainy, to those with lobed painted forms moving across them. If his ovoids had been marble or bronze, their strangeness would be greatly modified and they would be seen in the context of traditional sculpture. The kind of colour native to the synthetic materials used by many of these artists is dull, neutral, unbeautiful, or else acrid, garish, rather than the cheerful primaries. Yet they use colour very specifically, like painters, investing their three-dimensional forms with an aggressive quality not found in most polychrome sculpture.

Two artists whose forms might be called eccentric, but not their materials, are Frederick Kiesler and Vreda Paris, both of whom work in bronze. Kiesler's 'creatures' and 'landscapes' were not wholly abstract, but Vreda Paris' quasi-scatological and erotic shapes evoke rotten potatoes, pancakes, extracted organs on a dissecting table (perhaps the famous Surrealist dissecting table where umbrella and sewing machine met). The platform isolates forms and controls the space they are seen in, enlarging their scale. In addition, these grotesque, improbable forms are, almost humorously, made permanent and valuable-looking by being cast in handsome, gleaming bronze, and it is the bronze that restores to them the role of sculpture.

Alice Adams was an accomplished weaver for many years; when she turned to sculpture, she acquired no sacred sense of medium, and was free to invent. Her familiarity with flexible, manipulable materials led her to work with forms that are patently man-made, but have a strangeness operating close to a natural level. The gawky, semi-architectural armatures of chicken wire, industrial cable

and link-fencing retain traces of biomorphism, though not so much as her older work, which evoked unnamed creatures with rough tangles of fibre and painted cable. Adams' animate references are erotic and often humorous, whereas Robert Breer's white Styrofoam 'floats' are more ominous. Unseen motors enable them to creep at an almost imperceptibly slow pace, and they constantly alter the space in which they move. Their simple, angular, quasi-geometric shapes dispel by understatement most of the biological suggestions that arise from their motion, and unlike the related kinetic sculptures of Pol Bury, they avoid cuteness. One of the most effective eccentric abstractions utilizing movement that I have seen is by an artist not usually involved with the idiom. Charles Mattox's giant 'hair ball' – a sphere covered with long, coarse black fur – jiggles solemnly on springs attached to a structural framework.

In 1924, André Breton wrote that for him the most effective image was the one with the highest degree of arbitrariness. The artists discussed here reject the arbitrary in favour of a single form that unites image, shape, metaphor and association, confronting the viewer as a whole, an undiluted aesthetic sensation, instead of as a bundle of conflicting or balanced parts. Evocative qualities are suppressed to subliminal level without benefit of Freudian clergy. The distinction made by the Surrealists between conscious and unconscious is irrelevant, for the current younger generation favours the presentation of specific facts – *what* we feel, *what* we see rather than why we do so.[2] Known and stereotyped Freudian symbolism is distilled into a nearly passive sensuous experience. The Surrealist poet Pierre Reverdy said thirty years ago that 'the characteristic of the strong image is that it derives from the spontaneous association of two very distant realities whose relationship is grasped solely by the mind', but that 'if the senses completely approve an image, kill it in the mind.'[3] This last qualification clearly separates Surrealism from its eccentric progeny. For a complete acceptance by the senses – visual, tactile, 'visceral' – the absence of emotional interference or literary pictorial associations, is what the new artists seem to be after. They object to the isolation of biological implications and prefer their forms to be felt, or sensed instead of read or interpreted. Sensual aspects are, perversely, made unpleasant, or minimized.[4] Metaphor is from subjective bonds. Ideally, a bag remains a bag; it does not become a uterus; a tube is a tube and not a phallic symbol; a semi-sphere is just that and not a breast. Too much free association on the viewer's part is combatted by formal understatement, which stresses non-verb response and often heightens sensuous and/or sensual reactions by crystallizing them.

Abstraction cannot be pornographic in any specific sense, no matter how erotically suggestive it becomes. (There is no pornographic music.) Instead of employing biomorphic form, usually interpreted in terms of sexual references in Surrealism and Abstract Expressionism, several of these artists employ a long,

slow, voluptuous but also mechanical curve, deliberate rather than emotive, simulating rhythm but only vestigially associative – the rhythm of post-orgasmic calm instead of ecstasy, action perfected, completed and not yet stated. The sensibility that gives rise to an eroticism near inertia tends to be casual about erotic acts as stimulants, approaching them non-romantically.

Eccentric abstraction has been called 'sick', an 'aesthetic of nastiness', or 'funny-looking'. The giggles it provokes are, however, giggles of uneasiness and perhaps even awe, like the giggles provoked by aspects of 'new eroticism' supposedly languishing in the studios because it is too strong for public consumption, but I doubt that more pictures of legs, thighs, genitalia, breasts and new positions, no matter how 'modernistically' portrayed, will be as valid to modern experience as this kind of sensuous abstraction. Abstraction is a far more potent vehicle of the unfamiliar than figuration, and erotic sensation thrives on the unfamiliar. Although it is too early to tell, there is a good possibility that the eccentric abstraction tendency, or something like it, will be the first style to supersede Surrealism instead of merely developing areas of its relative failure in the visual arts. The future of sculpture may very well lie in such non-sculptural styles.

1 [footnote 5 in source] Kurt von Meier and Carl Belz, 'Funksville: The West Coast Scene', Art and Australia, vol. 3, no. 3 (December 1965) 201.

2 [7] See G.R. Swenson, The Other Tradition (Philadelphia: Institute of Contemporary Art, 1965).

3 [8] From 'Le Cant de Crin', quoted in Marcel Raymond, From Baudelaire to Surrealism (New York: Wittenborn, Schultz, 1950) 288.

4 [9] See Barbara Rose, 'Filthy Pictures: Some Chapters in the History of Taste', Artforum, vol. 3, no. 8 (May 1965) 24.

Lucy R. Lippard, 'Eccentric Abstraction', Art International, vol. 10, no. 9 (November 1966) 28–40.

Lynne Cooke
Palermo's Porosity//2010

He just has a far greater porosity than the others.
– Joseph Beuys

Shortly after entering Joseph Beuys' class at the Kunstakademie Düsseldorf in 1964, Peter Heisterkamp adopted the moniker Blinky Palermo. In appropriating

the name of the manager of American boxer Sonny Liston (whom he supposedly resembled), the young artist affirmed his long-standing reverence for American culture, its jazz, its Beat literature, and above all its post-war art. Soon Heisterkamp-turned-Palermo began to meet a number of his American contemporaries, including Carl Andre and Robert Ryman, when they travelled to the Rhineland to make their European debuts in galleries where he, too, would shortly present his inaugural exhibitions. In late 1970, accompanied by his close friend Gerhard Richter, Palermo set out on the first of several visits to North America. At the end of 1973, he decided to relocate on a more permanent basis, establishing a studio in Manhattan that he would maintain for the rest of his life.

That Palermo's art is little known in the country he was so passionate about may be attributed to several factors. Most of his works belong to public institutions and private collectors in Germany, and none of his major exhibitions has ever travelled to North America. During his few years in the United States, he was generally seen as an outsider or an emerging artist rather than as the established figure he was in his homeland. And, not least, he shunned public discussion of his practice and his ideas. Reflected in his fondness for Ludwig Wittgenstein's contention 'Whereof one cannot speak, thereof one must be silent', his laconic stance has permitted others to speak for him.[1]

Such acts of ventriloquism have been facilitated by the curious shape-shifting that permeates Palermo's biography. In 1964 Beuys' critique of his new student's painterly practice came with the recommendation that if Palermo wanted to change his way of working he needed to change himself[2] – embracing a pseudonym signified a wholesale revision in his attitude toward art-making. This name change was but the last in a series of substitutions that began in infancy. Born in 1943 in Leipzig, Palermo and his twin brother assumed their mother's name, Schwarze, in the absence of their father. Following their adoption at an early age by foster parents named Heisterkamp, the twins were relocated to Münster, West Germany, where they grew up. Palermo began his studies at the Werkkunstschule in Münster, then transferred to the Kunstakademie Düsseldorf in 1962, first studying with Bruno Goller and, two years later, with Beuys. This recurrent play with identity, coupled with his tragically brief career – he died while on a trip to the Maldives in 1977 – contributed to the romantic myth that colours most popular accounts of Palermo's practice. Like James Dean, whom Palermo was thought to resemble not just physically, and his near contemporaries Robert Smithson and Eva Hesse, Palermo has become the subject of biographical fantasies that routinely parse his art through the filter of his persona.

Although Palermo's work was largely misunderstood by both critics and the wider public when exhibited in New York City in the late 1970s, it can be seen to

have been formative for a generation of American artists then coming to maturity.[3] Nonetheless, the ongoing marginalization of his art in the United States – together with the lack of autograph statements, writings and interviews – has meant that, compared with his close friends and fellow painters Gerhard Richter and Sigmar Polke, he has been the subject of relatively little scholarship in English. And even though publication of a well-documented and fully illustrated catalogue raisonné in 1995 provided a crucial tool, critical reappraisal began only nine years later, when German conservator Pia Gottschaller published *Palermo: Inside His Images*, an in-depth analysis of the Metal Pictures (the body of work Palermo conceived after he relocated to the United States late in 1973).[4] In 2008 the German-born American academic Christine Mehring presented the first in-depth study of his oeuvre,[5] and in 2009 Dia Art Foundation followed with a monograph dedicated to what is often considered Palermo's magnum opus, *To the People of New York City* (1976), the most ambitious of his Metal Pictures. In parallel with their German colleagues, a coterie of Anglophone specialists has emerged; it quickly became apparent that their readings of Palermo's art greatly differed from the interpretations long prevailing in his homeland.

In a telling survey of US-German artistic interchange in the post-World War II era published in 1996, German art historian Stefan Germer outlined the terms in which these dissenting positions were first codified and then enshrined: Anglophone critics tended to align Palermo's work with the neopositivist self-reflexivity of Minimal art, in contrast to their German counterparts, who imputed a spiritually redemptive agenda to monochrome abstraction.[6] Anne Rorimer, the first American art historian to address Palermo's work in detail, initiated the debate in a controversial article published in *Artforum* in 1978.[7] Titled 'Blinky Palermo: Objects, *Stoffbilder*, Wall Paintings', Rorimer's text singled out three bodies of Palermo's works for discussion while excluding the late Metal Pictures. The works from the decade of his early maturity – that is, from 1964 through 1974 – she contends, are 'central to any consideration of artistic concerns and innovations, in Europe and America *both*, after 1965'.[8] Her account of the radical nature of Palermo's ideas in the context of the late 1960s was based in a close formal-materialist analysis.[9] Situating Palermo's practice in relation to those of his non-German peers Sol LeWitt, Bruce Nauman, Richard Tuttle, Daniel Buren and Ellsworth Kelly, among others, Rorimer took a stance markedly at odds with that of her German colleagues, among the earliest being Bernhart Schwenk, who finished his dissertation on Palermo's art in 1991, thirteen years after Rorimer's article. Now curator at Munich's Pinakothek der Moderne, he espoused what was to become a characteristically German viewpoint: 'At home in the world of materials he knows, [Palermo] transcends his picture-objects in order to construct a spiritual world, and is thus a European artist through and through.'[10] In the

introduction to the 1995 catalogue raisonné of Palermo's paintings and objects, a similar line of argument was taken by Klaus Schrenk, who discussed the artist's formative years in Beuys' class in some detail, before mentioning in passing Richter and Polke. 'The physical presence of colour and the immaterial effect which it seems to create together permit the viewer to experience the often inexplicable character of art as a spiritual force', he contended.[11]

These polarized positions, in turn, impact upon any evaluation of Palermo's contribution to the history of post-World War II art. For most European commentators, as for the artist's friends and colleagues, Palermo was unquestionably a painter: that is, an artist preoccupied with problems integral to painting as a historical genre. By contrast, for some of the most influential historians publishing in English today, Palermo's work is best read in conjunction with that of such peers as Daniel Buren and Michael Asher, for he, too, brilliantly problematized the question of the viability of painting as a vanguard practice. For the former group, his preoccupation with painterly practices culminates in 1976 with *To the People of New York City*; for their Anglophile antagonists, Palermo's achievement is best exemplified by works such as the wall painting for Documenta 5 in 1972 and the iconic *Blaue Scheibe und Stab* (Blue Disk and Staff, 1968).

Benjamin Buchloh, the renowned German art historian long resident in the United States, succinctly outlined this position in his contribution to an influential anthology surveying twentieth-century art published in 2004. Buchloh's account echoes that of Rorimer, his former student.[12] Focusing on the monochrome wall painting Palermo executed in a stairwell in the Museum Fridericianum in Kassel for Documenta 5, Buchloh argued that the 'central role' Palermo played there – along with such participants as Buren, Marcel Broodthaers and Hilla and Bernd Becher – was due to the way they 'installed works that would subsequently be seen as the foundational models of European conceptual art and its strategies of institution critique'.[13] By concentrating, like Rorimer, on the works Palermo made prior to his move to the United States in late 1973, Buchloh honed his internationalist evaluation of the artist as one of the seminal figures of conceptual art.[14] Removing Palermo from what may be termed the mainstream to the vanguard – that is, from the history of post-World War II painting to a conceptual lineage defined by more theoretically oriented hybrid practices – Buchloh in addition severed his subject's relations with most painters, above all Richter, with whom Palermo had long felt a great affinity.

In the fall of 2002, almost twenty-five years after Rorimer's pioneering contribution appeared in its pages, *Artforum* published a second major text on Palermo. It inaugurated a range of reappraisals by a new generation of scholars. In her short but closely argued article, Christine Mehring positioned Palermo's work for the first time in relation to a more encompassing socio-historical

context.[15] A comment made by Beuys is central to her thesis. In suggesting that his former student's work betrays 'the impulse of the era',[16] Beuys implied, she argued, that irrespective of the diversity of its modes, forms and materials, Palermo's art is 'always saturated with the marks of its time'.[17] Thus, for Mehring, 'banality was Palermo's ingenuity'. Recourse to banality, she asserted, 'deflated popular hopes of reviving the utopias of modernism's past and put painting ahead of the grand socio-political ambitions of his environmentalist peers'.[18]

In her study of vanguard artistic impulses between the late 1950s and early 1970s, Briony Fer carved out a very different position from those taken by previous scholars. 'Looking at Palermo's work now', she wrote in 2004, 'it seems odd to think of him as a painter at all, or to describe his work as painting'. And, to ground what at first might seem an unlikely claim, she asserted that 'the work poses as much a problem of description as interpretation of its 'point of view'.[19] Her focus is a handful of works made in the late 1960s – 'bits and pieces of things' – after the artist had (supposedly) repudiated such conventions normative to painting as the laying of pigment on a canvas support in a rectangular format.[20] Small watercolours and drawings, together with modestly scaled wall reliefs and objects, some but not all of which contain gesturally applied colour in oils, provide the principal examples on which she based her intriguing analysis. She also cursorily mentioned a couple of the almost thirty Wall Drawings and Paintings that the artist executed between 1968 and 1973, including the work made for Documenta 5. In her conclusion Fer, like Buchloh and Rorimer, sidestepped all reference to painting per se: 'It is unclear whether Palermo makes a space of left-overs, of found, redundant things and materials or whether he makes a space of new possibilities', she argued, before concluding: 'In the end, I think, it has to be both.'[21]

In the 1984 interview in which Beuys made the statement that proved so fundamental to Mehring's thesis, Palermo's mentor and long-standing friend made another striking comment. Serving as the epigraph of this essay, this remark concerned what Beuys termed the 'porosity' of Palermo's work.[22] Beuys' observation may be read in a number of different ways. Perhaps most obviously, it alludes to the fact that, unlike many of his contemporaries, Palermo was exceptionally open: he did not suffer from what has been called 'the anxiety of influence'. Highly knowledgeable with respect to technique, Palermo was well informed about some of the more arcane practices of his medium's devotees and explored an unusually wide range and number of his predecessors' strategies. If prompted by more than simple curiosity or wayward wandering – by an openness that implies porosity – such inquiries ultimately proved less defining than broadly informative.[23] Yet Beuys' observation also intimates how susceptible Palermo's work has been to interpretation from a plethora of discursive positions. With their contributions to

[*Blinky Palermo: Retrospective 1964–1977*], Suzanne Hudson and James Lawrence join the ranks of Rorimer, Fer, Buchloh, Mehring, Schwenk and Schrenk.

In a signal departure from the well-trodden path paved with testimony from the artist's friends and mentors, Hudson tracks one of the very few instances in which Palermo offered guidance to his thinking and his practice. When asked to provide a text for the catalogue that would accompany the presentation of some of his Metal Pictures at the XIII. São Paulo Bienal in 1975, Palermo suggested, instead of the anticipated artist's statement, a newspaper article on the subject of catastrophe theory.[24] Adopting French mathematician René Thom's novel thesis as a lens through which to address notions of order in Palermo's practice, Hudson offers a challenging reading of how it operates both at a microscopic level – that is, how it impacts upon the structure of an individual work – and at the macroscopic – that is, as it threads together his aesthetic and life's work.

Commissioned to write specifically on Palermo's drawings, Lawrence begins by noting that this body of works is singular in the artist's oeuvre in that it offers 'a survey of Palermo's concerns'. Numbering more than four hundred and thus constituting more than half his extant production, the works on paper provide 'a record of his enduring sensitivity to a varied visual syntax'. Even Palermo's earliest figurative studies on paper and on canvas – quasi-Surrealist, quasi-Beuysian images rendered in sombre, muddied browns, greys and greens – attest to 'an idiomatic recapitulation of signature techniques in modern art', Lawrence claims. These juvenilia are consequently symptomatic of what would prove to be an abiding capacity to signal 'awareness without adopting an agenda'.[25] In summarizing the important ways in which he considers Palermo to have been 'open to influences but not defined by them',[26] Lawrence identifies several crucial features or traits that cross the categories into which the artist's oeuvre is generally divided (Objects, *Stoffbilder* [Cloth Pictures], Wall Drawings and Paintings and Metal Pictures): a 'ludic appeal', or an ability to be light-hearted without any loss of consequence; an 'irrepressible' feeling for colour; and a very evident sense of pleasure stemming from his intimate involvement in the process of making.[27] While a hallmark of his practice as a whole, this last quality, Lawrence demonstrates, is nowhere more evident than in the drawings.

The remaining two essays in this publication, written by veterans of Palermo studies, address issues relating to spatiality. Drawing on the highly detailed research she undertook for her doctoral thesis on the artist's Wall Drawings and Paintings, Susanne Küper traces Palermo's increasingly diverse ways of engaging the architectural contexts in which he realized these works. Although he was initially indebted to certain of Beuys' interactions with architectural sites, she argues, Palermo fastidiously distanced himself in his finished work. That is,

where Beuys' persona was a crucial conduit in the construction of an art based on a social agenda, Palermo probed what he called 'space activation' by focusing exclusively on the site itself. On occasion this led him into studies based on perspectival vantage points, at other times it resulted in a mirroring or refracting of key architectural features in a given context, and in yet other instances it veered toward decorative schemes and historical decor.

Although each work was intended to make the viewer reflexively aware of the spatial character of the site, in later works he oriented the viewer by means of colour coding and sequencing. Constant throughout, however, was his commitment to an experiential form of apprehension: irrespective of how conceptual the point of departure of any particular project may have been, Palermo insisted that his work required a direct interaction. To better position her subject's in situ practice and his preoccupation with 'space activation', Küper, like many anglophone scholars, goes beyond Palermo's intellectual roots in the Rhineland to draw on the writings of Robert Smithson, Buckminster Fuller and John Cage as touchstones that illuminate his aesthetic.

Benjamin Buchloh has long defended the positioning of Palermo's art in relation to an international arena that includes such peers as Ryman, Kelly, Tuttle, Buren and Frank Stella. For Buchloh, relationships among these artists were not predicated on dependence and influence; rather, they consisted in shared (or parallel) strategies for probing the paradigms and viability of painting as a vanguard practice. Drawing once more on the much referenced interview with Beuys from 1984, Buchloh focuses on the notion of triangulation as a leitmotif through which to examine Palermo's artistic and identity formation. In positing a series of relations involving Beuys, Yves Klein and Barnett Newman as key to Palermo's artistic maturation, Buchloh argues that the artist 'shared a collective desire to accept an Americanization of identity as a solution to the seemingly unresolvable conflict of having lost access to an acceptable German national culture while at the same time wanting desperately to reinstate an elementary credibility for that culture beyond the crimes of the fathers and their collective inability to mourn their victims'.[28] Palermo's artistic identity 'had to be post-national and post-traditional', he contends, 'and internationalist in its aspiration while insisting at the same time – along with Beuys – on the inevitably local, regional and national specificity of his claims for the conception of new idioms of abstraction'.[29]

Palermo's work thus evolved in response to, or against, Beuys' preoccupation with 'a space of traumatic memory' – a space of fragmentation and loss – and in reaction to the spectacularization of space that, spearheaded by Klein, was then emerging in the work of the Zero group in Düsseldorf. The multifarious and extraordinarily subtle ways Palermo devised to inscribe the spectator phenomenologically into the space and thereby activate an engagement –

sometimes literal, sometimes metaphoric – between artwork and viewer ended in a subversion of traditional object-viewer relationships. Spaces were created for potential or even actual cohabitation.

Buchloh's account, like Küper's, sets terms for a rethinking of Palermo's landmark work, *To the People*, as a hard-won environmental piece. Composed of some forty elements, the fifteen-part work requires a minimum of 275 linear feet for its installation. (The distances between single components within any of the fifteen parts are fixed; the distances between parts are not.) As a result spectators engage in a complex movement through space and time, which grounds them in what Jaleh Mansoor has persuasively defined as a social space. Mansoor, another of Buchloh's former students, has rigorously probed the work's implications in light of Palermo's adoption of a structure and form that originate in the artistic vanguards of interwar Europe. Since any form of address would, she argued, 'already imply some form of coherence among its addressees', the work functions less 'as an *address* to the audience' than as 'an insinuation of the conditions for the possibility of assembly, newly understood as constituted by a linkage of singularities rather than as a fusion, a totality'.[30] Engaging the 'possibility of singularity-as-sociality', *To the People* responds, she has concluded, 'to a specifically post-war European social and historical matrix'.[31]

Executed in Germany after he temporarily moved back there in late 1976, Palermo's vast work is addressed to the inhabitants of his beloved Manhattan. Although his time there had been fruitful in artistic terms, his relocation must be considered largely a failure as a career move; he had garnered no critical or institutional support and few sales in the United States, in contrast to Europe, which provided him with steady critical acclaim and ongoing commissions. Palermo continued to believe, nonetheless, that his affinities with the radical achievements of post-World War II American art and the discourse it produced were intellectually critical to his future development. Revealing his conviction that cultural geography was formative – namely, that a locale would impact upon his production in significant ways – he uncharacteristically chose names referencing places as titles for a number of his Metal Pictures – for example, *Wooster Street, Coney Island* and *14th Street* (all 1975). If it was axiomatic for him that different materials and techniques would produce works of a new kind, nevertheless, his move to acrylic paint on rectangular (metal) supports led to a more conventional idiom, one that is closer to that of traditional painterly genres, than were the pictorial languages he had previously devised. At the same time it was clear that his roots were European and that certain aspects of his formation and heritage, which continued to inform his work, set him apart from his American peers. The most telling example of this dichotomy is the counterpointing of the epistolary address to the citizens of his adopted

city, inscribed on the verso of the panels, with the choice of a palette comprising the colours of the German flag – red, yellow and black.

Once before, at a similarly critical moment in his career, Palermo had consciously exposed the pivotal position he felt placed him between two lineages. Prior to his move to the United States in late 1973, he participated in a group show devoted to the problematics of painting, which included works by major European and North American artists. Whereas some, like Agnes Martin and Brice Marden, upheld a commitment to painting as autonomous artwork, others, including Daniel Buren and Niele Toroni, addressed it from outside, as it were, in a conceptual discourse grounded in the specificities of site. For his contribution, Palermo installed his signature blue triangle over several doorways leading into galleries; in addition, he placed another blue triangle, this one painted on canvas, beside its mirrored equivalent on an otherwise empty wall in one of the large galleries. As visitors approach the artist's signature motif, they see themselves inscribed in the context through their reflection in the glass: here object-viewer relationships are couched in terms of poetic metaphor rather than institutional critique. Palermo's contribution was singular in that it distanced him equally from both his European and his American contemporaries. After all, he could have made a wall drawing of the kind he was known for – one that, as in Documenta 5, engaged the architectural features of the context – and thereby associated himself with the discourse of Buren and Toroni. Or, he could have shown some of his Cloth Pictures and thereby affiliated himself with the practices of Marden and Martin. That he did neither, opting instead for a disarmingly modest, wittily astute intervention, was fully in line with his idiosyncratic independence of spirit.

A retrospective of Palermo's works must attempt to reveal the many and finely nuanced sides to what became a highly refined and sophisticated practice. However, one body of work, the Wall Drawings and Paintings, can now be known only through documentation, and that, the artist warned, is no substitute for the experience of having encountered a work *in situ*. Nor can an exhibition today do justice to the restless shifts in Palermo's thinking during the last months of his life.[32] The goal, then, is necessarily less to survey his oeuvre comprehensively than to question the central issues underlying his practice, not least his deep involvement with the presentation of his work. Palermo's visual acumen in this pursuit was frequently noted, as he rigorously separated his practice into discrete modes for public presentation.

For example, in 1973, he had made a show devoted exclusively to the Objects at Städtisches Museum Mönchengladbach. Although some forty were itemized in the catalogue checklist, only thirteen were installed, doubtless because he wished each of these irregularly shaped artefacts to engage directly with the expansive, unbounded space of the wall on which it was hung. Prior to leaving for the United

States at the end of that year, he had spent a considerable amount of time assembling and collating documentation of the Wall Drawings and Paintings, creating an archive that recapitulated realized works along with others that remained at the level of proposals. And, the following year, an exhibition devoted exclusively to Palermo's works on paper was held at the Kunstraum München. At the time of his death, he was involved in plans for yet another exhibition that would be organized according to three distinct groups of works – works on paper, Cloth Pictures and Metal Pictures – that were to be presented in three very discrete spaces. This division, according to Gerhard Storck, the show's curator, was intended to allow a viewer to discern three of the stages that Palermo felt were most important in his development with respect to painting.[33]

This methodology, based in a careful packaging of Palermo's works into distinct, cohesive groupings for public presentation, has strongly influenced the oeuvre's critical reception. Though it began with Rorimer's article, whose very title confirmed the strategy, justification for this approach ultimately lies not only in artistic precedent but also in the consistency and coherence within each of the groups. But since it depends, too, on the comprehensiveness of this system, a retrospective can provide an opportunity for exploring this idiosyncratic approach and its implications in some detail. As this show and the catalogue raisonné each indicate, there remain a good many other pieces that do not fit within Palermo's categories. First, there are early abstract paintings, like *Komposition mit 8 roten Rechtecken* (Composition with 8 Red Rectangles, 1964) and *Straight* (1965), made in the wake of his epiphanic journey to the Stedelijk Museum in Amsterdam, where he saw works by Kazimir Malevich and Piet Mondrian for the first time. In addition, there are 'pictures' made intermittently through the later 1960s and early 1970s, such as an untitled painting that contains a black triangle on a white ground; a black monochrome composed of two Formica parts, their junction cemented with tape; a work consisting of a wax-crayon line drawing on a white canvas ground; and the 'hidden picture', in which the glass of a framed painting has been extensively overpainted with a concealing coat of grey. Some, like the black monochrome and the wax-crayon drawing, may be viewed as hybrids: attempts to expand a certain vocabulary or idiom by building on the lessons adumbrated in the Cloth Pictures, in the former instance, and by building on precedents in the Wall Drawings and Paintings, in the latter. If others of these anomalies strike out in new directions that ultimately had no issue, some seem to have a delayed effect. Consider, for example, Palermo's evolving interest in the question of the spatial envelope created by the corner of a room. In 1970 it provoked two related but distinct responses: *Untitled*, composed of four small canvases painted red, yellow, black and white, installed to straddle two walls; and his contribution to the exhibition 'Strategy: Get Arts' at the Edinburgh College of

Art, where he painted the cornice of a stairwell so that each of the four sides took on a different hue – red, white, blue or yellow. Echoes of these very different works may be felt in *Himmelsrichtungen* (The Cardinal Points, 1976), a four-part, room-filling structure with monochrome glass panels of yellow, red, black and white, made for the 37th Venice Biennale. Neither *Untitled* nor *Himmelsrichtungen* neatly fits into any of Palermo's standard groupings.

As these various examples indicate, Palermo's strategies for probing the fundaments of painting proved extraordinarily fertile and protean. Nevertheless, there were fallow periods – most acutely, the first two years he spent in New York, when he destroyed almost all the work he made. Among the most important of the various reasons he gave for relocating to the United States were his expectation of finding there a receptive climate for abstract painting and his desire to engage with his American peers, with whom he had been dealing at arm's length for almost a decade.[34] His departure was spurred, too, by the difficult period he had recently weathered in the Rhineland, where American Pop art was making strong incursions into the market for painting, and environmental and installation based practices had begun to dominate institutional programming. Although his Wall Drawings and Paintings had afforded him considerable currency in the latter circles, Palermo was a painter by avocation, and the inevitable temporality of those projects must ultimately have grated on him. The Cloth Pictures may also have come to appear limited in that they relied heavily on contextualization for their meaning: made from samples of store-bought cloth sewn together and then stretched over frames, their identity as artworks required that they be presented within a museum context and discourse. Perhaps he was also irked by certain chromatic restrictions inherent in their very fabric. Well suited to the creation of harmonious colour chords, their specific tonalities seem not to have lent themselves, in Palermo's eyes at least, to compositions based in the primaries or in other predetermined sets (such as black, yellow and red – the colours of the German flag) that permit an exploration of colour's semiotic and declarative roles. (The single exception that proves the rule regarding this intuition – if that is what it was – is the monumental *Triptychon* [Triptych] from 1972, where he deployed the primaries red, yellow and blue, in combination with black and muted variants.)

Toward the end of the decade, often in concert with his close friend Richter, Palermo embarked on a variety of sorties that may not have resulted in substantial bodies of work but nonetheless attest to his ongoing preoccupation with the corpus of possibilities integral to traditional problematics of painting – that is, to painting as an autonomous artefact that embodies a set of well-rehearsed conventions.[35] Despite a difference of some eleven years in age, the two artists grew close during this difficult period, when they felt themselves besieged: 'At

the end of the 1960s the art scene underwent its great politicization', Richter later recalled. 'Painting was taboo, because it had no "social relevance" and was therefore a bourgeois thing.'[36] By the time the Cloth Pictures got under way in mid 1966, Richter was on the threshold of an 'uncertain interval'.[37] Rather than the younger artist simply following in the tracks of his older and more experienced friend, a dialogue emerged as Richter turned to Palermo as someone whose commitment to, and preoccupation with, abstract painting would prove increasingly relevant and stimulating.

The two artists' painterly preoccupations dovetailed to the point that they undertook a number of collaborative ventures.[38] In the untitled pair of diptychs they jointly made in 1971–72, arguably their most ambitious collaboration, Richter's contributions are based on a highly abstract fragment of a photograph of a light bulb. The pale beige surfaces Palermo executed might seem at first glance simply tuned to complement his friend's palette; however, these thinly painted, uninflected surfaces may be read as slyly referential, in that their hue can be associated with skin tones. Far from arbitrary, Palermo's choice of colour speaks to the function it serves here: it creates a skin, or protective membrane, over the canvas support, foreshadowing the role the rust-resistant industrial paint would serve in a trio of monochrome works from 1973.

If Richter admired his young colleague's steadfast commitment to abstract painting, irrespective of how fraught or outmoded this endeavour might have appeared to others, Palermo, in turn, seems to have responded to the older artist's search for a viable mode of gestural abstraction.[39] Continuing up until the younger artist's death, these exchanges may also have fuelled idiosyncratic ventures like Palermo's anomalous *Triptychon*. In many respects at odds with his approach to colour in other Cloth Pictures, *Triptychon* may be read as a riposte to Richter's trio of vast paintings for BMW in 1973, *Red, Yellow and Blue*, with their images of brushwork in close-up, in that what these atypical ventures share is a focus on primaries.

First in the Grey Paintings and Inpaintings and later in the works made with squeegees, Richter developed a form of gesturalism that eschewed expressive effects. This has no direct counterpart in Palermo's practice. Notwithstanding his recourse to erasure in *Ohne Titel (Verstecktes Bild)* (Untitled [Hidden Picture], 1971), Palermo's intermittent and recurrent forays into gesturalism attest to an abiding effort to make it, too, somehow part of his repertoire of effects – that is, to develop it as a mode parallel to his more habitual research into the monochrome.[40] An unprecedented attempt to fuse these two otherwise quite distinct idioms may be seen in some of the works found in his studios after his death: they include a four-part untitled Metal Picture from 1977, another untitled work in the form of a single, medium-size vertical panel, and a number of related

multipartite works on paper, including a series called *12 Monate* (12 Months, 1976), in most of which geometric forms coexist with more gestural elements. In the untitled four-part painting, narrow borders of black, alternately vertical and horizontal, bound the small panels' edges. Each interior is occupied by an irregular yellow wedge that spills off at least one of the four sides, where it is cut by a black band. In the single-panel piece, brown paint is loosely scumbled over flat, geometrically defined zones, obscuring their monochrome forms.

While it is unclear where this attempt to combine two seemingly antithetical languages might have led Palermo – his oeuvre was obviously truncated *in medias res* – his involvement with gestural mark-making was long-standing. Appearing intermittently over the entire course of his working life, it was never wholly relegated to the margins of his practice. Although this gesturalism appears most often in the more intimate vehicles of watercolour and paper, where it forms part of an arsenal of informal, immediate and spontaneous ways of working, he never relinquished his desire to reconcile it with the staples of his vocabulary: the monochrome and the geometric format.

While few historians have turned to Richter, as opposed to Beuys, as a source of information on Palermo, it was Rorimer – perhaps surprisingly, given the terms in which she couched the various bodies of Palermo's work – who first interviewed the older artist about Palermo for publication; she concluded her article with his testimony, made just over a year after Palermo's death: 'Gerhard Richter, with whom Palermo collaborated on several works, confirms the observations of others that Palermo never spoke about his work in theoretical terms, although he talked about art a great deal. He believed in painting – in the visual communication of ideas which he could not otherwise express'.[41] Richter here recapitulates views that Palermo had himself expressed in one of the few public statements he offered: 'I pursue no specific direction in the sense of a style. I have no programme', he declared in an interview in 1969. 'What I have is an aesthetic concept, whereby I try to keep as many expressive options open for myself as possible.'[42] Galvanized by painterly dialogues with Richter in the late sixties and early seventies, Palermo's recurrent forays into gesturalism then and later vividly attest to the extraordinary openness – or porosity – that was in so many ways a hallmark of his practice.

Not only by all accounts but also as evidenced in the work itself made over a mere dozen years, Palermo was committed to resurrecting painting rather than to undermining it. However anxious he might have become about its viability, he was never ready to dismiss it wholesale. Arguably no one of his generation with the exception of Robert Ryman, whom he deeply admired alongside Richter, has more subtly and inventively limned new avenues for this form. Palermo's dedication to painting, like theirs, was premised on a critique of accepted notions of what it had been. In revealing something of the ingenuity,

modesty, wit and intelligence with which he strove to reanimate it, this retrospective may also make evident why, for many artists working today, his name figures prominently among those most revered.

1 Ludwig Wittgenstein, *Tractatus Logico-Philosophicus* (New York: Harcourt, Brace, 1922) 189.

2 See Laszlo Glozer, 'On Blinky Palermo: A Conversation with Joseph Beuys', in *Blinky Palermo: To the People of New York City*, ed. Lynne Cooke and Karen Kelly, with Barbara Schröder (New York: Dia Art Foundation/Düsseldorf: Richter Verlag, 2009) 23.

3 Dieter Schwarz attributed these misunderstandings to their merely fleeting contact with his work. See Dieter Schwarz, 'To the People of New York City: A Multipart Address', in *Palermo: To the People …*, op. cit., 151. See also David Reed's 'Exchange', in ibid, 111–28.

4 Pia Gottschaller, *Palermo: Inside His Images* (Munich: Siegl, 2004).

5 See Christine Mehring, *Blinky Palermo: Abstraction of an Era* (New Haven and London: Yale University Press, 2008). The previous year, a retrospective in Düsseldorf had introduced yet other voices to the debate, including Ann Temkin and Yve-Alain Bois. See, for example, Mehring's essay 'Palermo's Cloth Pictures: Modernism by the Yard', in *Palermo*, ed. Susanna Küper, Ulrike Groos, and Vanessa Joan Müller (Cologne: DuMont, in association with Kunsthalle Düsseldorf and Kunstverein für die Rheinlande und Westfalen, 2007) 37–75.

6 Stefan Germer, 'Intersecting Visions, Shifting Perspectives: An Overview of German-American Artistic Relations', in *The Froehlich Foundation: German and American Art from Beuys to Warhol*, ed. Monique Beudert (London: Tate Gallery, 1996) 9–34. […]

7 Anne Rorimer, 'Blinky Palermo: Objects, *Stoffbilder*, Wall Paintings', *Artforum*, vol. 17, no. 3 (November 1978) 28–35; reprinted in *Blinky Palermo* (Barcelona: Museu d'Art Contemporami de Barcelona/ACTAR, 2003) 49–81. […]

8 Rorimer, 'Blinky Palermo: Objects, *Stoffbilder*, Wall Paintings', op. cit., 28 (my emphasis).

9 Ibid.

10 Bernhart Schwenk, *Similes of the Enigmatic: On the Painting of Blinky Palermo* (Frankfurt am Main: Museum für Moderne Kunst, 1990) 50.

11 Klaus Schrenk, 'An Essay on Palermo's Artistic Oeuvre', in *Palermo: Werherzeichnis*, ed. Thordis Moeller, vol. 1, *Bilder und Objekte* (Stuttgart: Oktagon, in association with Kunstmuseum Bonn, 1995) 34.

12 Rorimer was an occasional student of Benjamin Buchloh's in Düsseldorf, where he lectured at the Kunstakademie in the mid 1970s. Reprinted on various occasions – most recently in 2003 in the catalogue to the retrospective organized by the Museu d'Art Contemporani de Barcelona – her pioneering text from 1978 may owe its ubiquity not just to the persuasiveness of its arguments but also to the lack of other authoritative accounts. Like Buchloh later, she also excluded the last phase of Palermo's oeuvre, and nowhere in her quite detailed excursus did she refer to him as a painter per se. (In a note appended to the original article, Rorimer pays tribute to Buchloh for his help in shaping the text.)

13 Benjamin H.D. Buchloh, in *Art since 1900: Modernism, Antimodernism, Postmodernism*, ed. Bois,

Buchloh, Foster, Krauss (London: Thames & Hudson, 2004) 554. According to Buchloh, 'The international exhibition Documenta 5, held in Kassel, West Germany, marks the institutional reception of conceptual art in Europe' (ibid.).

14 To be fair to Buchloh, his position is more complex. See also Buchloh, 'Einheimisch, Unheimlich, Fremd: Wider das Deutsche in der Kunst?' in *Von hier aus: Zwei Monate neue deutsche Kunst in Düsseldorf*, ed. Kasper König (Cologne: DuMont, 1984) 162–79, especially 169–72. Buchloh explained his lack of interest in the last works in an interview with the author published in the Düsseldorf catalogue: 'To me, the metal paintings indicate the most manifestly Americanized phase in Palermo's career. They seem to result directly from his introduction to, and confrontation with, American minimalist painting.' (Buchloh, 'On Palermo: Benjamin Buchloh in conversation with Lynne Cooke', in *Palermo*, ed. Küper, Groos and Müller, op. cit., 149)

15 Christine Mehring, 'Four of a Kind: The Art of Blinky Palermo', *Artforum*, vol. 41, no. 2 (October 2002) 138–43. In 2005 Mehring published a second article, 'Decoration and Abstraction in Blinky Palermo's Wall Paintings', *Grey Room*, no. 18 (Winter 2005) 82–107.

16 Beuys, in Glozer, 'On Blinky Palermo', 27.

17 Mehring, 'Four of a Kind: The Art of Blinky Palermo', 139. Thus, for example, the commercial fabrics used in the Cloth Pictures, which Mehring describes as 'drenched in consumer culture', 'accentuated their department-store origin', 'while their simple shapes and crisp demarcations resembled the fashionable forms of sixties Volkswagen ads and Courrèges dresses' (139).

18 Ibid., 140.

19 Briony Fer, *The Infinite Line: Re-making Art after Modernism* (New Haven and London: Yale University Press, 2004) 190.

20 Ibid., 190–204.

21 Ibid., 204.

22 Beuys, in Glozer, 'On Blinky Palermo', op. cit., 27.

23 Robert Storr completely missed the critical edge in Palermo's practice when he couched it in terms of flâneurie: 'Stumbling upon one thing and then another, picking up first this idea and then that one so as to examine them with a kind of inquisitive equanimity, Palermo meandered through the art of the 1960s and 70s like a beachcomber after the flood tide' (Robert Storr, 'Beuys' Boys', *Art in America*, vol. 76 , no. 3 [March 1988] 167).

24 In addition he offered a few, mostly technical, comments about making the Metal Pictures, the works that were to be shown.

25 James Lawrence, 'Unfolding: Palermo on Paper', in *Blinky Palermo: Retrospective 1964–1977*, op. cit., 80–82.

26 Ibid. 82.

27 Ibid., 85 and 100.

28 Benjamin H.D. Buchloh, 'The Palermo Triangles', in *Blinky Palermo: Retrospective 1964–1977*, op. cit., 27.

29 Ibid., 28.

30 Jaleh Mansoor, 'Palermo's *To the People of New York City*' in *Palermo: To the People*, op. cit., 183.

31 Ibid., 185.

32 Unfortunately, access to most of his late works has long been blocked by a collector whose refusal to make these works (and others) available has for years hindered Palermo studies.

33 See Gerhard Storck, 'Zur Ausstellungskonzeption', in *Palermo: Stoffbilder 1966–1972* (Krefeld: Kaiser Wilhelm Museum/Museum Haus Lange, 1977) 7.

34 A primary motivation for residing at least part-time in Manhattan, he wrote in his 1974 application for an extension to his visa, was to 'exchange ideas with American artists' (Palermo, application form to US Immigration and Naturalization Service, December 1974; published in *Blinky Palermo, 1964–1976* [Munich: Galerie-Verein, 1980] 114). A further incentive was the fact that he would continue to benefit from the support of the Heiner Friedrich Gallery, since its founder had decided to emigrate and establish a branch of his operations in Manhattan at the same moment.

35 As he struggled to free himself from the orbit of Beuys, his dominating teacher, he was drawn increasingly into a circle of painters, in particular Polke and Richter, with whom he became somewhat identified in the mid 1960s, when he embarked upon the Cloth Pictures. While he shopped for bolts of fabric with Polke on occasion, Richter's first wife, Ema, sewed together the lengths of cloth according to his instructions. (Ema Richter, in *'To the people ...': Sprechen über Blinky Palermo*, ed. Digne M. Marcovicz [Cologne: Walther König, 2003] 109.)

36 Gerhard Richter, quoted in Robert Storr, *Gerhard Richter: Forty Years of Painting* (New York: Museum of Modern Art, 2002) 54–5. Rather than trying to answer charges that painting was outmoded or unviable, and so make it 'relevant', Palermo seems to have been largely indifferent to or accepting of abstraction's essentially apolitical character – compare, for example, his stance with the politically activist position taken by Jörg Immendorff, another erstwhile Beuys student-turned-painter.

37 Storr, *Gerhard Richter: Forty Years of Painting*, op. cit., 50.

38 See Christine Mehring, 'Light Bulbs and Monochromes: The Elective Affinities of Richter and Palermo', in *Palermo: To the People*, 45–77.

39 Richter spoke of these as the most difficult years of his professional life. See Mehring, *Blinky Palermo: Abstraction of an Era*, 185. See also Jürgen Harten, 'The Romantic Intent for Abstraction', in *Gerhard Richter. Bilder 1962–1985* (Cologne: DuMont/Kunsthalle Düsseldorf, 1986) 43.

40 This two-way relationship manifested itself again in 1976, when Palermo presented his project that used four glass panels, painting a monochrome colour field onto each. That year Richter returned to the use of glass panels in freestanding structures, which he had first explored in 1968.

41 Rorimer, 'Blinky Palermo: Objects, *Stoffbilder*, Wall Paintings', op. cit., 35.

42 Palermo, quoted in *Palermo: Bilder und Objekte* (Wuppertal: Von der Heydt-Museum, 1968) n.p.; reprinted in *Circa 1968* (Porto: Museu Serralves, 1999) 498.

Lynne Cooke, 'Palermo's Porosity', in *Blinky Palermo: Retrospective 1964–1977* (New York: Dia Art Foundation/New Haven and London: Yale University Press, 2010) 11–23.

Catherine Quéloz
At the Crossroads of the Disciplines:
An Economy of Regard//1991

The work of Günther Förg projects the spectator into a multidimensional space in which a variety of practices (painting, photography, sculpture, architecture) constitute parts of a single but divided and fragmentary text. The interaction of these traditional practices, which were long restricted to their respective fields, upsets the viewers' habits, making them question the contents of the visual representation – realist, symbolic, abstract – and wonder about the meaning implied by this mixing of different codes.

By emphasizing the discontinuous, the allegorical and the mechanical, this work signals the dissolution of the modernist paradigm, while at the same time its iconography recalls the richness of its contradictions.

The Limits of Painting

Painting, which lies at the origin of Förg's explorations, still plays a fundamental role in his multidisciplinary work. When Förg started out in the 1970s, abstract painting, with its considerable debt to the reductive theory of Clement Greenberg,[1] had reached a dead end. As Yve-Alain Bois has pointed out, Robert Ryman was probably the artist who most fully explored both the limitations and the possibilities of getting beyond this position:

> It is only with Robert Ryman that the theoretical demonstration of the historical position of painting as an exceptional realm of manual mastery has been carried to its full extent and, as it were, deconstructed. By his dissection of the gesture, or of the pictorial raw material, and by his (non-stylistic) analysis of the stroke, Ryman produces a kind of dissolution of the relationship between the trace and its organic referent. The body of the artist moves towards the condition of photography: the division of labour is interiorized. What is at stake for Ryman is no longer affirming the uniqueness of the pictorial mode of production vis-à-vis the general mode of production of commodities, but decomposing it mechanically. ... he is ... the guardian of the tomb of modernist painting, at once aware of the end and also knowing the impossibility of arriving at it without working it through.[2]

In his earliest works, Förg, too, explores the limits of painting. Very soon on, he tries to induce a state of crisis by introducing problematics characteristic of other disciplines, thus contesting the essential specificity of modernism. Förg's first paintings (monochromes or duochromes) are done on various supports

(muslin, wood, copper, lead, aluminium). They are often conceived in several parts and in series, or presented as a sequence. The serial, repetitive aspect and this diversity of materials used as support denote an interest in the construction and installation of the object, at the expense of gesture or texture, and undermine the notions of uniqueness and technical accomplishment. The paint, oil or acrylic, is usually thinly and rapidly applied, contenting itself with covering a surface rather than creating a form. The imprecision of the boundaries between colours reinforces the impression that these are hastily executed works produced in an almost mechanical manner, one after the other. It is therefore impossible to consider this pictorial trace as the result of an expressionist or stylistic intention, or to associate it with the exploratory diversity of procedures used by Ryman, despite certain affinities.

In Förg's work, be it his bronze or copper reliefs (which bear the rough, uncontrolled trace of his hands and fingers: scratches, gashes) or his paintings, gesture can never be understood as the desire to affirm the uniqueness of craft in opposition to mechanical modes of production. Indeed, in the case of the bronzes, the artist's intervention is not direct, having been realized in the negative in plaster, then moulded: the process of production (which functions on the same principle as photography) attenuates the expressionist element.[3] By its mechanical character (rapidity of execution, seriality) and, above all, by its indexical quality, which makes it dependent upon real space, the painting tends to associate with, rather than to oppose, the functioning, the space and the temporal quality of photography.

The individual paintings do not escape this index-like quality[4] with which Förg has succeeded in endowing his work. Since painting has no internal logic, since it is not understood as a flat, continuous, limited, detachable surface, it is dependent upon its environment. With Förg, indeed, individual paintings are understood as initiators, as empty signs which are filled with meaning only when physically juxtaposed with an external referent or object: the rest of the installation, the series, the place, the observer.

In the 1960s, abstract painting aspired to a kind of logical investigation of pictorial codes and, in doing so, became associated with the convention of painting as a continuous present which both supports the work conceptually and is understood as its content. Here, we are confronted with the expulsion of convention. The code of the photographic message ('codeless') replaces that of painting. For the same reasons, the boundaries between painting and sculpture, painting and architecture become extremely tenuous.

The Conditions of Photography
Despite the dramatic changes in signification around 1910, due to two principal

events (the development of an abstract pictorial language and the expansion of photographic practices), nothing seems more diametrically opposed than photography and abstract painting – the first depending entirely upon the world as the source of its images, the other eschewing this world and the images that it provides. However, as we have seen, Förg's painting does not avoid the world around it: on the contrary, the conditions characteristic of photography seem to overflow, implacably, into abstract painting, so much so that photography can be said to become progressively the operative model for abstraction.

Certainly, from the 1980 onwards, Förg's research and reflections on painting led him to begin – at first fairly crudely – to combine the two practices. In his first works, he combines photography with a *Stoffbild* (a pre-prepared red canvas bought and set directly on a stretcher), an object which refers us to the dual limits of abstract painting – the monochrome and the unmarked canvas – while avoiding any reference to the act of painting. Later, when he mixes painting and photography (1982), he uses an aluminium support, parts of which he leaves visible, and whose reflective surface integrates the space around it, reflecting the colours of its setting, the silhouette of its observers. This phenomenon relates pictorial and photographic images in the same opacity; symbolically, the spectator becomes the subject of the image.

At the same time as he abandoned traditional supports, Förg decided to intervene directly on the wall. His first mural paintings date from 1978 and appear as marks made on architecture. The colours of these wall paintings, as well as the internal divisions between the colours, are brought out by an external situation – a situation in the world – in this case, the architecture of a given place, which they simply record (division, flatness). The effect of the work is to produce a relation to its subject – architecture – whose nature is that of a mark, a trace. The painting thus becomes a sign, related to its referent in a physical way; this is precisely the quality of photography.

The wall paintings have nothing to do with the tradition of work *in situ* to which one might be tempted to compare them. They do not produce any particular discourse on the predetermination, recuperation and utilization of the institutional space, or on the production and consumption of art. They do not refer to the specificity of a given place but rather introduce a notion of space in the wider, generic sense: a utilitarian space, to move about in, pass through, exchange in: an architecture.

Architectural Perspectives

Considered in terms of installations, the materials used as supports for the painting or photography suddenly take on a strategic importance in the architectonic qualities of the work. The weighty reality of the paintings' supports

(copper, lead, bronze) prevents us from considering the painting as an image. As for the photographic image, initially set on a reflective support – aluminium – and later placed under glass, it functions as an imprecise mirror which records and superimposes its surroundings on the image. These effects disturb our reading, prevent our eyes from isolating the image, from reading it independently of its context. Within this critical approach, photographic representation (just like pictorial representation) is considered as an element of reality rather than as something transparent to reality. In using these means to cast doubt on the position of dominance usually conferred on the beholder, Förg questions the position of the subject in photography. The play of reflections on the glass sometimes multiplies the effects of the image, appearing as the metaphor of the phantasms and detours of memory which slip into and infiltrate the act of looking. Thus, visual representation, be it realist, symbolic or abstract, is never immediate or fixed. The image refuses to lend itself to a frontal reading.

This snapshot quality is apparent in the framing and reflections (reflection of the photographer), to which can be added, in famous architectural settings, a temporal sense that is rarely present in documentary photography. Details (vegetation, traces of decay, neglect) accentuate the disparity between the time of the object, the time of the monument, and that of the spectator. This element, which adds an almost 'private' (but not subjective) quality to the images, forestalls any emblematic reading. The visual properties, the grain of materials and the structures of space seem more important than objects or historical references. And if the manner of looking embodied in the portraits (mainly portraits of women) accentuates the intimate nature of the undertaking, it above all questions the social and sexual position of the beholder. Should woman be content to remain the object of our gaze? Might she not accede to the position of subject?

The work is sometimes haunted by the first names of women, and by the signatures of famous architects. One notes a particular interest in the work of Terragni (who, by playing with the materials of architecture, managed to integrate conceptual, structural and symbolic forms) and in the contrast between structural rigour and the aleatory play of light in Mies van der Rohe, whose Barcelona pavilion has been described by Kenneth Frampton as follows:

Contemporary photographs reveal the ambivalent and ineffable quality of its spatial and material form. From these records we may see that certain displacements in its volume were brought about by illusory surface readings such as that effected by the use of green tinted glass screens to emerge as the mirror equivalents of the main bounding planes. These planes, faced in polished green Tinian marble, in their turn reflected the highlights of the chromium vertical glazing bars holding the glass in place.[5]

As in the Renaissance *camera obscura*, photographic representation implies both a frame – a scene or an object – and a point of view. And one can see that Förg's work, like that of the photographer or of certain architects, is organized according to an economy of regard. Rigorous geometrical structure is deconstructed in the play of light and materials. Architecture, like painting, sculpture or photography, can give the beholder either a unique, fixed position (as in the panoptic view evident in photographs of groups of children) or, to the contrary, a mobile position (as in Mies) which fragments, perturbs given structures, opening itself to the unforeseen and to the viewer's own subjectivity.

Just as the Barcelona pavilion describes through the filter of photography, so Förg's work is always to be read through other practices. This strategy emphasizes the rupture between signifier and signified, encouraging shifts of meaning and syncopation in the experience of the subject.

1 Greenberg describes the essence of modernism as residing in the use of a discipline's characteristic methods in order to criticize that discipline, and this not to subvert the discipline, but to anchor it more solidly in its sphere of competence. (See Clement Greenberg. 'Modernist Painting', in *Arts Yearbook IV*, 1961 and in Gregory Battock, ed., *The New Art: A Critical Anthology* (New York: Dutton, 1973) 66–77.

2 Yve-Alain Bois: 'Painting: The Task of Mourning', in *Endgame: Reference and Simulation in Recent Painting and Sculpture* (Boston: Institute of Contemporary Art/Cambridge, Massachusetts: The MIT Press, 1986) 31.

3 Concerning the question of the unique and the multiple, it is interesting to note that Förg recently produced a series of monotypes (by definition, a unique reproduction) with three copies of each one.

4 Charles S. Peirce describes an index as a 'sign, or representation, which refers to its object not so much because of any similarity or analogy with it, nor because it is associated with general characters which that object happens to possess, as because it is in dynamical (including spatial) connection with the individual object, on the one hand, and with the senses or memory of the person for whom it serves as a sign, on the other hand.' In J.M. Baldwin, ed., *Dictionary of Philosophy and Psychology*, vol. I (1902) (Gloucester, Massachusetts: Peter Smith, 1960) 530.

5 Kenneth Frampton, *Modern Architecture: A Critical History* (London: Thames & Hudson, 1985) 164–5.

Catherine Quéloz, 'At the Crossroads of Disciplines: An Economy of Regard', in *Günther Förg* (Paris: Musée d'art moderne de la Ville de Paris, 1991) 37–9.

we_°_°_°_°_°_

°_°_°_°_°_°_°_°_°_°_°_° enter a world

°°_°_° where_°°°°_ °_°technology°_°_°_°_°_°_

becomes_°_°_°_°_°_°autonomous from nature

°°_°_°°°° °°°_°_°°° _°_°_and our environment_°_°_itself

becomes abstract_°°°°°°°°°°°_

 °_°_°_both
visually_°_°_°°°_°_°_and _°°physically_°°

 °°_°_°_°°°°°° _°_°°_°_°°_

 °_°_°_°_°_°_°_°_°_°_°_°_°_°_°_°_°

°° °_°

Peter Halley, 'Abstraction and Culture', 1991

ECONOMIC ABSTRACTION

Fredric Jameson
The End of Temporality//2003

After the end of history, what?[1] No further beginnings being foreseen, it can only be the end of something else. But modernism already ended some time ago and with it, presumably, time itself, as it was widely rumoured that space was supposed to replace time in the general ontological scheme of things. At the very least, time had become a non-person and people stopped writing about it. The novelists and poets gave it up under the entirely plausible assumption that it had been largely covered by Proust, Mann, Virginia Woolf and T.S. Eliot and offered few further chances of literary advancement. The philosophers also dropped it on the grounds that although Bergson remained a dead letter, Heidegger was still publishing a posthumous volume a year on the topic. And as for the mountain of secondary literature in both disciplines, to scale it once again seemed a rather old-fashioned thing to do with your life. *Was aber war die Zeit?*

What is time? A secret – insubstantial and omnipotent. A prerequisite of the external world, a motion intermingled and fused with bodies existing and moving in space. But would there be no time, if there were no motion? No motion, if there were no time? What a question! Is time a function of space? Or vice versa? Or are the two identical? An even bigger question! Time is active, by nature it is much like a verb, it both 'ripens' and 'brings forth'. And what does it bring forth? Change! Now is not then, here is not there – for in both cases motion lies in between. But since we measure time by a circular motion closed in on itself, we could just as easily say that its motion and change are rest and stagnation – for the then is constantly repeated in the now, the there in the here … Hans Castorp turned these sorts of questions over and over in his own mind.[2]

In any case, neither phenomenology nor Thomas Mann offered promising starting points for anything calculated to fire the imagination.

What clearly did so, however, was the spatial alternative. Statistics on the volume of books on space are as alarming as the birthrate of your hereditary enemy.[3] The rise of the intellectual stock of architecture accompanied the decline of belles lettres like a lengthening shadow; the opening of any new signature building attracted more visitors and media attention than the newly published translation of the latest unknown Nobel Prize winner. I would like to see a match between Seamus Heaney and Frank Gehry, but it is at least certain that postmodern museums have become at least as popular as the equally postmodern new sports stadia and that nobody reads Valéry's essays any more, who talked about space beautifully from a temporal point of view but in long sentences.

So the dictum that time was the dominant of the modern (or of modernism) and space of the postmodern means something thematic and empirical all at once: what we do, according to the newspapers and the Amazon statistics, and what we call what we are doing. I don't see how we can avoid identifying an epochal change here, and it affects investments (art galleries, building commissions) as much as the more ethereal things also called values. It can be seen, for example, in what has happened to what used to be called the *système des beaux arts* or the hierarchy of the aesthetic ideal. In the older (modernist) framework, the commanding heights were those of poetry or poetic language, whose 'purity' and aesthetic autonomy set an example for the other arts and inspired Clement Greenberg's paradigmatic theorization of painting.

The 'system' of the postmodern (which claims not to have one) is uncodified and harder to detect, but I suspect it culminates in the experience of the space of the city itself – the renovated and gentrified post-urban city, the new crowds and masses of the new streets – as well as from a music that has been spatialized by way of its performance frameworks as well as of its delivery systems, the various boomboxes and Walkmans that inflect the consumption of musical sound into a production and an appropriation of sonorous space as such. As for the image, its function as the omnipresent raw material of our cultural ecosystem would require an examination of the promotion of photography – henceforth called postmodern photography – from a poor relation of easel painting into a major art form in this new system of things.

But such descriptions are clearly predicated on the operative dualism, the alleged historical existence, of the two alternatives. The moderns were obsessed with the secret of time, the postmoderns with that of space, the 'secret' being no doubt what André Malraux called the Absolute. We can observe a curious slippage in such investigations, even when philosophy gets its hands on them. They begin by thinking they want to know what time is and end up trying more modestly to describe it by way of what Whitman called 'language experiments' in the various media. So we have 'renderings' of time from Gertrude Stein to Husserl, from Mahler to Le Corbusier (who thought of his static structures as so many 'trajectories'). We cannot say that any of these attempts is less misguided than the more obvious failures of analytic cubism or Siegfried Giedeon's 'relativity aesthetic'.[4] Maybe all we do need to say is contained in Derrida's laconic epitaph on the Aristotelian philosophy of temporality: 'In a sense, it is always too late to talk about time.'[5]

Can we do any better with space? The stakes are evidently different; time governs the realm of interiority, in which both subjectivity and logic, the private and the epistemological, self-consciousness and desire, are to be found. Space, as the realm of exteriority, includes cities and globalization, but also other people and nature. It is not so clear that language always falls under the aegis of time

(we busily name the objects of the spatial realm, for example), while as for sight the inner light and literal as well as figurative reflection are well-known categories of introspection. Indeed, why separate the two at all? Did not Kant teach us that space and time are both *a priori* conditions of our experience or perception, neither one to be gazed at with the naked eye and quite inseparable from each other? And did not Bakhtin wisely recombine them in his notion of the chronotope, recommending a historical account of each specific space-time continuum as it jelled or crystallized? But it is not so easy to be moderate or sensible in the force field of modernism, where Time and Space are at war in a Homeric combat. Indeed, each one, as Hegel said about something else, desires the death of the other.

They even took Karen Karstedt to the Bioscope Theater in Platz one afternoon, because that was something she truly enjoyed. Being used to only the purest air, they felt ill at ease in the bad air that weighed heavily in their lungs and clouded their minds in a murky fog, while up ahead on the screen life flickered before their smarting eyes – all sorts of life, chopped up in hurried, diverting scraps that leapt into fidgety action, lingered, and twitched out of sight in alarm, to the accompaniment of trivial music, which offered present rhythms to match vanishing phantoms from the past and which despite limited means ran the gamut of solemnity, pomposity, passion, savagery and cooing sensuality ...

The actors who had been cast in the play they had just seen had long since been scattered to the winds; they had watched only phantoms, whose deeds had been reduced to a million photographs brought into focus for the briefest of moments so that, as often as one liked, they could then be given back to the element of time as a series of blinking flashes. Once the illusion was over, there was something repulsive about the crowd's nerveless silence. Hands lay impotent before the void. People rubbed their eyes, stared straight ahead, felt embarrassed by the brightness and demanded the return of the dark, so that they could again watch things, whose time had passed, come to pass again, tricked out with music and transplanted into new time.[6]

Under these circumstances, the best we can do in the way of synthesis is to alert ourselves to the deformation of space when observed from the standpoint of time, of time when observed from the standpoint of space. The great structuralist formula itself – the distinction between the synchronic and the diachronic – may be offered as an illustration of the second deformation and is always accompanied by a label that warns us not to confuse the diachronic with time and history nor to imagine that the synchronic is static or the mere present, warnings most often as timely as they are ineffective.

Even if such a shift from a temporal to a spatial dominant be acknowledged, however, it would seem momentous enough to demand further explanation; the causal or historical hypotheses are here neither evident nor plausible. Why should the great age of Western imperialism, for example beginning with the conference of Berlin in 1885, more or less contemporaneous with the flourishing of what we call modern art – be any less spatially impressionable than that of globalization today? By much the same token, why should the stressed and harried followers of today's stock market listings be any less temporally sensitive than the residents of the first great industrial cities?

I want to suggest an account in terms of something like existential uneven development; it fleshes out the proposition that modernism is to be grasped as a culture of incomplete modernization and links that situation to the proposition about modernism's temporal dominant. The argument was suggested by Arno Mayer's *Persistence of the Old Regime*, which documents a counterintuitive lag in the modernization of Europe, where, even at the turn of the last century and the putative heyday of high modernism, only a minute percentage of the social and physical space of the West could be considered either fully modern in technology or production or substantially bourgeois in its class culture.[7] These twin developments were not completed in most European countries until the end of World War II.

It is an astonishing revision, which demands the correction of many of our historical stereotypes; in the matter that concerns us here, it will therefore be in the area of an only partially industrialized and defeudalized social order that we have to explain the emergence of the various modernisms. I want to conjecture that the protagonists of those aesthetic and philosophical revolutions were people who still lived in two distinct worlds simultaneously; born in those agricultural villages we still sometimes characterize as mediaeval or pre-modern, they developed their vocations in the new urban agglomerations with their radically distinct and 'modern' spaces and temporalities. The sensitivity to deep time in the moderns then registers this comparatist perception of the two socio-economic temporalities, which the first modernists had to negotiate in their own lived experience. By the same token, when the pre-modern vanishes, when the peasantry shrinks to a picturesque remnant, when suburbs replace the villages and modernity reigns triumphant and homogeneous over all space, then the very sense of an alternate temporality disappears as well, and postmodern generations are dispossessed (without even knowing it) of any differential sense of that deep time the first moderns sought to inscribe in their writing.

It is an explanation, however, which does not yet include the macro-economic level of the world system and its temporalities. Imperialism and colonization must evidently have their functional relationship to the uneven development of

town and country in the metropolis itself, without imposing any particularly obvious priority of time over space. And as for globalization, it was precisely on the strength of some new spatial dominant and some new experience of spatiality that its structural distinction from an older imperialism had been argued in the first place.

But one of the fundamental determinants of that new experience can be found in the way imperialism masks and conceals the nature of its system, a structural camouflage to which the 'communicational rationality' of globalization no longer has to resort (its opacities are of a different type altogether). For one thing, the imperial powers of the older system do not want to know about their colonies or about the violence and exploitation on which their own prosperity is founded, nor do they wish to be forced into any recognition of the multitudinous others hidden away beneath the language and stereotypes, the subhuman categories, of colonial racism.[8] 'Not so very long ago', remarked Jean-Paul Sartre in a famous phrase, 'the earth numbered two thousand million inhabitants: five hundred million men, and one thousand five hundred million natives'.[9] Later on, I will argue that the momentous event of decolonization, the 'transformation' of these natives into men, is a fundamental determinant of postmodernity; the gendered term also reminds us that this story could also be told in terms of the other half of the human race and of the liberation and tendential recognition of women in this same period.

As far as modernism is concerned, however, the epistemological separation of colony from metropolis, the systematic occultation of the colony from metropolis, the systematic occultation of the colonial labour on which imperial prosperity is based,[10] results in a situation in which (again using a Hegelian formula) the truth of metropolitan experience is not visible in the daily life of the metropolis itself; it lies outside the immediate space of Europe, in the colonies. The existential *realia* of the metropolis are thus severed from the cognitive map that would alone lend them coherence and re-establish relationships of meaning and of its production. The new daily life is thereby rendered at best enigmatic and at its most extreme absurd (in the philosophical sense), while abstract knowledge of the colonial situation and its worldwide economic structure necessarily remains abstract and specialized; the colonial labourers and producers have no direct experience of the 'advanced' world for which their exploitation is responsible. Modernism can be positioned as a reproduction of the abstractions to which metropolitan phenomena have been reduced at the same time that it seeks to recomplete those afterimages in a formal way and to restore (but also purely formally) something of the life and vitality, the meanings, of which they have been deprived.

If something like this faithfully characterizes the situation of modernism and

the incomplete modernization that it expresses, then it becomes clearer how that situation changes when we pass from imperialism to present-day globalization. What could not be mapped cognitively in the world of modernism now slowly brightens into the very circuits of the new transnational cybernetic. Instant information transfers suddenly suppress the space that held the colony apart from the metropolis in the modern period. Meanwhile, the economic interdependence of the world system today means that wherever one may find oneself on the globe, the position can henceforth always be coordinated with its other spaces. This kind of epistemological transparency no doubt goes hand in hand with standardization and has often been characterized as the Americanization of the world (if not its Disneyfication). The attribution is not misleadingly incorrect but omits the way in which the new system also transmits oppositional tendencies and their messages, such as the ecological movement; paradoxically, like the anti-globalization movement itself, these are political developments predicated on the damage done by globalization at the same time that they are themselves enabled by it.

At any rate, this new transparency of the postmodern world system (which resorts to new techniques of distortion by way of a suppression of history and even, as we shall see, of time and temporality itself) now also explains the shift from the abstract and initiatory forms of modernism to what look like more popular and representational kinds of art and writing (and music) in postmodernity, a shift often and widely considered to be a return to realism and figuration. But I think that postmodernism is not really figurative in any meaningful realist sense, or at least that it is now a realism of the image rather than of the object, and has more to do with the transformation of the figure into a logo than with the conquest of new 'realistic' and representational languages. It is thus a realism of image or spectacle society, if you will, and a symptom of the very system it represents in the first place.

Yet these forms are clearly more popular and democratic (or demotic), more accessible, than the older hermetic 'high modernisms', and this is perfectly consistent with the thesis of an immense expansion of culture and of cultural literacy and the cultural realm itself in the postmodern period. The place of culture and its consumption is radically different in the new global dispensation than it was in the modernist period, and one can register a different kind of transnational flow of imagery and music, as well as of information, along the networks of a new world system.

So far, however, we have not yet set in place the mediations that are capable of linking up these two levels of the individual subjectivities (of the artists as well as of the dwellers in the everyday) and of the larger macro systems as those move from an old-fashioned colonial administration of vast territories by

means of armies and bureaucracies (essentially by the Europeans and to a lesser extent by the United States and Japan) to some new organization of power and exploitation in the form of transnational corporations and banks and by way of capital investment. Each of these descriptive levels contains its own structural contradictions, but there are other tensions and dissonances that emerge only when we seek to relate the two. This is the sense in which the dialectic of the local and the global has seemed to displace traditional oppositions between the public and the private, if not (in the era of the 'death of the subject') those most ancient and classical ones of all, between the particular and the universal, if not indeed between the subject and the object itself.

Such mediations are presentational techniques fully as much as they are empirical facts; they furnish the tropes for innumerable postmodern histories or newer historical narratives and are to be found in abundance in the varied investigations of what is called cultural studies. We might, for example, have dramatized the waning of concepts and representations of production by way of the displacement of old-fashioned industrial labour by the newer cybernetic kind, a convulsive shift in our cognitive mapping of reality that tends to deprive people of their sense of making or producing that reality, to confront them with the fact of pre-existing circuits without agency, and to condemn them to a world of sheer passive reception. To insist on the mediation of the labour process is thus to dispel the banal and apolitical conception of a service economy but also to insist on the epistemological and cultural consequences of this shift, consequences insufficiently foregrounded by the current language of some opposition between 'Fordism' and a newly 'flexible' capitalism.

For myself, I have long felt that one of the most effective mediations to be constructed between the cultures of postmodernity and the infrastructure of late capitalist globalization was to be found in the peculiar phenomenon of finance capital, as that has been revived and transformed in present-day society where for most people it seems to loom larger than production itself, at least on their television screens.[11] Finance capital suggests a new type of abstraction, in which on the one hand money is sublimated into sheer number, and on the other hand a new kind of value emerges, which seems to have little enough to do with the old-fashioned value of firms and factories or of their products and their marketability. The recent business failures like Enron seem to suggest that the value of a given stock cannot long be separated from the profitability of the firm it is supposed to 'represent' or express, but I think they demonstrate the opposite, that under the conditions of finance capital stock value has a decidedly semi-autonomous status with respect to its nominal company and that, in any case, postmodern 'profitability' is a new category, dependent on all kinds of conditions unrelated to the product itself, such as the downsizing of employees at the

demand of banks and investment institutions and the draining of the company's assets (sometimes fatally) in order to inflate dividends.

This new kind of abstraction can be correlated with postmodernism in art along the lines suggested earlier, namely, that the formal abstractions of the modernist period – which corresponded to the dialectic of value of an older monopoly stage of capitalism – are to be radically distinguished from the less palpable abstractions of the image or the logo, which operate with something of the autonomy of the values of present-day finance capital. It is a distinction between an object and its expression and an object whose expression has in fact virtually become another object in its own right.

Most significant for us in the present context, however, is the impact of the new value abstractions on everyday life and lived experience, and this is a modification best articulated in terms of temporality (rather than image theory). For the dynamics of the stock market need to be disentangled from the older cyclical rhythms of capitalism generally: boom and bust, accumulation of inventory, liquidation and so forth, a process with which everyone is familiar and that imprints a kind of generational rhythm on individual life. This process, which also creates the impression of a political alternation between Left and Right, between dynamism and conservatism or reaction, is of course to be sharply distinguished from the far longer cycles of the so-called Kondratiev waves, fifty or sixty-year periods that are as it were the systole and diastole of the system's fundamental contradiction (and that are, by virtue of their very dimensions, less apparent to those biological individuals we also are). From both these temporal cycles, then, is to be distinguished the newer process of the consumption of investment as such, the anxious daily consultation of the listings, deliberations with or without your broker, selling off, taking a gamble on something as yet untested (one imagines a Whitmanesque list opening up, expansive, celebratory, revelling in the ideology of democratic 'participation'). The narrowing and the urgency of the time frame need to be underscored here and the way in which a novel and more universal microtemporality accompanies and as it were condenses the rhythms of quarterly 'profit taking' (and is itself intensified in periods of crisis and uncertainty). The futures of the stock market – whether in the literal and traditional sense of investments in crops and other seasonal goods not yet in existence or in the more figurative sense of derivatives and speculations on the company reports and the exchange listings – these 'futures' come to be deeply intertwined with the way we live our own individual and collective futures generally, in a period in which careers are no longer stable and lay-offs a seemingly inevitable hazard of professional and managerial as well as proletarian levels of society.

By the same token, the new rhythms are transmitted to cultural production in the form of the narratives we consume and the stories we tell ourselves, about

our history fully as much as about our individual experience. It is scarcely surprising that the historical past has diminished accordingly; to be sure, the recent past is always the most distant in the mind's eye of the historical observer, but deficiencies in the high school history books are scarcely enough to account for the alarming rate at which a somewhat more remote past is in the process of being evacuated – the media's 'exhaustion' of its raw material of events and information is not alien to the process. Any modification of the past, no matter how minute, will then inevitably determine a reorganization of the future, but the keenest observers of the immediate post-war period (in the moment of what may now be called late modernism)[12] can scarcely have anticipated that wholesale liquidation of futurity of which the revival of Hegel's 'end of history' was only an intellectual symptom. Confusion about the future of capitalism – compounded by a confidence in technological progress beclouded by intermittent certainties of catastrophe and disaster – is at least as old as the late nineteenth century, but few periods have proved as incapable of framing immediate alternatives for themselves, let alone of imagining those great utopias that have occasionally broken on the status quo like a sunburst. Yet a little thought suggests that it is scarcely fair to expect long-term projections or the deep breath of great collective projects from minds trained in the well-nigh synchronic habits of zero-sum calculation and of keeping an eye on profits.

Such propositions seem to imply or posit a fundamental gap or dialectical leap between older and newer forms of communication. Leaving aside the question of technological determinism, there is still an argument to be made about the radical distinction between informational conduits from the telephone back to the semaphore or the smoke signal, whose infrastructure can be found as deep as the astonishing reaches of the Neolithic trade routes and the cybernetic technologies of the present, whose novelties and innovations play a basic causal role in any definition of the postmodern (on any social level). I do think it is possible to devise a phenomenological description of the communicational act that registers such differences and their structure. On the telephone people can no doubt give tips on future developments and place tentative orders, but these messages must still coexist with the body of paper itself – the bills of exchange or lading, the weight of documents, the very bundles of paper money itself, as the last makes its cumbersome way laboriously around the world. Speculation on such bills is another matter; it is no longer a question of buying things but rather of juggling whole labour forces. One can electronically substitute one entire national working class for another, halfway around the globe, wiping out industry after industry in the home country and dissipating accumulated months of value-producing labour overnight. By the same token, the very bills themselves can quickly be reduced to worthless scraps by trading against the currency in

question and reducing its former value to the approximate zero of undesirability on the world's currency markets. But this is something new and it again documents the wholesale replacement of the old subject-object relationship, the logic of reference, with a new one, which might better be called the semiotic or, indeed, the logic of the signifier.

I put it this way to underscore another fundamental symptom of the process, which is the projection out of the new media of a whole new set of ideologies appropriate to their dynamics, namely, the new communicational and linguistic or semiotic philosophies that have in the twentieth century seemed to consign several thousand years of traditional philosophical history to obsolescence on the grounds that it left out the centrality of language. This is probably not the right way to handle the matter of truth and error in philosophy, but for the moment it is sufficient to shake ourselves into a certain (truly philosophical) wonderment at the extraordinary proliferation of theories of communication, which (no doubt, like everything else, from Nietzsche on) have come to dominate official thinking today, not merely in philosophy, but also in sociology, in political philosophy, and perhaps even in biology and evolution, with their notions of DNA as a code and of the virus as a messenger.

At least, indeed, from the first stirrings of the notion of intersubjectivity in the 1920s all the way to Habermas and the full-blown structuralisms,[13] what I will call the ideology of communication has come to blanket the field and to discredit any philosophical representations that fail to acknowledge the primacy and uniqueness of language, the speech act, or the communicational exchange. Yet any linguistic philosophy ought to be in an excellent position to grasp the purely representational (dare one even say aesthetic) nature of philosophy and its systems and propositions and minimally to conclude that they cannot exactly be correct or incorrect. One would not want to deny its moment of truth to the communicational philosophies either, provided it is understood that they have discovered those truths as the latter were in the process of historical development and emergence.

Communicationality has emerged as the central fact of world society in the course of a historical process, the very one to which we have been referring here, namely, the transfiguration of capitalism into its third, late or postmodern stage. What one must say is not that ideologies of communication are somehow true in the absolute (or by virtue of 'human nature', as the speaking animal) but rather that they have become true historically to the degree to which contemporary capitalism is increasingly organized on a communicational basis.

But to position language at the centre of things is also to foreground temporality, for whether one comes at it from the sentence or the speech act, from presence or the coeval, from comprehension or the transmission of signs and signals, temporality is not merely presupposed but becomes the ultimate

object or ground of analysis. What I have here been calling space therefore risks becoming a misnomer. Always and everywhere we have rather to do with something that happens to time; or perhaps, as space is mute and time loquacious, we are able to make an approach to spatiality only by way of what it does to time.

Predictably, the 'end of temporality' is one of those things, and we need to begin the inventory of its forms. I read into the record, for example, the reaction of an astute listener to an earlier version of these speculations: 'In Japan', she said, 'the cell phone has abolished the schedule and the time of day. We don't make appointments any more, we simply call people whenever we wake up'. Older habits of clock time are thereby eclipsed, the 'signifier' of the single day called into question; some new non-chronological and non-temporal pattern of immediacies comes into being. We might have also mentioned the streamlining of television news whereby, apparently for the benefit of a new youth public, current events are provided throughout the program in a 'crawl' that summarizes the latest current events, so precious time need not be wasted in waiting for the coverage in question. Impatience is probably not the right word for this promotion and transfiguration of the synchronic (any more than entertainment has much explanatory value when dealing with the appeal of mass culture). But the phenomenon does redirect us to the existential level of the matter, which in contemporary theory takes the form of the study of the quotidian or of everyday life.

During the structuralist period, the existential, the realm of so-called lived experience (*expérience vécue*), was deliberately displaced and marginalized, if not discredited altogether, as an essentially 'humanist' inquiry, whose organizing categories, from 'alienation' to 'experience' itself, were philosophically flawed and complicitous with the various ideologies of the subject, the ego and consciousness. Structuralism has come and gone; this particular debate has dried up altogether (along with the very denunciation of humanism itself, which could still come in handy from time to time) without having produced much in the way of conceptual results, as though in the meantime experience itself (or what used to be meant by it in reality) had also evaporated.

Yet Althusser had one suggestive thing to say about time, which may be retained as a productive starting point (whatever consequences it was meant to have in his own arguments). This is the proposition that each mode of production generates its own unique and specific temporality;[14] the premise no doubt posits the primacy of labour time, implying that the temporality of a given type of production has a more general influence on the way time is conceptualized and lived in the rest of the society. It is a proposition we are probably generally inclined to take for granted when it comes to the difference between an agricultural society and an industrial one, but the principle here invites us to subtler differentiations for a whole range of distinct modes of production and, in

particular, to construct mediations between the labour process generally and the more specific 'structures of feeling' (to use Raymond Williams' inspired formula) that can be detected at work in cultural expressions and everyday life.

The Althusserian suggestion is, to be sure, dangerous to the very degree to which it promotes a lapse into that very historicism he was concerned to denounce, some Spenglerian conflation of the various levels of a given historical period, in which a specific form of temporality becomes the hallmark of everything from architecture to statecraft, from mathematics to artistic style. Rather than a period style, therefore, it seems more desirable to stage the 'end of temporality' as a situation faced by postmodernity in general and to which its artists and subjects are obliged to respond in a variety of ways. This situation has been characterized as a dramatic and alarming shrinkage of existential time and the reduction to a present that hardly qualifies as such any longer, given the virtual effacement of that past and future that can alone define a present in the first place.

We can grasp this development more dramatically by thinking our way back to an age in which it was still possible to conceive of an individual (or existential) life as a biographical destiny. Destiny is to be sure something you can only perceive from the outside of a life, whence the idea, classically formulated by Mallarmé, that existence only becomes a life or destiny when it is ended or completed: 'Tel qu'en Lui-même enfin l'éternité le change', as the poet put it in his evocation of a particularly blighted destiny.[15] Yet it is doubtful whether antiquity itself registered this radical transformation from the being-for-itself to the being-for-other-people (to use Sartrean terminology), from personal consciousness to the alienation of destiny. The Greeks seem to have felt death more as a dialectical passage from quantity to quality:

Then learn that mortal man must always look to his ending,
And none can be happy until that day when he carries
His happiness down to the grave in peace.[16]

And perhaps the Christian insistence on the determining effect of the final moment (as in Dante) reflected something of the same sense of the belated unification of life and fate or destiny.

But save for extraordinary moments of violence and irony – such as the great political assassinations beloved of the media – my own feeling is that we do not live life in this classical fashion any longer. Whether it was ever authentic to see one's self as shaped by fate, whether Athenian tragedies that coordinate a blinding present of time with a revelation of destiny are to be taken as signs of a relationship to Being we ought to envy, modern existentialism has certainly taught a very different lesson; its insistence on our temporal imprisonment in the

present discredits ideas of destiny or fate and renders the ancient view of biography alien to us. Perhaps we have come to associate the classical perspective with the violence and brevity of life in the ancient city-state, or perhaps our own attitudes on the subject are conditioned by the modern American concealment and sanitization of death. At any rate, this shift in conceptions of destiny and existence seems sufficient to qualify modern existentialism – the sense of a unique subjectivity and a unique existence in the present – as one plausible beginning for what we will characterize as the reduction to the present in postmodernity.

But the function of this existential reduction was still a relatively positive and progressive one in the modern period, and the account of existentialism in terms of death is to that degree a misleading one, despite Heidegger's (and Nazism's) formation in the carnage of World War I and Sartre's relationship to the German occupation of France in World War II. What the innumerable holocausts of this period deconceal (to use an existential neologism) is not so much death and human finitude as rather the multiplicity of other people; it is the spectacle of that multiplicity of lives that is then starkly revealed by the horrors of the trenches or the mass executions and not some metaphysical condition to be brooded over by priests and philosophers or impressionable adolescents.

This is why we must link the positive political content of modern existentialism with demography rather than with modern warfare and must identify its fundamental moment of truth not so much in the slaughter of the world wars as in the movement of decolonization that followed them and that suddenly released an explosion of otherness unparalleled in human history. Here too no doubt the first experience of the masses of the industrial big cities offered a foreshadowing of this world-historical turning, yet those masses (a nation within the nation, as Disraeli famously called them) were still contained and concealed behind reassuring categories of caste and class, just as the subsequent incorporation of foreign colonies can be made acceptable in the mind of the colonizers by a variety of categories of race and biological inferiority. It is the explosive fact of decolonization that now sweeps these comfortable categories away and confronts me with an immense multitude of others, which I am called upon to recognize as equals or as freedoms.[17] But in our present context the point to be made has to do with the impact of this recognition on the experience of the bourgeois self, for it is the proliferation of all these innumerable others that renders vain and inconsequential my own experience of some essence I might be, some unique life or destiny that I might claim as a privilege (or indeed as a form of spiritual or existential private property). The stripping away of that form of temporality – the security of the ego or the unique personal self – is comparable to the stripping away of universals in a nominalist age; it leaves me alone with my unique present, with a present of time that is anonymous and no longer

belongs to any identifiable biographical self or private destiny. It is surely this demographic plebeianization of my subjectivity that is the achievement of existentialism and that is prolonged into the poststructuralist campaign against the so-called centred subject,[18] a progressive direction as long as the reduction to the present is conceived in this essentially political way and not translated back into interesting new forms of subjectivity as such.

But this is precisely what happens in the postmodern period, where the reformulation of depersonalization in terms of time (along with the failure of the worldwide revolutionary movements) leads to renewed privatization. I want to illustrate this process by way of two unrelated philosophical positions that both in one way or another posit a reduction to the present of which they are symptoms fully as much as theories. The first is the notion of 'ideal schizophrenia' developed by Gilles Deleuze and Félix Guattari in their *Anti-Oedipus*, the other, less well known, is that of the aesthetic of suddenness (*Plötzlichkeit*) proposed and elaborated by the distinguished German critic Karl Heinz Bohrer (editor of *Der Merkur* and a conservative polemicist of rare quality).

The presentation of the ideal schizophrenic as the 'true hero of desire' by Deleuze and Guattari is argued largely on the strength of the perpetual present attributed to this 'conceptual personage' (although Guattari was a psychiatrist, the ideal schizophrenic in question here is not the clinical patient or psychotic sufferer but rather a sublimated composite of the latter's traits, which are in any case perpetual possibilities for any form of human reality). This absolute present is then a new kind of freedom, a disengagement from the shackles of the past (the family and, in particular, Freud's conception of the Oedipus complex) as well as from those of the future (the routine of the labour process under capitalism). The schizophrenic is here opposed to the ego-fortress of the paranoid, the source of all fascisms and authoritarianisms, and thus becomes a political ideal as well as an ethical one. Deleuze tells us that he abandoned this notion of ideal schizophrenia in the face of the tragedies and devastation of the drug culture in the 1970s;[19] he replaced it by a more interestingly collective concept, the nomadic horde or guerilla band, which is of relevance here only if you diagnose anarchism as a kind of political or collective reduction to the present.

As for Deleuzian schizophrenia, however, the diagnosis is an ambiguous one and turns on the difficulty of distinguishing a critique from a projection. In so far as the freedom from time is just that reduction to the present we have been examining, what looks like a critique of our social order and the conceptualization of an alternative to it (in the *Anti-Oedipus*) turns out in reality to be the replication of one of its most fundamental tendencies. The Deleuzian notion of schizophrenia is therefore certainly a prophetic one but it is prophetic of tendencies latent within capitalism itself and not the stirrings of a radically different order capable

of replacing it. Indeed, it is questionable whether Deleuze was ever interested in theorizing any alternative social order as such.[20]

Besides the nomadic horde, I believe that another concept in the toolkit of late Deleuze can be seen as a variation on the ideal schizophrenic, and that is the enormously influential, and also relatively incomprehensible, theme of virtuality, which has been saluted as the first original philosophical conceptualization of the computer and cyberspace. This is as it were a different way of making the present self-sufficient and autonomous and independent in quite a different fashion from those dimensions of past and future from which the earlier concept also wanted to escape. But here the formative reference is to Bergson and not to the clinic; we will return to the consequences of this shift in registers in a moment. Turning now to Bohrer, whose work is quite independent of the French poststructuralist context and is inspired both by German Romanticism (and classical German philosophy) as well as by the still suspect writer on whom he wrote his first book (Ernst Jünger), his conception of 'suddenness' is an openly temporal one and posits a theory of the specificity of the aesthetic on the basis of its 'sudden' independence from past and future and of the emergence of a new temporal form beyond history. It is an argument clearly indebted to Nietzsche but just as significantly to Adorno, in whose tradition Bohrer also paradoxically stands. The concrete analyses and readings are of the greatest interest,[21] but two other points need to be made about this position that very explicitly proposes a reduction of the aesthetic to the sheerest present of time (it is not always clear whether Bohrer means thereby to characterize the aesthetic in a general way or to limit his theory to the more specifically modernist experience of art).

The first point to be made is the (equally explicit) identification of 'suddenness' or the aesthetic instant with violence as such and in particular with what we may call the aesthetic violence of Ernst Jünger. We may leave ideological judgements out of the discussion; we may even agree that this view of the aesthetic tends to translate violence into a specific form of temporality (under which a variety of non-violent phenomena may also be ranged) rather than to translate the aesthetic itself into violence after the fashion, say, of the sacrificial violence of Bataille. Still, the association of violence and an aesthetic reduction to the present will prove to be significant, as I will show in a moment.

The other remark to be made about this aesthetics, explicitly directed against history and the political historicism of writers like Walter Benjamin, is simply this: even the possibility of stepping, for an 'instant', outside of history is a possibility that is itself profoundly historical and has its properly historical preconditions.

But about both Deleuze and Bohrer in their very different ways, it is now necessary to observe the following: whenever one attempts to escape a situatedness in the past and the future or in other words to escape our being-in-

time as such, the temporal present offers a rather flimsy support and a doubtful or fragile autonomy. It thus inevitably comes to be thickened and solidified, complemented, by a rather more metaphysical backing or content, which is none other than the idea of eternity itself. Indeed, if one traces Deleuzian virtuality back to its source in Bergson and in the strangest of all modern idealistic texts, *Matter and Memory*, one finds this temporal doubling of the present explicitly identified as eternity, as what is out of time altogether. In Bohrer's case the reduction to the present becomes rather the Nietzschean one and finds its justification in the eternity of the famous eternal return. But in both these instances, getting out of time always overshoots the mark and ends up in a non-temporality I doubt we can accept today.

It is only fair to add that this position also comes in as it were a materialist version, promoted by certain contemporary feminisms and with a decidedly radical or progressive character. For the reduction to the present, from this perspective, is also a reduction to something else, something rather more material than eternity as such. Indeed, it seems clear enough that when you have nothing left but your temporal present, it follows that you also have nothing left but your own body. The reduction to the present can thus also be formulated in terms of a reduction to the body as a present of time. [...]

1 See, for the history and analysis of the concept, Perry Anderson, 'The Ends of History', *A Zone of Engagement* (London, 1992) 279–375.

2 Thomas Mann, *The Magic Mountain: A Novel*, trans. John E. Woods (New York, 1995) 339.

3 Some five thousand volumes in the last three years, according to *Worldcat* (internet).

4 Siegfried Giedeon, *Space, Time and Architecture* (Cambridge, Massachusetts, 1982) 850.

5 Jacques Derrida, *Marges de la philosophie* (Paris, 1972) 47 ('D'une certaine manière, il est toujours trop tard pour poser la question du temps').

6 Mann, *The Magic Mountain*, op. cit., 310–11. See also Henri Bergson, *L'Evolution créatrice*, in *Oeuvres*, ed. André Robinet (Paris, 1991) 753.

7 See Arno J. Mayer, *The Persistence of the Old Regime: Europe to the Great War* (New York, 1981).

8 I use the word *recognition* in the strong Hegelian sense of the famous Master-Slave dialectic or as what Sartre would call the recognition of another freedom. See for a recent discussion Axel Honneth, *The Struggle for Recognition: The Moral Grammar of Social Conflicts*, trans. Joel Anderson (Cambridge, 1995).

9 Jean-Paul Sartre, preface to Frantz Fanon, *The Wretched of the Earth*, trans. Constance Farrington (New York, 1968) 7.

10 The breakthrough argument for an inclusion of colonial labour as an essential, and not merely incidental, component of capitalism's 'primitive accumulation' is of course that of Rosa Luxemburg, *The Accumulation of Capital*, trans. Agnes Schwarzschild (New York, 1968).

11 I take my understanding of contemporary finance capital from the path-breaking discussion in

Giovanni Arrighi, *The Long Twentieth Century: Money, Power and the Origins of Our Times* (London, 1994). See also Fredric Jameson, *The Cultural Turn: Selected Writings on the Postmodern, 1983–1998* (New York, 1998) 138–43.

12 As defined in Jameson, *A Singular Modernity: Essay on the Ontology of the Present* (New York, 2002), which develops at greater length many of the themes of the present essay.

13 The telltale slogan of 'intersubjectivity' (invented by the phenomenological sociologist Alfred Schutz) is the giveaway clue to the humanist character of these ideologies. My critique of them is not particularly inspired by any defensive pre-emption of language-based critiques of Marxism, for the Habermassians demonstrated long ago that class struggle was itself a communicational structure; see Jürgen Habermas, *Knowledge and Human Interests*, trans. Jeremy J. Shapiro (Boston, 1971) 283.

14 Louis Althusser and Étienne Balibar, *Reading Capital*, trans. Ben Brewster (New York, 1970) 99. It is important to add that for Althusser a mode of production has no single temporality but rather a system of distinct and interlocking times.

15 Stéphane Mallarmé, 'Le Tombeau d'Edgar Poe', *Poésies*, ed. Lloyd James Austin (Paris, 1989) 99.

16 Sophocles, *King Oedipus*, in The Theban Plays, trans. E. F. Watling (New York, 1986) 68.

17 See note 8, above.

18 It is the central theme of Deleuze's philosophy (and is presupposed, perhaps in a slightly different way, by Jean-François Lyotard's work). Both acknowledge the priority of Sartre's early 'Transcendence of the Ego'.

19 In the posthumous television interviews, *L'Abécédaire de Gilles Deleuze*.

20 But see, on the 'anarchist' tendencies of the Deleuze/Guattari books, Jameson, 'Marxism and Dualism in Deleuze', *South Atlantic Quarterly*, no. 96 (Summer 1997) 393–416.

21 See Karl Heinz Bohrer, *Suddenness: On the Moment of Aesthetic Appearance*, trans. Ruth Crowley (New York, 1994) as well as *Das absolute Praesenz* (Frankfurt, 1994) and *Die Aesthetik des Schreckens* (Munich, 1983), on Jünger.

Fredric Jameson, extract from 'The End of Temporality', *Critical Inquiry*, vol. 29, no. 4 (Summer 2003) 695–718.

Peter Halley
Abstraction and Culture//1991

Surprisingly, most of the current discussion of abstraction continues to focus on the idea of abstraction as a stylistic device or invention, borne out of artists' formal concerns; it treats abstraction as a phenomenon whose history can still be traced as a series of stylistic changes within the language of modernist art itself. Further, abstraction continues to be seen as a superior language of emotional expression, in which the 'free' play of 'pure' colour, form and gesture enable artist and viewer to commune on an emotive or spiritual 'plane' beyond the narrative and representational.

Somehow, it must be said that to limit our understanding of the meaning of abstraction (or anything else) to an incantatory recital of its own formal history is a denial – a denial of the myriad connections between culture and other histories and between the artist and the world.

In thinking about this most rarified of visual languages, it seems we intellectually retreat into the cloister of high culture; we deny that abstraction is a reflection of larger historical and cultural forces, we deny that the phenomenon of abstraction only gains meaning to the extent to which it does reflect larger forces and is embedded with their history.

In fact, as early as the 1930s, Meyer Schapiro made this perspective clear with remarkable precision. 'Abstraction', he wrote, 'reflected the economic mechanization of consciousness' in our culture, our submission 'to some external purpose' that was 'indifferent to the individual'.

But after Schapiro came Barr and Greenberg, whose efforts relocated abstraction in a tightly-locked garden of Kantian design where cultural power has been all too content to keep it for all these years.

*

Part of this problem is that we have lost sight of abstraction's relationship to historical events themselves. Most importantly, there are essential distinctions to be made between pre-war and post-war abstraction. To some extent, our contemporary vision of pre-war abstraction as utopian, inventive and

experimental may well be true. But as Barnett Newman wrote about the post-war period:

> You must realize that ... we felt the moral crisis of a world in shambles, a world devastated by a great depression and a fierce world war, and it was impossible at that time to paint the kind of paintings that we were doing – flowers, reclining nudes, and people playing the cello. At the same time we could not move into the situation of a pure world of unorganized shapes and forms, or colour relations, a world of sensation. And I would say that for some of us this was our moral crisis in relation to what to paint. So that we actually began, so to speak, from scratch, as if painting were not only dead but had never existed.

The moral and historical crisis to which Newman refers is essential to our understanding of what constitutes abstraction today. This crisis was as consuming to a European artist like Beuys as it was to the American Newman. We can see the pre-war as a time of historical innocence during which abstract art played out the technological and cultural imperatives that governed it with seemingly unselfconscious spontaneity. In the post-war era, a re-examination of this utopian exuberance and historical innocence became imperative.

Similarly, with the war, the spiritualist yearnings and sensate hermeticism of previous abstraction came to an end. Post-war abstraction was to be dominated by one overriding response to culture: spirituality and phenomenology supplanted by alienation as the guiding impetus behind abstraction.

An analogy can be made to Julian Jaynes' imaginative book *The Origin of Consciousness in the Breakdown of the Bicameral Mind*. Jaynes argued that the mode of thought that we call consciousness arose in Greece around 1000 BCE as a result of cataclysmic volcanic activity that disrupted social patterns in the ancient Mediterranean world. Similarly, the cataclysm of World War II and invention of the Bomb at war's end can be credited with shocking abstraction into a new arena of consciousness. (Regrettably, the materialism and anti-intellectualism that largely held sway in the 1980s has done much to erode this post-war self-consciousness and ethical imperative.)

*

But how is abstraction related to larger social forces and intellectual trends in our century? In fact, abstraction in art is simply one manifestation of a universal impetus toward the concept of abstraction that has dominated twentieth-century

thought. In every area of intellectual endeavour, the twentieth century has seen the idea of abstraction replace empiricism, the guiding ideology of nineteenth-century thought and culture.

Abstraction is based on the idea of the organization of discrete, specific incidents into more generalized, repeatable patterns. In the visual arts, this has led to the idea that specific visual incidents can be represented by generalized forms, which eventually free themselves from their actual phenomenological source. Abstraction in the visual arts is also based on the idea that the interrelationship between parts in a work of art is more important than their individual symbolic identity. As we will see, this emphasis on linguistic relationships is echoed in other areas of twentieth century thought as well.

It is important to remember that the visual principles of abstraction are not confined to high-art practice, but rather extend to all aspects of our visual culture. Abstraction appears no less in commonplace popular forms than it does in the works of Kandinsky, O'Keeffe or Kelly. Thus, if one thinks of the ubiquitous codified signs that direct travellers to baggage, toilets or tobacco shops in the contemporary multilingual airport, one observes that these representations of the male or female body, or of a piece of luggage, or a cigarette, employ a highly abstract language of generalized shapes that are completely removed from specific representation as well.

Similarly, a comparison between a mid twentieth-century comic strip like *Peanuts* or *Felix the Cat* and nineteenth-century political caricature reveals that while the nineteenth-century caricaturist exaggerated the specific empirically-observed traits of his subject (a large nose, blotchy skin, etc.), Charlie Brown or Felix are abstract representations of codified *gestalts* of a little boy or cat, providing only diagrammatic visual patterns. This impulse to cartoon abstraction is essential to our entire visual culture. It has advanced so far in recent years that even in the movies, which still purport to film specific events, the actual human characters have begun to mimic the codified abstract world of their cartoon cousins. (*Back to the Future*, *Batman* or *Total Recall* are good examples of this phenomenon.)

Clearly, these same principles govern non-visual areas of culture as well. As Jean Baudrillard has stated it, the model, that is to say the abstract model, takes precedence over the specific in all areas of contemporary life. Thus, in the academic world, the psychologist, the economist or the sociologist seek to establish the existence of generalized patterns of behaviour that then act as a lens through which to view specific incidents. The aberrant individual must be classified as

psychopathic, sociopathic or borderline. The economy (itself an abstraction) must be categorized as in growth or recession and its output measurable.

Much of the pioneering work in recognizing the impact of these notions of systemization and categorization, it should be remembered, was done by Michel Foucault. His examination of the systematization of medicine and mental disorder are crucial studies. As a simple and poignant example, one remembers that his later work on sexuality is itself a modern phenomenon.

In the same way, modern physics and biology are also governed by a highly codified concept of the combination and breakdown of neutral abstract units (be they sub-atomic particles or strands of DNA). This emphasis on the linguistic structure of matter, wherein the behaviour of matter can be seen as obeying grammatological laws based on the recombination of abstract elements, has its exact equivalent in the workings of abstraction in the visual arts.

The phenomenon of abstraction is reflected in technology no less than in intellectual production. Marxian thought has posited that ideology is the key to understanding consciousness; however, as technology has assumed a more and more autonomous role in affecting social structure, it seems essential that it be examined as a power to be reckoned with, a power that is equal in importance to ideology. A number of social theorists have pursued this tack, including Mumford, Giedion, Ellul and Debord. In addition, there is today a good deal of social history being written that recognizes the effect of technological change on culture. One might mention Wolfgang Schivelbusch's book *Enchanted Night*, which is a history of artificial illumination in the nineteenth century, or Stephen Kern's *The Culture of Time and Space 1880–1918*, which examines the effects of technological change in travel and communications on the arts in the Cubist era.

In this century, technology has itself become more abstract, and it has transformed the world we live in into an abstract environment. Technology in this century has essentially separated itself, step by step, from any relationship to what is commonly thought of as nature: the horse is replaced by the mechanical automobile, the candle by the electric light, etc. Technology has steadily become more and more autonomous, as muscle is replaced by steam, then by electricity, then by nuclear power. When we come into contact with automobiles, electric lights, air conditioning and telephones, we enter a world in which we are no longer tied to the natural forces that these devices replace. We enter a world where technology becomes autonomous from nature, and our environment itself becomes abstract, both visually and physically.

In addition, the rapid changes made in travel and communications in this century have pushed us exponentially into a world that no longer depends on the 'real' or 'natural' time or space. We take it for granted that we can speak with someone halfway around the world or that it takes just a few hours to travel thousands of miles. Such disjunctions in space and time have also created a world that is both malleable and free from natural referents.

If we examine the daily life of a middle-class person in the United States or Europe, we get a picture of an existence of extraordinary hermeticism. People live in sealed houses or condos in highly controlled landscapes. They travel in the sealed environment of the automobile along the abstract pathway of the highway to equally artificial office parks and shopping malls. When one speaks of abstract art, it is essential to remember that it is only a reflection of a physical environment that has also become essentially abstract.

*

Whenever Andy Warhol spoke about death, or sex, or any other troubling emotional situation, he would say, 'It's so abstract.' While the history of post-war abstraction reflects these intellectual and technological changes, abstract art has by no means constituted simply their chronicling or representation. Rather, post-war abstraction is characterized by a certain emotional refusal brought about by alienation. If post-war abstraction chronicles anything, it is the emotional blankness, emptiness and numbness of an abstract world where social relations have become as untethered as technology has.

In her important work on suburbia, *The Moral Order of a Suburb*, M.P. Baumgartner has written that we live in a world of 'moral minimalism' and of 'weak bonds', where people would rather leave a situation than face social confrontation, where families change houses so that each member can have his or her own separate room and avoid contact with one another. At the same time, we live in a world where the brutal yet unreal effects of commodification have intensified rather than lessened, where status is determined by one's ability to attract dollars, and abstract economic changes can instantly shatter the imagined security of the individual.

Thus, abstraction really has nothing to do with aesthetic concerns, nor can it be formally characterized by the use of specific shapes, techniques or configurations. A Car Crash by Warhol, a Joke by Richard Prince, or a Filler by Meyer Vaisman – all reflect the same empty anguish that characterized the work of Rothko and de

Kooning, that continued in the stoic hermeticism of early Stella or Ryman, or in paintings like *No* by Johns, and in the serio-comic meditations of Nauman or Smithson. Abstract art is simply the reality of the abstract world.

Peter Halley, 'Abstraction and Culture', *tema celeste* (Autumn 1991) 56–60; reprinted in Peter Halley, *Recent Essays 1990–1996* (New York: Edgewise Press, 1997) [author's typographic setting retained].

Sven Lütticken
Living with Abstraction//2008

The Abstract World

For his 2002 *Poster Project* commemorating the attack on the World Trade Center, Hans Haacke produced an edition of monochrome white posters from which the silhouettes of the Twin Towers had been cut out; these were glued onto New York poster walls, with the underlying printed matter partly visible in the negative volumes.[1] For the [prototype] design of his 'negative' poster, Haacke used an advertisement for a Broadway production from *The New York Times Magazine* as background, and on the city's poster walls it was likewise fragments of ads that were visible in the towers' silhouettes – often ads for shows, films or records. Thus Haacke's *Poster Project* enacted a dialectics between commodity and structure, between spectacle as visual appearance and the abstract machine sustaining and producing it. Although ostensibly commemorating 9/11, the project in effect questioned the destroyed building itself; in creating a montage of commodity-images and a blank frame, Haacke articulated the split between capitalism's visual façade and its aniconic infrastructure. However, this opposition is anything but absolute. After all, as the effectiveness of Haacke's negative silhouettes shows, in the Twin Towers the ultimate abstraction of capitalism's deterritorialized flows had taken on an iconic character, and on the other hand Marxian theory has argued that commodities themselves are pseudo-concrete manifestations of abstract exchange-value: as Terry Eagleton put it, 'the commodity erases from itself every particle of matter; as alluring auratic object, it parades its own unique sensual being in a kind of spurious show of materiality'.[2]

Marxism always analysed capitalism as a process – as liberatory as it is violent and destructive – that abstracts people and goods from feudal social bonds, replacing them with the abstract bond of exchange value. This means that all modern – commodified – art is fundamentally abstract, regardless of whether it

consists of squares and rectangles or represents cute kittens: 'As uninteresting as obsolete postage stamps, and offering as little variation as these, literary or artistic productions are now signs of nothing but abstract commerce'.[3] But is there any sense in which formal abstraction in art can reflect, and reflect on, this regime of abstract exchange? In 1937, Meyer Schapiro argued that there are problems with theories that derive abstraction in art either from the forms of industry or from 'the abstract nature of modern finance, in which bits of paper control capital and all human transactions assume the form of operations on numbers and titles', since abstract art did not emerge in the most industrially advanced nations or in the main centres of finance – and moreover, many early abstract artists positioned their work squarely in opposition to what they perceived as the *materialism* of modern society.[4]

One way out of this quandary was offered by Adorno's sophisticated argument that formal abstraction is the result of a new 'interdiction' of representation that stemmed from the imperative for the work of art to absorb its 'deadliest enemy, exchangeability', resisting abstraction by representing it negatively.[5] Abstract art is thus positioned as perhaps the modern art par excellence – its 'windowless monads' showing the abstract nature of society by refusing to represent its glimmering surfaces, or even its dark underside, giving back a blank stare rather than attempting to adjust traditional representation to a post-traditional world. However, this negative theology of abstraction – of which Gerhard Richter's reading of the gestural abstraction of *art informel* as befitting a post-traditional world is another instance – has increasingly been challenged by practices that seek to give a more precise social and political meaning to abstract structures.[6] Curiously, this development occurs at a time when capitalism seems to abstract itself beyond recognition, into a post-visual, 'conceptual' phase in which the relevance of formal abstraction becomes ever more doubtful; if the commodity was always pseudo-concrete and abstract to the core, at least it had a material manifestation. In the 1970s, Baudrillard used the 'binary' towers as signs for the transition from a regime of production to one of pure semiosis, of capital becoming coded information circling the globe – the ultimate abstraction.[7] Can such abstraction still be made visible, however inadequately, now that Baudrillard's double icon is gone?

Abstract Art against Abstract Thought

Starting in the 1980s, Peter Halley decoded abstract art as being 'nothing other than the reality of the abstract world': abstraction in art was 'simply one manifestation of a universal impetus towards abstract concepts that has dominated twentieth-century thought'.[8] Historically, things are far more complicated; for Adorno, modern art is precisely about resistance to the concept

(*Begriff*). Modernism in art amounted to a fight for the rights of the 'non-identical' in the face of the concept – which is, *pace* Hegel, an abstraction.[9] Whereas Hegel sees the concept as 'the truth of being', as an active principle that manifests itself objectively, Adorno was to examine the refuse of this subsumption of being under the concept, the non-identical remainder of philosophical abstraction.[10] Art was crucial for Adorno because it operates not conceptually but with a latently 'magical' procedure, one harking back to its dawn: it is fundamentally mimetic. As such, art corrects conceptual knowledge (*begriffliche Erkenntnis*).[11] However, if art is to be successful it is not to engage in an abstract negation of reason, but by absorbing the remainder of triumphant reason, its non-identical other, into its mimetic appropriation of rational procedures. Art, in other words, is reason turned against itself.[12] This is why works of art are quasi-linguistic; they are hieroglyphic writings whose code has been lost.[13]

The voluminous textual output of early abstract artists notwithstanding, a resistance to language as a medium of conceptual thinking was central to their practice. Even though Mondrian opened his groundbreaking 1917 essay with the statement that 'life is becoming more and more *abstract*', he took care to point out that his art stands 'between the absolute-abstract and the natural or the concrete-real. It is not as abstract as abstract thought, and not as real as tangible reality. It is aesthetically living plastic representation: the visual expression in which each opposite is transformed into the other.'[14] Abstract art is thus conservative, shying away from ultimate abstraction. It represents the failure, or the refusal, to abstract itself beyond the visual. It does not deal with concepts; it creates a new plastic expression by juxtaposing colour and line, horizontal and vertical, outwardness and inwardness, nature and spirit, individual and universal, female and male; it gives a determinate or concrete expression to the universal by putting 'purified' forms and colours in rhythmic compositions. Mondrian thus tries to mediate between two realms, the stuff of the senses and 'abstract thought'. His adherence to the archaic and stubbornly material medium of easel painting implies a conservative protest against the onward march of abstraction – a decision to confront the concept with its refuse, with corrections and imperfections, with blotched and botched areas of paint.

The 1928 *Picture-Poem* is a rare case in which Mondrian integrated text into his art; it is a gouache and ink drawing on paper in which a Michel Seuphor poem is set in a typical Mondrian composition (not too elegantly; two lines are broken off clumsily at the end). Even if the piece can be said to prefigure conceptual art in its use of graphically arranged language and in being suitable for reproduction in various formats, the piece retains traces of its handmade nature, and the text is a poem. Compare, by way of contrast, recent pieces by Joseph Kosuth titled *Mondrian's Works*, in which graphic reproductions of Mondrian compositions are

inscribed with quotations from Mondrian's writings. While the principle may at first sight seem similar to *Picture-Poem* it is in fact diametrically opposed: here statements by Mondrian become *content* for a managerial approach to language, one that effectively reduces a sustained writing effort to soundbites; these are then integrated in compositions that are used as typographic clichés, as Flusserian 'programmed surfaces', concepts encoded on a carrier (glass, in this case).[15] Such conceptual art mirrors an economic regime in which 'abstract thought' itself becomes increasingly operative and concrete, in the process largely leaving behind language as the master medium of abstraction: 'abstract thought', as Paolo Virno puts it, 'has become a pillar of social production'.[16]

In the late 1960s, when Sol LeWitt characterized the idea as a 'machine that makes the art', he was effectively mimicking the corporation's attitude toward its patents and brands, which are 'machines for making products' – the latter activity possibly being farmed out to others, just like LeWitt would soon have assistants all over the world.[17] Abstract thought thus reveals its complicity with that other fundamental form of abstraction: exchange. Adorno already argued against the fetishization of 'scientific reflection' as the sole agent of abstraction; abstraction also takes place in the 'universal implementation' of exchange, which abstracts from qualitative aspects of the relation between producer and consumer, reducing all relationships to abstract links of exchange.[18] In the decoding of ancient structures, monetary and conceptual abstraction go hand in hand; while both predate capitalism by a long time, what is crucial is that only capitalism allows for a truly 'universal implementation' of the exchange system, doing away with traditional limitations, transforming God-given hierarchy into mobile capital. In the process, conceptual abstraction transforms itself into the purposive rationality of modern science.

Recent research emphasizes the role of scientific discourse and experiments, particularly in optics, in the emergence of abstract art.[19] Particularly interesting is the use, in nineteenth-century optical research, of abstract colours and patterns to abstract the fundamental laws of perception from the plenitude of sensuous experience. Around 1800, some panels were prepared for Goethe's study of colour that could pass for studies made by Bauhaus students more than a century later. And is not the dissolving of particulars, their conversion into interchangeable units – freeing, as Mondrian might say, forms from their limitations and putting them in 'purer relationships' – precisely the modus operandi of the capitalist economy? Perhaps history, graphically represented, is but the merger of different paths of abstraction. In advanced capitalism, concept and coinage reveal their historical complicity.

Marx already noted that money, liberated from precious metals in the form of paper currency, becomes a pure sign.[20] 'Scientific reflection' has since followed

suit, becoming operative in the coding procedures of both biotechnology and information technology – the latter also facilitating the abstraction of the money sign beyond paper. Is it any wonder that technological reason has been an economic engine of the first order? In being transformed into coded information that can be sold over and over again – software that can be licensed innumerable times, dematerialized information circling the globe – the concept becomes currency. In the hyper-abstraction of conceptual capitalism, the logos triumphs over the non-identical refuse that is sensory experience. Does this mean that abstract art, being residually concrete, is doomed to become obsolete?

Abstraction, Concretely

Mondrian's brittle surfaces and *pentimenti* bear silent witness to a struggle to 'liberate' formal relationships from oppressive conventional restrictions, by 'plastic' rather than by conceptual means. For many artists even the term 'abstract art' became suspect. Hence the success, in the 1930s, of Van Doesburg's term *art concret* – though Mondrian refused to embrace it.[21] Given concrete art's status as 'abstract merchandise', pseudo-concrete art might have been a better name. Perhaps the technocratic bent of 'concrete art' à la Max Bill or Richard Paul Lohse is a tacit acknowledgement of this: this art already seems 'programmed' rather than composed, and in the 1960s and 1970s artists associated with the *art concret* tradition would be among the first to embrace computers for art-making, inaugurating the triumph of the abstract concept turned operative code. In the process, form radically changed its status. From being a manifestation of sensuous thinking, form becomes design – that is to say, an implementation of a concept by coding or programming surfaces rather than an extraction of form from an engagement with a surface's properties. The more 'orthodox' and generic forms of conceptual art partake in this becoming-design of artistic form.[22]

This did not, of course, spell the end of painting as a successful commodity, but it became ever more clear that the painting as physical object is a stand-in for its own value, and as such radically contingent. In this respect Yves Klein's legendary 1957 exhibition in Milan, in which eleven more or less identical blue monochromes were offered for sale at different prices, is crucial. The monochrome is the end of painting as formal articulation, and here structure is not integral to an individual painting, but a matter of abstract relations between different pseudo-concrete objects. No wonder that since the 1970s, from Blinky Palermo to Günther Förg and from Peter Halley to David Reed, the paintings become elements in an installation, parts of a larger structure – a form of interior design. As a response to the loss of meaning of the individual painting, the painting installation was highly successful. What was missing was any sense that these

spaces were models for a reconstructed aesthetic life, as in dreams of or proposals for abstract environments, from Mondrian to Oiticica.

Mondrian's conception of the future Neo-Plasticist culture was messianic in the sense that all would be the same, yet completely transformed and transfigured. In 1921–22, when struggling with the question of the possible end of painting and its integration in a Neo-Plasticist architecture to come, he showed a keen awareness of his art's ambiguous position.[23] For the time being, a true Neo-Plasticist architecture seemed impossible; while economic imperatives and modern production methods favoured straight lines and a lack of ornamentation, these same economic imperatives curtailed the development of architecture into the harmony that Mondrian envisaged. Capitalism, as it were, created an anticipatory mockery of Mondrian's abstract future. No wonder that Mondrian's 'determinate relations' would be simplified and bowdlerized into generic patterns suitable for product design – the very opposite of Mondrian's practice of thinking with and through form.

The becoming-design of abstraction is reflected in the installations of Liam Gillick, which utilize post-painterly design elements, coded implementations of a concept that can be re-used and adapted to different situations. Gillick's 2005 show at the Palais de Tokyo, '*Texte court sur la possibilité de créer une économie de l'équivalence*', is informed by what has become Gillick's master myth, his narrative about unemployed workers of a closed-down factory transforming this former site of production into one of 'postproduction', now 'constructing ideas rather than cars'. The formal intervention – a floor with red glitter, an abstract landscape of cut-out metal mountain silhouettes, and cages in sundry colours – relate to this narrative and to the workers' interventions in the factory and its environment, but without losing or dissimulating their status as speechless stand-ins, as contingent decor. Gillick's props have liberated themselves from the fetishistic illusion of concretion in much more radical manner than the painting installations of a Förg; no wonder that his current series of quasi-retrospectives, 'Perspectives', contains only indirect representations of his work in an architectural setting that makes the space look like a trendy mausoleum. The hermetic (non)relation between Gillick's written scripts and his neo-modernist structures rhetorically foregrounds the impotence of formal abstraction fully to signify; thus they become a strategic, post-Fordist, programmed version of the Adornian pseudo-sign. The shards of Gillick's broken allegories suggest that abstraction has now progressed so far that there is no outside to abstraction: when the abstract is the concrete, there is nothing left to abstract. Is formal abstraction, as developed in early to mid twentieth-century art, therefore irrelevant for present concerns?

As Vilém Flusser noted, to abstract means to subtract, and specifically to subtract from objects. Throughout history, abstraction has been a movement

away from objects and to information. Flusser avers that this movement has now reached its apogee, as the number of *non-things* has exponentially increased; we live in a world of images that might just as well be termed *post-images* since they are coded, the result of programming rather than of traditional representation. In a situation in which the 'non-thing' and thus abstraction has triumphed, to abstract can no longer mean to abstract non-things from things, but rather to abstract *Sachen* [stuff/matter] from abstraction.[24] A *Sache* [thing] is not some seemingly self-evident physical object, but a matter of convention, of social agreement or dissent. The aim is not so much to oppose abstraction with 'concrete facts'; rather, it is to make concrete the omnipresence of abstraction. On the basis of Marx's analysis of capital, various Marxists have argued that under capitalism abstraction is no longer purely 'ideal' or conceptual but a social reality; it is the 'real abstraction' of labour-power and, by extension, of all exchange.[25] In the past decades, the two 'real abstractions' of finance and technology have increasingly converged and penetrated society to an unprecedented degree, forming what I have called a regime of *concrete abstraction*.[26]

One practice that seems to address this state of affairs is that of the Dutch artist Krijn de Koning. The coloured walls of his installations penetrate pre-existing architectural structures in often supremely illogical ways, effecting cuts in the sites and objects with which they engage in dialogue (a sink, for instance, may suddenly be situated at floor level). Thus they suggest that abstraction already penetrates everything, and that this state of affairs may hold a liberating potential: what exists, exists to be tampered with and pushed to its limits.[27]

Inside Abstraction

If abstraction is not an exceptional operation but the rule, if we thus live in a regime of actually existing abstraction, is there then no point any more in criticizing our abstract world? Throughout the twentieth century, theorists diagnosed ever more extreme levels of abstraction; in the 1970s and 1980s, Baudrillard argued that abstraction in the age of the digital 'is no longer that of the map, the double, the mirror or the concept' but 'the generation by models of a real without origin or reality'.[28] But this means, as Baudrillard was wont to emphasize, that the illusion of some lingering 'authentic' realm of non-alienated experience has to be given up. In the age of 'social networking' and sites such as MySpace, this has become more obvious than ever. Perhaps Harun Farocki's video installation *Deep Play* (2007), with its overlay of graphic, diagrammatic abstractions of a football game on video footage, is the most elegant meditation on the concrete abstract. This situation, however, should not be taken as cause for Baudrillardian hysteria. Modern 'critical' discourse on abstraction has been accused – not least by Baudrillard, in a fine case of the pot calling the kettle black – of a romantic,

primitivist streak. Does criticizing abstraction not presuppose an ideal of aboriginal purity, a lost Eden untainted by abstraction? Recent artistic and intellectual practices suggest that there is an alternative: to intervene in actually existing abstraction not in the name of some ideal of authenticity, but in order to go beyond the limits and constraints inherent in this particular concretion of the abstract.

One crucial tool to emerge was the diagram; if diagrams are (in Deleuze and Guattari's vocabulary) 'abstract machines' that programme reality, diagrammatic art, as it were, reverses the machine in order to decode the cryptic structures resulting from this. Flow-chart diagrams had risen to cultural prominence in the 1950s and 1960s, being used both to programme and to navigate complex social and technological systems; as such they were open to critical appropriation, to be hacked. Informed by cybernetics and semiotics, Stephen Willats pioneered this practice in his work since the early 1960s; less explicitly, practices such as Hans Haacke's and Allan Sekula's were also in many ways diagrammatic. Haacke charted the slumlord empire of Shapolsky and Co.; later Sekula embarked on his mapping of the largely invisible streams of sea transport in his *Fish Story* project. In the 1980s, Peter Halley desublimated the squares and lines of modernist abstraction by reading them as the coded signs of a society in which abstraction is indeed the norm, the production of reality by models. In his massive paintings with their synthetic Day-Glo colours, abstraction became utterly diagrammatic, standing for hypercapitalist society as a whole, without going into specifics. While his paintings were marketable luxury goods, they were clearly permutations of a basic concept, squashed and stretched in various ways, filled in with different colour schemes; furthermore, Halley's installations emphasized their lack of completion by combining them with wallpaper that contained appropriated and hence more 'realistic' flow charts.

In the 1990s, artists rejected Halley's version of the diagrammatic in favour of practices that once more analysed specific networks and structures. In contrast to Halley, whose cells and conduits are a cartoon-like simplification, artists such as Mark Lombardi or the Parisian collective *Bureau d'études* seek to chart very precise structures; Lombardi for instance tracing the involvement of the Bush clan in various economic networks and their political interests. In a number of charts from recent years, *Bureau d'études* seek to trace nothing short of the 'World Government' of state and think tanks, with its affiliated 'global laboratory' of surveillance and technology. *Bureau d'études* use a 'pictographic grammar' of signs denoting various social and political actors; these are connected by an intricate network of lined, in sub-systems that are placed in an overall pattern; the results look like Piranesian flowcharts. As this bewildering structure suggests, it would be naïve to presume such diagrams have an overwhelming and immediate effect. In a lecture/performance in which he traces CIA flights in an

increasingly intricate diagram, Walid Raad stressed that 'revelations' about contemporary political or economic activities seem to have very little effect.[29]

Yet tracing relations within the regime of concrete abstraction is a crucial step toward conceiving of alternatives – abstracting from and beyond actually existing abstraction. In his *Hacker Manifesto*, McKenzie Wark détournes the 'classic' leftist discourse on abstraction by arguing for the revolutionary potential of abstraction: 'To abstract is to construct a plane upon which otherwise different and unrelated matters may be brought into many possible relations. To abstract is to express the virtuality of nature, to make known some instance of its possibilities, to actualize a relation out of infinite relationality, to manifest the manifold.'[30] In other words: one must not only make visible actually existing relations, but also actualize possible relations between matters that are usually kept separate, and break neo-feudal hierarchies and inequalities programmed into actually existing abstraction – think, for instance, of the different rules that apply to streams of commodities and streams of migrants.

The status of the work of art as a special and highly auratic commodity is itself carefully kept intact; in order for blue-chip artworks to be as expensive as luxury yachts, they must be presented as being fundamentally different from such other luxury goods. Practices such as that of *Bureau d'études* by and large have a tactical approach to this context, using its funds to enable their diagrammatic investigations but staying on the margins by producing cheap and multiple printed matter – or online pieces – that are unsuitable for financial speculation. However, a merely instrumental relation with art also leads to an impoverishment that is equally political and aesthetic. The work of art can become an exemplary – and thereby truly instructive – commodity only when it reflects on its own status within the regime of concrete abstraction. After all, abstraction can no longer be seen as some foreign world to be mapped by intrepid explorers. We are the natives of abstraction.

1 See http://creativetime.org/archive/?p=144

2 Terry Eagleton, *The Ideology of the Aesthetic* (Oxford/Cambridge, Massachusetts, 1990) 209. The term *pseudo-concrete* is used by Karel Kosik in his *Dialectics of the Concrete*, originally published in Czech in 1963.

3 'Aussi peu intéressantes que les timbres postes oblitérés, et forcément aussi peu variées qu'eux, les productions littéraires ou plastiques ne sont plus les signes que d'un commerce abstrait' (author's translation). Michèle Bernstein, et al., 'Les Distances à garder', in *Potlatch*, no. 19 (April 1955). See *Guy Debord présente Potlatch (1954–1957)* (Paris, 1996) 144.

4 Meyer Schapiro, 'The Nature of Abstract Art' (1937), in *Modern Art: Nineteenth and Twentieth Centuries* (New York, 1978) 207.

5 Theodor Adorno, 'Ästhetische Theorie', *Gesammelte Schriften*, 7 (Frankfurt am Main, 1972) 203.

6 For Richter on the exemplary status of *art informel*, see 'Brief an Jean-Christophe Ammann' (February 1973), in *Text. Schriften und Interviews*, ed. Hans-Ulrich Obrist (Franfurt am Main/ Leipzig, 1993) 74.

7 Jean Baudrillard, *Symbolic Exchange and Death* (1976), trans. Ian Hamilton Grant (London/New Delhi, 1993) 69.

8 Peter Halley, 'Abstraction and Culture' (1991), in *Recent Essays 1990-1996* (NewYork/Paris/Turin, 1997) 27, 32 (reprinted in this volume, 138–43).

9 The German term is *Begriff*, trans. into English as either concept or notion.

10 For Hegel, the term Idea stands for the concrete concept – the identity of concept/notion and the real, the concept's objective manifestation.

11 Adorno, *Ästhetische Theorie*, op. cit., 173. [An English translation of Adorno's *Aesthetic Theory* was published by the University of Minnesota Press in 1997.]

12 'Kunst ist Rationalität, welche diese kritisiert, ohne sich ihr zu entziehen.' Ibid., 87.

13 Ibid., 189.

14 Piet Mondrian, 'The New Plastic in Painting' (*De Nieuwe Beelding in de Schilderkunst*, 1917), in *The New Art – The New Life: The Collected Writings of Piet Mondrian*, ed. and trans. Harry Holtzman and Martin S. James (New York, 1993) 28, 36.

15 Kosuth already quoted Mondrian in a 1996 neon piece installed at the train station of Eindhoven, *Play of Advice*.

16 Paolo Virno, *A Grammar of the Multitude*, trans. Isabella Bertoletti, James Cascaito, Andrea Casson (Los Angeles/New York, 2004) 63.

17 For an analysis of LeWitt's linking of idea and machine in his 'Paragraphs on Conceptual Art' (1967) within the context of the post-Fordist economy, see Sabeth Buchmann, *Denken gegen das Denken: Produktion, Technologie, Subjektivität bel Sol LeWitt, Yvonne Rainer und Hélio Olticica* (Berlin, 2007) 48–54.

18 'In dessen universalem Vollzug [des Tausehes], nicht erst in der wissenschaftlichen Reflexlon, wird objektiv abstrahlert.' Theodor W. Adorno, *Gesellschaft* (1965), in *Gesammelte Schritten, vol. 8: Soziologische Schriften I*, ed. Rolf Tiedemann (Frankfurt am Main,1972) 13. See also Fredric Jameson, *Late Marxism: Adorno or the Persistence of the Dialectic* (London/New York, 2007) 35–42.

19 See for instance the catalogue *Aux Origines de l'abstraction* (Paris: Musée d'Orsay, 2003).

20 Karl Marx, *Das Kapital. Kritik der politschen Ökonomie, erster Band* (1883), in Karl Marx/Friedrich Engels, *Gesamtausgabe*, vol. 11.8 (Berlin, 1989) 149.

21 A term used by Mondrian since the late 1910s is 'abstract-real' art, emphasizing that in his painting the abstract was made real.

22 See also Camiel van Winkel, 'Information and Visualization. The Artist as Designer' in *The Regime of Visibility* (Rotterdam, 2005) 107–71.

23 Piet Mondrian, 'The Realization of Neo-Plasticism in the Distant Future and in Architecture Today (Architecture Understood as Our Total Nonnatural Environment)' (1922), in *The New Art – The New Life*, op. cit., 164–72.

24 Vilém Flusser, 'Auf dem Weg zum Unding', in *Medienkultur* (Frankfurt am Main, 1997) 185–9.

25 See also Sven Lütticken, 'Krijn de Koning: Ruining Representation', in *Krijn de Koning* (Rotterdam, 2007) 227–37.

26 See for instance Anselm Jappe on *Realabstraktion in Die Abenteuer der Ware: Für eine neue Wertkritik* (Münster, 2005) 35–6. It is marginally interesting to note that Mondrian, who rejected the term *art concret*, often spoke of 'abstract-real' art, though of course he did not conceive of the reality of abstraction in terms of exchange.

27 See chapters 3 and 4 of my book *Idols of the Market: Modern Iconoclasm and the Fundamentalist Spectacle* (Berlin/New York, 2009).

28 Jean Baudrillard: 'The Precession of Simulacra', in *Simulacra and Simulation*, trans. Sheila Faria Flaser (Michigan: University of Michigan Press, 1994) 1.

29 Walid Raad's *I feel a Great Desire to Meet the Masses Once Again* is a lecture/performance held at various venues over the past few years.

30 McKenzie Wark, *A Hacker Manifesto* (Cambridge, Massachusetts, 2004).

Sven Lütticken, 'Living With Abstraction', *Texte zur Kunst*, no. 69 (March 2008); reprinted in *Microhistorias y macromundos. vol. 3 – Abstract Possible*, ed. Maria Lind (Mexico City: Instituto Nacional de Bellas Artes y Literatura, 2011) 92–111.

Ina Blom
The Logic of the Trailer: Abstraction, Style and Sociality in Contemporary Art//2008

It is January 2008, and the latest trend in the world of publishing is the subject of some newspaper debate. These days, apparently, more and more authors and publishing houses are posting so-called book trailers on YouTube: movie-style clips that visualize the key elements of a book's narrative through a fast-paced mix of still and moving images set to booming music and voice-overs. In fact, the only thing to tell the viewer that this is a book trailer and not the trailer for a film or a television mini-series is the tendency to show here and there glimpses of printed pages, illustrations and cover designs. Authors are easily confused with actors: in the trailer for *The Shirt Deal*, a perky Stephen J. Cannell walks through the fictional 'set' of his mystery novel as he recounts its plot, his 'author look' no doubt part of the set design programme.

As far back in media time as 2004, an exhibition project by Liam Gillick apprehended this deft merge of previously separate media realms. Expanses of dirt-brown carpeting, moulded into heaps and folds, created a sort of landscape

in the Micheline Szwajcer gallery in Antwerp, but this just seemed to be the setting for the key event. At the far end of this carpet-landscape a 7-minute trailer for the updated version of French sociologist Gabriel Tarde's 1896 science fiction novel *Underground (Fragment of Future Histories)* was displayed on a 1969 Brionvega Cuboglass television set.[1]

At first glance it seemed like a straightforward promotional event: a book had been published; now the sales apparatus was activated. But this event was also a work of art. In fact, it was a work whose penchant for obliqueness or hermeticism opened a dialogue with the question of abstraction in art as well as with the notion of the increasing abstraction of social relations under late capitalism (according to Theodor Adorno, the reality to which abstract art responds). The objects of Adorno's analysis were quite literally all present: on the one hand a literary text – an instance of human creativity and reflection – captured by the promotional logic of the culture industry. And on the other hand the cubes, rectangles and squares of high modernist abstraction – only this time domesticated as stylish design objects for social usage, apparently devoid of all potential for radical transcendence. The radically cubical Brionvega TV set was one such object, as were the shiny new examples of Gillick's so-called 'discussion platforms', the minimal-style canopies of aluminium and coloured Plexiglas that seem to furnish so many of his installations.

And yet this work's specific brand of obliqueness breaks with the very terms of abstraction presented above. Its own forms or strategies of abstraction should, first of all, be understood as situational, or site specific. The site it brings forth is nothing less than the new world of total design, the intensified processes of 'life-aesthetics' or self-styling that form the basis for the specific alignment of governmental and capital interests in contemporary bio-politics and its post-Fordist forms of production. The work should then be seen as an intervention in the elusive continuity between artistic, aesthetic and social forces established by a politics that capitalizes on mental and bodily processes, the forces of sensation and affects. And in turn its insistence on obliqueness may be seen in terms of the revised understanding of dominance and resistance that comes with this politics.

The updating of Gabriel Tarde's sociological/fictional novel had been done by Gillick: in a conscious decision to 'support' the logic of globalization exemplified by the 1904 English translation (and so not even consult the French original), a few minor changes to this text were made. Mentions of cinematography – the big novelty in Tarde's days – were for instance systematically exchanged with 'video'. But Gillick's updating also pertained to the design solution for the book. Now this vintage piece of utopian imagination was framed by his habitual play with colourful modernist/constructivist style languages, complete with sans-serif typeface all through the main text – as if to underscore the essential 'modernity'

or 'actuality' of Tarde, the basic requirement for his commodification. The final book product was displayed on one of the carpeted heaps: the room was, in fact, an elaboration on the concept of the stylistically apposite book fair stand or press conference environment.

The question was only what this environment was actually supposed to promote or present. At first glance the book trailer basically seemed to animate the book design, rather than any narrative the book might contain. The glossy black cover was dominated by a pattern of thick, pastel-coloured lines that might easily be interpreted as beams of multicoloured light moving through dark space. And on the TV screen similarly luminous multicoloured text fragments from the book danced their little dance to midi-files of mediaeval-sounding flute music – much the way graphic design on TV generally ballets around in honour of some coming attraction (as in the intro to any news show). But 'design' did not stop there. For here even the TV apparatus was a highly conspicuous style icon, chosen as if to support the style of both book and trailer. Entirely cubical and encased in shiny metallic finish on every side except one, the Brionvega is advertised by one of its purveyors as 'more than a television set' since 'when it is off it is hard to know what exactly it is'. It is therefore also an 'absolute clear sign', 'desirable even before you know what it's used for'.[2] In fact, the TV set used to display Gillick's book trailer had all the hermetic glamour of the 1960s minimalist cubes – the objects that were at once the epitome of modernist abstraction, and instances of the same abstraction turned inside out, transformed into a projective space of social relations.[3] By the same token the Brionvega also evoked all their ambivalent connections to the world of interior design, the moment when minimal art slides into minimal style, when the most radically impersonal art objects in history turns into signifiers of personal taste. This is, incidentally, also the moment where the conveyor belt model of industrial mass production evoked by minimalist serialism and standardization seemed to give way to a post-industrial production of subjectivity that is largely driven by media-apparatuses: the Brionvega quite simply seemed fraught with all these social/aesthetic shifts. Which is probably why it was used for this particularly slick exhibition display-cum-media event, alongside Gillick's minimal-style 'discussion platforms'. Under the lamp-like halo of colour they produce (this time dirt brown to match the carpet) discussion or socializing of some sort is supposed to take place – an activity that is, however, never actually realized. Again, what seems to count is the evocation of the shift from the transcendent abstraction of classic modernism to the immanence of today's social or relational art practices, the supposed immediacy of 'interaction', 'exchange' or 'togetherness'. Yet in the end it is precisely the meaning of 'the social' that is contested with Gillick's operations of abstraction.

Put together, all these design elements, each of them essentially hermetic,

each somewhat absurdly layered on top of each other, make up what might be called a style site. By a style site I mean an artistic production that presents conspicuous stylistic phenomena not as a trait of some artistic signature, nor as an indicator of the artist's desire to merge the fields of art and design, but as an object of articulation in its own right. If this is possible it is mainly because style here is presented as a point of social crisis or complexity – in fact as a 'question of style' that pertains to specific social sites. On a general level, such questions of style may be discovered wherever relations between appearance, recognition and social identity are opened up – that is, whenever one tackles the difficult issue of unforeseen appearances, social phenomena that have yet to be identified. Style site works could then be seen as a variant of site-specific practices in art, mainly related to the way such practices tend to distance themselves from formalist and historicist approaches to art.[4] For while style is obviously a key 'question' in art-historical writing, it is still mainly handled in terms of predetermined appearance or constant form – an effect of the categorizing concerns of this discipline.[5] In contrast, Walter Benjamin read *Jugendstil* as a symptom of the paradoxes connected with the efforts to give a recognizable public 'face' to modernity: in his work *Jugendstil* is then less a 'period style' than a social site.[6] Today, the question of the unforeseen social appearance is, so to speak, an inbuilt feature of the bio-political logic of style: the desire-element in life-styling is linked to the promise of escape from definable forms of subjectivity, the notion of open-ended becoming. And so the 'question' of the contemporary style site could be seen to turn around processes of de-subjectivization.

This may be the reason why Gillick's promotional work seems to obstruct access to the idea of what exactly is being presented or promoted. Instead, design appears as a quasi-autonomous object of reflection that runs in tight loops around itself. Displayed on an iconic piece of 'design technology', the book trailer is foregrounded as a format, a matter of design solutions, which in turn presents the idea of the book as an object residing within the precisely designed framework of a promotional space. It is the almost hysterical over-determination of style factors in Gillick's work, their lack of definitive grounding, that brings out a sense of style as question or crisis of appearance, that is, as a social site. Through this operation it becomes abundantly clear that style, here, is not just a trait that adheres to some defined project or object, whether 'artistic' or utilitarian, but is itself seen as a sort of productive machine. While most site-specific artworks open onto social practices not primarily associated with the realm of art, or else with the institutional frameworks of art production and display, this work seems, rather, to play off art's imbrication in the contemporary production of open-ended subjectivity.

And the significance of media apparatuses and technologies for this

production – in particular the real-time technologies that seem to mime the dynamic flow of human memory and perception itself – may perhaps account for the emphatic association between style and televisuality in Gillick's work.[7]

However, in this style conundrum, the social ideas presented in Gabriel Tarde's fiction are not lost: they are activated, and their specific mode of utopian imagination constitutes a force that will have to be accounted for. In fact, this is where we may really start to unravel the strange connection between 'sociality' and 'obliqueness' in Gillick's work. 'Obliqueness' was a term used by Gillick himself when trying to place this type of work within the expanding and increasingly controversial catalogue of 'social' art – more specifically its distance to the more transparent or hands-on approaches of much activist or community-oriented artwork.[8] In this last category, the question of representation often seems to play a critical role: the question of how, or through what artistic/ strategic means, specific groups, communities, issues and interests are represented or formalized. In contrast, works such as Gillick's seem to leave the very framework of representation behind: with its apparently free associations between visual, spatial, textual, mediatic and temporal elements, its purported sociality cannot be mapped or located as one delimited or familiar 'object', the way a community, an issue or an institution can.

It is therefore tempting to interpret its strategies as a specific form of artistic abstraction. But again, this specific operation differentiates itself from the type of scenario in which economic abstraction is seen as the root form of all abstraction, so that the differentiating, qualitative potential of individual sensation is understood to be systematically turned into a quantifiable economic potential, a process that goes hand in hand with new forms of political instrumentality. For one thing, to accept this framework of analysis would also be to accept the fundamental problem that haunts this particular conception of abstraction. As Tim Black has pointed out, Adorno's denunciation of a world reduced to the abstract quantities of exchange relations may have been exemplified with reference to modern capitalism, but in actuality his analysis of reification, or the tendency to identify things with their conceptual abstraction (and thus also with their potential for exchange), moves as far back in human history as primitive animism and can not be said to be derived from capitalism specifically. In [Max Horkheimer and Adorno's] *Dialectic of Enlightenment* this impulse towards conceptualization and abstraction is understood to originate in the need to protect oneself from the random brutality of nature.[9] But if it is basically the human capacity to symbolize that is the problem, Adorno's notion of abstraction is not only a superbly formulated instance of the specifically modernist distrust of all forms of representation. It is also, by the same token, partaking in the semiotic logic of representation and the whole analytic apparatus

that goes with it. Within this framework, the essence of the social, the very idea of the possibility of the social, is identified with the concept of exchange and the notion of the eternal circulation of exchanges. From ritual to capital, this is the 'stuff' that the social is made of; this is the proper domain of the social. And in extension of this, any conception of 'social' art is bound to contend with the practices and problems of exchange – in ethical, aesthetic, political and moral terms. The problem with this analysis is the too smooth alignment of human interchange and the exchange mechanism of capital: capital becomes the principle from which everything else is derivated, and is placed in the default position of dominance and initiative, a position that can only be negated. Here the post-workerist position developed from Marx's writings (by Antonio Negri, among others) presents an alternative: the creative initiative is rather seen to reside with the workers themselves, who invent new values and forms of togetherness. Capital continually works to catch up with such creativity. Likewise, the contemporary processes of de-subjectivization might be seen as a continual challenge to capital rather than simply a mere effect of its 'logic'. And from this perspective the new significance of style could also be approached in less negative terms: as an apparatus of social invention.

To see the connection between sociality and obliqueness in Gillick's style site work is then to pay attention to the link between invention of sociality and operations of abstraction. Going nowhere in particular, evoking 'sociality' yet supporting no communal action in the sense associated with the tradition of communal or activist art practices that extend from Vienna Actionism to Atelier Van Lieshout, Gillick's style site seems to resist being understood in terms the habitual models of exchange. In other words, its obliqueness or abstraction, its refusal of any final connection between style and purpose, or style and the recognition of objects or identities, is the result of a logic of association. Gillick perpetually traces connections between elements not normally connected – between sociological fiction and minimalist cubes, between graphic design and television signals – and these connections or associations each bring up moments of difficulty, moments where understanding stops and where thinking and knowledge meets a challenge.

As it happens, this logic of associations has its own specific purchase on social thought. It is related to a mode of thinking where 'the social' is not understood as a specific domain of reality governed by a specific set of generic principles, a 'context' in which non-social activities take place. The social is, rather, a principle of connectivity and productivity, something that can be traced in the surprising associations between things that are themselves not social, or in the continual bifurcation of reality that arise wherever the precise components of an object or a situation are contested, because new information, new forms of knowledge or

action that result from human creativity tends to make the world more complex. And this, of course, is where the forces of Gabriel Tarde's fiction enters Gillick's work, since this fiction springs out of a form of sociology that was based on precisely such a logic of associations.[10] A fantasy of a post-catastrophic underground world where the basic alimentary needs of the remaining population are already taken care of, Tarde's *Underground (Fragments of Future Histories)* toys with the possibility of describing social relations in other terms that those based on the always negative premises of concepts such as need-fulfilment, consumption or compensation for lack. To this end he invents a human society that can only be properly described in terms of the intensive and differentiating potential of aesthetic and affective phenomena: 'The mental space left by the reduction of our needs is taken up by those talents, artistic, poetic and scientific, which multiply and take deep root. They become the true needs of society. They spring from a necessity to produce and not from a necessity to consume.'[11]

Along with the slogan 'To produce is a passion, to consume is only a taste', the above quote also happens to be one of the key sentences dancing around in Gillick's book trailer. These are the exact words that are dressed up as luminous television design. The trailer is obviously a typical example of the techniques of capture at work in the aesthetic industries – a device devoted to the task of exploiting the never-ending desire for the next big thing, of keeping audiences in a perpetual state of alertness. But here it also appears under a different guise. For if the assemblage-like presentations of the typical trailer format tend to work, it is precisely because they trigger forces of invention and production that cannot meaningfully be traced back to a single artist creator; the type of forces that are, in fact, central to Tarde's alternative conception of the social and the elements through which it may be traced.[12] (After all, nobody cares about the author of a trailer and everybody cares about its capacity to suggest and to trigger.) As it happens, a 'logic of the trailer' seems to run through numerous works that seem to play off the social forces at work in contemporary design and media environments. The *Briannnnnn and Ferrryyyyyy* project of Gillick and Philippe Parreno (and a long host of other contributors) for a large part reads like a long trailer bouncing off the objects and institutions of copyright law. This is mainly because the titles, credits and other information far exceed the length whatever content this DVD project contains, but also because this content 'consists of an endless array of questions, quotations and potentialities rather than any clear-cut demonstration of legal dilemmas'.[13] And Tobias Rehberger's *On Otto* uses a cinema poster and trailer – normally the end stages of a film production – as the very point of departure for a cinematic production made in the reverse: the resulting film project results in a multitude of effects, except, perhaps, that of a replete cultural object. As a long list of hyper-professionals from the world of

Hollywood cinema do what they know best, and yet the effect is that of a simultaneous unknowing of cinema and a reinvention of cinematic potential.

The design or style elements that loop seductively around themselves in Gillick's trailer for 'Underground' then only seem to perpetuate the logic of production or invention informing the trailer format itself: This particular trailer simply promotes the forces of sensation and affect that are key elements in the social construction dreamt up in *Underground (Fragments of Future Histories)*. As it turns out, Gillick's trailer really did present the content of the book after all. For in this fictional world, superior emphasis is placed on the productive role of aesthetic creation, on a multifarious styling or designing of persons and environments. Importantly, this activity completely passes beyond the focus on monuments or products that informed life in the old world on the surface of the earth – a world where (art) objects stood out as entities under sharp sunlight and where the social world was also mapped in quasi-objective terms, as a domain, space or structure to be grasped in its totality.

One among many contemporary works elaborating the reality of style as a social site, the exhibition promoting the updating of Gabriel Tarde then gives a sort of object lesson in the possible new role given to artistic abstraction. Neither a return to the old issues of formalism, nor a critical mimicry of abstraction as a symptom of an economic and political reality that continually escapes the grasp of its subjects, works establishing a contemporary style site seem to do two things at once. They obviously close in on the elusive aesthetic and affective forces at work in contemporary capital, as well as on their specific machineries of production. But in the same process they dissipate the very idea of a totalizing grasp or overview of such forces, including the transcendental status given to concepts such as capital, labour and art. Promoting difficulty, hermeticism or obliqueness in the name of art is here, above all, a contribution to a sort of epistemological landslide: a call for a critical re-description of whatever it is that we call social forces.

1 The updated edition was published by Les Presses du Réel, Dijon, in 2004.

2 See the product presentation of the Brionvega Cuboglass television set at www.singulier.com

3 The double character of Minimalism is described by Hal Foster in *The Return of the Real* (Cambridge, Massachusetts: The MIT Press, 1996) 35–71.

4 See Ina Blom, *On the Style Site. Art, Sociality and Media Culture* (Berlin and New York: Sternberg Press, 2007).

5 In his long and nuanced discussion of the concept of style Meyer Schapiro notably delivers a basic definition of style as 'constant form', in *Theory and Philosophy of Art: Style, Artist, Society* (New York: George Braziller, 1994).

6 This reading of Walter Benjamin is provided by Andrew Benjamin in *Style and Time* (Evanston:

Northwestern University Press, 2006) 5–38.

7 This interpretation of real-time technologies is elaborated by Maurizio Lazzarato in *Videophilosophie, Zeitwahrnähmung in Postfordismus* (Berlin: b-books, 2002).

8 Liam Gillick, 'Contingent Factors: A response to Claire Bishop's "Antagonism and Relational Aesthetics"', *October*, no. 115 (2005) 95–107.

9 Tim Black, review of Fredric Jameson, *Late Marxism: Adorno or the Persistence of the Dialectic*, published on *Culture Wars* (June 2007) (www.culturewars.com)

10 This strand of sociology has extensively developed by Bruno Latour, in particular in *Reassembling the Social* (Oxford: Oxford University Press, 2005). Here he posits Gabriel Tarde as the point of departure of a form of social thinking that presents a radical break with the tradition that extends from Durkheim to Bourdieu. It breaks in particular with any notions of some kind of social totality or macro level providing a general framework for explaining singular phenomena.

11 Gabriel Tarde, *Underground (Fragments of Future Histories)* (Dijon: Les Presses du Réel, 2004) 8.

12 Maurizio Lazzarato has discussed this aspect of Tarde's thinking in *Puissances de l'invention. La psychologie économique de Gabriel Tarde contre l'économie politique* (Paris: Les Empêcheurs de penser en rond, 2002), as well as in his introduction to the updated version of *Underground (Fragments of Future Histories)*.

13 'Liam Gillick and Philippe Parreno talk about *Briannnnnn and Ferryyyyyy*', *Artforum* (February 2005) 144–7.

Ina Blom, 'The Logic of the Trailer: Abstraction, Style and Sociality in Contemporary Art', *Texte zur Kunst*, no. 69 (March 2008); reprinted in *Microhistorias y macromundos. vol. 3 – Abstract Possible*, ed. Maria Lind (Mexico City: Instituto Nacional de Bellas Artes y Literatura, 2011) 74–88.

Hito Steyerl
Documentary Uncertainty//2007

I vividly remember a strange broadcast a few years ago. On one of the first days of the US invasion of Iraq in 2003, a senior CNN correspondent was riding in an armoured vehicle. He was jubilant as he stuck a direct broadcast cell phone camera out of the window. He exclaimed that never before had this type of live broadcast been seen. And that was indeed true. Because there was hardly anything to see on these pictures. Due to the low resolution, the only thing to be seen were green and brown blotches, slowly moving over the screen. Actually, the picture looked like the camouflage of combat fatigues; a military version of abstract expressionism. What does this type of abstract documentarism tell us

On one of the first days of the US invasion of Iraq in 2003, a senior CNN correspondent was riding in an armoured vehicle. He was jubilant as he stuck a direct broadcast cell phone camera out of the window. He exclaimed that never before had this type of live broadcast been seen. And that was indeed true. Because there was hardly anything to see on these pictures. Due to the low resolution, the only thing to be seen were green and brown blotches, slowly moving over the screen. The picture looked like the camouflage of combat fatigues – a military version of abstract expressionism

Hito Steyerl, 'Documentary Uncertainty', 2007

about documentarism as such? It points at a deeper characteristic of many contemporary documentary pictures: the more immediate they become, the less there is to see. The closer to reality we get, the less intelligible it becomes. Let us call this 'the uncertainty principle of modern documentarism'.

But actually, this principle does not only apply to documentary pictures, but also to their theory. Because a lot of documentary theory is just as blurred as the pictures, which the correspondent transmitted from Iraq. The more we try to pinpoint the essence of the documentary, the less we are able to comprehend. The reason is that the notions used to describe them are just as ill-defined as the pictures. Let us take an obvious example: the role of the documentary in the field of contemporary art. Talking about this is complicated by two facts. The first is that there is no viable definition of 'documentary'. The second is that there is no viable definition of 'art' or even the 'field of contemporary art'. And if we still want to reflect on the connection of both, we have to face the fact that we barely know what we are talking about.

The same applies to most of the notions which are traditionally used to define the documentary. Terms like 'truth', 'reality', 'objectivity' and so on are characterized by the lack of any generally valid interpretation and of any clear cut definitions. Thus, we are faced with the first paradox: the documentary form, which is supposed to transmit knowledge in a clear and transparent way, has to be investigated using conceptual tools, which are neither clear nor transparent themselves. The more real documentary seems to get, the more we are at a loss conceptually. The more secured the knowledge that documentary articulations seem to offer, the less can be safely said about them – all terms used to describe them turn out to be dubious, debatable and risky.

I do not want to reiterate, like in an exercise of Negative theology, all the definitions that the documentary mode fails to live up to. Most obviously, it is not consistently objective, whatever objectivity might mean in the first place; it contains facts without ever being able to be entirely factual. While it might aim to represent the truth, it usually misses it, at least according to its own standards. Post-structuralism has taught us how 'reality', 'truth' and other basic notions on which possible definitions of documentary rest are at best as solid as the fleeting reflections on a troubled surface of water. But before drowning in the uncertainty and ambiguity that these paradigms prescribe, let us perform one very old-fashioned Cartesian move. Because, amidst all this ambivalence, our confusion is the one thing which remains certain and even reliable. And it will invariably, if unconsciously, represent our reaction to documentary materials as such. The perpetual doubt, the nagging insecurity – whether what we see is 'true', 'real', 'factual' and so on – accompanies contemporary documentary reception like a shadow. Let me suggest that this uncertainty is not some shameful lack, which has

to be hidden, but instead constitutes the core quality of contemporary documentary modes as such. The questions which they invariably trigger, the disavowed anxieties hidden behind apparent certainties, differ substantially from those associated with fictional modes. The only thing we can say for sure about the documentary mode in our times is that we always already doubt if it is true.

Nothing but the Truth

Doubting documentary representation is of course nothing new. It is as old as the documentary form itself. Its truth claims have always been questioned, deconstructed or called arrogant. The general relationship towards documentary claims has always been one of a disavowed impasse. It oscillates between belief and incredulity, between trust and distrust, hope and disillusionment.

This is also the reason why the documentary form has always presented its audiences with philosophical problems. Whether or how they represent reality has forever been contested. The main argument runs between proponents of realism and constructivists. While the former believe that documentary forms reproduce natural facts, the latter see them as social constructions. Realists think that reality is out there and that a camera can capture its essence. Constructivists stress the function of ideology or understand truth as a function of power. Michel Foucault once coined the expression of a politics of truth. According to constructivists the documentary form does not represent 'reality' but the 'will to power' of its producers.

But both positions are problematic. While realists believe in an objectivity that, more often than not, turns out to be extremely subjective and which has nonchalantly passed off hideous propaganda as truth, constructivists end up not being able to distinguish the difference between facts and blatant misinformation or, to phrase it more directly, between truth and plain lies. While the position of realists could be called naïve, the position of constructivists runs the danger of sliding into opportunistic and cynical relativism.

What do we make of this impasse? The lesson is that we should accept the intensity of the problem of truth, especially in an era in which doubts have become pervasive. The constant doubt about whether what we see is consistent with reality is not a shameful lack, which has to be disavowed, but on the contrary is the decisive quality of contemporary documentary forms. They are characterized by an often subliminal, but still nagging, uncertainty, as well as the question: Is this really true?

This principle of documentary uncertainty is obviously just a provisional definition of modern documentary; it is highly contextualized within our historical moment. But at no time than in the contemporary context of globalized media circuits has it been more accurate. In this age of widespread anxieties, of

precarious living conditions, of general uncertainties and media-provoked hysteria and panic, our belief in the truth claims articulated by anyone, let alone the media and their documentary output, is shaken. But at the same time, more than ever before, our living conditions depend on remote events that we have very little control over. The ubiquitous corporate news coverage which we endure on a daily basis sustains the illusion of control, while simultaneously demonstrating that we are reduced to the role of passive bystanders. While rehearsing attitudes of rational response, they transmit fear on a most basic, affective level. Thus, documentary forms articulate a fundamental dilemma of contemporary risk societies. Viewers are torn between false certainties and feelings of passivity and exposure, between agitation and boredom, between their role as citizens and their role as consumers.

Documentarism in the Field of Art
In comes the field of art. In the 1990s, documentary forms became popular again after a twenty-year long hiatus induced by Reaganism and the artistic dumbing down which came with it. During this time, the field of art suffered the same onslaught in the public sphere as the field of documentary production. Since the documentary mode was automatically associated with publicness, state funding and the arena of communicative rationality, in many cases, it was advocated by reflex within the field of art. Art also partly tried to assume the role of an alternative media circuit. This aspect has been pointed out by Stefan Jonsson, who argued, that the field of art could become some sort of alternative CNN, which would elucidate the blind spots of corporate journalism and of globalisation in general.

But there were also other developments within the field of art in the 1990s, which made documentary modes an obvious choice for artists. First, the practice of so-called 'contextual art', in which producers tried to figure out the economic and political conditions of their own activities. Since documents were usually involved in assessing these parameters, working with or upon them was self-evident. Documents were used, or sometimes simply brandished, in order to evidence archival research, social inquiries or alternative knowledge production. A further affinity was created by the impact of Cultural Studies on the field of art and consequently there emerged a preoccupation with the politics of representation. The awareness of power relations within, not only documentary articulations, but all forms of representation, was heightened and in many cases also transformed by new modes of narration, which reflected their own implication in authority and in the hierarchies of knowledge production with their effects on gender and other social relations.

All of these influences, which are of course interconnected and overlapping, made documentary one of the most important characteristics of the field of art

in the 1990s and in the early twenty-first century. But what did these developments mean? Within the wave of excitement associated with the use of social documentarism, important aspects of the character of documents were neglected by many producers. Since documentarism was automatically assumed to be enlightened and critical, many producers paid little attention to the fact that, on the contrary, documents are usually condensations of power. They reek of authority, certification, expertise and concentrate epistemological hierarchies. Dealing with documents is thus a tricky thing; especially if one aims to deconstruct power, one has to keep in mind, that existing documents are – as Walter Benjamin once wrote – mainly made and authorized by victors and rulers.

Thus an ambiguous situation has been created within the field of art. Superficially, or on the content level, many documentary articulations seemed to erode or even attack unfair power structures. But on the level of form, by relying on authoritative truth procedures, the conventional documentaries have intensified the aura of the court room, the penitentiary or the laboratory within a field of art, which was already quite saturated with these mechanisms. The institution of the so-called White Cube has been criticized for providing a clinical constellation of gazes with aesthetics and social values, which are actually quite similar to the ones deployed within conventional documentary modes. As is well known, documentary production has taken on forensic duties for a long time, and has functioned in the service of a large-scale epistemological enterprise that is closely linked with the project of Western colonialism. Reporting the so-called truth about remote people and locations has been closely linked to their domination. Not only mainstream documentary truth procedures, but even the features of the photographic technology, based as they are on military technology, testify to this historical link.

Jacques Rancière has recently described the importance of these structures of seeing and knowing as the 'distribution of the sensible'. According to him, the political component of any aesthetic endeavour is precisely located in the way in which certain aesthetic regimes enable certain visibilities or articulations and disable others. Thus, the political importance of documentary forms does not primarily reside in their subject matter, but in the ways in which they are organized. It resides in the specific distributions of the sensible implemented by documentary articulations. And this applies not only to corporate documentarism, but also to those documentary productions which take up their standards, their truth procedures, their formal vocabulary, and their scientific and objectivist attitude.

Beyond Representation

Even the claims of a more radical politics of representation fail to live up to the challenge that contemporary documentary presents. The documentary form as

such is now more potent then ever, even though we believe less than ever in documentary truth claims. Documentary reports are able to unleash military interventions, to provoke pogroms, international relief efforts, euphoria as well as mass panic. And this is due to their function within global cultural industries, which commodify information and, more importantly, transform it into powerful and moving affects. We identify with victims, heroes, survivors, lucky winners, and the impact of this identification is heightened by the presumed authenticity of the experiences we believe to be sharing. Pictures that appear ever more immediate, which offer increasingly less to see, evoke a situation of constant exception, a crisis in permanence, a state of heightened alert and tension. The documentary form thus becomes a major player within contemporary affective economies. It intensifies a general feeling of fear, which characterizes the governmental address of our historical moment. As Brian Massumi has demonstrated using the example of the colour-based terror alerts in the United States, power now also addresses us on the level of affect. Plain colours trigger off multiple emotional reactions. Television in the age of terror creates a 'networked jumpiness' by modulating the intensity of collective feelings. Ironically, power takes on the artistic gesture of abstraction. Politics as such are increasingly shifting into the realm of pure perception. They are not only aestheticized. They have become aesthetical as such, as they work (through) the senses. The relationship between politics and art is thus being reconfigured on a level beyond representation.

Contemporary artistic documentarism, with its focus on a politics of representation, has not yet paid sufficient attention to this change; politics as such are moving beyond representation. Very tangible developments make clear that the principle of representative democracy is becoming increasingly problematic. The political representation of the people is undermined in many ways – from the non-representation of migrants to the creation of strange democratic hybrids like the European Union. If people are no longer represented politically, then maybe other forms of symbolic representation are undermined as well. If political representation becomes abstract and blurred, so might documentary representation. Is this also a way to interpret CNN's abstract documentarism? A documentarism which moves beyond representation?

There is still another aspect of the documentary images by CNN mentioned in the beginning. There could not be any less 'objective document' (so to speak) than those pictures, since they are made from the position of so-called imbeddedness, which basically renounces most pretensions of objectivity and critical distance. In order to be able to join the troops, journalists had to endure quite dramatic restrictions of the freedom of press. But what if we had to realize that, in this world, we are all somehow embedded in global capitalism? And that the step back,

towards critical distance and objectivity, was, under these circumstances, always already an ideological illusion? In one sense, this is probably true. And paradoxically, one can thus say that there is no more truth and certainly not within documentarism. But let us reverse the perspective: what if the contrary is the case and it is precisely those blurred and unfocussed pictures from the cell phone camera that express the truth of the situation much better than any objectivist report could? Because these pictures do not really represent anything. They are just too unfocussed. They are as post-representational as the majority of contemporary politics. But amazingly, we can still speak of truth with regard to them.

Those CNN images still vividly and acutely express the uncertainty, which governs not only contemporary documentary image production, but also the contemporary world as such. They are perfectly true documents of that general uncertainty, so to speak. They reflect the precarious nature of contemporary lives as well as the uneasyness of any representation. Finding a critical position with respect to these images implies much more than simply taking this into account or exposing it. It means replacing the set of affects which is connected to this uncertainty – namely stress, exposure, threat and a general sense of loss and confusion – with another one. And in this sense, the only possible critical documentary today is the presentation of an affective and political constellation which does not even exist, and which is yet to come.

Hito Steyerl, 'Documentary Uncertainty', *A Prior*, no. 15 (2007).

Stephen Zepke
Art as Abstract Machine//2005

And the question is still what it was then, how to view scholarship from the vantage point of the artist and art from the vantage of life.
– Friedrich Nietzsche, *The Birth of Tragedy*

Art as Abstract Machine. This title is not a description but an imperative. It urges an action, an undertaking, a perpetual departure, for wherever we start, it remains to be done. A machine has to be constructed, and art as abstract machine will require an artist adequate to the task: a mechanic. For each machine its mechanic: 'the painting machine of an artist-mechanic'.[1] We are already – as always – in the middle of things, a swirling cacophony of questions: A mechanic?

A machine? Who? What? When? And given all that, what does this machine produce? And for what reasons? But these questions are the necessary conditions for any construction, for their answers will be the components of new machines that will themselves depart, to test out new directions. The abstract machine is nothing but this unfolding of complexity, a fractal engineering inseparable from life, a blooming of multiplicity.

But let's step back from this complexity that will nevertheless remain the condition of our investigation. We don't want to crash and burn, not yet. Let's try taking one question at a time. If our title is an imperative what does it bid us do? To construct an abstract machine, obviously, but how? And to risk another question, already, what does it do? (We will see how these questions, to immediately step into Deleuze and Guattari's vocabulary, will become indiscernible.) Deleuze and Guattari give what seems a straightforward answer: 'The diagrammatic or abstract machine does not function to represent, even something real, but rather constructs a real that is yet to come, a new type of reality' (*A Thousand Plateaus* [1980; 1988] 142/177; henceforward *ATP*). Art as abstract machine's first principle: it is real and not a representation. Deleuze and Guattari, whether discussing art, philosophy or anything else, will not stop coming back to this first principle.[2] And as such, it immediately implies another – its necessary compliment – that constructing an abstract machine is to construct construction itself. The abstract machine is the vital mechanism of a world always emerging anew, it is the mechanism of creation operating at the level of the real. Here, a new world opens up, a living world in which nothing is given except creation. To open a world, to construct a new type of reality, this is the ontological foundation of the world – of *this* world and of all the others – on an abstract machine guiding its becoming.

The abstract machine creates a new reality, constructs new ways of being, but although inseparable from this innovation of existence, it has no being. The abstract machine is the entirely immanent condition of the new, and thereby receives its Nietzschean definition: its being is becoming. For now we will unfold the implications of this ontology rather rapidly, any beginning must involve a certain reckless plunge … The abstract machine doesn't represent anything because nothing exists outside of its action, it is what it does and its immanence is always active. In the middle of things the abstract machine is never an end, it's a means, a vector of creation. But despite the abstract machine having no form, it is inseparable from what happens: it is the 'non-outside' living vitality of matter (But is it an inside? As we shall see the question marks a certain limit to an old and no longer useful topological vocabulary.) As a result, abstract machines are neither ideal identities nor categories of being, and remain entirely unaffected by any transcendent ambitions.

But before we get into the intricacies of this technical philosophical terminology we should remind ourselves that we are speaking of practical matters, of machines and their constructions. Building an abstract machine is more DIY than techno-science, and requires a bit of the mad professor.[3] Deleuze and Guattari, mad professors no doubt, adopt the language of the construction site, an earthy directness reflecting the pragmatism required by the job at hand. Machines eat and sleep, they remind us, they shit and fuck (*Anti-Oedipus* [1972; 1983] 117). We are, no mistake, machines. 'Everything is a machine' (*AO*, 2/8). Our task – to be done with techno – paranoia – is to turn these machines creative, to liberate their parts in an explosion that remakes the world. The mechanic is, to use another of Deleuze and Guattari's colourful phrases, 'the cosmic artisan: a homemade atomic bomb' (*ATP*, 345/426). 'There is a necessary joy in creation', Deleuze says, 'art is necessarily a liberation that explodes everything'.[4] But the abstract machine is not an expression implying technophilia either, and is inseparable from a mechanics of the flesh, an example of Deleuze and Guattari's avowed materialism: 'The abstract machine is pure Matter-Function' (*ATP*, 141/176). The world is a plane of matter-force, a material process of experimentation connecting and disconnecting machines. On this plane abstract machines act as guidance mechanisms – 'probe-heads' (*têtes chercheuses, ATP*, 190/232) – steering the world on its 'creative flight' (*ATP*, 190/233). The abstract machine is therefore both vital and material, it exists, Deleuze and Guattari write, as the 'life proper to matter as such, a material vitalism that doubtless exists everywhere but is ordinarily hidden or covered, rendered unrecognizable, dissociated by the hylomorphic model' (*ATP*, 411/512). Hylomorphism is an operation that moulds matter into forms according to an ideal model, an operation by which the world appears as obedient and predictable representations. Once more, the abstract machine *against* representation.

We have already sketched – at a speed that no doubt calls out for a subsequent slowness – the underlying structure of this book's diagram. First, not only the echo of Nietzsche in the abstract machine's *against*, but Deleuze and Guattari's mobilization of his ontology of becoming. Second, the necessity of Spinoza to any philosophy of immanence. Spinoza will be the permanent signature of Deleuze and Guattari's immanent machinery, of its expression and construction. Third, a materialism inseparable from a vitalism; in other words, Bergson. These are the abstract co-ordinates of Deleuze and Guattari's philosophical machine, and are mapped in the first three chapters of this book. These chapters layout the basic components of Deleuze and Guattari's ontology, while seeking to show how they work, how they must be put to work in constructing an expression of the living materiality of the world, in constructing an abstract machine. Understanding this ontology will therefore confront us with the immediate necessity of understanding

its appearance in and as life, an understanding inseparable from an experience of the new realities that are forever being created. At this point it becomes obvious that the ontology of the abstract machine implies an aesthetic, because its existence is indiscernible from its appearance in and as experience.

What then, to ask the question of aesthetics, are the conditions of this experience? This question calls to account another of Deleuze and Guattari's philosophical interlocutors: Kant. Unlike Nietzsche, Spinoza and Bergson however, Kant is less a 'fellow traveller' than an adversary, and the site of combat will be the aesthetic. For Deleuze and Guattari aesthetics is not the determination of the objective conditions of any possible experience, nor does it determine the subjective conditions of an actual experience *qua* beautiful. Aesthetics instead involves the determination of real conditions that are no wider than the experience itself, that are, once more, indiscernible from this experience. Aesthetics then, is inseparable from ontology, because experience is, for Deleuze and Guattari, irreducibly real. To construct an abstract machine will mean constructing a new experience indissociable from a new reality. The sensible, like the thinkable, is nothing but the temporary conditions from which an abstract machine departs, following Spinoza's 'war cry' (the phrase is Deleuze's) 'we don't even know what a body can do' (*Expressionism in Philosophy: Spinoza* [1968; 1992] 255/234). This introduces another of our constant concerns, how can we create a new body, a new sensibility adequate to a life of ontological innovation? Art emerges here as a privileged site of corporeal experimentation. Art as abstract machine gives a genetic definition of art, one that transforms both its ontological and aesthetic dimensions. 'Everything changes once we determine the conditions of real experience', Deleuze writes, 'which are not larger than the conditioned and which differ in kind from the categories: [Kant's] two senses of the aesthetic become one, to the point where the being of the sensible reveals itself in the work of art, while at the same time the work of art appears as experimentation' (*Difference and Repetition* [1968; 1996] 68/94). An abstract machine determines the real conditions of experience, conditions neither subjective nor objective (they have become abstract), and that can only be experienced in the work of art (in a machine). A work entirely experimental, inasmuch as art is a permanent research on its own conditions, and is always constructing new machines. Feedback loop. Once more, this will be an overarching concern of this book, to understand the necessary and active immanence of abstract and actual, infinite and finite in the machine of art. The work of art understood in this way will give a real experience, an experience of its real conditions, an experience of and as its immanent abstract machine in the process of (re)constructing reality. Which is to say – or what can be said before we say everything else – art is an experience of becoming, an experiential body of becoming, an experimentation producing new realities. The implications are

obvious: there is neither an ontology of art nor an aesthetics of art, each in its own realm of competency, each with its own all too serious professors. There are artists constructing abstract machines, mechanics engaged in the pragmatic practice of *onto-aesthetics*. Cosmic artisans everywhere setting off their atom bombs.

Our diagram has already grown quite complex. The co-implication of ontology and aesthetics in art as abstract machine – the onto-aesthetics of art – involves a redefinition of experience by which its objective and subjective conditions are dissolved in the real, the reality of the world as it becomes nothing else than itself. Art in these terms is an autogenesis expressing the world (its real conditions) by constructing experience (its real experience). And what is this experience? A simple question that it will take a whole book (and no doubt not just this one) to answer. Art is, before all else, and as Deleuze and Guattari put it, a sensation. A sensation of this work, but this work, this sensation, it does nothing if it does not restore us to our constitutive infinity by creating the world anew. Deleuze and Guartari's understanding of art as sensation will set off from Nietzsche's statement serving as the epitaph above, to view scholarship from the vantage of art – it means our investigations only begin when we start to create – and art from the vantage of life – meaning our creations must become alive. Art will be nothing (at least not for us) if it is not this ongoing expression of life in the construction of living machines.

Expression and construction are the doubled dimensions of art as abstract machine. The abstract machine expresses the autogenetic and infinite processuality of its real conditions (the infinite, a cosmic world), which appear as the construction of this reality, this art-work. But, once more, doubled, the abstract machine expresses the infinite, but also constructs it, right here right now: 'The field of immanence or plane of consistency must be constructed.' Deleuze and Guattari write: 'It is constructed piece by piece, and the places, conditions, and techniques are irreducible to one another. The question, rather, is whether the pieces fit together, and at what price. Inevitably there will be monstrous crossbreeds' (*ATP*, 157/195). To express an infinite world in constructing a finite artwork, to make art in other words, is a process by which the becoming of the world is expressed in a construction which works upon its own conditions, which operates at the level of its constitutive mechanism. Any construction of art then, any sensation, emerges through an abstract machine to express an infinite plane by way of an actual becoming whose very specificity and precision involves or infolds a change in its real conditions. The world is this genetic plane of immanence, a Bergsonian multiplicity, which in being expressed in a finite construction, an art-work, a sensation, changes in nature. At this point it is not a question of distinguishing expression and construction as two dimensions or moments of sensation, because they have become

indiscernible on the single multiplied plane of onto-aesthetics. All that remains is to affirm their identity, construction = expression.[5]

This affirmation will be another theme of this book, echoing in its different terminologies. It appears as Nietzsche's interpretation and evaluation of will to power, as Spinoza's affects of joy and beatitude in God/Nature, as the actual and the virtual dimensions of duration in a Bergsonian cinema, as traits of content and expression in the abstract machine, and finally as the affect and the percept in sensation itself. In all these cases it is the affirmation of becoming that puts immanence to work in a feedback loop of construction and expression, making becoming the being of a work of art that, as Deleuze and Guattari put it, 'wants to create the finite that restores the infinite' (*What is Philosophy?* [1991; 1994] 197/186).

We could well ask, as some already have, whether Deleuze and Guattari are offering us a modern version of Romanticism here, whether onto-aesthetics is simply art expressing nature. Certainly Deleuze and Guattari pass through Romanticism, and although they find a stopping place in the inhuman rupture of the sublime – a rupture and rapture – they do so only by changing its Nature. A change that rejects the sublime's Kantian conditions, removing art from any romantic analogy with the divine, and placing it back among the animals. All this will be developed later of course, but I mention it here as the first qualification of what is the necessary correlate of the construction = expression equation, an 'atheistic mysticism'. This is a phrase employed by Deleuze to describe Spinoza's philosophy of immanence, and is the only way to understand Deleuze and Guattari's ironic deification of Spinoza as the 'Christ of philosophers' (*WP*, 60/59). Spinoza is the philosopher who thought the 'best' plane of immanence, the 'best' God, because through the attributes the plane's (God/Nature) expression in the joy of affectual assemblages is nothing but the ongoing construction of an infinite and divine *here* and *now*; God yes, but *Deus sine natura*. Spinoza's revolutionary formula introduces an atheist God to philosophy – an atheism inseparable from a true philosophy of immanence – because reason is the way to express God/Nature constructing itself, and immanence achieves nothing without this identity of expression and construction. To put it simply, Spinoza overcomes transcendence because, as Deleuze puts it, 'expression is not simply manifestation, but is also the constitution of God himself. Life, that is, expressivity, is carried into the absolute' (*EPS*, 80-1170).

This strange atheism that in Spinoza never stops speaking of God, and in Deleuze and Guattari never stops seeking to become adequate to becoming itself, will be the consistent aim of a *practical philosophy*. Philosophy, like art, is a construction site, a workshop producing abstract machines with cosmic ambition. Deleuze and Guattari are continually coming back to this mystical practice, the

production of what Michel de Certeau has called 'the infinity of a local singularity'.[6] From the Nietzschean simulacrum as the superior form of everything that is to the seed/universe of the cinematic crystal image, from the visions of cinema's seer to Bacon's BwO [body without organs], from Goethe's differential colour theory to Leibniz's imperceptible waves infolding perception in the ocean of experience, Deleuze and Guattari describe the atheistic mysticism of a philosophy of immanence, the construction and expression by an abstract machine of a '*local absolute*' (*ATP*, 382/474). This vision of a mystical Deleuze and Guattari is, I am well aware, regarded with suspicion by many commentators.[7] Nevertheless, with the important addition of its atheist condition, this seems to me the best way to approach the profusion of mystical formulations in Deleuze and Guattari's work, and their consistent attempts to find our real conditions on a cosmic plane of production.

Mystical atheism is the real condition of Deleuze and Guattari's pragmatic philosophy. Mysticism is the experience of immanence, of the construction/ expression of the at once infinite and finite material plane on which everything happens. Thus, mysticism as an experience of immanence is necessarily atheist, because it cannot involve transcendence of any kind (where to?). Atheist mysticism replaces transcendence with construction/expression, first of all as a construction of the body – atheism *against* asceticism. Mysticism is a physical practice: how do you make yourself a body without organs? Furthermore, mysticism is a creative process that, whether in the realm of philosophy, art, or somewhere else, is inseparable from affirmation. Deleuze and Guattari identify the same philosophers as philosophers of affirmation as they did the philosophers of immanence, the holy trinity: Nietzsche, Spinoza, and Bergson. It's no accident of course, as in each case it is by affirming the immanence of a fundamentally creative life that the joy proper to mysticism will explode on its lines of flight, all the way to infinity. Deleuze reads Nietzsche's affirmation of will to power, the affirmation of affirmation as he puts it, as the practical mechanism of overcoming, the door through which we eternally return. Similarly, it is the Spinozian affect of joy that constructs the rhizomatic compositions of power constituting the ever increasing All, and culminating in the mystical affect of beatitude, the love by which God/ Nature loves itself. In Bergson Deleuze finds in the intuition of the *élan vital*, an intuition Bergson associates with artists and mystics, an affirmation capable of entering into the creative process itself. 'If man accedes to the open creative totality', Deleuze writes of Bergson, 'it is therefore by acting, by creating rather than by contemplating' (*Bergsonism* [1966; 1991] 111/118). Deleuze suggests as a slogan, and it's a joke, but perhaps only half a joke, 'It's all good, but really'.[8]

Affirmation is the mechanism of immanence, the means by which to construct a joyful expression. No doubt Deleuze's affirmation of affirmation also has a

serious philosophical function as the antidote to that other notable philosophical double-banger, the negation of negation (just as overcoming in this context is the overcoming of *Aufhebung*). But it is also the guiding thread of Deleuze and Guattari's work in a practical sense, for they very rarely discuss artwork, at least, which they do not *like*. (And in a wider sense this would be the rationale behind Deleuze's refusal to specifically deal with the philosophy of Hegel.) But behind this seemingly banal observation lies an important new element to Deleuze and Guattari's abstract machine, and that is its ethical dimension. Affirmation is an ethical choice, a choice for the creative energies of life, first of all our own. This will be an ethics that will immediately appear in our first chapter on Nietzsche, where affirmation returns will to power eternally, a return that will be our own overcoming. Here affirmation takes on a critical function, because a true affirmation of immanence will involve the destruction of nihilism, of all the resentful negations defining the human, all too human. As Nietzsche said, and it is a slogan that will accompany us through the course of this book: no creation without destruction. A motto for the artist first of all. Affirmation, and the mystical onto-aesthetics it enables, is nothing if not critical. It is, in fact the creative process of critique, and involves violence and cruelty, and their correlate: pain. Just like nature. Any creation worth its name will therefore encompass the destructions necessary to set it free, an explosion that destroys negation and propels its liberated matter into the new. Affirmation is therefore like a leap of faith, a leap into the chaos of the world in order to bring something back, in order to construct something that expresses life beyond its sad negation. And how could it be anything else? Because from our subjective perspective, from within its narrow and blinkered vision, the life of matter, the cosmic infinity of our here and now is what cannot be experienced or thought, at least not without some recourse to mollifying images of a transcendent beyond. This unthought of thought, the insensible in sensation, this is the impossible aim of Deleuze and Guattari's project. Not, once more, to transcend the world, but to discover it as it is, to create a thought, a sensation, a life that participates in the world's joyful birth of itself: a dancing star. This, Deleuze writes, 'is the impossible which can only be restored within a faith … Only belief in the world can reconnect man to what he sees and hears' (*Cinema 2* [1980; 1989] 172/223).

To reconnect man to what he sees and hears, this is nothing less than the project of art. A critical project for sure, because art has been overcoded with so many merely human ambitions, so many representational limitations. Let us not forget: 'No art and no sensation have ever been representational' (*WP*, 193/182). First, we need a machine to clear the canvas (or the screen, the page, the compact disc) of all the clichés which prevent a creation. Second, we need an affirmation that is strong enough to actually create something, because a constant risk of

destruction is that nothing new will emerge from it. Nothing is sadder than a void, nothing so ugly as a black hole. And art can just as easily be these things, a soporific or worse, a poison. Art as abstract machine therefore involves an ethical choice, a selection and conjugation of those matter-flows which are in the process of escaping from themselves, it must affirm only what is the most deterritorialized. Art must be critical enough to divert its contents and expressions back to the plane of consistency, to achieve an absolute deterritorialization. But then, something must happen, something must emerge, the creative life of this plane must be expressed in a sensation. And sensations must be created, as any artist knows, for the machine to work.

In this way the abstract machine operates at the interstice between finite and infinite, it deterritorializes the concrete world, breaking matter out of its overcoded forms, to put it back into contact with its vitality, with its living flows, its inhuman and inorganic nature. This is art's infinite material dimension, and here, absolutely deterritorialized, the machine begins to work, 'flush with the real' as Deleuze and Guattari put it, constructing flows of matter-force into expressive sensations. This is the bacchanaal of art, immersed in the real, affirming its own creative ecstacies. Deleuze is a laughing Dionysus: 'Yes, the essence of art is a kind of joy', he affirms, 'and this is the very point of art'.[9]

Here art will become a politics of lived experience, a realm of experimentation that opens life up to alternative modes of being, affirming new realities, new communities and new methods of self-organization. Art becomes a kind of bio-politics, an experimentation with life as it is lived, a contestation in the realm of experience with everything that seeks to prevent us from affirming our power of composition. Art is a mechanism to increase our power, to liberate ourselves from the limits of representation (and the political operation of these limits is a constant subtext of Deleuze and Guattari's discussion). Art is the freedom to experiment on our conditions of existence, and is the ethical condition of any revolution. Art as ethics, and as bio-politics, serves to emphasise the fact that art is always concerned with very practical problems. In this sense Deleuze and Guattari offer a philosophy of art-*work*, and it only begins – *for real* – when we put it to work for *and against* ourselves. [...]

Stephen Zepke, extract from introduction, *Art As Abstract Machine: Ontology and Aesthetics in Deleuze and Guattari* (London and New York: Routledge, 2005) 1–10.

All cities are geological,
they stink of the past
nothing can grow there

here in this mineral desert
we have found the **BLANK SLATE**
that will enable us to start
all imagining anew

Mai-Thu Perret, *The Crystal Frontier*, 2008

SOCIAL ABSTRACTION

Anthony Davies, Stephan Dillemuth, Jakob Jakobsen
There is No Alternative: The Future is Self-Organized//2005

As workers in the cultural field we offer the following contribution to the debate on the impact of neoliberalism on institutional relations:

Cultural and educational institutions as they appear today are nothing more than legal and administrative organs of the dominant system. As with all institutions, they live in and through us; we participate in their structures and programmes, internalize their values, transmit their ideologies and act as their audience/public/social body.

Our view:

These institutions may present themselves to us as socially accepted bodies, as somehow representative of the society we live in, but they are nothing more than dysfunctional relics of the bourgeois project. Once upon a time, they were charged with the role of promoting democracy, breathing life into the myth that institutions are built on an exchange between free, equal and committed citizens. Not only have they failed in this task, but within the context of neoliberalism, have become even more obscure, more unreliable and more exclusive.

The state and its institutional bodies now share aims and objectives so closely intertwined with corporate and neoliberal agendas that they have been rendered indivisible. This intensification and expansion of free market ideology into all aspects of our lives has been accompanied by a systematic dismantling of all forms of social organization and imagination antithetical to the demands of capitalism.

As part of this process it's clear that many institutions and their newly installed managerial elites are now looking for escape routes out of their inevitable demise and that, at this juncture, this moment of crisis, they're looking at 'alternative' structures and what's left of the Left to model their horizons, sanction their role in society and reanimate their tired relations. Which of course we despise!

In their scramble for survival, cultural and educational institutions have shown how easily they can betray one set of values in favour of another and that's why our task now is to demand and adhere to the foundational and social principles they have jettisoned, by which we mean: transparency, accountability, equality and open participation.

By transparency we mean an opening up of the administrative and financial functions/decision-making processes to public scrutiny. By accountability we mean that these functions and processes are clearly presented and monitored, and that they can, in turn, be measured and contested by 'participants' at any

time. Equality and open participation is exactly what it says – that men and women of all nationalities, race, colour and social status can participate in any of these processes at any time.

Institutions as they appear today, locked in a confused space between public and private, baying to the demands of neoliberal hype with their new management structures, are not in a position to negotiate the principles of transparency, accountability and equality, let alone implement them. We realize that responding to these demands might extend and/or guarantee institutions' survival but, thankfully, their deeply ingrained practices prevent them from even entertaining the idea on a serious level.

In our capacity as workers with a political commitment to self-organization we feel that any further critical contribution to institutional programmes will further reinforce the relations that keep these obsolete structures in place. We are fully aware that 'our' critiques, alternatives and forms of organization are not just factored into institutional structures but increasingly utilized to legitimize their existence.

The relationship between corporations, the state and its institutions is now so unbearable that we see no space for negotiation – we offer no contribution, no critique, no pathway to reform, no way in or out. We choose to define ourselves in relation to the social forms that we participate in and not the leaden institutional programmes laid out before us – our deregulation is determined by social, not market relations. There is no need for us to storm the Winter Palace, because most institutions are melting away in the heat of global capital anyway. We will provide no alternative. So let go!

The only question that remains is how to get rid of the carcass and deal with the stench:

We are not interested in their so-called assets; their personnel, buildings, archives, programmes, shops, clubs, bars, facilities and spaces will all end up at the pawnbroker anyway …

All we need is their cash in order to pay our way out of capitalism and take this opportunity to make clear our intention to supervise and mediate our own social capital, knowledge and networks.

As a first step we suggest an immediate redistribution of their funds to already existing, self-organized bodies with a clear commitment to workers' and immigrants' rights, social (anti-racist, anti-sexist, anti-homophobic) struggle and representation.

There is no alternative! The future is self-organized.

In the early 1970s corporate analysts developed a strategy aimed at reducing uncertainty called 'there is no alternative' (tina). Somewhat ironically we now find ourselves in agreement, but this time round we're the scenario planners and

executors of our own future, though we are, if nothing else, the very embodiment of uncertainty.

In the absence of clearly stated opposition to the neoliberal system, most forms of collective and collaborative practice can be read as 'self-enterprise'. By which we mean, groupings or clusters of individuals set up to feed into the corporate controlled markets, take their seats at the table, cater to and promote the dominant ideology.

Self-organization should not be confused with self-enterprise or self-help, it is not an alternative, or conduit into the market. It isn't a label, logo, brand or flag under which to sail in the waters of neoliberalism (even as a pirate ship – as suggested by MTV)! It has no relationship to entrepreneurship, or bogus 'career collectives'.

In our view self-organization is a byword for the productive energy of those who have nothing left to lose. It offers up a space for a radical repoliticization of social relations – the first tentative steps towards realizable freedoms.

Self-organization is:

Something which predates representational institutions. To be more precise: institutions are built on (and often paralyse) the predicates and social forms generated by self-organization.

Mutually reinforcing, self-valorizing, self-empowering, self-historicizing and, as a result, not compatible with fixed institutional structures.

A social and productive force, a process of becoming which, like capitalism, can be both flexible and opaque, therefore more than agile enough to tackle (or circumvent) it.

A social process of communication and commonality based on exchange; sharing of similar problems, knowledge and available resources.

A fluid, temporal set of negotiations and social relations which can be emancipatory – a process of empowerment.

Something which situates itself in opposition to existing, repressive forms of organization and concentrations of power.

Always challenging power both inside the organization and outside the organization; this produces a society of resonance and conflict, but not based on fake dualities as at present.

An organization of deregulated selves. It is at its core a non-identity.

A tool that doesn't require a cohesive identity or voice to enter into negotiation with others. It may reside within social forms but doesn't need take on an identifiable social form itself.

Contagious and inclusive, it disseminates and multiplies.

The only way to relate to self-organization is to take part, self-organize,

connect with other self-organizing initiatives and challenge the legitimacy of institutional representation.

We put a lid on the bourgeois project, the national museums will be stored in their very own archive, the institutes of contemporary art will be handed over to the artists' unions, the universities and academies will be handed over to the students, Siemens and all the other global players will be handed over to their workers. The state now acts as an administrative unit – just as neoliberalism has suggested it – but with mechanisms of control, transparency accountability and equal rights for all.

There is No Alternative: The Future is Self-Organized. *Art and Social Change: A Critical Reader.* Postscript. April 2008: This text can be freely distributed and printed in non-commercial, no-money contexts without the permission of the authors. It was originally conceived as a pamphlet with the aim of disrupting the so-called critical paths and careers being carved out by those working the base structure of the political-art fields. We're aware of contradictions, limits and problems with this text and invite all to measure the content in direct relation to the context in which it may appear. In fact, it has come as no surprise to us that its dodgy legitimizing potential has been most keenly exploited by those it originally set out to challenge. Having let it fly we now invite you, the reader, to consider why it's in this publication/exhibition, whose interests it serves and the power relations it helps to maintain.

There is No Alternative: The Future is Self-Organized. Exhibition Reader (*Microhistorias y Macromundos III – Abstract Possible*) Postscript. December 2010: Given the situation, the global social crisis that we confront on a daily basis, the struggle of comrades everywhere and at all times – we welcome and support the actual self-organization taking place on the streets, in the non/ workplace, the school, the home. In the same breath, if we can be bothered to even draw it, we hold in utter contempt the sad farce, the vacant charade that passes for political action and engagement in the art system. Destroy the museum ...

There is No Alternative: The Future is Self-Organized. *Abstraction.* Postscript. October 2012: In addition to the three strands of abstraction proposed by the editor of this publication – formal economic and social – we would like to add institutional. Which is to say we would like to note the dismal and frustrating 'negotiation' between us, the authors of this text, and the various institutional representatives charged with securing its republication. *There is No Alternative: The Future is Self-Organized* has been freely available online and distributed in various forms since it was first published in late 2005. It has passed through many and varied institutional contexts, some less problematic than others, and yet, here in late 2012, within a publishing framework which claims to be 'not profit making', and primarily aimed at a 'student market' it has found its absolute negation. When, as happened here, institutional representatives present their own reprehensible and exploitative working conditions not as a basis for struggle, opposition and solidarity but as an invitation to join the race to the bottom – the game is over.

Anthony Davies, Stephan Dillemuth, Jakob Jakobsen, 'There is No Alternative: The Future is Self-Organized' (Copenhagen, 12 June 2005), in *Art and Its Institutions*, ed. Nina Möntmann (London: Black Dog Publishing, 2006); reprinted in *Microhistorias y macromundos. vol. 3 – Abstract Possible*, ed. Maria Lind (Mexico City: Instituto Nacional de Bellas Artes y Literatura, 2011) 216–22.

Nina Möntmann
Opacity//2006

The project *Opacity* has been realized as a series of different formats and collaborations, exploring in what way today's art institutions are used and challenged within contemporary artistic processes. The artists Kajsa Dahlberg, Danger Museum (Øyvind Renberg and Miho Shimizu), Markus Degerman, Stephan Dillemuth, Gardar Eide Einarsson, and Sofie Thorsen, and the participating institutions NIFCA in Helsinki, UKS/Unge Kunstnernes Samfund in Oslo, Index in Stockholm, and the Secession in Vienna, made close exchanges in several workshops, an exhibition, panel discussions, a screening and the production of a fanzine. The starting point of the discussions was the observation that institutions underwent several constitutive changes in the aftermaths of the 'institutional critique' of the 1970s, as well as in the 1990s. This becomes apparent in the process of turning the critique initially made against an institution into an institution's auto-critique, as well as in the education of curators, art historians and artists, to which it became an integral part. By this, institutional critique proved to be a method rather than a genre. Today a critique is no longer put up against the institution in order to deconstruct it. Instead, a certain opacity, which has been criticized in the work of powerful institutions, can however be useful on the part of smaller institutions and groups, in order to try out new forms of collaboration between different positions in the art field (artists, curators, academics or activists), and also employ links to other fields, creating an alternative agenda for institutional work. Brian Holmes has talked of a 'tactical necessity of disappearance', practised by groups working on a process-related basis – a strategy that institutions could learn in order to redefine themselves.

The project *Opacity* has been developed in close collaboration between curators and artists. Therefore several workshops have been scheduled. Concepts of autonomy, freedom, internal process and uncertainty have been discussed in relation to opacity, as well as the history of critical and affirmative work, respectively, within institutions.

Regarding the internal perspective of the artist as an involved team mate in cultural production, the question arises: how can an art institution be used from within as an arena or a tool for re-politicization, taking into consideration both the necessary factors of decision and desire? Where do the possibilities lie, and what do the presumed failures tell us about the societal role and reach of the various art institutions?

The project *Opacity* proposed and discussed a collaborative and productive model, which researched current conditions of institutional work and proposed and analysed alternative strategies, be they activist, appropriative, mocking, actual or purely utopian. We wanted to initiate a discussion, trying to imagine an institution as a place for temporary withdrawal, for working in an opaque space behind the scene, as one critical strategy among others within the field of institutional work. With the presumption that the participation of artists in institutional systems shouldn't exclusively be aimed towards the show or display, we instead turned software into hardware and set up a temporary model that includes artistic practice as an operation mode for institutions.

Gallery Tour

Markus Degerman
I have been involved in designing spaces for art institutions for the last couple of years. For *Opacity* I have been working with the interior of UKS and made subtle changes in order to give it a new setting with references which, at least for a while, could function as a resistance to the aestheticization of the art institution. I installed pre-painted white baseboards around the walls of the gallery, a suspended ceiling in the reception room and green dot-shaped marks on the glass doors of the entrance. These are materials which, perhaps because of their everyday connotations, are at the same time both commonly used and paradoxically rarely noticed. They are also interior elements, which have often been disregarded by designers as objects to design and instead left for engineers and technicians to model. Maybe this is also why they are usually among the first elements to be removed when spaces are re-shaped to be more 'designed' and aesthetic.

Danger Museum
For *Opacity* we combined a collage series started during a residency at Sparwasser HQ in Berlin, with pieces that relate to the UKS exhibition space and ideas of public image and credibility. The collages, or so-called concept illustrations, show an imagined opening at Sparwasser HQ. The gallery is presented as a shabby, underground hang-out. Yet in photographs that reconstruct the scenes in the collages, those hip and laidback social moments freeze in clichéd poses.

We further displayed Danger Museum's trademark browsing table of multiples and artists' books. It traces the group's activities from their early days as an independent, mobile initiative, to their current work with established art spaces.

In response to UKS' recently acquired gallery and institutional makeover, we have refurbished one of the lamps from the old gallery bar. The 1970s Vico Magistretti lamp blends in with the industrial chic and ambition of the new UKS, whilst being a historical relic for the gallery's audience.

UKS' new image is further addressed in a collage that places the viewer behind the foyer desk and in the receptionist's personal space, contrasting with a sleek gallery interior.

Kajsa Dahlberg

In my video *20 Minutes (Female Fist)* I have been interested in groups who are working politically while being outside any given, or pre-existing, political framework. Who is politically active without being politically organized in a conventional way?

The video consists of an interview with a member of a lesbian activist group. She speaks about a lesbian-separatist porn film project and about the necessity of creating separate rooms in order to build up and define one's own culture. 'These are fragile rooms, but a place where one has the chance to find a position rather than just be hurled around in a society where one feels weird and out of place.' She also talks about not wanting dialogue, as a political strategy.

Most of the film is shot with the lens cap still on the camera, but ends with a silent scene from a lively public place in Copenhagen. Here the story becomes a way of charging the image of the 'normal' public place with different meanings.

Besides having a personal interest in both political activism and lesbian identity, I'm interested in how both formally and ideologically one could make a film about a group whose whole idea is to refuse to be represented or defined. Conceptually the project is an investigation of how one can use the medium of video, in unsullied terms, in forms not already associated with (for instance) the media's oppressiveness toward lesbians. What images and sounds could be produced which would distort the possibility for an acknowledgement as such? And how does one find a way to talk about this quite opaque political activism, without necessarily making it more transparent?

Stephan Dillemuth

I have built a façade that resembles the generic retail store, now often obsolete and taken over by 'alternative galleries' and project spaces. Despite the precarious nature of those spaces, its exterior is richly decorated with shells, pearls, snails, mushrooms and UKS-related paperwork, like files and leaflets.

This façade is merely a dummy, but it seems to have an inner agenda, at least the cardboard cannon that points out into the public implies that there is warfare going on. But what does the cannon protect? There is a secret staircase to the basement, there are broken champagne bottles of highest quality, and a light that flickers in the dark …

Sofie Thorsen

The slide-projection *We used to run an art space just across the street from here* takes its departure point from the storefront typical of small-scale artist-run and independent spaces, and works around the idea of the façade as a space that is communicative towards a public. Images of such an entrance situation, with a shop window and a door towards the street, alternate with a short, model-like story about a small independent art space, without the town or the space being specified. Neither do the images show the space itself. The story is rather simple, but addresses issues such as gentrification of neighbourhoods, strategies and effects of self-organization, and the spaces in which this can happen. Although the same few images repeat themselves throughout most of the piece, towards the end images of entrances to Viennese post-war social housing, decorated with mosaics of urban construction sites, are mixed in. This is an art in public space with a political and educative purpose, and represents an opposition to the self-organized, individual practice of opening and defining your own space as an emerging artist.

Gardar Eide Einarsson

The wall text is a quote taken from one of the latest books by Philip K. Dick. I was interested in the idea of the paranoiac's take on institutional critique (and societal institutions in general). In a way, that is anyway always the reactionary defence against the pointing out of any kind of institutional problematics ('you are inventing problems', etc.); the paranoiac knows that he or she might be inventing problems but also knows that s/he might equally well be right. The latest writings of Philip K. Dick can be regarded as a conversation with himself as to whether or not he is delusional, or just very perceptive.

Nina Möntmann, 'Opacity: Current Considerations on Art Institutes and the Economy of Desire' (including statements by the artists), in *Art and Its Institutions*, ed. Nina Möntmann (London: Black Dog Publishing, 2006); reprinted in *Microhistorias y macromundos. vol. 3 – Abstract Possible*, ed. Maria Lind (Mexico City: Instituto Nacional de Bellas Artes y Literatura, 2011) 206–14.

Irit Rogoff
'Smuggling': An Embodied Criticality//2006

This is a collaborative project between the British theorist Simon Harvey, who has developed its theoretical framework,[1] the Turkish video artist Ergin Cavusoglu, who has been working as an artistic researcher into the practices of smuggling[2] and myself, operating both academically and curatorially. It is our endeavour, which we share with so many others at this moment, to understand our work as a vehicle for the production of new subjects in the world. We also share the recognition that the subjects and forms we have inherited neither accommodate the complex realities we try to live out in the present, nor the ever more attenuated ways we have of thinking about them.

The term 'smuggling' here extends far beyond a series of adventurous gambits. It reflects the search for a practice that goes beyond copulative conjunctions such as those that bring together 'art and politics', 'theory and practice' or 'analysis and action'. In such a practice we aspire to experience relations between the two as a form of embodiment, which cannot be separated into their independent components. The notion of an 'embodied criticality' has much to do with my understanding of our shift away from critique and towards criticality, a move that I would argue is essential for the actualization of contemporary cultural practices.

Briefly, this is a shift away from a model which says that the manifest of culture must yield up latent values and intentions through endless processes of investigation and uncovering. Using literary and other texts, images and other forms of artistic practice, Critical Analysis attempts to turn the latency of hidden conditions, unacknowledged desires and power relations into a cultural manifest. Using the full range of structuralist, post-structuralist and 'post-post-structuralist' tools and models of analysis we have at our disposal, we have been able to unveil, unravel, expose, lay bare the hidden meanings of cultural circulation and the overt and covert interests that these serve. But there is a serious problem here, as there is an assumption that meaning is immanent, that it is always already there and precedes its uncovering.

Criticality
But as we have moved to engage increasingly with the performative nature of culture, with meaning that *takes place* as events unfold, we need also to move away from notions of immanent meanings that can be investigated, exposed and made obvious. For some time we thought that a teaching practice that exposes what lies beneath the manifest, and a learning practice that entails a guided

'seeing through' things, was what was required. That it will somehow counter any inherent naïveté by helping students work against naturalized assumptions – what we conventionally termed in education 'being critical'. While being able to exercise critical judgement is clearly important, it operates by providing a series of signposts and warnings but does not actualize people's inherent and often intuitive notions of how to produce criticality through *inhabiting* a problem rather than analysing it. This is true across education, whether theoretical or practice oriented. It is equally true of experiencing art and other aspects of manifest culture. Within this shift we have had to be aware not only of the extreme limitations of putting work in 'context', or of the false isolation brought about by fields or disciplines, but also of the following factors:

1. Meaning is never produced in isolation or through isolating processes but rather through intricate webs of connectedness.

2. Participants, be they audiences, students or researchers, produce meaning not simply through the subjectivities they project onto works whose circuits of meanings they complete, but through relations with one another, and through the temporality of the event of the exhibition, class, demonstration or display.

3. College courses, artworks, thematic exhibitions, political publications and other forums dedicated to making culture manifest, or work to re-produce them into view, do not have immanent meanings but function as fields of possibilities for different audiences, in different cultural circumstances and wildly divergent moods, to produce significance.

4. In a reflective shift from an analytical to a performative function of observation and participation, we can agree that meaning is not excavated for, but rather, *takes place in* the present.

The latter exemplifies not just the dynamics of learning from, looking at and interacting with artworks in exhibitions and public spaces but echoes also the modes by which we have inhabited the critical and theoretical over the recent past. It seems to me that within a relatively short period we have been able to move from criticism to critique, and to what I am calling at present criticality. That is, we have moved from criticism, a form of finding fault and exercising judgement according to a consensus of values, to critique, which examines the underlying assumptions that might allow something to appear as a convincing logic, to criticality, which operates from an uncertain ground of actual embededness. By this I mean that criticality, while building on critique, wants

nevertheless to inhabit culture in a relation other than one of critical analysis; other than one of illuminating flaws, locating elisions, allocating blame.

But what comes after the critical analysis of culture? What goes beyond the endless cataloguing of the hidden structures, the invisible powers and the numerous offences we have been preoccupied with for so long? Beyond the processes of marking and making visible those who have been included and those who have been excluded? Beyond being able to point our finger at the master narratives and dominant cartographies of the inherited cultural order? Beyond the celebration of emergent minority group identities, or the emphatic acknowledgement of someone else's suffering, as an achievement in and of itself?

What interests me in 'criticality' (and I am aware that this is a contingent and not entirely satisfactory term, not least because it is already occupied with various meanings I am not much interested in – but at the moment it is the best I have at my disposal) is that it brings together that which is being studied and those doing the studying, in an indelible unity. Within what I'm calling 'criticality' it is not possible to stand outside of the problematic and objectify it as a disinterested mode of learning. Criticality is then a recognition that we may be fully armed with theoretical knowledge, we may be capable of the most sophisticated modes of analysis but we nevertheless are also living out the very conditions we are trying to analyse and come to terms with. Therefore criticality is a state of duality in which one is, at one and the same time, both empowered and disempowered, knowing and unknowing – thus giving a slightly different meaning to Hannah Arendt's notion of 'we, fellow sufferers'. So it would seem that criticality is in itself a mode of embodiment, a state from which one cannot exit or gain a critical distance but which, rather, marries our knowledge and experience in ways that are not complimentary. Unlike 'wisdom', in which we supposedly learn from our experience, criticality is a state of profound frustration, in which the knowledge and insights we have amassed do very little to alleviate the conditions we live through. So, you might well ask, what is the point of it? Well, I would answer, the point of any form of critical, theoretical activity was never resolution but rather heightened awareness, and the point of criticality is not to find an answer but rather to access a different mode of inhabitation. Philosophically we might say that it is a form of ontology that is being advocated, a 'living things out', which has a hugely transformative power, as opposed to pronouncing on things. In the duration of this activity, in the actual inhabitation, a shift might occur that we generate through the modalities of that occupation rather than through a judgement upon it. That is what I am trying to intimate by 'embodied criticality'.

But there is an actual project to hand, an actual engagement with the practice of curating, an attempt to produce it as an embodied criticality. So first then, why invoke the notion of smuggling in relation to the curatorial?

Put simply, I would say that it tallies with several of our major concerns at present. Obviously, within a European context, the preoccupation with migration, with the sanctioned and unsanctioned movements of people and the huge political implications that this movement is producing in terms of reactions, hostilities, fears, policies, false economies, etc., is so obvious that it does not really require much elucidating. Thinking of events in England and France over the past year (from the deaths of Chinese migrant workers at Morecombe Bay in the winter of 2004 to the riots in the banlieues of Paris in the autumn of 2005) and the frenzy of soul-searching, denial, social policy and legal responses these elicited – thinking of these, we have to agree that this movement of people has resulted in far greater shifts than obvious demographics, and that it is producing a necessary though thoroughly uninvited reconceptualization (albeit sometimes through negation) of notions of rights, citizenship and belonging. In which case I would argue that 'smuggling' is a potent model through which to track the flights of knowledge, materials, visibility and partiality, all of whose dynamic movements are essential for the conceptualization of new cultural practices. In addition, and equally importantly, I want to see if 'smuggling', with its necessary 'shadow play', can be an active, political mode of 'being in the world' to paraphrase Merleau-Ponty; if it can be the mode of artists, curators and criticality itself.

At the heart of 'smuggling' is obviously contraband, its materiality and its facticity. And one of the questions we need to ask is how do critical subjectivities intersect with contraband and what new forms of critical empowerment come out of this? In addition we would want to ask whether smuggling enables communication, and if we can conceive and materialize a new theory of mobility out of it, one that links it more closely to the notions of 'fieldwork', i.e. the work *of fields* rather than that which is located *in fields*, a term we are privileging at present as an understanding of our practice.

For some time now we have been differentiating between 'curating', the practice of putting on exhibitions and the various professional expertises it involves, and 'the curatorial', the possibility of framing those activities through series of principles and possibilities. In the realm of 'the curatorial' we see various principles that might not be associated with displaying works of art; principles of the production of knowledge, of activism, of cultural circulations and translations that begin to shape and determine other forms by which arts can engage. In a sense 'the curatorial' is thought, and critical thought at that, that does not rush to embody itself, does not rush to concretize itself, but allows us to stay with the questions until they point us in some direction we might not have been able to predict.

What I am trying to get at is a move away from intention, illustration, exemplification – a move that does not go in the direction of furnishing good, or

not so good, ideas with a rich set of instances. Because the conventional work of curating that followed along these lines simply reproduced existing subjects in the world, be these 'Conceptual Art 1966–1978' or 'The Fantasy of the Urban' or 'The Late Rembrandt' or whatever other stylistic or social/historical subjects are in circulation, pre-packaged and ready for use. In addition there are some highly performative instances, instances that perform certain aspirations and inaugurate the subjects behind them into worlds they would like to inhabit; like those I have been seeing around Eastern Europe such as 'Vilnius/New York' or 'Budapest/New York', or elsewhere 'Tokyo/Paris', whose raison d'être has to do with a desire to enter and inhabit a particular world which they admire or to which they aspire. While seemingly very banal, I think these are actually more interesting than the pre-packaged ones, for they point to some unspeakable desire, and what people desire is always more interesting than what they consume, consciously and knowingly.

Moving to 'the curatorial' then, is an opportunity to 'unbound' the work from all of those categories and practices that limit its ability to explore that which we do not yet know or that which is not yet a subject in the world.

I have for some years been preoccupied with geographies and territorialities, with boundaries and circulations, always keeping in mind Jacques Derrida's belief that boundaries, whether they are narrow or expanded, do nothing more than establish the limits of the possible. Thus, and perhaps most importantly for my purposes, I have been trying to envisage what an 'unbounded', an unbounded space, an unbounded practice, an unbounded knowledge, might be. Trying to think these issues alongside the curatorial, I would like to introduce the notion of 'smuggling' as a model and subject for curatorial thought and activity. On the one hand it will allow me to set up a series of dynamics between curating, critical thinking and the actualization of both emergent issues and emergent operating modes around us. On the other hand it is an actual project which a group of us are developing at the moment; theorist Simon Harvey, artist Ergin Cavusoglu, myself and members of a new programme at Goldsmiths called 'Research Architecture', and it is one which we hope will become an actual exhibited project. In this instance we are talking about 'smuggling' as both our subject matter and also as our operating methodology. We are not trying to illustrate 'smuggling' through various works of art but to produce it as an operational device which allows us to bring our speculations concerning global circulations, cultural difference, translations, legitimacies, secure inhabitation, visibility and the queering of identity into play as they circle and hopefully produce 'smuggling' as a new subject in the world.

So what are the principles by which this notion of' smuggling' operates? Firstly it is a form of surreptitious transfer, of clandestine transfer from one realm

into another. The passage of contraband from here to there is not sanctioned and does not have visible and available protocols to follow. Its workings embody a state of precariousness which is characteristic of many facets of our current lives.

Smuggling operates as a principle of movement, of fluidity and of dissemination that disregards boundaries. Within this movement the identity of the objects themselves is obscured; they are not visible, identifiable. They function very much like concepts and ideas that inhabit space in a quasi-legitimate way. Ideas that are not really at home within a given structure of knowledge and thrive in the movement between things and do not settle into a legitimating frame or environment. The line of smuggling does not work to retrace the old lines of existing divisions, but glides along them. A performative disruption that does not produce itself as conflict. In Ergin Cavusoglu's video installation *Downward Straits* (2003), a large dark vessel glides along the waters of the Bosphorus in the middle of the night, the brilliant lights of Istanbul in the background emphasizing its own blank darkness. The ship is a smuggler's vehicle, one of the many that wait for its chance in the night when the pilot boats that guide the bona fide vessels through the channel that connects the Black Sea with the Sea of Marmara are not operating. Instead of the guidance of the experienced pilots, these ships navigate with a shared Citizen's Band radio channel in which they warn each other of the many obstacles that await in the dark. It is surprising to have smuggling presented to us as a collaborative enterprise, since it is most normally shown as the domain of unruly individuals. But what has really interested me in this evocation of a smuggling practice is how it does not breach a line, does not turn it into a 'border' in the classic sense, but traces a parallel economy, going over its lines again and again and in the process making them an inhabitation, expanding the line of division into an inhabited spatiality that someone else might also occupy, slip along until the opportune moment comes along to slip over. As an exhibition practice this form of smuggling, which traces and retraces the lines of its supposed boundaries of exclusion, allows the curatorial to become a cross-disciplinary field without any relation to a master discipline (art exhibitions enriched by contextual or other materials), to put entities in a relation of movement to one another.

In the latest Sarai reader, *Sarai 05*, there is a quite remarkable piece by Lawrence Liang entitled 'Porous Legalities and Avenues of Participation'. In it he produces a long quote from Raqs Media Collective, who are part of Sarai, concerning the role of networks and seepages which are performed by migrants, hackers, pirates, aliens and squatters. These people, says Raqs, travel with the histories of the networks they were part of and are equally able to perform the insistent, ubiquitous insider knowledge of today's world.

How does this network act and how does it make itself known in our

consciousness? We like to think of this in terms of seepage. By seepage, we mean the action of many currents of fluid material leaching onto a stable structure, entering and spreading through it by way of pores, until it becomes a part of the structure, in terms of its surface, and at the same time continues to act on its core, gradually to disaggregate its solidity. To crumble it over time with moisture. In a wider sense, seepage can be conceived as those acts that ooze through the pores of outer surfaces of structures into available pores within the structure, and result in a weakening of the structure itself. Initially the process is invisible, and then it slowly starts causing mould and settles into disfiguration – and this produces an anxiety about the strength and durability of the structure.[3]

One of the most interesting things that 'smuggling' as a model allows us to do is rethink the relations between that which is in plain sight, that which is in partial sight and that which is invisible. Here we might think of the logic of street markets, of the jumble of things that are piled in them, in part legally obtained and in part less legally obtained. Objects whose journeys to their present location cannot be told in an overt and straightforward way – in England, euphemistically characterizing their quasi-legality, one says 'they might have fallen off the back of a lorry'. But where did they fall off, who pushed them off and who picked them up? What is so rich about the notion of 'smuggling' is that the entire relation to an origin is eroded and the notion of journey does not follow the logic of crossing barriers, borders, bodies of water, but rather of sidling along with them, seeking the opportune moment, the opportune breach in which to move to the other side. In that street market all these objects, their origins obscured, lie entangled in each other side by side, their journeys only partially visible, and they produce a new relation between themselves. What came in the back of a lorry from Afghanistan, or at the bottom of a suitcase from Bangladesh, or in the intestines of a human 'mule' from Colombia, or the pirated tapes and disks of western entertainment industries, all begin to develop another relationality to one another that could never be accommodated through nationally located cultures or conventional commodity circulations.

Recently being introduced to the dissemination patterns of the activist publication 'Make World', I understood that their global movement, in the suitcases and rucksacks of those who shared their values and aspirations, owed its logic and its exceptional effectiveness to smuggling. Here, in the same way that smuggled contraband undermines inherited systems of value, it also demands an engagement with the law. It asks how contraband is implicated in systems of law; can these be put to flight? In fact, in a broader sense it demands that we ask whether law is, by definition, bound to contraband activity?

We have in recent years spoken much and often of not wanting to set up conflictual and binary engagements, of not wanting to have a fight with the art

academy in the name of a progressive or revolutionary practice, of not wanting to battle it out with the museum for greater accessibility (not least because this allows for 'populism' to gain an upper hand) or to waste time on battles between what is sanctioned 'inside' the art institution versus what takes place more organically 'outside' within the public sphere. Instead we have opted for a 'looking away', or a 'looking aside', or a spatial appropriation, which lets us get on with what we need to do or imagine, without reiterating that which we oppose. In theoretical terms we have moved from criticism to critique, to criticality, to the actual inhabitation of a condition in which we are deeply embedded as well as being critically conscious. 'Smuggling' exists in precisely such an illegitimate relation to a main event or a dominant economy, without being in conflict with it and without producing a direct critical response to it. And it is through such a practice that less legitimate, less valued materials – materials such as tele-novelas and Bollywood movies shown far way from their original cultures and providing some identificatory text, some comfort for the global poor or the global displaced – are suddenly and unexpectedly allowed to address the big questions – questions of immigration, of the cross-cultural, of how one culture infiltrates another. In some of Mike Nelson's installation works, in the prolonged passage between the room-like spaces he sets up, we encounter small traces of the daily life of migrant communities within the great urban megalopolises. The wall calendar of some far-off home country here, a prayer rug there, the occasional sign for travel, or money wiring or internet contact, the indications of a mini-cab office or some other occupation which has the easy access to employment that so many migrants need. Here we begin to recognize that the traces are everywhere, that our daily urban environment is fully inhabited by them, that those who are not recent immigrants also inhabit the sign systems of displacement and can read them, are habituated to them, quite as well as they can, their familiar inherited ones. This is an act of smuggling, an embodied criticality acting outside structures of representation and objectification.

Here is Melek Ulugay, one of the heroines of Kutlug Ataman's *Women Who Wear Wigs* (1997) describing her time on the run from the police in Turkey, who thought she was a terrorist on the run, rather than a left-wing sympathizer, courier, etc. which she actually was. Her journey, which lasted many years, and is described with a reflective self-irony, included various disguises and pretences whose point, it would seem, was never to mislead anyone.

I am quite convinced of looking like a peasant woman, but I don't think I can fool the villagers. Because later we went to Antep. We're hiding-out in the house of a smuggler. He's smuggling between Turkey and Syria. So we went to his house. That first day there were about five of us. It was a house in the Armenian quarter of

Antep, with a courtyard. It was actually the annexe to an old church, and so all the walls were covered with crosses. Anyway, so we're there, having a cup of coffee each. The smuggler asks, 'How are you?' and welcomes each one of us separately, as is the custom in this region. Then he looks at me and says, 'Sister, you're in disguise, aren't you?' I am shocked. I mean, as a smuggler, he could not have better interpreted and verbalized my appearance! It was a very nice way of saying, 'You're not a peasant!' What I mean to say is, no matter how hard you try to look like someone else, people always see, they always detect the real person hiding behind.

What Melek Ulugay's hapless adventures smuggle into the public sphere is not goods, or subversive practices, or even ideological stances, as much as empathies and identifications and understandings of the immense political potential hidden within the small gestures of everyday politeness. Courteous smugglers, empathetic prostitutes, beguiled students, knowing peasants, populate her narrative as they come to inhabit 'the political' in a Turkey in turmoil, without uttering a single political statement.

Spatially too, 'smuggling' is rife with possibilities, as it helps us to unthink those binaries of inside the museum and outside in public space; and as for all its purported secretiveness, it embodies a state of 'unboundedness'. Working with 'Research Architecture' we envisage a project to design a containing space – one that echoes the containers in which things move around, and at the same time one that opens out to the world – framing the exhibition in that duality of partial visibility which is the status of smuggled goods, people, ideas and concepts, in its points of arrival.

In effect, smuggling produces subjects and objects and practices that exist in the realm of the 'untaxable'. And by this I mean a great deal more than that which escapes the regimes of levied tax. The 'untaxable' is a mode of eluding existing categories and being unable to operate with them, and as such it is not a resistance but an embodied criticality. In its array of partial splits and internal incoherences, the 'untaxable' of smuggling provides the inhabitation of a category of refusal.

I hope that I've been able to point to some of the ways in which I think 'the curatorial' operates as, hopefully, a mode of smuggling. Of how the subject matter and the operating modes dovetail one another, dance and swish their skirts around one another, so that they never settle into illustration, never settle into containment and stasis. In smuggling we may have an actualized manifestation of a theory of 'partial knowledge' and of 'partial perception' that we have long been looking for.

1 Simon Harvey, 'Smuggling – In Theory and In Practice', unpublished Ph.D dissertation (University of London, 2004).

2 Ergin Cavusoglu, *Point of Depature* (Film and Video Umbrella, 2006).

3 Lawrence Liang, 'Porous Legalities and Avenues of Participation', *Sarai Reader 05: Bare Acts* (2005).

Irit Rogoff, 'Smuggling: An Embodied Criticality', in *Under Construction: Perspectives on Institutional Practice* (Cologne: Verlag der Buchhandlung Walther König, 2006); reprinted in *Microhistorias y macromundos. vol. 3 – Abstract Possible*, ed. Maria Lind (Mexico City: Instituto Nacional de Bellas Artes y Literatura, 2011) 186–203.

Mai-Thu Perret
The Crystal Frontier//2008

OXO

The more horses you put to, the faster your progress – not of course in the removal of the cornerstone from the foundation, which is impossible, but in the tearing of the harness, and your resultant riding cheerfully into space.
Franz Kafka

OXO

NEW PONDEROSA YEAR ZERO is the true life story of a group of girls, in their twenties and thirties, who decided to follow the activist Beatrice Mandell and create an autonomous community in the desert country of New Mexico. While the reasons for their discontent with mainstream society were different for each of the girls, they all shared the desire to give this unlikely social experiment a try. The decision to make it all-female did not stem from their personal hatred of men, but from Mandell's conviction that a truly non-patriarchal social organization had to be built from the ground up, starting with a core group of women who would have to learn how to be perfectly self-sufficient before being able to include men in the community. Mandell's theories were a mixture of classic feminist beliefs about the oppression of women, and what could best be described as her psychedelic-pastoral tendencies.

The number of community members oscillated between eight and a dozen, since participants were always free to leave and come back. This openness was of course the cause of a great number of organizational difficulties, but it probably also explains why New Ponderosa managed to last beyond the euphoria of the

beginning. The desert can be an exceptionally hostile environment, even if you happen to live by a well, and the enormous amount of work it took to start the first crops and keep the livestock alive explains a lot of the tensions on the ranch. There were also the inevitable personal conflicts that people experience when living together in isolated environments.

The goal of the participants of New Ponderosa Year Zero was to rely on the crops they grew and the livestock they raised (a few cows and palomino ponies) for their survival. Of course, the income from the first year had to be supplemented by personal money the girls had saved before coming there, and by some donations from a few supporters who had stayed back in the cities. This agrarian lifestyle was also to be supplemented from the profits from their production in the decorative arts, which from the beginning played an essential role in the project.

oxoxoxo *Beatrice's diary, March 24th entry* oxoxoxoxoxoxoxoxoxoxoxoxoxoxoxoxoxoxo

THE ARTS AND CRAFTS MOVEMENT

We believe we can construct our own personal Eden, here and now, through a return to both nature and craft.

We believe that the rejection of craft in our post-industrial society is also a rejection of the part women play in this society. We refuse to be instrumentalized operators of man's machines – secretaries and factory workers, bus terminal operators and disembodied voices of automated clocks. We've all come to the conclusion – through group discussion, consciousness-raising, and our own reading of history – that until we came here we were in fact already machines, sophisticated extensions of computers and automated devices. We feel we were closer to the machines we operated than to the CEOs up there who harnessed our power.

Probably our greatest freedom lies in the absolute unity of the hand and the aim that drives it. Each bedspread or lamp or wicker chair is a protest against the badly turned out factory goods American towns are flooded with daily.

Sitting on the porch at sunset I can see the mountains far in the distance, everything is perfectly still, and the only things moving are the horses grazing next to the barn. I am working on a new bedspread today, something embroidered

with geometric motifs. When I get tired of my work I can go and check on my horse, my palomino pony.

I think of new patterns to work on every day.

oxoxoxo *Marina's diary, April 10th entry* oxoxoxoxoxoxoxoxoxoxoxoxoxoxoxoxoxoxoxo

'WE ARE BUT OLDER CHILDREN'
(LEWIS CARROLL, *ALICE*)

I think we are the true psychic pioneers of the American West. I think what we are building here is more than just one isolated example of people dropping out of wider society. If we can build a farm and an alternative system of exchange and production, then it is not only for our private enjoyment and survival. It might serve as a model, as something for other dissatisfied people like ourselves to emulate and reproduce, in their own way and time. If we can invent something, then it means that other people will be able to do it too.

Yesterday I went riding out to the river on my own, for a little break from the group. On the way back I stopped to let the pony rest. I was looking for that cactus Paula was telling us about, the one you can use like magic mushrooms. I didn't find the right plant, but I found a dead tarantula, it must only have been there for a short time, it looked fresh and almost alive.

I'm almost pathologically afraid of spiders, but this time I decided to face my fear and look carefully at the thing. It was black and very hairy, with a pinkish cast. Dead and still, it didn't look half as scary as the small city spiders that used to make me afraid of going to sleep in the dark when I was a child.

I can't stop thinking about this dead beast now. I'm trying to figure out what it is in spiders that scare me so much. I used to have nightmares about them crawling over my face at night, and I would try getting my mother to let me sleep in her bed, to protect me from them. She almost always refused, and I think she never once understood how terrified I was, or how she was letting me down. I realize now that I've always associated spiders with her rejection. In dreams where my mother rejects me, she is the black spider.

Since we are going to start making rugs and decorations, I think I would like to

start working on a series of spiders. There is something logical for me in trying to work over my fear of my mother and my feelings for spiders in objects of everyday use. These rugs should look like toys, I think, like playthings for little girls to learn not to be afraid of the dark any more.

oxoxoxo *Marina's diary, May 10th entry* oxoxoxoxoxoxoxoxoxoxoxoxoxoxoxoxoxoxo

Very sad day today. A second cow died. I'm not exactly sure what to do or how to help them, nothing in my books seems to really make a difference. Sometimes in moments like this I get scared and feel like maybe we weren't really meant to come here, that the whole enterprise is doomed. Maybe we should try to recruit a new girl who has worked on a farm, someone from the country to teach us city girls.

Amazing discussion with the others last night. Trying to solve some of the building questions, and to plan ahead for the extension of the community. Debating how to share the work and how to respect each other's personal space. We came here to be free, and I feel that rows of little bunk beds in parallel lines are just not the right solution.

Little glass bungalows, with solar energy panels on flat roofs, arranged on a star shaped axis, leaving each of the girls free to choose who they live with, and to organize their private time as they wish. The bungalows would be entirely devoted to the business of living and offer a full view of the valley we all came here for. At the centre of the star, a large communal building with a dining room overlooking the mountain, a couple of rooms for group work such as weaving and a large kitchen and laundry room.

But I'm dreaming.

WHY DID I LEAVE? WHY DID I COME HERE?

LET ME TELL YOU A STORY

I LEFT BECAUSE I WAS TIRED OF

PEOPLE LIKE YOU

I THINK

SOCIETY IS A HOLE

IT MAKES ME LIE TO MY FRIENDS

AREN'T YOU SO FUCKING TIRED

OF WAITING?

I UNDERSTAND THE WORD

SECESSION

I KNOW THE MEANING OF

REVOLUTION

I WAS TIRED OF BEING ALONE

ECHO CANYON

In the ruins of the convention centre they run for their lives looking for the space that will take them back to their original position. When you rotate the head of the spider, third from the left on the blue-lit panel, a door opens on the inside of her head and she remembers which song to sing. Feral children who seem to have been here forever haunt the underground caves beneath the floating pavilion. I know this because from the first time I came here I have often tried to enter and been scared shitless by their meaningless moaning. It strikes me that they might be happier than we are. There is something mineral about these creatures, who have never received the blessing of instruction. They hang together upside down from the ceiling like bats, or is it me who has simply lost my ability to walk underground? As though you were about to disclose some momentous and yet (or is it 'and hence') rarely uttered truth, the first time you brought me here you told me it was something all creatures were born able to do, and which I had lost growing up in the anaesthetic atmosphere of the city. Clearly I thought this was a lie and another one of your tricks, trying to take advantage of my impressionable mind deranged by solitude and isolation. Now I am no longer sure. I would like to return to the surface but realize that once again it is but another of those labyrinths you have contrived. Underground beneath the second house they say there is a secret world of caves, shards of crystal as big as baseball bats hang down from the ceiling and there is water of a special kind that quenches all thirst and also all desire, and they say you have made up all these stories to placate your followers. Imagine for an instant that the meaning of all the images could be reshuffled and the knife would mean the mother and the rat the silver chain. Clearly I thought this was a lie and another one of your tricks, trying to take advantage of my impressionable mind deranged by solitude and isolation. Now I am no longer sure. When you rotate the head of the puppet a door opens on the inside of your head and you remember which song to sing.

The capitalist is interested only in the different machines of production that he can connect to his machine of exploitation: your arms, if you are a janitor; your brains, if you are an engineer; your looks, if you are a cover girl. I was a factory worker and I was a stripper and before that, before I started this gradual process of dropping everything out, of dropping out of everything, I was a good student at a good school. The struggle accelerates and you realize that the name tags you had for your sense of oppression, loneliness and alienation were actually just that, name tags and not concepts. I watched them crumble before my eyes, everything I thought I had learned in the name of the intellect and not of experience and who was I really helping painting cars in a factory in the name of a class struggle that still only saw me as a girl. From there on to the seedier clubs on the East and then the West Coast, and that wasn't giving me power either, but at least I was finally getting closer to what it feels like for a girl. I remember getting a kick out of feeling hands sticking money into my panties as I was throwing my ass toward their face. Dialogue with a consumer product, that's what it felt like, like when you are stripping an orange, slowly working in a spiral with the knife, like those tacky little Russian dolls we used to get for Christmas, and you just keep removing layers until you've reached the emptiness inside.

And then one day I met Marina and she was always drawing these buildings, real castles in the air, diagrams for powerless structures, diagrams for free schools, communal housing and slumber parties, the lineaments of a concrete utopia. Something like a qualitative leap happens when from two hands you jump to four, and suddenly we were revolutionaries.

Can anybody really imagine how hot it is up here? Burning by day and freezing by night, and our plans for the buildings keep changing and we're still living in the barn, a band of little girls stalled right at the door of the castle, dazed and thirsty. Marina drives us crazy with her drawings that seem to change every day, and at the same time I can't help but accept that there is a certain logic to the way things are happening here, to the way we are starting small and all working on these tiny, movable projects like the furniture and the horses and the tapestries. We are so excited by all the possibilities, and afraid of the foreclosure that will inevitably come once we've committed to a particular design.

oxoxoxo *Partially destroyed legal note pad. Date and author unknown.*

All cities are geological, they stink of the past. Nothing can grow there. Here in this mineral desert we have found the blank slate that will enable us to start all imagining anew. The city landscape is closed, so we sought the open plain, stretching as far as the eye can see. In this antediluvian land nothing draws us toward the past. We are starting with a tent and soon there will be a house and a village and then a city.

Our bodies free to bask in the sun, to be blown about by the wind, we will comprehend our relations and renovate nature, claiming back the life that has been stolen away from us, mutilated by patriarchy and capital, our bodies no longer cut off from each other.

oxoxoxo *The next three entries are records of daily activities.*
 Date and author unknown.

7.00	Wake up.
7.10	Morning ablutions at the well.
7.30	Feed horses and cows.
8.30	Breakfast in the kitchen, most of the others are up.
9.00	Work, either on the farm or on the new building.
12.00	Prepare lunch with the other girls.
12.30	Eat lunch, outside on the terrace.
1.30	Too hot to work outside, reading and drawing in the library.
3.30	Work, either on the farm or on the new building.
5.30	A ride in the desert.
7.30	Yoga and pranayama session.
8.00	Eat dinner, outside on the terrace.
9.00	Group discussion, planning ahead.
10.30	Bedtime.

6.00	Swallow a first handful of mushrooms.
7.30	Walk over to the isolation bungalow.
9.00	Nightfall. Switch on black lights and sit upright trying not to concentrate.
11.00	Clouds. Metal dragons followed by an expanse of mercury, curvaceous growths, an angry mob running to the hanging of the king on the *Place de Grève.*
6.00	Daybreak. Swallow another handful.
11.00	Spiders. Exhausted. There are chains coming out my eyes and I must take the greatest pains to avoid them knotting up.
1.00	A grid now covers the entire surface of the desert.
3.00	I know the others are here, somewhere, but I cannot hear them.
5.15	Anxiety, I suddenly think about my mother.
6.00	Back inside I lay my head on the pillow and fall asleep instantly.

OXO

5.30	Wake up.
5.45	Feed the horses.
6.00	Breakfast and make sandwiches.
6.30	Saddle horses.
6.45	Ride off toward the mountains.
12.00	Lunchtime. There are white flowers on the bushes.
2.30	Lumberyard. Order wood for the new bungalows.
3.30	Ride back & a long discussion on functionalism.
9.30	Home. Unsaddle and feed the horses.
10.00	Eat dinner, outside on the terrace.
11.00	Redraw the room plans with Dominique.
1.00	Fall asleep, exhausted.

oxoxoxo *Beatrice's notebook. Date unknown.* oxoxoxoxoxoxoxoxoxoxoxoxoxoxoxoxo

'Seriality' defines, according to Jean Paul Sartre, the repetitive and empty character of a mode of existence arising from the way a practico-inert group functions. What we aim for through our multiple activities, and above all through the assumption of responsibility with regard to oneself and to others, is to be disengaged from seriality and to make individuals and groups re-appropriate the meaning of their existence from an ethical and no longer technocratic perspective. It is a matter of bringing forward the sort of activities that favour an assumption of collective responsibility, and yet are focused in a re-singularization of the relation to work, and, more generally, personal existence. The institutional machine that we posit doesn't simply remodel the existing subjectivities, but endeavours, instead, to produce a new type of subjectivity.

oxoxoxo *Incomplete letter found with Marina's papers, date and author unknown.*

I am in P. I live in an attic. On the fifth floor. It's already spring, the window is open. The traffic is awful. Yesterday, I was watching people dance and I really wanted to be home and not here.

It's true, you're right, the streets are interesting when there is traffic, and at night when they are lit up. As for the advertising, I was very disappointed. I expected something much better, it is so mediocre that there really isn't anything to say about it. The neon signs are not bad, not really because of what they promote but because there are so many of them and they're well fabricated. I couldn't find the poster you told me about though. In general, from an artistic point of view, P. is very provincial. On the other hand, the bridges and the escalators are very beautiful. For some time there has been a growing demand for everything new, and now they've started selling the kind of novelty fabrics we love to imitate at home, but there are also a lot of geometric patterns. All the rooms are covered with this style of wallpaper. I'd like to send you catalogues, but I haven't had time to find those stores yet, there are so many streets I don't know.

Yesterday night I walked down the streets on my own, I saw a lot of circuses and movie theatres, but I didn't dare to go anywhere, there are so many places where you must pay to go in and it's hard when you don't speak the language. I observe everything. What imbeciles and idiots people are: they have so much and they don't do anything, they 'make love', as they say so delicately. The woman as object fabricated by the capitalist West will be its downfall. Everything about

them is fabricated: the hands, the postures, the bodies. There are dozens of theatres where naked women spend the entire night walking about the stage silently, wearing huge expensive feathers, in front of an expensive decor, and nothing happens, they walk by and that's all, everybody's happy. Every single one is different. And what's the point? They parade naked and that's all. They don't speak, they don't dance, they don't move. They just walk on by, one after the other ... In groups of three, five or twenty ... and that's it. And even now, I couldn't possibly tell whether it is exactly 'nothing', or whether they are 'objects'.

In truth there is very little to see in this exhibition. They've built an enormous number of pavilions, from afar they are all ugly and from up close it's even worse. Everything is cluttered.

What this signifies is that we must work, and work, and work. The new light does not only represent the liberation of the worker, it also signifies a new attitude toward men, toward women, toward objects. Even objects, in our hands, must be our equals, real comrades, and not the sad and grey slaves they are here. They'll become our friends and comrades, and we will learn to laugh, have fun and talk with them. Look how many objects there are here, coldly ornamented and coldly ornamenting the city from outside, while from inside they are doing their hard work, like slaves plotting a disaster to avenge themselves from their oppressors. To live here you either have to be against everything or to become a thief. That's what makes me love the way we see things. Now I understand the capitalist who has too little, the opium of life really is objects. They are absolutely unable to tell the difference between an object and an ersatz. We will never be able to build a new model for life if our relationships are like the ones of those Western bohemians. That's the real problem. First there is our way of life. Then we must come together, stay united, and trust each other. Now I understand that we must never imitate anything, but to create what is new following our own taste.

The club is ready now, I'm sending you the photographs. It is really so simple, clean and light that one never wants to make it dirty. A lot of enamel, a lot of white, a lot of black and a lot of grey.

oxoxoxo *Partially destroyed piece of paper. Date and author unknown.*

We fight among ourselves about this idea of geometry (the geometric versus the organic). Some say that what we should wear are clothes that are as close to being naked as possible. The proponents of the geometric disagree, so do the advocates of clothing as masquerade. They say fuck this shit it's so dry and protestant.

oxoxoxo *The next four entries appear to have been written by Diotima.*
They were found as stapled typewritten sheets, the date is unknown.

NO MORE CITY

I wake up and it's still dark around me. I can feel the smouldering ashes, the soft hiss of the wind against the sand, and when I open my eyes there are roadrunners and jackrabbits hopping about the bush. I close my eyes again and roll against my friend sleeping next to me. If I feel cold I can get up and close the curtains, light the fire again. If I'm too hot I'll open them or go lie on the chaise longue on the porch. Horses are waking up somewhere in the distance, the little ones running in circles around their mothers, begging to be fed. Somebody must already be awake next door, I can hear rumours of conversations, the sound of girls waking up, a faint peal of laughter, a yapping dog. It can't be later than six in the morning, and I remember that at this time in the city I would still be fast asleep, lost in slumber, dreaming of escape. I remember the closed landscape, the sediment of meaning upon meaning, story upon story, oppression upon oppression. Suburban masses sleepwalking through waking life, from one gesture to the next, political prisoners of a grey-tinged nightmare. Have they ever known real darkness, real light, do they ever wake up and long for a dawn that never vanishes?

We are building the hacienda. A pyramid of love. Somewhere in the city armies of cops are massing, manufacturing a confrontation, the banks are closed because they are afraid of the people, they are turning the people against the people. Petty bourgeois daddies are buying guns to protect their rented apartments and semi-detached houses. To protect their right to ride their leased BMWs from their TV screens to the bank and the insurance company. Their houses are the sad, prefab shells of what housing could have been. The city is a place where you can't get lost, it's an outside without an inside. We will not work to prolong a mechanical civilization and frigid architecture that ultimately lead to boring leisure and endless war.

We were bored in the city. I remember a time when I believed that you could just get lost inside your head, inside your body, inside the city, drifting high on drugs, moving in and out of consciousness. When I thought I could still save something of that dying hull, find a space for myself and my loved ones somewhere inside the cracks of capital. Working the day and partying at night, my body always a tool, a cog in the machine. Spacing out in front of a computer screen, answering the phone, never making anything that was truly mine. Caught in the dance of the machine. Here is some news: you CAN stop the groove. We have said: 'No more'. This world is a nightmare from which we have decided to awake. I dream with my eyes open, I close my eyes in order to see.

OXO

SOME NOTES ON TIME

Smash the clock. Smash mechanical clocks, automated recordings, assembly lines, the abject dejection of a grey morning in the city when you wake up depressed and premenstrual, a blank eternity of standardized moments laid out in a grid before you. The city is spleen, it's the hysterical rise of excitement at one moment and the fall into deep depression 20 minutes later.

Here there is both so much and so little to do, housework and drawing and dairy writing and whatever you want, at first your mind is at loss, both crushed by the cyclical regularity of these everyday tasks – the almost pre-modern routine, the dishes, the roof, the drains, the well, the horses, the cows, the chickens and the rabbits – and afraid of not knowing what to do with yourself, how to keep yourself busy, without distractions, TV, cable, the phone ringing with your friends asking you to go out for a drink. When I arrived here for the first few days I just didn't know what to do with myself. It was an exercise in the taming of time.

Not having a clock is a very strange thing, at first you experience it as a kind of deprivation, something that is missing, a lack of framing. One of my worries at the beginning was that I wouldn't know how much I slept, that I would either slumber for hours or be deprived of some essential, clearly quantifiable nutrient. But the anxiety doesn't last long, there is the rise and fall of the sun, the animals that run over to the hedge in the evening when it is time to feed them. I got to enjoy my lack of control, as if the feeling of being lost in what you are doing with no way of knowing exactly how long it took was actually a way of recovering the

fulness of time. There are funny moments, like when you are tripping and you really follow your mind where it wants to take you.

OXO

ARCHITECTURE

Right now there is very little here; two dilapidated buildings that we have modified, one for the animals, another for the workshop and our meeting room, and two smaller structures where we both sleep and eat. These we have built ourselves. At first we thought this would be the easiest plan, but we quickly got frustrated with it, there is something much too rigid about it. The separation of work and leisure into clearly discrete units is clearly a kind of ideological remnant, which must be removed. How do you integrate the basic needs for infrastructure and adequately equipped rooms with the desire for flexibility, versatility, the possibility of change? The solution we found for the living spaces is a pretty good one, a simple, self-supporting roof with only one wall on one of the shortest sides (it's a rectangle), and only curtains on the others. Inside each of these there are tall dividers, movable partitions somewhere in between a screen and a wall. It enables us to retain privacy while making for a very flexible use. We love the curtains because it is so hot here that there is almost no need for walls, it keeps us close to the weather and the whereabouts of the animals outside. I'm still rather unhappy with the separate workshop and farm building, although maybe keeping the animals at a distance is the most reasonable plan. Nobody likes the smell of cow shit.

OXO

ANIMAL ARCHITECTURE

We are trying to develop some new ideas for the raising and keeping of farm and domestic animals. So far it's all pretty experimental, and often rather sobering. It's hard to know what another species really needs. Communication remains minimal, and fraught with projections of all kinds on our part. As for what they actually feel …

This document seems to have been written roughly at the same time as the announcement on the following page.

She says she has come here precisely to break with what she was before. She wants to destroy everything she used to be before. She obsesses over fake relations, fake exchanges, the kind of barters that she says cost you nothing but actually eat your soul away. She is a lifestyle totalitarian, like other people are love totalitarians. The way we survive, I think what bothers her is that we actually do survive. Before, when we were still living on Beatrice's trust fund, she found nothing to complain about, and she was the most agreeable of companions. The fact that the money we were living on was earned dishonestly, a fat cheque sitting in a bank accruing interest on some previously doctored deal, didn't bother her at all. Everybody has a point at which they stop being able to identify compromise, a kind of ethical horizon line beyond which they believe that things are no longer under their control and should therefore be ignored. But her horizon encircles everything she makes. One day I told her that wage slavery was nothing but another form of prostitution and she then pushed this idea to another level; for her parting with anything she had made became tantamount to selling her own body. I ask her if she thinks we'd be better off starving. She refuses to reply and simply tells me that every question carries the mould of the answer the one who phrases it desires to receive. She has nothing but contempt for our potential customers. She imagines corrupt yet additive-free cigarette smoking pseudo-liberals strolling along the aisles of the market place, desultorily eyeing our wares, holding them in their hands, maybe trying them on and comparing them to the other designer items they have amassed in their closets back home. I think she is so protective of the bond we've formed, of the freedom we've built for ourselves, that she wants to deny everybody else the possibility of ever coming close to it. Her thinking regarding objects approaches the pre-modern. The only way I can explain it to myself is as a kind of voodoo. She profoundly resents providing others with a vicarious way of easing their discomfort with the alienated life they lead. Among us, she is the destructive character. Needless to say, we would never want to see her go away. [...]

Dear

I am writing late at night, taking advantage of that moment before sleep when everybody busies themselves discussing the affairs of the day together, to continue our interrupted conversation. I must admit I was saddened by your abrupt departure, for I truly believed that our exchange had begun rather well, and I was hopeful it would lead to more extended developments.

Although you made every polite effort to keep a restrained and gentle composure, I saw very well that you were startled by what you witnessed here. You probably thought that the decorations were bizarre, the furniture uncomfortable, and our attitude incomprehensible. Maybe I should have provided you with a better introduction to our views and beliefs, instead of letting you drop unprepared into the midst of our little world. Did it really seem that strange to you? Or was it just that something rang true and made you run away? On the night of your arrival we were celebrating the outcome of our fevered dreams, and were probably too intoxicated to properly take care of you. Garlands of flowers had been woven around the fences and multi-coloured flags were hanging about the meeting room. We had prepared a kind of special punch, a fire had been lit in the courtyard, the animals had been fed and had gone to sleep. We were playing music, playful ballads in a forgotten tongue, joyful elegies, ecstatic dirges. In moments like this, you see, we become what we strive to be, and the space between the different fictions we all have in our heads, and reality collapses onto itself for a suspended moment. So suddenly all you saw was a group of girls like a pack of wolves. Probably all those bared teeth, that pitiless leanness, was not what you expected from a women's commune. But am I really responsible for your disappointment? I had just invited you here and truly had no idea of how it would turn out.

I truly hope that you will consider everything that we talked about and maybe come back for a while. But if you do, it must be with a real understanding of the fact that the revolution starts inside you, first and foremost. The rest is just icing on the cake, and we have little patience for it. Nobody gets mothered here.

Rest assured that I remain, stubbornly, your friend,

.....................

oxoxoxo *From a handbill, date and author unknown.* oxoxoxoxoxoxoxoxoxoxoxoxoxo

We sleep in the open air, eat simple meals of fruit and vegetables by the fireplace and wear loose-fitting garments of natural fibres, closed with ties rather than buttons.

Mai-Thu Perret, extracts from 'The Crystal Frontier', in *Mai-Thu Perret: The Land of Crystal* (Zurich: JRP Ringier, 2008) 109–49. Typographically adapted for this volume from the original artist's book, in which each entry appears on a separate page.

Liam Gillick
Abstract//2011

By making the abstract concrete, art no longer retains any abstract quality, it merely announces a constant striving for a state of abstraction and in turn produces more abstraction to pursue. It is this failure of the abstract that lures and hypnotizes – forcing itself onto artists and demanding repeated attention. The abstract draws artists towards itself as a semi-autonomous zone just out of reach. It produces the illusion of a series of havens and places that might reduce the contingent everyday to a sequence of distant inconveniences. It is the concretization of the abstract into a series of failed forms that lures the artist into repeated attempts to 'create' the abstract – fully aware that this very act produces things that are the representation of impossibilities. In the current context this means that the abstract is a realm of denial and deferment – a continual reminder to various publics that varied acts of art have taken place and the authors were probably artists.

The creation of an art of the abstract is a tautology. It cannot be verified independently. We have to accept that the concretization of the abstract is a record of itself. It points towards something that cannot be turned into an object. But there – in front of us – is this non-existence. Even further, this non-existence in concrete form can take up a lot of space, supposedly pure colour and variegated form. The grander the failed representation of the abstract becomes the more striking the presence of failure – at the heart of which is a very human attempt to capture an unobtainable state of things and relationships to the unknowable. The abstract in art is a process of destruction – taking that which cannot be represented

and forcing it into an incomplete set of objects and images which exist as a parallel lexicon that form a shattered mirror to that which cannot be represented. There is nothing abstract about art that is the result of this destructive desire to create an abstraction. It is a process of bringing down to earth that which continues to remain elusive. It is this search that connects the desire to create abstraction with utopias and is at the heart of its neo-romantic ideology. It is the basis of the symbolic politics of abstraction and its parallel course as marker of hope and ultimate failure. It is the process of attempting to reproduce the abstract that causes the truly abstract to retain its place just out of reach.

The abstract therefore – in the current aesthetic regime – always finds form as a relational backdrop to other activities, terrains and interactions. By destroying the abstract via making it concrete, the ambient and the temporary are heightened and become an enduring associative abstraction that replaces the lack in the artwork. The abstraction that is produced by abstract art is not a reflection of the abstraction at the start of the process. The making of a concrete structure produces further abstraction – the art object in this case is merely a marker or waypoint towards new abstraction. Tackling the job of producing something concrete through a process of abstraction neither reproduces abstraction nor does it provide us with anything truly autonomous. It produces a lack and points towards further potentially endless processes of abstraction. It is this potential endlessness – that remains productive while reproducing itself – that is the key to the lure of abstract art. The procedure of producing abstract art does not fill the world with lots of abstraction – despite appearances to the contrary – instead it populates the space of art with an excess of pointers that in turn direct attention towards previously unaccounted for abstractions. This is at the heart of the lure of the abstract – this explains why artists keep returning to the elusive zone. Abstraction is not the contrary of representation – a recognition of which is the key to understanding the complete failure of Gerhard Richter's work for example – rather abstraction in art is the contrary of the abstract in the same way that representation is the contrary of the real.

Concrete structure in this case also lacks. It does not hold a functional role within the culture beyond its failure to be an abstraction. The concrete structure becomes a marker that signifies art and points to all other art as structures that contain excessive subjectivities. Abstraction in this case has little to do with minimalism or formalism. Yet it can easily become either of these things with just a slight tweak in any direction. The intention to create a minimal or reductive gesture, object or environment requires a suppression of abstraction towards the deployment of materials that may or may not be in balance or sync with their objectness. This is not the same as the creation of an abstract artwork. The desire to develop a minimalist practice is a denial of the abstract and an attempt to

concretize the concrete. Through this process there is the demonstration of a desire to ignore and go past the failure of abstraction. It is through minimalistic gestures that artists attempted to cut out abstraction's failure of transformation and invited us instead to focus on what we imagine is a material fact or set of facts about a material within a given context. The emergence of an identifiable minimalist practice more than forty years ago, while attempting to avoid the problem of abstraction, failed truly to trouble the problem of abstraction. Minimalism highlighted evasion. The minimal created a series of half-facts, all of which continued to allude to the abstract of art. This explains the spiritualization of the minimal in the contemporary context, its interchangeability and absorption into the aesthetic of the wellness centre and the kitchen, and the association of truth to materials with relationships to cosmic, pick-and-mix spirituality.

The failure at the heart of the abstract is its enduring critical potential. The demonstration of the concrete brings down metaphors, allusions and other tools that can be deployed for multiple ends to a set of knowable facts. Any attempt to represent through art will always deploy a degree of artifice – this is not a moral judgement, just a state of things. The failed abstract reproduces itself. It does not point to anything other than its own concrete form. Its concrete presence replaces the attempt to pin down the abstract and becomes a replacement object that only represents the potential of the abstract. This process of looking at replacement objects is one of the most provocative aspects of some art in the twentieth century. The presence of replacement objects as key markers within the trajectory of twentieth-century modernism is what provokes confused and sublime responses. It is not the forms themselves that have this essential quality. The search for ever more 'true' abstraction merely created and continues to create more replacement objects that scatter the globe as reminders of the failure of the concrete in relation to the abstract. This replacement function explains why the concrete in relation to the abstract is so vulnerable to being deployed for ends other than the progressive and neo-transcendental. The earlier concretization of the abstraction of corporate identity via the creation of logos and smooth minimal spaces can be viewed in parallel to the failure of the abstract in the late modern period – particularly in the US.

So the endurance of abstraction is rooted in this desire to keep showing the impossibility and elusiveness of the abstract. At the same time it reveals the processes of manipulation that take place within unaccountable realms of capital – the continual attempt to concretize abstract relationships and therefore render them into a parallel form that can be more easily exchanged. Where in the past the concrete was created from the abstract of the corporate, now these processes of concretization have moved into every realm of the 'personal'. The abstract art produced alongside such a period is a necessity, forming a sequence of test sites

to verify, and enable us to remain vigilant about, the processes of concretization that take place around us in the service of capital. The transformation of relationships into objects via a mature sensitivity to a process of concretization is tested and tracked when the most vivid current artists deploy what appears to be abstract but is in fact a conscious deployment of evasive markers.

Liam Gillick, 'Abstract', in *Microhistorias y macromundos. vol. 3 – Abstract Possible*, ed. Maria Lind (Mexico City: Instituto Nacional de Bellas Artes y Literatura, 2011) 158–66.

Gerald Raunig
Instituent Practices//2009

When we posit in our project *transform* the provisional thesis that, following the two phases of institutional critique in the 1970s and the 1990s, a new phase will emerge,[1] this thesis is based less on empirical findings than on a political and theoretical necessity, which a look at the deployment of institutional critique makes evident. Both strands of the meanwhile canonized practice of institutional critique had their own strategies and methods conditioned by the context, were simultaneously similar to one another (more similar than the delimitations of the art history canon and the art criticism canon would suggest) and different from one another, depending on the social and political circumstances. In particular, the circumstances have changed tremendously since Michael Asher, Robert Smithson, Daniel Buren, Hans Haacke, Marcel Broodthaers and others introduced the first wave of what came to be known as institutional critique, which led almost seamlessly into the multiple branches of artistic projects circulating under the same name in the late 1980s and the 1990s. If institutional critique is not to be fixed and paralysed as something established in the art field and confined within its rules, then it has to continue to develop along with changes in society and especially to tie into other forms of critique both within and outside the art field, such as those arising in opposition to the respective conditions or even before their formations.[2] Against the background of this kind of transversal exchange of forms of critique, but also beyond the imagination of spaces free from domination and institutions, institutional critique is to be reformulated as a critical attitude and as an instituent practice.

In his lecture entitled 'Qu'est-ce que la critique?' in 1978, Michel Foucault described the spread and replication of governmentality in Western Europe in

the sixteenth century, claiming that along with this governmentalization of all possible areas of life and finally of the self, critique also developed as the art not to be governed *like that*. Even without going into more depth here on the continuities and breaks between the historical forms of developing liberal governmentality and the current forms of neoliberal governmentality,[3] it may be said that the relationship between *government* and *not to be governed like that* is still a prerequisite today for reflecting on the contemporary relationship between institution and critique. In Foucault's words:

> this governmentalization, which seems to me to be rather characteristic of these societies in Western Europe in the sixteenth century, cannot apparently be dissociated from the question 'how not be governed?' I do not mean by that that governmentalization would be opposed in a kind of face-off by the opposite affirmation, 'we do not want to be governed, and we do not want to be governed at all'. I mean that, in this great preoccupation about the way to govern and the search for the ways to govern, we identify a perpetual question which could be: 'how not be governed like that, by that, in the name of those principles, with such and such an objective in mind and by means of such procedures, not like that, not for that, not by them'.[4]

Here Foucault insists on the shift from a fundamental negation of government toward a manoeuvre to avoid this kind of dualism: from *not to be governed at all* to *not to be governed like that,* from a phantom battle for a *big other* to a constant struggle in the plane of immanence, which – as I would like to add – is not (solely) actualized as a fundamental critique of institutions, but rather as a permanent process of instituting. Foucault continues:

> And if we accord this movement of governmentalization of both society and individuals the historic dimension and breadth which I believe it has had, it seems that one could approximately locate therein what we could call the critical attitude. Facing them head on and as compensation, or rather, as both partner and adversary to the arts of governing, as an act of defiance, as a challenge, as a way of limiting these arts of governing and sizing them up, transforming them, of finding a way to escape from them or, in any case, a way to displace them ...[5]

These latter categories are the ones I want to focus on in terms of the transformation and a further development of the question of contemporary forms of institutional critique: transformations as ways of escaping from the arts of governing, lines of flight, which are not at all to be taken as harmless or individualistic or escapist and esoteric, even if they no longer allow dreaming of

an entirely different exteriority. 'Nothing is more active than fleeing!', as Gilles Deleuze and Claire Parnet write,[6] and as Paolo Virno echoes almost literally: 'Nothing is less passive than the act of fleeing, of exiting'.[7]

If 'the arts of governing' mean an intertwinedness between governing and being governed, between government and self-government, then '*transforming* the arts of governing' does not consist simply of any arbitrary transformation processes in the most general sense, because transformations are an essential quality of the governmentality setting. It is more a matter of specifically *emancipatory* transformations, and this also rescinds a central aspect of the old institutional critique. Through their emancipatory character these transformations also assume a transversal quality, i.e. their effect goes beyond the particular limitations of single fields. Counter to these kinds of emancipatory transversal transformations of the 'arts of governing', there is a recurring problem in art discourse: that of reducing and enclosing more general questions in one's own field. Even though (self-) canonizations, valorizations and depreciations in the art field – also in debates on institutional critique practices – are often adorned with an eclectic, disparate and contradictory selection of theory imports, these imports frequently only have the function of disposing of specific art positions or the art field. A contemporary variation of this functionalization consists of combining post-structuralist immanence theories with a simplification of Bourdieu's field theory. The theories that argue on the one hand against an outside in the sense of Christian or socialist transcendence, for instance, and on the other for the relative autonomy of the art field, are blurred here into the defeatist statement, 'We are trapped in our field' (Andrea Fraser). Even the critical actors of the 'second generation' of institutional critique do not appear to be free from these kinds of closure phantasms. Fraser, for instance, conducts an offensive self-historicization in her Artforum article 'From the Critique of Institutions to an Institution of Critique' (September 2005) with the help of a brief history of the terms, ultimately limiting all possible forms of institutional critique to a critique of the 'institution of art' (Peter Bürger) and its institutions. In reference to Bourdieu, she writes:

> … just as art cannot exist outside the field of art, we cannot exist outside the field of art, at least not as artists, critics, curators, etc. And what we do outside the field, to the extent that it remains outside, can have no effect within it. So if there is no outside for us, it is not because the institution is perfectly closed, or exists as an apparatus in a "totally administered society", or has grown all-encompassing in size and scope. It is because the institution is inside of us, and we can't get outside of ourselves.[8]

Although there seems to be an echo of Foucault's concept of self-government

here, there is no indication of forms of escaping, shifting, transforming. Whereas for Foucault the critical attitude appears simultaneously as 'partner' and as 'adversary' of the arts of governing, the second part of this specific ambivalence vanishes in Andrea Fraser's depiction, yielding to a discursive self-limitation, which only just allows reflecting on one's own enclosure. Contrary to all the evidence of the manifold effectivity not only of critical art practices throughout the entire twentieth century, she plays a worn-out record: art is and remains autonomous, its function limited to the art field. 'With each attempt to evade the limits of institutional determination, to embrace an outside, we expand our frame and bring more of the world into it. But we never escape it.'[9]

Yet exactly this would also be a point in Foucault's concept of critique, the critical attitude: instead of inducing the closure of the field with theoretical arguments and promoting this practically, thus carrying out the art of governing, a different form of art should be pushed at the same time which leads to *escaping the arts of governing*. And Foucault is not the only one to introduce these new non-escapist terms of escape. Figures of flight, of dropping out, of betrayal, of desertion, of exodus, these are the figures proposed – especially against cynical or conservative invocations of inescapability and hopelessness – by several different authors as post-structuralist, non-dialectical forms of resistance. With these kinds of concepts Gilles Deleuze, Paolo Virno and several other philosophers attempt to propose new models of non-representationist politics that can equally be turned against Leninist concepts of revolution as taking over the state and against radical anarchist positions imagining an absolute outside of institutions, as well as against concepts of transformation and transition in the sense of a successive homogenization in the direction of neoliberal globalization. In terms of their new concept of resistance, the aim is to thwart a dialectical idea of power and resistance: a positive form of dropping out, a flight that is simultaneously an instituent practice. Instead of presupposing conditions of domination as an immutable horizon and yet fighting against them, this flight changes the conditions under which the presupposition takes place. As Paolo Virno writes in *The Grammar of the Multitude*, the exodus transforms 'the context within which a problem has arisen, rather than facing this problem by opting for one or the other of the provided alternatives'.[10] When figures of flight are imported into the art field, this often leads to the misunderstanding that it involves the subject's personal retreat from the noise and babble of the world. Protagonists such as Herman Melville's 'Bartleby' in Deleuze and Agamben or the 'virtuoso' pianist Glenn Gould in Virno are seen as personifications of individual resistance and – in the case of Bartleby – of individual withdrawal. In a conservative process of pilferage and reinterpretation, in art-critical discourse these figures are thus so far removed from their starting point that flight no longer implies, as it does with

Deleuze, fleeing to look for a weapon. On the contrary, here the old images of retreat into an artist hermitage are re-warmed, which are not only deployed in neo-cultural-pessimistic (art) circles against participative and relational spectacle art, but also against collective interventionist, activist or other experimental strategies; for instance when the head of *Texte zur Kunst*, Isabelle Graw turns to 'the model of the preoccupied painter working away in his studio, refusing to give any explanation, ostentatiously not networking, never travelling, hardly showing himself in public', the reason for this is allegedly to prevent the principle of the spectacle from 'directly accessing his mental and emotional competencies'.[11]

Although Graw refers to Paolo Virno directly before the passage quoted, neither Virno's problematization of the cultural industry nor his concept of exodus tends toward these kinds of bourgeois expectations of salvation by the artist-individual. With the image of the solitary painter, who eludes the 'new tendency in capitalism to take over the whole person'[12] by obstinately withdrawing his person, Graw links a contemporary analysis with an ultra-conservative consequence. Even after the countless spectacular utilizations of this stereotype, it appears that the same old artist image – counter to Virno's ideas of virtuosity – can today still or once again be celebrated as anti-spectacular.

What the post-structuralist proposals for dropping out and withdrawal involve, however, is anything but this kind of relapse into the celebration of an individual turning away from society. The point is to thwart dichotomies such as that of the individual and the collective, to theorize, offensively, new forms of what is common and singular at the same time. Particularly Paolo Virno has lucidly developed this idea in *A Grammar of the Multitude*. In allusion to the concept of the General Intellect, which Karl Marx introduced in his *Outlines of the Critique of Political Economy*, Virno posits the concept of the 'public intellect'. The assumption of Marx's concept indicates that 'intellect' is not to be understood here as a competence of an individual, but rather as a shared tie and constantly developing foundation for individuation. Thus Virno neither alludes to media intellectuals in the society of the spectacle, nor to the lofty ideas of the autonomous thinker or painter. That kind of individualized publicity corresponds more to Virno's negative concept of 'publicness without a public sphere': 'The *general intellect*, or public intellect, if it does not become a *republic*, a public sphere, a political community, drastically increases forms of submission.'[13]

Virno focuses, on the other hand, on the social quality of the intellect.[14] Whereas the alienated thinker (or even painter) is traditionally drawn as an individual withdrawing from idle talk, from the noise of the masses, for Virno the noise of the multitude is itself the site of a non-state, non-spectacular, non-representationist public sphere.

This non-state public sphere is not to be understood as an anarchic place of

absolute freedoms, as an open field beyond the realm of the institution. Flight and exodus are nothing negative, a reaction to something else, but are instead linked and intertwined with constituent power, reorganizing, reinventing and instituting. The movement of flight also preserves these instituent practices from structuralization and closure from the start, preventing them from becoming institution in the sense of constituted power.

What does this mean in relation to the artistic practices of institutional critique? From a schematic perspective, the 'first generation' of institutional critique sought a distance from the institution, the 'second' addressed the inevitable involvement in the institution. I call this a schematic perspective, because these kinds of 'generation clusters' are naturally blurred in the relevant practices, and there were attempts – by Andrea Fraser, for instance – to describe the first wave as being constituted by the second (including herself) and also to attribute to the first phase a similar reflectedness on their own institutionality. Whether this is the case or not, an important and effective position can be attributed to both generations in the art field from the 1970s to the present, and relevance is evident in some cases that goes beyond the boundaries of the field. Yet the fundamental questions that Foucault already implicitly raised, which Deleuze certainly pursued in his Foucault book, are not posed with the strategies of distanced and deconstructive intervention in the institution: Do Foucault's considerations lead us to enclose ourselves more and more in power relations? And most of all, which lines of flight lead out of the dead end of this enclosure?

To make use of Foucault's treatments of this problem for the question of new instituent practices, I would like to conclude this article with a longer recourse to the later Foucault, specifically to his Berkeley lecture series 'Discourse and Truth' from fall 1983 and the term *parrhesia* broadly explained there.[15]

Parrhesia means in classical Greek 'to say everything', freely speaking truth without rhetorical games and without ambiguity, even and especially when this is hazardous. Foucault describes the practice of *parrhesia* using numerous examples from ancient Greek literature as a movement from a political to a personal technique. The older form of *parrhesia* corresponds to publicly speaking truth as an institutional right. Depending on the form of the state, the subject addressed by the *parrhesiastes* is the assembly in the democratic agora, the tyrant in the monarchical court.[16] *Parrhesia* is generally understood as coming from below and directed upward, whether it is the philosopher's criticism of the tyrant or the citizen's criticism of the majority of the assembly: the specific potentiality of *parrhesia* is found in the unequivocal gap between the one who takes a risk to express everything and the criticized sovereign who is impugned by this truth.

Over the course of time, a change takes place in the game of truth 'which – in the classical Greek conception of *parrhesia* – was constituted by the fact that

someone was courageous enough to tell the truth to *other people*. [...] there is a shift from that kind of parrhesiastic game to another truth game which now consists in being courageous enough to disclose the truth about *oneself*.[17] This process from public criticism to personal (self-) criticism develops parallel to the decrease in the significance of the democratic public sphere of the agora. At the same time, *parrhesia* comes up increasingly in conjunction with education. One of Foucault's relevant examples here is Plato's dialogue *Laches*, in which the question of the best teacher for the interlocutor's sons represents the starting point and foil. The teacher Socrates no longer assumes the function of the parrhesiastes in the sense of exercising dangerous contradiction in a political sense, but rather by moving his listeners to give account of themselves and leading them to a self-questioning that queries the relationship between their statements (*logos*) and their way of living (*bios*). However, this technique does not serve as an autobiographical confession or examination of conscience or as a prototype of Maoist self-criticism, but rather to establish a relationship between rational discourse and the lifestyle of the interlocutor or the self-questioning person. Contrary to any individualistic interpretation especially of later Foucault texts (imputing a 'return to subject philosophy', etc.), here *parrhesia* is not the competency of a subject, but rather a movement between the position that queries the concordance of logos and bios, and the position that exercises self-criticism in light of this query.

In keeping with a productive interpretation for contemporary institutional critique practices, my aim here is to link the two concepts of *parrhesia* described by Foucault as a genealogical development, to understand hazardous refutation in its relation to self-revelation. Critique, and especially institutional critique, is not exhausted in denouncing abuses nor in withdrawing into more or less radical self-questioning. In terms of the art field this means that neither the belligerent strategies of the institutional critique of the 1970s nor art as a service to the institution in the 1990s promise effective interventions in the governmentality of the present.

What is needed here and now, is *parrhesia* as a double strategy: as an attempt of involvement and engagement in a process of hazardous refutation, and as self-questioning.

What is needed, therefore, are practices that conduct radical social criticism, yet which do not fancy themselves in an imagined distance to institutions; at the same time, practices that are self-critical and yet do not cling to their own involvement, their complicity, their imprisoned existence in the art field, their fixation on institutions and the institution, their own being-institution. Instituent practices that conjoin the advantages of both 'generations' of institutional critique, thus exercising both forms of *parrhesia*, will impel a linking of social

criticism, institutional critique and self-criticism. This link will develop, most of all, from the direct and indirect concatenation with political practices and social movements, but without dispensing with artistic competences and strategies, without dispensing with resources of and effects in the art field. Here exodus would not mean relocating to a different country or a different field, but betraying the rules of the game through the act of flight: 'transforming the arts of governing' not only in relation to the institutions of the art field or the institution art as the art field, but rather as participation in processes of instituting and in political practices that traverse the fields, the structures, the institutions.

1 http://transform.eipcp.net/about

2 On the temporal and ontological antecedence of critique/resistance, see Gilles Deleuze, *Foucault* (1986) (Minneapolis: University of Minnesota Press, 1988) 89: 'The final word of power is that resistance comes first' (translation modified on the basis of the French original), and Raunig, the chapter 'The Primacy of Resistance' in *Kunst und Revolution* (Vienna: Turia+Kant, 2005).

3 See Isabell Lorey, 'Governmentality and Self-Precarization: On the Normalization of Culture Producers', in Simon Sheikh, ed., *CAPITAL (It Fails Us Now)* (Berlin: b_books, 2006).

4 Michel Foucault, 'What is Critique?', in Sylvére Lotringer and Lysa Hochroch, eds, *The Politics of Truth: Michel Foucault* (New York: Semiotext(e), 1997) 28.

5 Ibid, 8.

6 Gilles Deleuze and Claire Parnet, *Dialogue* (Frankfurt am Main: Suhrkamp, 1980) 45.

7 Paolo Virno, *Grammatik der Multitude. Mit einem Anhang: Die Engl und der General Intellect* (Vienna: Turia+Kant 2005) 97.

8 Andrea Fraser, 'From the Critique of Institutions to an Institution of Critique', *Artforum* (September 2005) 282.

9 Idem.

10 Paolo Virno, *Grammatik der Multitude*, op. cit., 48.

11 Isabelle Graw, 'Jenseits der Institutionskritik. Ein Vortrag im Los Angeles County Museum of Art', *Texte zur Kunst* (September 2005) 46.

Gerald Raunig, 'Instituent Practices: Fleeing, Instituting, Transforming in Art and Contemporary Critical Practice', in *Art and Contemporary Critical Practice: Reinventing Institutional Critique*, ed. Gerald Raunig and Gene Ray (London: Mayflybooks, 2009); reprinted in *Microhistorias y macromundos. vol. 3 – Abstract Possible*, ed. Maria Lind (Mexico City: Instituto Nacional de Bellas Artes y Literatura, 2011) 248–62.

Emily Roysdon
Ecstatic Resistance//2009

Ecstatic Resistance is a project, practice, partial philosophy and set of strategies. It develops the positionality of the impossible alongside a call to rearticulate the imaginary. *Ecstatic Resistance* is about the limits of representation and legibility – the limits of the intelligible, and strategies that undermine hegemonic oppositions. It wants to talk about pleasure in the domain of resistance – sexualizing modern structures in order to centralize instability and plasticity in life, living and the self. It is about waiting, and the temporality of change. *Ecstatic Resistance* wants to think about all that is unthinkable and unspeakable in the Eurocentric, phallocentric world order.

The project is inspired by several years of witnessing and participating in projects that re-imagine what political protest looks like. And what it feels like. With one foot in the queer and feminist archives, and another in my lived experience of collectivity,[1] I first began to use the phrase as a way to think through all the reverberations and implications of the work I saw around me – work I was both invested in and identified with. *Ecstatic Resistance* became the form of my engagement, as both provocation and inspiration, challenge and context.

As an artist, it is very important to me to engage my peers' practices and to think publicly about the terms and contexts of aesthetic production; to develop concepts and experiences from the social and aesthetic fields in which I have had the privilege to situate my life. I was moved to articulate the connections I saw developing and to make explicit a vocabulary with which these artists and their works could make an impact on multiple disciplines. I also believe it crucial to situate these works within a genealogy of activity to assert the trans-historical-ness of the subjects, events, and strategies that are expounded here. *Ecstatic Resistance* is a thread of historical action that if seized upon has great potential to dismantle and restructure the cultural imaginary.

My project here is to write the echoes of ecstatic resistance, a vocabulary with which we can begin a conversation and hope that the related theses set the stage for future actions and articulations. In teasing out the ambitions and potential of the diverse works that inspired this project, I climbed my way through questions of occupation, universality, the unconscious, truth, technology, risk, ethics, and more. Eventually I centralized my understanding and my desire around a few keys terms: impossible, imaginary, pleasure, plasticity, strategy, communicability; connecting these ideas to talk about the image of resistance.

Ecstatic Resistance expresses a determination to undo the limits of what is possible to be.

I am looking for the body, my body, which exists outside its patriarchal definitions. Of course that is not possible. But who is any longer interested in the possible?[2]

Ecstatic Resistance develops a positionality of the impossible as a viable and creative subjectivity that inverts the vernacular of power. By exposing past impossibilities, the actor of history is thus revealed as the outcast of the contemporary. *Ecstatic Resistance* works to change this by celebrating the impossible as lived experience and the place from which our best will come.

Alongside the vitalization of the impossible life, *Ecstatic Resistance* asserts the impossible as a model for the political. Politics is a system of that which is forbidden and cannot be done. When politics is framed as 'reason and progress' it disguises the primacy of oppression. Changing the perspective of politics away from a positivity and pointing to its limitations and selective applications, reorganizes the hierarchy of political actors. The impossible always arrives.

'It is always the first time./ The written, the imagined,/ the confrontation with reality./ Must imagination shun reality,/ or do the two love each other?/ Can they become allies?/ Do they change when they meet?/ Do they swap roles?/ It's always the first time.' – Lady Windermere in *Johanna d'Arc of Mongolia*, Ulrike Ottinger.[3]

Ecstatic Resistance postulates the necessity of a new imaginary. The potential of this new imaginary is to move forward from a place that is unrestricted by patriarchal rationality and historical oppositions that serve only the man who is a man and looks like a man and wants to be a man.

Great feminist thinkers[4] have long written the desire to unbound sexual difference in the imaginary, to overthrow the rule which creates the world in which 'the woman is a defective man'. A world in which the idea of a *different* body is unspeakable within a system of meaning and recognition. Within this limited frame people have continuously composed their bodies in opposition – living, moving, struggling and improvising meaning. The persistence of these multi-valiant subjectivities has produced many things over time, but it is no longer possible to move forward without amending the imaginary harboured in our bodies and the language that comes forth from there. In order to develop this new imaginary we must be willing to disrupt our knowledge of self, and to risk unrecognizability.

This new imaginary is the recently returned phantom left hand of the impossible. It is our body map changing and reconnecting our idea of self to that

which was considered impossible – to feel things that can't be seen, to believe in a body outside the limits of the intelligible.

Health consists in having the same diseases as one's neighbours.[5]

Ecstatic Resistance asserts the centrality of plasticity – profoundly acknowledging the ability of brain, body and culture to reorganize itself. Plasticity is the subterranean quake to the caked shell of modernity. It's the cross-dressing, cell-splitting, boundary-shifting, apology-giving, friend-making mirror. Getting ready for an evening when the plasticity principle pushes up on the pleasure principle and says 'Think again. Think again. Your mind has changed as quickly as the clock. The world is not pleasure, pain, and gratification, we breathe struggle, improvisation and collaboration.'

Writing is precisely the very possibility of change, the space that can serve as a springboard for subversive thought, the precursory movement of a transformation of social and cultural structures.[6]

Ecstatic Resistance fundamentally alters the image and process of the political by developing strategies that bypass and subvert entrenched theoretical constructions that set the limits of the intelligible. Ecstatic strategies unearth the potential to find new ways of being in the world.

Working to renegotiate the vernacular of power and resistance, the limits of representation become scenes of improvisation in which the process of consolidation and the fallacy of transparency give way to the lived experience of contradiction and simultaneity.

Implicit is a critique of representation; explicit is the demand to recognize these strategies as significant contributions to the field of aesthetics and social change.

It wasn't a question of communication or something to be understood, but it was a question of changing our minds abut the fact of being alive.[7]

Ecstatic Resistance emphasizes 'the telling' as a key relational model between the unspeakable and communicability.

Communicability is defined by the laws of legitimacy – what is possible to say. The unspeakable exists outside of articulation, law, the imaginary and even alterity. 'The telling' theoretically triangulates these terms in the form of an encounter. Significant is the formulation of speaking as a desire, a desire to share, to articulate an experience to an/other. The telling springs forth from desire, the

tension between pleasure and need forge a route to bridge the encounter. Assisted by affect, the situation becomes improvisational – 'I must find a way': to say what I mean, to share what I've seen.

'The telling' occupies a space between reportage and the creative function of self-narrativizing. The act of sharing inaugurates the potential of one experience to accumulate and become a formative moment of transformation.

Ecstatic Resistance is an inquiry into the temporality of change. Time, the time of transformation, the duration and physicality of the experience of change. And drama – the arc of history. The temporality of the ecstatic opens a non-linear experience in which connections are made at breakneck pace and a moment later time appears to stop us in the dynamism of one challenging thought.

This disorganization of time is against the force of realism. It is a personal allowance that once incorporated proliferates the production of alternatives and builds new perspectives from the ruins. Excesses of experience become the fragments for the future. *Ecstatic Resistance* wonders about waiting – the dynamic between action and recognition, movement and the symbolic.

1 I worked for six years in the collective LTTR, producing an independent feminist art journal and events.

2 Kathy Acker, 'Seeing Gender', *Critical Quarterly*, vol. 37 (Winter 1995) 84 (found in Ulrike Müller's essay, 'No Land Ho. Kathy Acker's Literature of the Body', *springerin*, vol. IX, no. 1/03 (2003).

3 Ulrike Ottinger, *Image Archive* (Nurenberg: Verlag für moderne Kunst, 2005) 11.

4 Notably Hélène Cixous and Luce Irigaray.

5 Quentin Crisp, *The Naked Civil Servant* (1975), transcribed from film.

6 Hélène Cixous, 'The Laugh of the Medusa', trans. Keith Cohen and Paula Cohen, *Signs*, vol. 1, no. 4 (1976) 875–93.

7 John Cage, transcribed from radio interview, WNYC (27 August 2007).

Emily Roysdon, text from *Ecstatic Resistance*, typographic poster work (2009); reprinted in *Microhistorias y macromundos. vol. 3 – Abstract Possible*, ed. Maria Lind (Mexico City: Instituto Nacional de Bellas Artes y Literatura, 2011) 178–84.

Biographical Notes

Alfred H. Barr (Jr.) (1902–81) was an American art historian and the first Director of the Museum of Modern Art, New York, from 1929 to 1943.

Ina Blom is an art historian and curator, and Associate Professor at the Department of Philosophy, Classics, History of Art and Ideas at the University of Oslo, Norway.

Otto Carlsund (1897–1948) was a Swedish abstract painter and founder member of *Art Concret*.

Amilcar de Castro (1920–2002) was a Brazilian sculptor and graphic designer.

Lygia Clark (1920–88) was a Brazilian artist who worked in Rio de Janeiro and Paris.

Lynne Cooke is an art historian and Chief Curator at the Museo Centro de Arte Reina Sofía, Madrid. She was Curator at the Dia Art Foundation, New York, from 1991 to 2009.

Anthony Davies is a London based writer, organizer and independent researcher.

Stephan Dillemuth is a German artist based in Bad Wiessee and Munich, and a professor at Munich's Akademie der Bildenden Künste.

Judi Freeman is a curator and art historian whose posts have included curator of twentieth-century art at the Los Angeles County Museum of Art and at Portland Museum of Art.

Liam Gillick is a British artist based in London and New York.

Ferreira Gullar (José Ribamar Ferreira) is a Brazilian poet and critic who co-founded the neo-concrete movement in art and poetry in the late 1950s.

Peter Halley is an American artist and writer on art based in New York.

Jean Hélion (1904–87) was a French painter who explored abstraction between the mid 1920s and late 1930s.

Joe Houston is an art historian and writer and former Associate Curator of Contemporary Art at the Columbus Museum of Art, Ohio.

Jakob Jakobsen is a Danish artist, activist and organizer based in Copenhagen.

Fredric Jameson is William A. Lane Professor of Literature and Romance Studies at Duke University.

Lucy R. Lippard is an art historian and exhibition organizer based in New Mexico.

Sven Lütticken is a critic and art historian who teaches at the Vrije Universiteit, Amsterdam.

Nina Möntmann is a professor of art history and the history of ideas at the Royal University College of Fine Arts, Stockholm.

Hélio Oiticica (1937–80) was a Brazilian artist based in Rio de Janeiro.

Lygia Pape (1927–2004) was a Brazilian artist based in Rio de Janeiro.

Mai-Thu Perret is a Swiss-born artist based in Geneva.

Gabriel Pérez-Barreiro is Director of the Colleción Patricia Phelps de Cisneros in New York and Caracas.

Catherine Quéloz is an art historian and curator based in Geneva.

Gerald Raunig is a philosopher and art theorist based in Vienna.

Bridget Riley is a British artist based in London.

Irit Rogoff is Professor of Visual Cultures, Goldsmiths, University of London.

Emily Roysdon is an artist and writer based in London and Stockholm.

Meyer Schapiro (1904–96) was an Lithuanian-born American art historian and critic.

Claudio Mello e Souza (1935–2011) was a Brazilian writer and journalist.

Theon Spanudis (1915–86) was a Brazilian psychoanalist, writer and critic.

Hito Steyerl is a Berlin-based artist and writer.

Léon Tutundjian (1905–68) was an Armenian-born painter based for most of his life in Paris.

Theo van Doesburg (1883–1931) was a Dutch artist centrally associated with Dada in Holland, the founding of the De Stijl group, teaching at the Bauhaus and the founding of *Abstraction-Création*.

Kirk Varnedoe (1946–2003) was an American art historian and Chief Curator of Painting and Sculpture at The Museum of Modern Art, New York, from 1988 to 2001.

Marcel Wantz was a painter associated with the concrete art group in Paris in the early 1930s.

Franz Weissmann (1911–2005) was a Brazilian artist based in Rio de Janeiro.

Stephen Zepke is a philosopher and theorist of art and cinema based in Vienna.

Bibliography

Barr, Alfred H., *Cubism and Abstract Art* (New York: The Museum of Modern Art, 1936); reprinted
 edition (Cambridge, Massachusetts: The Belknap Press of Harvard University Press, 1986)

Battcock, Gregory, ed., *Minimal Art: A Critical Anthology* (New York: E.P. Dutton, 1968)

Bois, Yve-Alain, *Painting as Model* (Cambridge, Massachusetts: The MIT Press, 1993)

Bois, Yve Alain, and Rosalind Krauss, *Formless: A User's Guide* (New York: Zone Books, 1997)

Blom, Ina, 'The Logic of the Trailer', *Texte zur Kunst*, no. 69 (March 2008)

Carlsund, Otto, and Theo van Doesburg, Jean Hélion, Léon Tutundjian, Marcel Wantz, 'The Basis of
 Concrete Painting', *Art Concret* (April 1930)

Castro, Amilcar de, and Lygia Clark, Ferreira Gullar, Claudio Mello e Souza, Lygia Pape, Theon Spanudis,
 Franz Weissmann, *Neo-Concrete Manifesto* (1959)

Chave, Anna C., 'Minimalism and the Rhetoric of Power', *Arts*, vol. 64, no. 5 (January 1990)

Clark, Lygia: *Lygia Clark*, ed. Guy Brett (Barcelona: Fundació Antoni Tàpies, 1997)

Cooke, Lynne, 'Palermo's Porosity', in *Blinky Palermo: Retrospective 1964–1977* (New York: Dia Art
 Foundation/New Haven and London: Yale University Press, 2010)

Davies, Anthony, and Stephan Dillemuth, Jakob Jakobsen, 'There is No Alternative: The Future is Self-
 Organized', in *Art and Its Institutions*, ed. Nina Möntmann (London: Black Dog Publishing, 2006)

Fer, Briony, *On Abstract Art* (New Haven and London: Yale University Press, 1997)

Fer, Briony, *The Infinite Line: Re-Making Art after Modernism* (New Haven: Yale University Press, 2004)

Foster, Hal, *The Return of the Real* (Cambridge, Massachusetts: The MIT Press, 1996)

Gillick, Liam, *Proxemics: Selected Writings (1988–2004)*, ed. Lionel Bovier (Zurich: JRP Ringier, 2006)

Gillick, Liam: Aguirre, Peio, et al., *Meaning Liam Gillick* (Zurich: Kunsthalle Zurich/Cambridge,
 Massachusetts: The MIT Press, 2009)

Gillick, Liam, 'Abstract', in *Microhistorias y macromundos, vol. 3 – Abstract Possible*, ed. Maria Lind
 (Mexico City: Instituto Nacional de Bellas Artes y Literatura, 2011)

Guilbaut, Serge, *How New York Stole the Idea of Modern Art: Abstract Expressionism, Freedom and the
 Cold War* (Chicago: University of Chicago Press, 1985)

Halley, Peter, 'Abstraction and Culture', *tema celeste* (Autumn 1991)

Holmes, Brian, 'Artistic Autonomy and the Communication Society' (2003), *Unleashing the Collective
 Phantoms: Essays in Reverse Imagineering* (Brooklyn: Autonomedia)

Houston, Joe, *Optic Nerve: Perceptual Art of the 1960s* (London and New York: Merrell, 2007)

Jameson, Fredric, 'The End of Temporality', *Critical Inquiry*, vol. 29, no. 4 (Summer 2003)

Judd, Donald: Donald Judd, *Complete Writings, 1959–1975* (Halifax, Nova Scotia: The Press of the Nova
 Scotia College of Art and Design/New York: New York University Press, 1975)

Kracauer, Siegfried, 'The Mass Ornament' (1927); trans. in *New German Critique*, no. 5 (Spring 1975)

Lind, Maria, ed., *Microhistorias y macromundos, vol. 3 – Abstract Possible*, (Mexico City: Instituto
 Nacional de Bellas Artes y Literatura, 2011)

Lind, Maria: *Selected Maria Lind Writing*, ed. Brian Kuan Wood (Berlin and New York: Sternberg
 Press, 2010)

Lippard, Lucy R., 'Eccentric Abstraction, *Art International*, vol. 10, no. 9 (November 1966)

Lütticken, Sven, 'Living With Abstraction', *Texte zur Kunst*, no. 69 (March 2008)

Meyer, James R., *Minimalism: Art and Polemics in the Sixties* (New Haven and London: Yale University Press, 2001)

Meyer, James R., ed., *Minimalism* (London and New York: Phaidon Press, 2000)

Mondrian, Piet, 'Abstract Art (Non-Subjective Art)' (October 1941); reprinted in *The New Art – The New Life: The Collected Writings of Piet Mondrian*, ed. Harry Holtzman and Martin S James (New York: Da Capo Press, 1993)

Möntmann, Nina, 'Opacity: Current Considerations on Art Institutes and the Economy of Desire' (including statements by the artists), in *Art and Its Institutions*, ed. Nina Möntmann (London: Black Dog Publishing, 2006)

Neue Abstraction, special issue of *Kunstforum* (January/February 2011)

Newman, Barnett, 'The Plasmic Image' (1945); reprinted in *Barnett Newman: Selected Writings and Interviews*, ed. John P. O'Neill (Berkeley and Los Angeles: University of California Press, 1990)

Nickas, Bob, *Painting Abstraction: New Elements in Abstract Painting* (London/New York: Phaidon, 2009)

Oiticica, Hélio, 'Colour, Time and Structure' (1960); reprinted in *Painting at the Edge of the World*, ed. Douglas Fogle (Minneapolis: Walker Art Center, 2001)

Oiticica, Hélio: *Hélio Oiticica: The Body of Colour*, ed. Ann Gallagher (London: Tate Publishing, 2007)

Pape, Lygia: *Lygia Pape: Magnetized Space* (Madrid: Museo Nacional Centro de Arte Reina Sofia/Rio de Janeiro: Projeto Lygia Pape, 2011)

Paternosto, César, ed., *Abstraction: The Amerindian Paradigm* (Brussels: Societé des Expositions du Palais des Beaux-Arts de Bruxelles, 2001)

Pérez-Barreiro, Gabriel, ed., *Geometry of Hope: Latin American Abstract Art from the Patricia Phelps de Cisneros Collection* (Austin, Texas: Blanton Museum of Art/New York and Caracas: Fundación Cisneros, 2007)

Perret, Mai-Thu, 'The Crystal Frontier', in *Mai-Thu Perret: The Land of Crystal* (Zurich: JRP Ringier, 2008)

Quéloz, Catherine, 'At the Crossroads of Disciplines: An Economy of Regard', in *Günther Förg* (Paris: Musée d'art moderne de la Ville de Paris, 1991)

Raunig, Gerald, 'Instituent Practices: Fleeing, Instituting, Transforming in Art and Contemporary Critical Practice', in *Art and Contemporary Critical Practice: Reinventing Institutional Critique*, ed. Gerald Raunig and Gene Ray (London: May Fly Books, 2009)

Raymond, Yasmil, ed., *Abstract Resistance* (Minneapolis: Walker Art Center, 2010)

Rider, Alistair, *Carl Andre* (London and New York: Phaidon Press, 2011)

Riley, Bridget: *The Eye's Mind: Bridget Riley, Collected Writings 1965–2009*, ed. Robert Kudielka (London: Ridinghouse Editions/Thames & Hudson, 2009)

Rogoff, Irit, 'Smuggling: An Embodied Criticality' (2006), in *Under Construction: Perspectives on Institutional Practice* (Cologne: Verlag der Buchhandlung Walther König, 2006)

Roysdon, Emily, *Ecstatic Resistance*, poster work (2009); reprinted in *Microhistorias y macromundos, vol. 3 – Abstract Possible*, ed. Maria Lind (Mexico City: Instituto Nacional de Bellas Artes y Literatura, 2011)

Schapiro, Meyer, 'Nature of Abstract Art', *Marxist Quarterly* (January/February 1937)

Stepanova, Varvara, *On Constructivism* (1921), in Alexander Lavrentiev, *Varvara Stepanova: The Complete Work*, ed. John E. Bowlt (Cambridge, Massachusetts: The MIT Press, 1988)

Steyerl, Hito, 'Documentary Uncertainty', *A Prior*, no. 15 (2007); also http://re-visiones.imaginarrar.net

Tuchman, Maurice, and Judi Freeman, eds, *The Spiritual in Art: Abstract Painting 1890–1985* (Los Angeles: Los Angeles County Museum of Art/New York: Abbeville, 1986)

Varnedoe, Kirk, *Pictures of Nothing: Abstract Art Since Pollock* (Princeton: Princeton University Press, 2006)

Worringer, Wilhelm, *Abstraction and Empathy: A Contribution to the Psychology of Style* (1907) (Chicago: Ivan R. Dee, 1997)

Zelevansky, Lynn, ed., *Beyond Geometry: Experiments in Form, 1940s–1970s* (Los Angeles: LACMA/ Cambridge, Massachusetts: The MIT Press, 2004)

Zepke, Stephen, *Art As Abstract Machine: Ontology and Aesthetics in Deleuze and Guattari* (London and New York: Routledge, 2005)

Index

Abstract Expressionism 12, 17, 51, 79, 88, 96

Abstraction-Création 12, 82

Acker, Kathy 225n2

Adams, Alice 95-6

Adès, Dawn 69n1

Adorno, Theodor 19, 134, 143, 144, 145, 150n5, 151n11, n18, 153, 156

Agamben, Giorgio 217

Akhöj, Kasper 24n2

Albers, Anni 14

Albers, Josef 14, 80, 86n6

Aldrich, Larry 78

Althusser, Louis 130, 136n14

Anderson, Jeremy 94

Anderson, Perry 135n1

Andrade, Edna 84, 86n24

Andre, Carl 51, 98

Anuszkiewicz, Richard 16, 82

Apollinaire, Guillaume 65

Arendt, Hannah 188

Armitage, Kenneth 66

Arp, Hans/Jean 29, 30, 31, 33

Arp, Sophie Taeuber- 72

Arrighi, Giovanni 136n11

Art Concret 11, 12

Asher, Michael 100, 214

Ashford, Doug 24n3

Ataman, Kutlug 193

Atelier Van Lieshout 157

Ay-O 90

Bacon, Francis (philosopher) 173

Baden, Mowry 94

Bakhtin, Mikhail 122

Balibar, Étienne 136n14

Barclay, Claire 24n3

Barr, Alfred H. (Jr.) 11, 12, 14, 28-33, 35, 36, 42-3, 46, 137

Bartana, Yael 22

Bataille, Georges 134

Baudrillard, Jean 139, 143, 148, 152n28

Bauhaus 32, 48, 81, 145

Baumgartner, M.P. 141

Becher, Bernd and Hilla 100

Belz, Carl 97n1

Benglis, Lynda 24n2

Benjamin, Andrew 159n6

Benjamin, Walter 134, 159n6

Bergson, Henri 120, 134, 135, 170, 173

Bernstein, Michèle 150n3

Beuys, Joseph 17, 22, 97, 98, 101, 102-3, 109, 110n2, 111n16, n22, 112n35, 138

Bill, Max 13, 146

Black, Tim 156, 160n9

Blom, Ina 19, 152-60, 159n4

Bohrer, Karl Heinz 134, 136n21

Bois, Yve-Alain 110n5, 113, 117n2

Bontecou, Lee 15, 90

Borgzinner, Jon 79, 85n2

Bourdieu, Pierre 160n10, 216

Bourgeois, Louise 15, 90

Brancusi, Constantin 52

Braque, Georges 48

Breer, Robert 96

Breton, André 96

Bronson, Jessica 24n2

Broodthaers, Marcel 100, 214

Buchloh, Benjamin H.D. 100, 101, 102, 103, 104, 110n12-13, 111n14, n28-9

Buckminster Fuller, Richard 103

Bureau d'études 149, 150

Buren, Daniel 99, 100, 103, 105, 214

Bürger, Peter 68, 69n5

Bury, Pol 96

Cage, John 103, 225n7

Carlsund, Otto 47

Campbell, Wayne 94

ACKNOWLEDGEMENTS

Editor's acknowledgements

I want to thank the artists who have contributed to the project *Abstract Possible*, in its different manifestations, from which this anthology emerged: Doug Ashford, Claire Barclay, José León Cerrillo, Yto Barrada, Matias Faldbakken, Claudia Fernandez, Priscila Fernandes, Zachary Formwalt, Liam Gillick/Anton Vidokle, Goldin+Senneby, Wade Guyton, Iman Issa, Gunilla Klingberg, Dorit Margreiter, Åsa Norberg/Jennie Sundén, Mai-Thu Perret, Falke Pisano, Yelena Popova, Seth Price, Walid Raad, Emily Roysdon, Alejandra Salinas/Aeron Bergman, Bojan Sarcevic, Tommy Støckel, Mika Tajima, Haegue Yang. My thanks extend to colleagues who invited me to curate something in their institutions, which then became 'Abstract Possible: The Trailer' at Malmö konsthall: Jacob Fabricius; 'Abstract Possible: The Tamayo Take at Museo Tamayo': Sofia Hernandez; 'Abstract Possible: The Birmingham Beat' at Eastside Projects: Gavin Wade, and 'Abstract Possible: The Zurich Test', the Postgraduate Programme in Curating, University of Zurich: Dorothee Richter. The latter project was produced and mediated by the students Milena Brendle, Chantal Bron, Melanie Büchel, Marina Coelho, Amber Hickey, Sonia Hug, Catrina Sonderegger, Jeannine Herrmann, Garance Massart-Blum, Maria Candida Palha de Araujo Pestana, Veronique Ribordy, Nicola Ruffo, Lindsey Sharman and Silvia Simoncelli. I also want to thank Niko Vicario and Katrin Ingelstedt for assisting me in researching texts on abstraction.

Publisher's acknowledgements

Whitechapel Gallery is grateful to all those who gave their generous permission to reproduce the listed material. Every effort has been made to secure all permissions and we apologize for any inadvertent errors or ommissions. If notified, we will endeavour to correct these at the earliest opportunity. We would like to express our thanks to all who contributed to the making of this volume, especially Ina Blom, Lynne Cooke, Anthony Davies, Stephen Dillemuth, Judi Freeman, Ferreira Gullar, Liam Gillick, Joe Houston, Jakob Jakobsen, Fredric Jameson, Peter Halley, Lucy R. Lippard, Louise Liwanag, Sven Lütticken, Nina Möntmann, César Oiticica, Gabriel Pérez-Barreiro, Mai-Thu Perret, Catherine Quéloz, Gerald Raunig, Bridget Riley, Irit Rogoff, Emily Roysdon, Hito Steyerl, Stephen Zepke. We also gratefully acknowledge the cooperation of ADAGP, Black Dog Publishing, George Braziller Publishers, Design and Artists Copyright Society, Peter Halley Studio, Harvard University Press, David Kordansky Gallery,

Los Angeles County Museum of Art, Merrell Publishers, Projeto Lygia Pape, Princeton University Press, Museo Nacional Centro de Arte Reina Sofía, Ridinghouse, Board of Trustees, National Gallery of Art, Washington, DC.

Whitechapel Gallery

whitechapelgallery.org

Whitechapel Gallery is supported by